Eve of a HUNDRED MIDNIGHTS

Eve of a

HUNDRED
MIDNIGHTS

The Star-Crossed Love Story of Two

World War II Correspondents and Their Epic

Escape Across the Pacific

BILL LASCHER

WM

William Morrow

An Imprint of HarperCollins*Publishers*

HarperCollins books may be purchased for educational, business, or sales promotional use. For information please e-mail the Special Markets Department at SPsales@harpercollins.com.

FIRST EDITION

Library of Congress Cataloging-in-Publication Data has been applied for.

ISBN 978-0-06-237520-9

16 17 18 19 20 OV/RRD 10 9 8 7 6 5 4 3 2 1

CONTENTS

Part Three

Eve of a HUNDRED MIDNIGHTS

PROLOGUE:
THAT STAGE OF THE GAME

*I*nside a Los Angeles living room, a woman in her late seventies held court. She wore a black sweater-vest with an embroidered Christmas tree and sat on a couch with her back to the windows. She held a glass of white wine and was gesturing with her other hand as she told a story.

This was my grandmother, Peggy Cole, the matriarch of a clan that stretched back for five generations of our Los Angeles family. She clung to few traditions, but did believe that whenever the family assembled, a "cocktail hour," with wine and cheese, was essential. And though her family consisted mostly of assimilated Jews, she thought Christmas was as good a time as any for us to gather.

Recently, Peggy and her husband, Curt Darling, had given up one of their homes, and she had been going through the oddities she'd accumulated over half a century. Peggy gave most of it away, but she kept one item aside that she wanted me to have.

As our family began opening gifts, my grandmother directed my attention to a weathered, brown, hard-sided rectangular case under the tree. It had two metal latches and a fraying leather handle, wasn't wrapped, and was heavy for its size. With two resonant clicks, I sprang the latches and opened up the case. Its insides smelled of the back corners of bookshelves, of old army footlockers, of history, of adventure.

Inside there was a small, elegant typewriter. Four banks of round, cream-colored keys rose from its low-profile, black metal frame. A gold leaf panel decorated either side of the machine. Its plunging neckline revealed rows of long, gray type bars. At the center of this décolletage, gold lettering on the frame spelled out "C–O–R–O–N–A" like a necklace charm.

Melville Jacoby seated in front of the Press Hostel in Chungking (Chongqing), China. *Photo courtesy Peggy Stern Cole.*

My grandmother told me that the typewriter—a Corona 4 portable, manufactured in 1930—had once belonged to her cousin. He had been a newspaper, magazine, and radio correspondent in the Pacific during World War II, she said, and before that he had lived in China as an exchange student. She

knew I had long dreamed of being a reporter myself, and she thought I was the one in the family who would most appreciate this typewriter.

I was dumbstruck. How had I never heard of this cousin and of all the adventure and romance surrounding him? His name was Melville Jacoby, but everyone knew him as Mel. Fantasies I'd long had of becoming a foreign correspondent were realities he'd lived. I had to know more.

When Mel bought the typewriter, he was roughly the same age I was that Christmas. Within a year of that holiday, I started working as a reporter at a coastal business journal, a job as sleepy as Mel's work was exciting. He had set out to help his generation come to know a distant land that most Americans still don't understand. He then tried to help them comprehend a war that circled the globe. But as glamorous as Mel's life seemed from the outside, he had struggled for a long time to find his career footing.

Shortly after that Christmas, I went to see my grandmother for the first of many visits. During each visit, after our wine and cheese, she pulled out a banker's box full of manila file folders that she'd rediscovered in her move. The files had titles like "Madame Chiang," "Burma Road," and "Philippine Clippings." There were a half-dozen brown photo albums whose pages had begun to stick together, but inside their protective cellophane sleeves were pristine photos of soldiers sharing cigarettes in a jungle, twenty-somethings in Oxford shirts with rolled-up sleeves laughing at desks piled high with newspapers, and world-weary Chinese men in sandals and robes sitting on piles of rubble in front of half-destroyed homes.

The closet also held other envelopes full of negatives, pamphlets from aid organizations, even a cookie tin containing 16-millimeter film canisters with fading ink labels. Across the top of a shallow green cardboard box someone had used a black

marker to write "WWII Letters." Inside were typewritten reports from battlefields in sweltering corners of China, copies of cabled dispatches dashed off from places like French Indochina to United Press bureau chiefs, and letters addressed to editors at *Time* magazine.

One letter was a carbon copy of a cable Mel had sent to David Hulburd, a news editor at *Time*. The letter described a fiery New Year's Eve in the city of Manila, its roads blocked and its harbor full of boats that had been destroyed by Japanese planes or scuttled by retreating American soldiers.

"There were no other ships and even if there were, the Japanese Navy was sitting outside Manila Bay—waiting," Mel wrote. "The Japanese forces were closing toward Manila from north and south Luzon in such force, with so many dive bombers, that it hardly seemed Bataan could hold a week."

Towers of flame and a waxing sliver of moon lit Manila as 1941 neared its violent close. Japanese troops were expected in the Philippine capital by morning. Every few minutes, explosions echoed throughout the city, heralding the new year that was just a few hours away. That night a scene of utter chaos spread along the waterfront, with the most activity concentrated around its warehouses and piers.

Across the street from the waterfront, nearly three dozen journalists were crammed into room 620 of the Bay View Hotel. Peeking through the room's blackout curtains, they could see retreating bands of American soldiers blowing up munitions dumps, setting fire to fuel reserves, and dynamiting radio installations. Only a few hours earlier that day, a hospital ship had been painted with the red and white markings of the Red Cross; now, just thirty minutes before midnight, the reporters

watched as the ship—the *Mactan*—cautiously threaded its way through the mines that had been planted all over the bay.

For days, members of the U.S. Army Transportation Service had been frantically trying to move merchant ships from Manila's piers and the mouth of the Pasig River. Those ships that the ATS couldn't move had been scuttled. Bombed and sabotaged vessels littered the harbor; according to historians E. Kay Gibson and Charles Dana Gibson, at least twenty large ships had sunk in the harbor by December 29.

That New Year's Eve the streets were filled with nervous Manila residents trying to get out of town before the Japanese arrived. As some fled, others tore through waterfront storage facilities. Some looted valuables, fuel, and food; others unhurriedly sifted through warehouses as local police either looked the other way or grabbed their own loot.

The reporters in the hotel fretted, bickered, and made wild guesses about their future. Manila had until this point been nominally protected by the United States, but with the U.S. military pulling out, the city would be abandoned by daybreak. The New Year would bring new rulers—the Japanese—who had closed in on the city after a fast drive across Luzon, the largest of the Philippines' more than 7,000 islands.

General Douglas MacArthur's U.S. Army Forces in the Far East had begun abandoning Manila on Christmas Day, and shortly after that MacArthur declared the capital an "Open City." It was an invocation of international law intended to limit damage to the city. It turned out to have been taken in vain: Japan continued and intensified its bombing of Manila after the declaration.

Meanwhile, MacArthur prepared for a last-ditch defense of the Philippines. Even as the country's capital burned, most of those under MacArthur's command—about 12,000 Americans

and 63,000 Filipinos—dug into positions at the base of Mariveles Mountain on the Bataan Peninsula, a jungle-choked outcropping around Manila Bay to the west.

Most forces that had not been sent to Bataan—including MacArthur and his headquarters staff—ended up on Corregidor, a heavily fortified, tadpole-shaped island two miles south of Bataan that stood sentinel over the entrance to the bay. Known as "The Rock" to most of MacArthur's forces, Corregidor bristled with anti-aircraft batteries and artillery installations, while a nest of tunnels and storerooms burrowed beneath the island's surface housed command centers, hospitals, and residences for officers and other VIPs. But as the Japanese approached the island began to feel more like a prison as supplies dwindled, the attacks worsened, and the possibility of reinforcements evaporated.

The journalists at the Bay View were deadlocked, and they began weighing their different options. They could search for a ship captain willing to navigate the mine-strewn bay and attempt to run a tightening Japanese blockade, or they could try to flee by land on routes that were either blocked by firefights or plugged up by slow-moving caravans of withdrawing troops and civilian refugees. Another option was one that thousands of other American and British civilians in Manila would take: remain in the city and hope to weather the enemy occupation.

Most of the reporters were veterans of a nearly five-year-old war between Japan and China. They had survived the air raids, occupations, and massacres in other cities across East Asia, but this time their own country was at war. If they were captured, they might be executed if Japan deemed their reporting too critical or their past ties to Chinese or American officials too tight.

This wasn't just Manila's last night of freedom. This was the last night the thirty-two reporters packed into the Bay View would spend together. A group bonded as tightly as any army platoon in the heat of battle—many of them had served alongside one another for years in the heat and stink and drama of China's wartime capital, Chungking (Chongqing; Chungking was how Westerners of the era wrote it), where they were once so young, so eager, and so ready to take on the world—would soon fracture.

Hosting the press corps in their room was a young couple who had been married only a month earlier: a fair-skinned but dark-featured twenty-five-year-old *Time* correspondent named Melville Jacoby, and Annalee Whitmore Jacoby, a former MGM scriptwriter, also twenty-five years old. Mel had already spent a number of years in China reporting on the Second Sino-Japanese War, which had merged with World War II, while Annalee had given up her Hollywood career to go to China and write about what she saw as the true epic of her time. They'd fallen in love in Chungking, only to follow the story that had brought them to Manila. Both had realized that if they stayed in Manila, they would almost certainly be killed, and yet escape was a gamble as well.

"The last two weeks in Manila were the worst," Annalee wrote later. "The Japanese were getting closer; we knew Mel would probably be killed if they got him; and every way of getting out failed as soon as we thought of it."

The Jacobys were not the only married journalists in the Bay View. Carl Mydans and Shelley Smith were both *Life* magazine contributors; as fellow Time Inc. hands, they had worked closely with Mel since the summer. Carl was a photojournalist who had shot the Russo-Finnish War of 1940 and documented the Great Depression, while Shelley was a writer who also meticulously cataloged and captioned her husband's photos.

When Mel and Annalee wed, Carl had been Mel's best man and Shelley—who had attended Stanford with both of the Jacobys—was Annalee's matron of honor. Besides one other *Time* reporter, they had been the only witnesses at the wedding. The Mydanses were more than colleagues: they were the Jacobys' closest friends in the Philippines. But at this crucial moment the friends disagreed about what they should do. Mel and Annalee wanted to flee Manila, while Carl and Shelley leaned toward weathering an occupation.

In Chungking, all four had been members of a tight-knit community of foreign correspondents, most of whom even lived together. Their friends had seen what Japanese soldiers did when they conquered other Chinese cities, most notoriously the former capital of Nanking (Nanjing). The possibility of similar atrocities in Manila loomed, but this night was also about survival and the ability to continue telling the war's story.

Mel also suspected there might be a mark on his head given his past encounters with the Japanese and the fact that he'd once worked for the Chinese government. A year earlier, after Mel photographed Japanese officers at a warehouse in Haiphong, Indochina (present-day Vietnam), they had chased and arrested him and the U.S. diplomat he was traveling with, prompting a brief diplomatic dustup. A month before the attacks at Pearl Harbor, Japanese diplomats had also warned Mel not to print anything negative about the Japanese officials passing through Manila.

Nobody in the room yet knew just how many thousands of American troops had gathered in Bataan or on Corregidor. As far as the reporters understood, MacArthur's troops would be lucky to last another week. Escape to either of these last-ditch positions might only mean delaying the inevitable. The frequent blasts persisting outside the hotel signaled how urgent

the reporters' situation was. On the streets below, the army was finishing its withdrawal while continuing to sabotage anything potentially of value to the Japanese.

The reporters continued to dissect their options in the Jacobys' hotel room. Despite the danger, Mel thought that remaining in the city might guarantee Annalee's safety better than escaping to some uncertain destination, but when he made this suggestion, Annalee wouldn't hear of it. She was certain Mel would die if they didn't flee.

"We're going, Mel," Annalee insisted.

Even this early in their marriage, Mel knew he wouldn't be able to change Annalee's mind.

Still, they needed a way out. Mel remembered that earlier he'd met two merchant mariners whose tug hadn't yet left Manila; if he could find them, he might be able to convince them to smuggle some reporters out of the city. In search of the captains and their ship, Mel left the hotel room and descended into the frenzy engulfing Manila's waterfront.

Part One

Chapter 1

"WHY SHOULD I CONTRIBUTE A LITTLE MORE TRASH?"

*J*esse Lasky arrived at downtown Los Angeles's La Grande Station on a Santa Fe Railway train. He told a cab driver he was looking for a place called Hollywood. It was January 1914, and the driver hadn't heard of the place. Eventually, however, they found a quiet development amid rustic canyons and orchards about seven miles west of downtown.

Lasky was looking for a business associate, Cecil B. DeMille, an unknown filmmaker from New York who ended up in Los Angeles after trying, unsuccessfully, to direct a feature-length movie in Flagstaff, Arizona. DeMille had wired his principal backer, Samuel Goldfish—who would later change his last name to Goldwyn—who dispatched Lasky to find out what the director was doing with their money. Eventually, Lasky and his driver arrived at the address DeMille had provided, a five-acre estate of palm trees and lemon orchards at the dusty intersection of Hollywood Boulevard and Vine Street. Lasky headed around back, near Selma Avenue, where he saw a barn. There, to his surprise, he found that DeMille had turned the barn into a film studio where crews were busily completing a western.

DeMille hadn't told Lasky or Goldwyn that he had sublet the barn from two other early film pioneers—Louis Loss Burns and Harry Revier—or that he was now using it to produce a movie. Lasky was sufficiently impressed by the production, however, and he and DeMille agreed to completely take over the lease. They used the barn to finish Hollywood's first feature, the unfortunately titled *The Squaw Man*. Released in 1914, the film was a success, and the partnership behind it led to the formation of Paramount Studios.

DeMille's and Lasky's success as filmmakers might not have come as easily had they not crossed paths with a Jewish, German-born merchant named Jacob Stern. In 1889 Stern moved to Fullerton, a then-rural town in Orange County, California. There Stern and a cousin opened a general store. Stern soon had six locations and shifted his business interests to real estate.

In 1904 Stern bought the property at Hollywood and Vine. It was a comfortable home where he and his wife Sarah could raise their four children: Harold, Elza, Helen, and Eugene. Eight years later, he leased out the barn that DeMille ended up using. It became one of the key sites around which Hollywood's film industry grew, and Paramount Studios kept its lot at that corner until the company grew too large to remain there.

Amid the hoopla of the movie business's early days, the Sterns' second daughter, Elza Stern, fell in love with a young man named Melville Jacoby, whose father, Morris, had come to Los Angeles from Poland and started a retail clothing business with his four brothers. Like the Sterns, the Jacobys emerged as one of Los Angeles's first commercially successful Jewish families.

Elza and Melville Jacoby were soon married. Their son, Melville Jack Jacoby, entered the world on September 11, 1916.

A booming Hollywood glimmered around the boy and his family, who thrived in the burgeoning city.

That is, until 1919. The First World War had just drawn to a close, leaving millions dead in its wake. An even deadlier scourge followed: Spanish influenza. The epidemic—believed to have originated in China—killed somewhere between 20 million and 40 million people around the globe. In the United States, nearly one-quarter of the population contracted the disease, including the elder Melville Jacoby. In January 1919, before his son was even two and a half years old, Jacoby died.

Elza Jacoby had a nervous breakdown following her husband's death. The Sterns swooped in and brought Elza back to their home at Hollywood and Vine, where together they cared for her and Mel. For the next four years, Elza's parents, siblings, and household staff helped raise the boy. Elza eventually recovered from her depression, strengthened in part by converting to Christian Science.

"As young as [Mel] was, he seemed to sense how very much a young mother needed him," Elza later told the writer John Hersey.

When Mel was six years old, Elza purchased a house in L.A.'s Benedict Canyon, where she tried to care for Mel on her own. Elza was attentive, and her son was dutiful, possibly too much so.

"My chief difficulty was to get him to go outside and play, so long as there was as much as a wastebasket to empty inside," she recalled, perhaps with a bit of motherly embellishment.

Mel's frequent visits to his grandparents' home while he was growing up let him observe Hollywood's early days. Despite the bustle around him, Mel seemed happiest in the Sterns' swimming pool. Elza always fretted about his long dives beneath the pool's surface. But Mel appealed to her newfound

religion, insisting that "God's under that water too. He'll show me how to come up again."

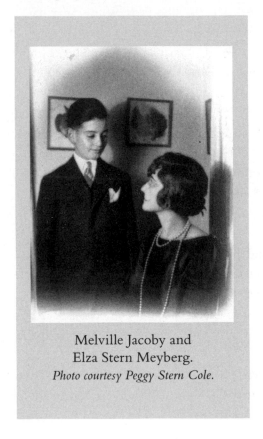

Melville Jacoby and
Elza Stern Meyberg.
Photo courtesy Peggy Stern Cole.

A few years after her first husband's death, Elza fell in love with Manfred Meyberg, another member of Los Angeles's tight-knit Jewish community. He had worked his way up from office boy to president at Germain's Seed and Plant Company, one of the era's largest agricultural supply companies.

On March 8, 1922, the year Manfred bought a controlling stake in Germain's, he and Elza wed. The marriage lightened Elza's spirits as well as Mel's. Though Mel welcomed "Uncle Manfred" into his life, he still spent enough time at his grand-

parents' home that their youngest son, Eugene, considered Mel—ten years his junior—more akin to a younger brother than a nephew.

If Mel felt smothered by Elza, he didn't make such feelings known. Still, Elza sent Mel away to summer camp when he was eight years old, in part to help put some distance between them.

"I still remember the expression on that little fellow's face, when I drove away and left him with all those strangers," she wrote nearly two decades later. "When he saw I was beginning to weaken, he said 'you promised me you wouldn't cry,' and I didn't—nor have I the many times in the past six years, when I have bid him goodbye—only because Melville has helped to make me a stronger woman."

Despite his father's early death, Mel had a happy childhood full of typical boyhood passions. He was a lifelong stamp collector, or philatelist, who would search for new designs throughout his journeys around the world. Mel's "boy" Elmer, a black and white Australian shepherd, meant so much to him that he sometimes sent postcards home addressed to the dog from his many travels; over the years lovers and friends would know to ask after Elmer, having either heard about or met the dog.

Mel also started writing early, beginning with small pieces that appeared in Hollywood's Selma Avenue Elementary School's weekly paper. After transferring to Hawthorne School in sixth grade, he became a sports editor. By the time he was a junior at Beverly Hills High—where he was an honor society member—Mel was the school paper's business manager and, later, its news editor.

A fan of camping and being outdoors, Mel also grew up when much of the Los Angeles area was still undeveloped and blanketed with sagebrush, oaks, and poppies. He had ample space to freely explore the wild hills and canyons surrounding

Beverly Hills and Hollywood, collect Native American arti-
facts, and attend summertime concerts at the Hollywood Bowl.

He often refused the box seats offered to his well-connected
family and chose instead to climb the outdoor amphitheater's
stairs to its highest row. There, lying on a bench and staring at
the night sky, he would lose himself in the stars and the music.

This wistful streak reflected in Mel's stargazing nights grew
into a restlessness as he got older. He recognized as much as
anyone his need for direction. Despite the relative comfort of
his childhood, Mel was eager to succeed through his own ef-
forts. Nevertheless, Mel wooed dates, impressed employers,
made friends, and developed sources with charisma augmented
by a dry sense of humor, handsome features, and a slim but
athletic body sculpted by years of swimming and recreational
boxing. At six-two, Mel was certainly tall. A hirsute man de-
scended from Central European Jews, he had fair skin with dark
hair and eyes, traits that later prompted a newspaper in China
to describe him as "a rugged dark featured young American."
Quick to flash his amused, closed-lip smile, he had a habit of
absentmindedly stroking his cheek as he thought.

"Mel was tall, dark, and slim, alternately boyish and then
mature beyond his [years]," another of his contemporaries
wrote.

After high school, Mel went to Stanford University. There he
signed up with the Reserve Officers' Training Corps (ROTC)
and even learned to fly. He also joined Stanford's water polo
team and made varsity by the end of his sophomore year.

"I'm nuts about water polo, and I can't wait to get into the
pools," he told his parents, undeterred by the black eyes, cut
lips, and bruises he also frequently acquired through the sport.

Two more friends of Mel's came with him to Stanford from
Beverly Hills: J. Franklin "Frank" Mynderse and Winton
"Whimp" Ralph Close. The trio were inseparable, and the

friendships garnered Mel a nickname from Whimp that would fit his entire life: Tony Tramp, "because he always wanted to go someplace."

In one citizenship class during his second semester at Stanford, Mel wrote a paper he titled "My Private Utopia." This "harmony"-themed society seemed to draw from the same idealism that helped shape Franklin Delano Roosevelt's New Deal. Mel's utopian vision featured a heavily managed economy, treasured scientific and industrial innovation, and insisted that beauty be "embodied in factories as well as homes." (In what must have been a nod to his stepfather's seed business and his mother's prizewinning yards, it even called for a home with a garden for everyone.)

This vision prioritized travel as a societal value and inextricably linked the economy to environmental preservation. Mel, who had taken several childhood trips through the country's young national park system, envisioned protecting nature as society's paramount cultural goal. Film, dance, and fashion were necessary for happiness, Mel wrote, but "they would [lose] their appeal if natural beauty should suddenly vanish."

Toward the conclusion of the paper, Mel seemed to return from some kind of mental vacation as he acknowledged that "ambitions, greed, fear, and drudgery" were realities that had to be addressed. Still, he had presented a beautiful dream.

Wrote his professor upon returning the assignment: "Don't you ever come clear down, will you?"

Though Mel easily made new friends at Stanford, he complained about the difficulty of fitting in with Stanford's fraternities and "eating clubs."

"Well, I've started being left out," he reported a month into his studies. "Mr. Wadsworth, bev. high, sent recommendations

to his fraternity here for all Beverly kids except Mel. I guess he didn't mention me because I don't hold my nose right. I am going to try out for the *Stanford Daily* staff tomorrow."

It was the next day that Mel began to find a place for himself. He joined fifty other "tryouts" vying for work at the *Stanford Daily* and made the cut as a reporter (though it was demanding and time-consuming work, especially alongside his water polo commitments). Around the time Mel tried out for the paper, a sophomore named Annalee Whitmore was a copy editor; she was a class ahead of Mel, and the pair rarely interacted.

In 1936, when Melville Jacoby entered his twenties, his life permanently pivoted, beginning with a family crisis.

At the beginning of the year, Elza and Manfred Meyberg were expecting their first child. But on the morning of January 20, Elza felt that something was wrong. Manfred rushed her across Los Angeles to Good Samaritan Hospital. Elza went into labor and gave birth to a daughter, Marilyn. But Marilyn never had a chance, and twelve hours after birth, she died. It was ten days before Elza's birthday. She and Manfred never had another child.

Elza, Manfred, and Mel were understandably devastated, but as summer approached Mel had exciting news: he had won a scholarship to study abroad, through a new student exchange program between the United States and China. Instead of returning to Stanford the next school year (when he would have been appointed an Army second lieutenant through his ROTC work), Mel would continue his studies at Lingnan University, a missionary school in Canton (Guangzhou), a southern port city on the Pearl River (Xi Jiang) Delta.

This student exchange program was part of the Pacific Area

Exchange, which a Hawaiian-born student named Frank Wilson began after independently enrolling in Lingnan three years earlier. By 1936, thirty-two students—mostly selected from the Ivy League and other elite American universities—had been invited to participate after intensive interviews, letters of recommendation, and an essay contest. They joined a Lingnan student body comprising primarily children from China's wealthiest families, as well as a number of American-born students of Chinese descent, who generally looked down upon their counterparts whose families hadn't left Asia.

Before school started, many members of the Pacific Area Exchange's 1936–1937 class traveled to China together by way of Japan. Mel didn't join them. Perhaps hoping to transform their lingering grief about losing baby Marilyn into positive energy, Mel's mother and stepfather offered to send him on a once-in-a-lifetime grand tour of the globe and readily funded the adventure. With their assistance, Mel bought a $500 around-the-world ticket that covered a berth on a boat from New York to London and on to Paris. It also paid for lodging in each city, and stays in Holland, Switzerland, and Italy. Included as well was space on another ship. That vessel crossed the Mediterranean, stopped in Malta, sailed through the Suez Canal to Yemen, and proceeded through India, Ceylon (present-day Sri Lanka), and Singapore. Finally, Mel continued to Hong Kong and Canton. Additional expenses along the way totaled $600.

A Stanford friend—a fellow Angeleno and *Daily* hand named John Kline—joined Mel for the journey. They crossed the Atlantic on a steamer packed with 600 other students, most from schools such as Duke, Harvard, Smith, and Princeton. Mel, who usually took pride in how he dressed, felt uncomfortable around the Easterners.

"I feel like a tramp in my finest duds," he admitted.

Mel was happy to check off castles, museums, cathedrals, and other standard tourist landmarks, but he also took note of a world becoming unsettled: shipyards operating at all hours building warships in England, German agents trying to recruit Nazis on street corners in Switzerland, and swarms of Fascist police and military all over the Italian streets. While Mel witnessed these scenes, fighting was breaking out between Spain's leftist Republican government and the right-wing nationalists led by Francisco Franco.

"Affairs in Europe are in an awful tangle," wrote Mel, who also encountered groups of refugees driven out by the Spanish Civil War on his journey. "It will be impossible to put off another war with all the arming & animosities now brewing."

Mel was not optimistic about the prospects for world peace.

"Yes sir, they are all waiting for the explosion over here," he added.

As Mel's voyage progressed from Europe through the Middle East and on to East Asia, he clamored for opportunities to experience local culture, the less touristy the better. These experiences included watching a Malaysian wedding, visiting a Zoroastrian Tower of Silence where vultures fed on corpses, and seeing moonlight filter through cocoa palms in Singapore.

"The people I guess made it nice for us, but the tropics and Orient get a hold on you," he wrote on the second-to-last leg of his trip. "Really, as much as I would like to be home, something is already anchored out here. It's just plain fascinating, that's all."

Finally, Mel arrived in Canton right on his twentieth birthday: September 11, 1936. At Lingnan, he and the other American students—twenty-three men and nine women—were required to live with Chinese roommates (each woman in the program had two roommates) and eat at least one meal per day in the university's dining halls.

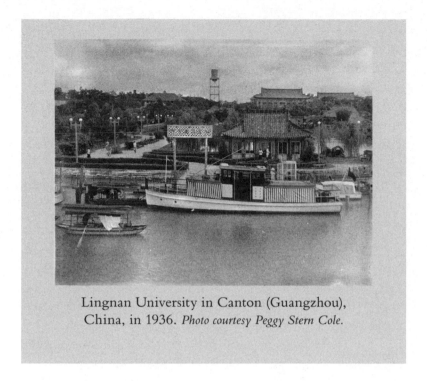

Lingnan University in Canton (Guangzhou), China, in 1936. *Photo courtesy Peggy Stern Cole.*

Beyond the pastoral island that housed Lingnan was a noisy harbor. A few months into his year at the school, Mel sat in an open dorm room window, listening to silence fall over the nearby port. He began a letter to his mother and stepfather:

The clatter of wooden shoes and the high pitched jabber of foreign voices has finally ceased. Even the village drums have quit their mighty rattle—in a word, it is now exactly one a.m. and the most glorious Oriental moon imaginable is rising. Its light makes visible the aged salt junks and square rigged whalers on the slug-gish river. All this I can see from the window as I sit and write you tonight.

Canton was one of the five "treaty ports" at which Western governments carved out essentially sovereign "extraterritorial" settlements from Chinese territory. It was a cauldron of political ferment in the early twentieth century. Here Sun Yat-sen—considered by Communists and Nationalists alike the father of modern China—began his revolutionary work. But Lingnan, accessible only by boat from Canton, was largely isolated from the surrounding turmoil.

Still, Lingnan's campus—with its palm-shaded brick dorms and vines creeping across walkways—was not hermetic. With the river's mouth just beyond campus, Mel could see waters packed with subsistence fishers, crowded sampans steered by large wooden rudders, cargo boats, and all manner of other craft. Countless thousands of destitute people, known as "those born on the waters" (Sui Seung Yan) and considered ethnically distinct from China's Han majority, worked and survived on the river. In the letter Mel wrote that night while sitting in his dorm window, he noted that local residents made the equivalent of only about 31 U.S. cents each to spend on food every month.

"The river people, a distinct tribe, have a hard life," he wrote. "I've noticed how hard they work. Women row, and children start before they can walk and few have slept on land."

Not all of Mel's letters contemplated social issues. Some dripped with privileged Western arrogance about the squalid conditions in China. Others glowed with wide-eyed wonder at the places he saw and even a touch of compassion for the people he met. Some brimmed with warm love for his family. Others bristled with the kind of filial griping that parents have endured through the ages.

The epistolary Melville Jacoby was at different moments a know-it-all, a brash adventurer, an insecure student, a casual—

even aloof—lad, and a charming flirt who frequently wrote about this or that date he had arranged.

Mel also wrote frequently about the friendships he was developing at Lingnan. He quickly bonded with his Chinese roommate, Chan Ka Yik, and Chan's best friend, Ching Ta-Min (who went by the Westernized name George Ching), who lived across the hall with a Harvard student named Hugh Deane.

"I tried to take them to see Chinese things," George later recalled. "Things that they don't have [in America]."

One day, for example, George took Mel and some other American students for an exotic dinner.

"The first course was snake soup," George remembered. "I tried it first, and said, 'Ah, very delicious,' so I convinced them to try it."

Two or three of the exchange students still refused. George insisted.

"Try a little bit," he said. "You come to China, I want to show you something that's good."

The Americans brought the soup to their lips hesitantly. As they took tiny sips, looks of surprised pleasure washed across their faces.

"They finished the whole thing, and later they ordered two more," George said.

Mel wasn't quite as enthusiastic when he wrote home about the meal.

"Roommate and a Chinese friend took me in last night for a snake dinner," Mel wrote. "Considered a real delicacy and is very costly over here. Suffered through five courses of the reptile and felt the effects last night. Some food, snakes."

In addition to this kind of culinary adventure, George and

Ka Yik were able to expose their American roommates and friends to Chinese experiences that might otherwise have been inaccessible. Both young men came from influential families. Until shortly before the semester started, George's father had been the mayor of Canton. George had been born in Berkeley, California, while his father studied at the University of California.

Ka Yik's father was a wealthy landowner. His brother was a high-ranking military officer who advised Pai Chung-hsi (Bai Chongxi). A onetime rival of China's Nationalist leader, Generalissimo Chiang Kai-shek (Jiang Jieshi), Pai became one of the Generalissimo's key strategists. In the southwestern province of Kwangsi (Guangxi), Ka Yik's family owned vast tracts of agricultural property that his father administered from a sprawling home just east of Jintian* village.

With their Chinese roommates as guides, Mel and a handful of other Americans shared many adventures in and around Canton. Through a complicated series of trades and purchases involving a camera, a chair, bicycles, a blanket, and a subscription to *Time,* Mel obtained a year-old motorcycle that he hoped would help him explore farther afield. He hoped to see the China beyond Lingnan's cloistered campus. Meanwhile, as the school year progressed he started paying more and more attention to the saber-rattling between China and Japan, the shake-ups in China's fragile national government, and other increasingly chaotic political and international events. Other students, among them Hugh Deane, also took notice.

* In the nineteenth century, this same riparian backwater produced one of China's most notorious would-be revolutionaries: Hong Xiuquan. Believing himself to be the brother of Christ, Hong led the Taiping Rebellion, a massive uprising that ultimately killed 20 million people.

"For most of the American students at Lingnan, the experience was a superficial adventure," Deane wrote after describing how some of Lingnan's Chinese students wanted Chiang's Kuomintang (Guomindang) Party to focus less on Communists and more on Japan, which had occupied Manchuria in 1931 and continued to threaten other parts of northern China. "We shopped for ivory and jade, visited Macao [Macau] for a bit of sin, and monasteries in the Kwantung [Guangdong] mountains for climbing and an exotic change. We accepted the misery around us, bargained with rickshaw pullers whose life expectancy was five years. But a few were caught up by the struggle going on in China, tried to understand it, and became involved in one way or another."

Mel, Hugh noted, was among those few.

Early that December, when Mel scrawled his letter from his moonlit dorm, China and Japan were racing toward war, and he wondered if, instead of staying at Lingnan after winter break, it made more sense for him to leave the school. Some classmates decided to drop out of the program to explore Asia. Mel criticized them at first, but reconsidered around the holidays. While he liked Lingnan, he felt that its academic offerings were limited and wondered whether he might be better served exploring other parts of China. He wanted to stop in Peiping (Beijing) and "see it before the Japanese [wreck] it," visit Japan itself, and perhaps even travel across Russia.

"I'm far from a Bolshevik, but I do believe Russia is worth looking into and really seeing what's what," he said.

Whatever Mel decided about the school year, he made one clear assertion about his future.

"As for me writing anything for publication, I don't want to ever do that," Mel wrote. "So please get that out of your mind. There are hundreds of other people here in the Orient from the

States who see just what I see and most of them have written about it. Why should I contribute a little more trash?"

In the middle of December, Chiang Kai-shek traveled to Sian (Xi'an) to confer with Marshal Chang Hsueh-liang (Zhang Xueliang)—also known as "the Young Marshal." The Young Marshal had inherited control of Manchuria after Japanese agents assassinated his father. But he was forced out after Japan invaded Manchuria and set up the puppet state of Manchukuo. The Young Marshal continued to direct his armies against Japan's forces in Manchuria until 1935, when Chiang's government instructed him to back off and instead focus on the Communist forces gathered at the inland city of Yenan (Yan'an), west of Sian.

A year earlier the Communists had arrived in Yenan at the end of their "Long March," a grueling, nearly 4,000-mile flight from power centers in Canton and Shanghai. Though it began with 100,000 troops and support personnel, only a few thousand marchers survived the yearlong trek across dozens of rivers and mountain ranges while beset by government attacks and starvation. After reaching Yenan, Mao Tse-tung (Mao Zedong) consolidated his power as the Communists' leader and his party cast the heroics of the march as one of its key foundational sagas.

Chiang had wanted the Young Marshal to help fight the Communists, but Chang, who still saw Japan as the greatest threat, devised a scheme to make that country the Chinese government's priority. On the pretext of discussing military strategy, the Young Marshal invited the Generalissimo to Sian. When Chiang arrived, forces loyal to the Young Marshal detained the Generalissimo and put him under house arrest in a

nearby villa. The kidnapper spent the next two weeks trying to compel his captive to commit to a "United Front" with the Communists against Japan.

"News flash, twenty hours old, but important enough to cause a war if one suspects it's true," Mel wrote of the Sian incident to his mother and stepfather just before Christmas 1936.

"It would be a good time with the English so busy for the [Japanese] to strike," Mel wrote. The Sian incident began on December 12, 1936. The day before, Great Britain's King Edward VIII abdicated his throne to marry the American divorcée Wallis Simpson.

News of Chiang Kai-shek's detainment spread through a shocked China. Rumors abounded. Had he been handed over to the Japanese as a prisoner? Had the Young Marshal engineered a coup? Kuomintang officials quickly spun the story. The message reaching Mel and others in Canton, for example, was that the Young Marshal had "sold out" to the Japanese.

"We think that Chiang Kai-shek is dead now, but even if he isn't, this move has lost him so much face that it will be a long time, if ever, before he regains the place he lost in the eyes of the people," Mel told his parents.

Chiang turned out to still be alive. Two weeks of back-channel negotiations among the Kuomintang, the Communists, and a number of foreign mediators won his release. In return for freedom (and the Young Marshal's surrender to house arrest), Chiang agreed to a United Front. The deal was structured to appear as if the Communists agreed to set aside differences with Chiang for the duration of the war, allowing the Generalissimo to maintain the face that Mel was certain he'd lost. The country needed to project the image of a powerful leader as it prepared for war.

=====

Although Mel noted the kidnapping, he wasn't initially distracted by the event. Having begun learning to fly at Stanford, Mel continued his training at an aviation school in Hong Kong while he was studying in China. There he met Carlos Leîtao, the son of a tycoon who owned the Bela Vista and Riviera Hotels in Macau, a Portuguese colony about sixty miles southwest of Canton. Carlos, whose Portuguese father had three wives and more concubines, all of whom were of Chinese ethnicity, invited Mel and other Lingnan friends to Macau for lively weekends full of parties flowing among the colony's hotels, cabarets, and casinos.

Just after the new year, on the first of these weekends, Carlos brought Mel to the Bela Vista, a colonial structure of pastel pink, white trim, and wide south-facing balconies that overlooked the winding Avenida de La Republica and the bay beyond. There, Mel met Carlos's large family. He was immediately entranced by Carlos's sister Marie.

"Everyone says she is the best looking girl that they have ever seen," Mel reported to his parents.

Through the ensuing months Mel would return frequently, whether to see Marie—the two began dating, though their outings were always chaperoned by her "mothers"—party with Carlos, or just relax in the tropical courtyards of the family's hotels.

Mel wrote many letters home expressing his fondness for Marie and admiration for Carlos. Many of his pictures and home movies also feature Marie striking poses with her siblings near Macau's waterfront and sashaying in fur-lined coats and formfitting gowns, her hair in meticulous braids or pinned in tight waves. Ultimately, though, the romance stayed in Macau.

At the end of January 1937, during Lingnan's long winter break, Chan Ka Yik led Mel, fellow Stanford student Jack Carter, and

Bud Merrell of Wesleyan to his homeland in Kwangsi, China's "Western Expanse."

A day into the trip, sticky-sweet clouds wafted from dazed opium addicts who lay across bare slabs of wood inside the riverboat cabin. On the ship's deck, pigs squealed from inside bamboo crates. In the ship's galley, soldiers beat a criminal who was chained mere feet from where passengers dined.

The four twenty-year-old boys ate quickly, doing their best to ignore the prisoner's rattling shackles, then rushed from the disturbing scene to their opium-polluted cabins. Meanwhile, the Pearl River rolled on, through mist-enshrouded hills and bright green rice paddies.

The aftermath of Chiang's disappearance still rippled through provincial China. In every town Mel and his friends visited, children gathered in schoolyards for lectures frothing with Nationalist propaganda, anti-Japanese rhetoric, and suspicions about foreigners, including themselves. In larger cities, police checked their passports and warned the Americans about taking pictures.

Once their boat reached Tai Hong Kwong, a village alongside a sharp bend in the Pearl River north of Kweiping (Guiping), Ka Yik led his American friends down the muddy, narrow streets to a shop belonging to his father.

A servant unlocked the door of the family's musty, cramped store.

"When we stepped into that dank and narrow shop we stepped into the middle ages absolutely," Mel wrote.

Ka Yik's cousin greeted the boys and led them up five rickety flights of stairs. The shopkeeper's wife was playing mahjong, even though the game was forbidden by the social reforms of the New Life Movement, the fascism-tinged cultural movement led by Chiang and his wife, Mayling Soong (Soong Meiling). In a room overlooking the village's waterfront, the boys

drifted off to sleep with the sound of pigs squealing in the distance aboard their erstwhile conveyance.

Morning brought a tour of the village, where most shop-keepers were tenants of Ka Yik's father. After a "noonday gorging" on sweet pancakes and other treats at a local teahouse, the boys returned to the family store. There a militia sent by Ka Yik's father greeted them; though much of the lawlessness that accompanied the upheavals of China's recent "warlord" era had subsided, bandits still occasionally attacked travelers.

"Quite an army it was," Mel wrote, noting the automatic Mausers the "soldiers" carried in their hands and the weapons' incongruity with the men's bare feet.

Army or not, the men were professional and clearly loyal to Ka Yik's family. They scurried into position to escort the students to the Chan compound. Each young man was immediately offered a sedan chair; they reluctantly accepted, as it would have been rude to refuse Ka Yik's hospitality. The porters wobbled under the Americans' weight—at the time, Mel checked in at 188 pounds—then gathered themselves and proceeded out of the village in single file. Hundreds of school kids chased behind and yelled at the spectacle.

Given his family's background in Hollywood, Mel was accustomed to wealth, but Ka Yik's home was something entirely unlike what he knew. Developed over centuries of feudal lordship, the home sprawled. Its entrance was framed by two identical towers with round octagonal observation platforms, topped by pointed, curved eaves. The compound's heavy stone gate led to an interior courtyard, then a set of three decorative archways at the building's formal entrance. There were potted plants everywhere, in the courtyards, along the walkways, and next to doorways. A number of long, low outbuildings ran up either side of the central structure. To Mel, the place looked more like a small city than a home.

Ka Yik's compound awed his American guests, but he was more excited to show them the fields and his family's farming techniques. Despite his father's extreme wealth and influence and his brother's connections, Ka Yik paid little attention to the rumblings that could upend his family; he was more passionate about his studies—agriculture—than he was about politics. He and Mel developed a rapport in part because Manfred Meyberg's work at Germain's Plant and Seed had rubbed off on Mel, who was conversant in agriculture. Mel's Chinese roommate was also a shy young man, the kind who asked his charming American friend to write letters to girls on his behalf and always asked about Mel's own dates, even after the school year was over.

"He talked about [Mel] often," Ka Yik's daughter, Emmy Ma, later said. "His eyes just lit up."

After the winter break, Mel decided to remain at Lingnan, though he reneged on his pledge not to write for publication. In part, it was the trip to Kwangsi that changed his mind. The journey's conditions may have been rugged, but the Pearl River had pulled Mel deeper into China.

After the Kwangsi trip, life at Lingnan shifted. Following the Sian incident, the school's student body began dwindling. Many students and some professors left to join China's military, but some of the Chinese students—like Chan Ka Yik and George Ching—remained. They even elected Mel and four other exchange students into a club of up-and-coming members of the Lingnan community. After picking apart each potential initiate, the club's members identified a key personality trait that qualified him for membership; Mel heard that he was chosen because the club's members liked the way he argued.

Though stepped-up military drills and general antipathy

toward foreigners made it harder for the exchange students to move freely off-campus during the spring of 1937, Mel's friendship with Lingnan's Chinese students continued to help him. For example, he and Ka Yik teamed up to acquire a new motorcycle. They combined their bargaining skills in another set of trades and purchases that ultimately netted them one with a sidecar. With Mel at the handlebars and Ka Yik in the sidecar, the pair frequently rode together to Canton.

"It is an incentive to make friends," Mel said. Ka Yik introduced Mel to modern young members of Canton society— indeed, the man Mel acquired this motorcycle from invited him up to spend the afternoon in the modern Westernized Canton apartment where he and his wife lived. Mel found such young people in Canton "more broad-minded than the Lingnan students who marry the first girl that they kiss."

Shedding taboos about kissing and flirting was just one way in which college students in China were adopting Western practices. Men were wearing suits with "shoulders padded out in the same fashion as Clark Gable's," Mel later wrote in an essay about cultural influences in China, while women were styling their hair into long wavy bobs and wearing "brilliantly colored dresses" cut to highlight their curves. Dancing remained forbidden, Mel wrote, but the students got around that by attending parties in private homes, where invitees danced around gramophones, or taking jaunts to Hong Kong.

These trips didn't just give Mel a more balanced look at Chinese society than what he'd been exposed to by the sheltered heirs he met at Lingnan or the poor crowds who plied the river near campus; they also gave Ka Yik a glimpse at modern culture. During their trips into the city, it was Mel who, though sometimes a bit reserved at home himself, nudged Ka Yik to open up in social situations, especially with young women.

"Roommate Chan danced for the first time last night and

has been telling me all the details including the fact he talked to the girl while he danced," an amused Mel reported to his family that spring. Such casual conversation between genders, he said, was a thrilling change of pace from tradition.

As much as Mel was having fun and beginning to feel at home in southern China, he still wanted to see more of Asia. As the semester at Lingnan drew to a close, he finalized plans for a trip through the interior of China, then on to Japan. Traveling through Russia or going to Angkor Wat and elsewhere in Southeast Asia no longer seemed feasible.

"I have kept in mind the one point that I want a balanced view of the Orient although necessarily delivered in a hurry," Mel said as he finalized his itinerary.

Finally, on June 23, 1937, with a lump in his throat, Mel watched Hong Kong recede over the horizon as the SS *Szechuan* left the harbor.

"I rather disliked leaving South China last week although I most certainly shall be glad to get home," Mel wrote. "I know what it is people feel towards the Orient but I can't exactly describe it. That I will return some day or the other I am more than certain."

The slow freighter continued up the Chinese coast, ultimately bound for the heavily Westernized metropolis of Shanghai. After a few days in that city—where Mel was disgusted by the "fat-bellied foreigners who are kings among themselves and servants" and where he visited red-light cabarets "so well policed that nothing was worth sticking around for"—he continued to Nanking, then China's capital, before heading to China's interior with another Lingnan exchange student originally from Hollywood, Harry Caulfield.

After celebrating Independence Day at the U.S. embassy in

Nanking, Mel and Harry began a two-day, two-night train ride to Sian. Centuries earlier, Sian had been China's capital, but more recent events interested Mel and Harry: it was only seven months earlier that Chiang Kai-shek had been kidnapped just outside of Sian.

Getting to Sian was hardly comfortable. Mel and Harry sat on a cushionless bench in a corner of their third-class railcar. Heavy scents of garlic and more obnoxious odors wafted in each time someone entered. Armed guards, better equipped than anyone Mel had seen in southern China, regularly patrolled the car. The ride was so bumpy that Mel's fingers slipped off his typewriter keys as he wrote an unusually typo-laden letter to his mother and stepfather. A group of small children, amazed by the sight of foreigners, crowded into the compartment and watched raptly as Mel typed.

"Wow, I wish this long night would end sometime," he wrote. Outside the rattling windows passed a landscape of cornfields, dusty plateaus, cave dwellings, and historic sites such as Kaifeng, a town known for its ancient population of Chinese Jews.

It was early on the morning of July 7 when Mel and Harry arrived at Sian. Mel relished the hot, dry air after his months in the south's stifling humidity. Walking along paved but dust-covered streets, they passed armed sentries stationed at three huge archways in Sian's forty-foot-thick, six-century-old walls. Many of the roughly 200,000 people who lived inside the walls wore flat, sombrero-like straw hats and occupied clay buildings that reminded Mel of Native American adobes.

"[Sian] is entirely different than anything we have seen before," Mel wrote to his parents. Once the terminus of the Silk Road, the city was also home to the twelve-century-old Nestorian Tablet, a nearly ten-foot-tall stone marker inscribed with Chinese and Syrian characters proclaiming Christianity's

arrival in China. Mel made an ink rubbing of the inscription and had his picture taken next to the tablet.

"So here we are in the Northwest looking at the remains of the beginnings of China and perhaps the world—maybe not, too," Mel wrote. "At least it is very interesting and a place very few people reach."

Mel and Harry spent forty cents in the local currency to rent a small room in a courtyard home, then sought out the few other Westerners who had reached Sian. One was Kempton Fitch, a young Texaco employee who had recently shuttled a series of Western journalists and academics to the Communist stronghold in nearby Yenan. The other was George Armstrong Young, an English World War I vet–turned–missionary who helped mediate Chiang's release during the Sian crisis. Fitch and Young explained nuances of that event that hadn't been reported in Canton to the students.

"After trying to fathom the bottom of the problem during the past few months all of us over here have found that one link, the Communists, missing," Mel admitted. "No one before told us that they came into the city here during the revolt."

Mel suspected that Chinese leaders, wanting to keep the rest of the world from knowing that the fate of the country's central government had rested on the Communists' actions, were keeping that part of the story away from newspapers back in the United States and elsewhere.

Mel and Harry wanted to see the site of Chiang's kidnapping itself, so the next morning they rode on the floor of a packed bus for a jolting forty-five-minute trip to the Huaqing Pool, the cave-hewn hot springs resort where Chiang was held. Government officials were already constructing a monument to the incident. Fitch had also suggested that he might be able to get the boys into Yenan, which was a two-day drive from Sian.

But as soon as Mel and Harry returned from the Huaqing Pool they learned about a new crisis across the country that would keep them from visiting Yenan. This crisis marked what many now regard as the beginning of World War II in Asia. It erupted just southwest of Peiping, another former capital, after six years of simmering tensions and occasional skirmishes that had followed Japan's invasion of Manchuria.

The fighting began along the banks of the Yongding River, where an eight-century-old arched span of white granite called Lugouqiao, or the Marco Polo Bridge, crossed its waters. Along each side of the bridge, there were stone rails that held the grinning faces of 501 sculpted lions. The mirth and joy carved into the statues contrasted sharply with the seriousness of the crisis approaching from either side of the river. The bridge separated two armies: the Chinese 29th Route Army, garrisoned behind the ancient walls of Wanping, a fortress at the east end of the crossing, and a company of Japanese soldiers camped on the other side.

On July 7, the commander of the Japanese contingent claimed that one of his soldiers had gone missing. Treaties signed after the 1900 Boxer Rebellion had given foreign powers—Japan included—the right to station troops in China as protection for their nation's interests in the country. Invoking these agreements, the Japanese commander demanded that he be allowed to search Wanping for his missing soldier. When China's 29th Route Army commander, Song Zheyuan, refused the Japanese commander's demands, shots rang out from both sides. Early the next morning, Japan reinforced its garrison with machine-gun units and armored vehicles, then again opened fire on the bridge and Song's army, which lost scores of soldiers.

The Japanese used the incident and Song's intransigence as a rationale for a full-scale attack on Peiping. The question then

became whether Chiang Kai-shek—who was at a summer resort in the mountains southwest of Nanking—would leave Song Zheyuan to handle the Japanese on his own or back up his general with the full force of his military. Such a response could plunge underprepared China into full-scale war with Japan.

The Kuomintang maintained a far-from-definitive hold on China, and the Lugouqiao incident tested the party's unity with the Communists. It wasn't clear who would join Chiang if he went to war. Japan had controlled much of northern China since it invaded Manchuria in 1931, while political rivals of Chiang's controlled other Chinese provinces and the militaries within them whose support Chiang would need for a full-scale war. On the other hand, if Chiang backed down, his inaction could embolden Japan.

"If it were just [Peiping], that would be one thing, but Chiang feared that the city would be just one more conquest in an ever-lengthening list of Japanese provocations in China," the scholar Rana Mitter later wrote.

And Chiang knew he was unlikely to receive international assistance. Europe was occupied with the Spanish Civil War and the rise of the Nazis in Germany and the Fascists in Italy. The United States, still reeling from the Great Depression, in addition to its memories of the First World War, wanted little to do with another distant struggle, yet less with a continent that policymakers, the media, and the public continued to discuss through Orientalist stereotypes. Few international powers wanted to be drawn into a messy regional dispute, one from which they could gain little, and it was highly unlikely that President Roosevelt would get American troops involved in China when he hadn't intervened in Spain.

"To return to a war in Europe would be unpopular; to enter

a conflict in China was close to unthinkable," Mitter wrote of U.S. foreign policy. "So if Chiang wanted to fight back against Japan, he would have to do it on his own."

Mel and Harry had no clue that any of this was happening until they reached Taiyuan, the capital of Shanshi Province (Shanxi), but the trip to Taiyuan gave them a glimpse of the high tensions in China. When they crossed the Yellow River in T'ung-Kuan (Tongguan), a Chinese customs official checking Mel's passport froze when he saw the visa for Mel's upcoming Japan tour. Because Japanese troops occupied nearby Inner Mongolia, local officials were nervous about spies, and this official was immediately suspicious of Mel and Harry. It didn't matter to him that they weren't Japanese.

"Anti-foreign feeling is strong and the countless officers about us have loaded guns which I am sure they wouldn't hesitate to use on us," Mel wrote after the official grudgingly let the students pass.

By the time Mel and Harry arrived in Taiyuan on July 11, the rumor mill had transformed the skirmishes outside Lugouqiao into full-scale attacks on China's main strategic corridor, a trunk rail line that connected Peiping to Hankow (Hankou, now part of Wuhan). The students were given wildly inflated reports that more than 1,000 soldiers had already died in the battle. The fear was that if Japan seized control of the railway, it could send troops stationed in Korea and Manchuria into the heart of China. Such an attack hadn't actually happened (Japan did make a few small air strikes on the rail line), but Mel and Harry couldn't get any solid information about what was going on because communication lines between Peiping and China's interior were down.

"All we did find out was that we couldn't go directly to

Peiping from there and would have to take a round about route," Mel wrote the day after they reached Taiyuan. They had hoped earlier to catch a flight on a German Junker that they'd heard was in Taiyuan and scheduled to fly to Peiping, but once they reached Taiyuan they discovered that Peiping's airfields were closed, so that option was out. As they realized that full-scale war could strand them in China's hinterlands, they also realized that they were running out of local currency. With war a looming possibility, nobody was willing to exchange currency, so Mel and Harry had to cobble together what money they had left to pay for an alternative, indirect train journey to Peiping.

The first night of their trip—an uncomfortable one—got them only as far as Yuanping, a "mud village with a bus station," about fifty miles north of Taiyuan. The next day's journey brought them to Kalgan (Zhangjiakou), a city bordering Inner Mongolia and surrounded by the Yinshan Mountains. Mel and Harry could see the Great Wall of China from Kalgan. They hoped to hike to it early the next day, but a messenger arrived from Peiping just before they left. He told the students to get to Peiping immediately, before the fighting there worsened and made travel even more difficult.

"Feel we had better get in there now as only one gate is open, streets are barricaded and this may be our last chance," Mel wrote before boarding a midnight train to Peiping.

Chapter 2

"THE ITCH IS PERPETUAL"

The next morning, July 14, 1937, Mel and Harry arrived at a railway station near the south wall of Peiping's old city. They then entered through the city's only open gate. The crackle of machine-gun fire and the thunderous drumbeat of distant artillery were constant for the next two days. Since Mel had arrived in China, he had watched the first stirrings of the conflict seethe beneath the quivering trigger fingers of paranoid officers in the country's interior. He had heard murmurs of antagonism around charcoal fires in rural schoolyards, where children chanted, "Down with Japanese imperialism." Propaganda posters depicted Chinese soldiers standing up to vicious-looking tigers, beastly stand-ins for the Japanese. Now, after July 7, the occupation had begun in earnest.

All-out war was not yet certain, but the crisis had paralyzed the entirety of Peiping's roughly twenty-two square miles. Mel and Harry hired a rickshaw to take them to the American legation. Its driver had to weave around roadblocks that had been placed in the streets to reach the College of Chinese Studies, where they planned to stay. (A year earlier, a relative of Mel's stepfather had introduced him to the school's cantankerous president.) With the city under martial law, its roads would be

empty come nightfall. Despite the stifling heat of summer, a 9:00 P.M. curfew kept residents indoors.

On the outskirts of Peiping, Japanese troops worked tirelessly to build a giant airdrome. It was already clear that this war would be fought from the sky. Mel guessed that Japan's low-level flight patrols over Peiping were calculated propaganda efforts meant to display the empire's airpower and instill fear in city residents. They succeeded.

This was not a safe time to be an American in China, though Mel did his best to assure his parents that the situation wasn't as "exciting as it sounds." Harry Caulfield's mother, worried that the conflict would strand Harry and Mel, had pulled strings and directly contacted Secretary of State Cordell Hull.

Hull acknowledged the violence—500 American Marines were marching in full-dress uniform through the American legation, with many patrolling its crenelated walls—but the State Department, he said, wasn't yet concerned. He stressed that the American mission in Peiping endeavored "to afford Americans all practicable protection." If conditions worsened, the embassy would give Americans sufficient warning of any danger and facilitate their departure.

"Home papers must be full of [what's] happening," Mel wrote. "Imagine the danger for foreigners is over rated, but the activities couldn't possibly be."

Within a few days of Mel's arrival in Peiping, there were still occasional bouts of gunfire in the distance, but the gunshots and artillery barrages had subsided and both the 29th Route Army and the Japanese North China Garrison Army had moved away from the Marco Polo Bridge. Local leaders on each side were discussing a tentative cease-fire, but both Chiang, who was meeting with his military council when the attack at the bridge happened, and newly appointed Japanese

prime minister Prince Konoye Fumimaro were preparing for war. Despite what he called "absurd" demands from Japan that China turn Hopei (Hebei)—the province surrounding Pieping—and neighboring Chahar into autonomous provinces, Mel doubted that Chiang Kai-shek would respond by declaring war on Japan.

"I am convinced that China is far from ready," he wrote from Peiping. "On the other hand, if foreign power intervenes to keep peace at any cost they may tell China to give in. If China gives into these demands she is about finished for a long time. It will mean Japan will repeat six months later a bit further south and so on until they reach Canton."

As more time went by, Mel surmised that Japan was stalling in order to rush more troops and equipment closer to Peiping.

"The Japanese are rotters for this every last one of them," Mel wrote. "They care little for anything and laugh at the foreign powers."

While negotiations continued, the crowds returned to Peiping's streets, but they mostly consisted of people trying to stock up on supplies and merchants trying to clear their stores of goods before it became impossible to do business. Occasional truckloads of troops raced through the city's streets, but it was never quite clear where they were going. Mel, meanwhile, was curious whether the government in Nanking was biding time as it reinforced its positions around Peiping. If that was indeed the case, he was certain that Japan would interpret such reinforcement as an act of war and strike back.

Mel, Harry, and other Lingnan friends who had arrived separately in Peiping took advantage of the relative calm to visit the Summer Palace, Yenching University, and the Temple of Heaven. Other cultural sites were cut off because they had been

closed and turned into staging grounds for Chinese troops, but Mel made the most of the trip and used a 16-millimeter camera to film the landmarks he could see. He also photographed the sandbags piled high along the walls of Beijing's *hutongs*— alleyways lined with courtyard residences and businesses—and the helmeted troops marching in the city's streets. Meanwhile, at Yenching, Mel met with journalism professors and local newspaper editors.

Among those Mel met was F. McCracken "Mac" Fisher, the United Press's correspondent in Peiping. He also met up with a Fox Movietone producer to learn what it might take to make newsreels in China.

"I would like to attach myself to some news agency," Mel wrote, though he was also realistic. "The chances are slim. I have no connections here for inside dope, and the town is full of news hawks."

Mel knew that he was in the midst of a geopolitical crisis, and that it wasn't being covered well in America. He was already hooked on China, and now he was starting to get hooked on the drama of a possible war, on the international intrigue, and on the history being written around him. These meetings gave him a tantalizing preview of what it might be like to write that history himself.

"You probably wonder why I don't get out of here while the getting is good," he wrote. "Frankly, I don't know why except I am fascinated by the hopes of seeing what is going to happen."

While he was in Peiping, Mel heard many stories about Japanese soldiers harassing Westerners in the city.

"They have the guts to destroy cameras of Americans and English even in this city if they want to and no one calls them on it," Mel wrote. In Shanghai he had heard similar rumors, and he had been warned by Western police in that city not

to photograph Japanese military. Undaunted, when Mel went to the Japanese embassy to see if, given the current crisis, he would still be able to travel to Japan, he brought his camera along, hoping to take pictures of the Japanese legation's fortifications, barbed wire, and heavily armed troops.

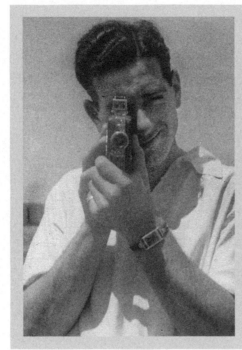

Melville Jacoby enjoyed photography and filming 16mm motion pictures as much as writing. *Photo courtesy Peggy Stern Cole.*

Only two days after guessing that China wasn't ready for war, Mel revised his predictions. He now thought war was likely because Japan's demands were "as preposterous as she is imperialistic." He thought China was held back only by its lack of military readiness and its economy; however, there was plenty of patriotism among the Chinese population, who desperately wanted to repel Japan.

Mel began to sour on the idea of visiting Japan after its bel-
ligerence in China. It didn't help that Japanese officials ques-
tioned him for hours when he went to their embassy to pick up
train tickets the day before he left, or that guards with bayonets
"none too comfortably" escorted him around the complex.

Nevertheless, the next day, July 23, Mel boarded another
train, this time to travel to Japan by way of occupied Man-
churia and Korea. To get to the train on time he had to leave
so early in the morning that he violated the city's curfew. His
rickshaw driver had to sneak around military checkpoints and
take routes off the city's main streets.

Mel was barely out of Peiping when he got his first real
glimpse of what the Japanese empire was up to in China. As his
train passed through Fengtai, the southwestern Peiping district
that was home to Wanping Fortress and Lugouqiao, Mel saw
Japanese soldiers digging trenches and installing field guns. Mel
guessed that there were thousands of them.

As Mel's train continued through Japanese-occupied Korea,
guards kept his compartment curtains drawn. Still, Mel was
occasionally able to peek out the windows. He glimpsed other
trains full of troops and tanks that screeched and clattered by
in the other direction as his own train stopped at rail sidings to
let them pass. He also saw bent-backed peasants toiling in rice
paddies, coal mines, and clear streams. At one station stop he
saw crowds of Japanese citizens banging drums and cheering
soldiers who were arriving on other platforms.

"They are pouring them up there it seems," Mel wrote.
"Enthusiasm knows no bounds even in Korea."

The next morning guards on the train pulled Mel into the
first-class car. When he arrived, a train conductor was taking
the film out of a European passenger's camera. The conductor
then turned to Mel and insisted, through limited English, that

he had been taking pictures of bridges and other strategic installations outside of Peiping. He and the guards lightened up after Mel mentioned an officer in his car who he'd spoken with earlier that day and who could vouch for him.

"The few other foreign passengers are laughing themselves sick at my troubles," he wrote. "I am beginning to think now that I am a spy myself."

Save for some intense questioning when Mel arrived at Japanese customs at the Korean port of Fusan (Busan), the journey proceeded without further incident. But once in Japan, Mel found himself under constant surveillance. Government agents in plain clothes and dark glasses tailed him wherever he went. For a while, he devised "hide-and-seek"–style games to try to evade his followers. In one city, he tired of pretending not to notice the surveillance and approached one of the agents directly to invite him to lunch.

On July 26, Japan launched an all-out assault on China. Every Japanese city Mel visited had nightly air raid drills, some of which even involved simulated poison gas attacks. By day, Japan's citizens crowded the city streets to cheer the soldiers marching off to war. Mel initially thought the hoopla, as the masses chanted and whipped themselves into an anti-Chinese fervor, was genuine, but he came to suspect the government's hand in the frothing crowds he saw throughout Japan.

"Propaganda is scattered the length of Japan," Mel wrote. "Strict censorship of the press keeps the people under the illusion that they are fighting a defensive war and that the sympathy of the world is with them. War enthusiasts are the militarists and the youth."

Mel's trip finally ended, after three weeks, in Yokohoma. He'd caught up with Harry Caulfield and their friend Eugene Johnson in Kyoto, and they traveled home to California together aboard the 583-foot-long, 17,000-ton *Chichibu Maru*.

One day during the voyage, a woman named Polly Thompson overheard Mel, Harry, and Eugene discussing the war in China. Thompson was the assistant for another *Chichibu Maru* passenger, Helen Keller, the deaf-blind author and activist. Thompson told Keller about the students, and Keller asked to meet them.

For the next two hours, Keller discussed China and Japan with Mel and his friends. To overcome the communication barrier, Keller felt Thompson's throat muscles as Thompson listened to the students; when she wanted to reply, she tapped out syllables with her fingers. Keller had been in Asia because Anne Sullivan, her "miracle worker," had made a dying wish that Keller visit the continent. Though Keller had not wanted to leave Sullivan's bedside, she finally relented and traveled to Japan on President Franklin Roosevelt's behalf as a "goodwill" ambassador. However, though she was able to visit Japan, Korea, and Manchuria, the outbreak of war kept Keller from touring unoccupied China.

Keller, Thompson, and the students wandered the decks of the ship as they discussed China, followed everywhere by Kamikaze Go, an Akita puppy that a Japanese police officer had given Keller. She wasn't fully convinced that Japan's cause was just, but she also wasn't a fan of Chiang Kai-shek, who was too conservative, she argued, to lead China.

"Discussing the Japanese people, she stressed her liking for them but declared herself '100 per cent against imperialism,'" wrote the *Stanford Daily*. "She also felt that the Japanese women should be given more educational advantages than they have at present."

Mel's talk with Keller gave him an opportunity to reflect on his past year, especially his travels to Sian and Nanking, his trip earlier in the year to Kwangsi, and the friendships he'd formed with George Ching, Chan Ka Yik, and Marie Leîtao. By the

time the *Chichibu Maru* arrived in San Francisco, he realized how much he had changed from the student, unsure about his future, who had left for China more than a year earlier.

As he prepared to begin his senior year at Stanford, Mel was not certain what his next steps would be, but he had at the very least caught an expensive malady: the travel bug.

"The itch is perpetual," Mel said. "Realizing I can't expect Papa to feed a parasite much longer, travel is out of the question unless done with a lucrative, or at least fairly lucrative purpose."

Back at school in Palo Alto, Mel was haunted by memories of the soldiers marching through Peiping, the suspicious customs officials, and the crowds worked up into patriotic ferment in both China and Japan. Indeed, Peiping fell two days after Japan's Kwantung army attacked, followed in another two days by the coastal city of Tientsin (Tianjin). That August, Japan began a punishing drive against Shanghai, and it would rout China's troops there the following November.

While Japan maintained its siege during the Battle of Shanghai, it also attacked Canton. Chan Ka Yik, Mel's former roommate at Lingnan, described Canton's deteriorating conditions in letters to Mel.

"The air raid in Canton by the Japanese bombers was so serious and so often," Ka Yik wrote, referring to three weeks of raids between September and October 1937. Classes were still under way at Lingnan, though the dorms and other important buildings were surrounded by sandbags, camouflaged searchlights, and anti-aircraft guns, and only 250 students remained. Soon Lingnan was moved to Hong Kong, where it borrowed space from the British University and held classes at night.

Refugees from Canton and elsewhere in China streamed

into Hong Kong and Macau, where residents watched Japanese planes take off daily from a nearby island to bomb Canton. Still, Marie Leîtao, the Macanese woman Mel had dated during his second semester at Lingnan, believed that Europe and the United States should remain uninvolved in the conflict.

"You Americans all should let China & Japan alone," she wrote. "All so one-sided. Give Japan a fair play. She's doing what England and the others did few centuries ago. I'm not Anti-Japanese. Are you?"

This was a complicated question. Mel knew there were many factors contributing to the conflict, and after witnessing how Japan had bullied China during his recent travels—not to mention the suspicion with which its officials had treated him—he'd become deeply interested in the dispute's causes. In a three-part series of "Inside China" columns that Mel wrote that fall for the *Stanford Daily,* he described his impressions of China and Japan as each country readied for war. The opening piece described Mel's experience watching China's many factions unify in the face of a greater outside threat.

"Life as an exchange student was anything but drab during the past year," Mel wrote in the first piece's opening. "Around us was a turbulent, restless country growing in nationalism and unifying itself in the face of Japanese aggression."

That summer, George Ching—the son of a former Canton mayor and Hugh Deane's roommate in China—came to the United States to study for his master's degree in economics. Wanting George to study with him at Stanford, Mel enrolled him in the school before George had even arrived. George's presence and Mel's continued correspondence with Marie and Ka Yik maintained his connection to China.

Meanwhile, Mel began his final year at Stanford with a newfound focus on Asian affairs and journalism. In one me-

andering school assignment written when he was back, Mel reflected that after being gone for more than a year, he realized how much he prized his independence.

"Personally, I hate to be dependent," he said. Somewhat paradoxically, he wrote that having his own car, partially paid for by his mother and stepfather, made him feel independent. But even his parents' help didn't seem to be enough to help Mel adjust to changes in Stanford's culture.

"Stanford is gradually being changed by an influx of Packard one-twenties," Mel wrote, adding that the sedans heralded a new era when a Stanford education had more to do with social status than academics. "Not only a period where the lamented moleskin and corduroy trousers disappear, but one in which a Stanford diploma means entrance to social life."

Rather than lament his exclusion from Stanford's social circles, Mel put his energy into work and joined Sigma Delta Chi, now known as the Society of Professional Journalists. His year abroad had also inspired Mel to pay more attention to international affairs, and in December he was elected chair of the Stanford student government's International Relations Committee.

Returned Lingnan exchangers Betty Leigh Wright and Margaret Wolverton were members of the club as well. Its top priority was establishing an "International House" at Stanford similar to the one at University of California at Berkeley. Already isolated by language difficulties, sixty-one international students from twenty-five countries also had to rent off-campus rooms in Palo Alto because Stanford lacked adequate housing for even its regular students. This left the foreign students with few chances to interact with Americans, or with one another.

But despite a full-page blitz of stories arguing in favor of the project and other coverage in the *Stanford Daily,* continued lobbying in the student government, and other campaigning,

the International House never materialized. Administrators wouldn't pay for the concept, especially as they struggled to house nearly 1,000 graduate students. Creative (or desperate) solutions, like using a dedicated floor in a crumbling dorm the school had already decided not to repair, failed too. Mel and the club also tried to establish two scholarships for financially strapped Chinese students to attend Lingnan. Mel and others had received such support to study in Canton, and such a gesture of goodwill seemed more necessary now that war conditions put pressure on Lingnan and its students, but the idea was never backed by Stanford's full student government.

Under Mel's leadership, however, the International Committee did streamline class registration for international students, which had long been a confusing mess for foreigners. The club also encouraged social interaction by hosting regular gatherings at professors' homes and an occasional picnic. Additionally, it organized a "Peace Day" celebration for the international students in April of each year.

Through the International Club, Mel met Shirlee Austerland, and the two started dating. A year behind Mel at Stanford, Shirlee was a politics major from Hilmar, California, a voracious reader, and an effusive letter writer. She and Mel had a fairly typical relationship consisting of outings in San Francisco to hear the symphony and see plays, cheering at Stanford football games, and having lunch with friends like George Ching, Franklin Mynderse, and Whimp Close.

Aside from these friendships, Mel maintained his correspondence with Chan Ka Yik, who thanked Mel for his "sympathy to our country." By spring, conditions in Canton had temporarily eased. Students were returning to Lingnan, and Ka Yik looked forward to graduating, even though he occasionally heard the sound of anti-aircraft guns firing and bombs exploding from the direction of Canton.

"Mel, you are the best foreign friend of mine, and you understand our country [and] our people more than the others," wrote Ka Yik, who by the fall would be back in Kwangsi, struggling to get by on $10 a month.

Mel graduated in June 1938 with "Great Distinction." That summer he worked for his stepfather, Manfred Meyberg, at Germain's Plant and Seed, to find out whether he could stomach taking over the family business. He couldn't.

In the fall, Mel returned to Stanford for a master's degree in journalism. That November he was Stanford's delegate to the Society of Professional Journalists' convention. Then, for their thesis, he and another master's candidate, Charles L. Leong of San Francisco, studied the coverage of Asia and its emergent war. Through case studies and interviews with journalists, they examined stories about the events leading up to the July 7, 1937, Marco Polo Bridge incident and American journalists' failure to cover not just the complex chain of events that precipitated the Second Sino-Japanese War but the many potential impacts of these events on readers in California.

While he worked on his thesis, Mel rented a room at 556 Alvarado Avenue in Palo Alto. His landlord was May Smith, the widow of Everett Smith, who founded Stanford's journalism program. Mr. Smith died before Mel arrived at Stanford, but his daughter, Shelley, attended for three years coinciding with Mel's attendance, though she didn't graduate.

Shelley had moved to New York after leaving Stanford. There she ended up with a job at *Life* magazine as a researcher. At the magazine, Shelley met a photographer named Carl Mydans. Carl and Shelley instantly fell in love. Married in June 1938, the Mydanses came to visit Shelley's mother later that

year, while Mel was renting a room from her. That gave Mel a chance to learn from Carl.

"He is a photographer for *LIFE* mag and a swell fellow," Mel told his parents. Carl took an interest in Mel's thesis and even asked to look over his extensive notes and source material. "I have learned a lot from talking to him already."

Despite Carl's encouragement, Mel did not take to graduate work at first. By early February, Chilton Bush, Mel's thesis advisor and the director of Stanford's journalism program, told Mel he was alarmed and disappointed by the quality of Mel's work. Discouraged by Bush's comments, Mel considered quitting his master's studies.

He didn't. He knew the problems with his thesis did not stem from lack of effort; after a few weeks of even more work, the project began to seem manageable again. There was little time for outside pursuits, like the flying lessons Mel had been taking. Aside from work on the thesis, he worked some training assignments at local papers and pitched freelance articles to national publications. He also attended lectures by prominent journalists and made numerous visits to local wire service offices. Impressed by Mel's dedication, Bush's attitude shifted. Where he once threatened to flunk Mel, he now pushed Mel on his thesis and helped him find career contacts.

That June, Mel briefly visited Los Angeles. While he enjoyed seeing his family, he realized that his hometown lacked the kind of opportunities he might find in San Francisco, or the place he really wanted to go: China.

"Perhaps I have the wrong slant on things, but I feel I would like just as broad an outlook on life as is possible to get and I can't have that spending all my life in Bel Air and sitting on the sand at the Beach club," he wrote.

That summer Mel broadened his outlook further by work-

ing nights at a fruit packing plant in nearby Sunnyvale. His wasn't the hardest task—he was a quality checker who ensured that each can of fruit salad or fruit cocktail had the right proportion of ingredients—but the summer job gave him his first experience with manual labor.

"Cannery work has done me good in several ways," he wrote. "Not only has it settled me to the idea of hard work, but it has brought me in contact with conditions I have been reading and thinking about for the last six years."

Despite the cannery's lessons about the working class, Mel was getting anxious about finishing his thesis by the end of the summer. As the deadline neared, it was Charlie Leong whom Bush threatened to flunk. Mel's writing partner only made matters worse when he took a full-time job that left him with no time to help Mel format the paper. Most of the work was done, but Bush still hinted that the whole thesis might need to be rewritten. Mel was reminded of how discouraged he'd been earlier in the year.

Bush's attitude was complex: though he was satisfied with the thesis's content, he thought the paper wasn't sufficiently polished. This was a frustrating assessment because Mel and Charlie were scheduled, only five days after Bush rejected the paper, to give a talk at Sigma Delta Chi's annual convention, an event that was coming to the Bay Area in part because of Mel's lobbying. Fearful that he would have to spend another year in school, Mel pushed Leong to wrap up his work. Somehow, by working through the night for days on end, they managed to wrestle their thesis into a form that Bush found more than acceptable.

It's unclear just why Bush changed his opinion so quickly. It's possible that Bush never was as disappointed in Mel as Mel had told his mother Bush was. In any case, Mel and Charlie analyzed 2,000 stories in three San Francisco newspapers for

the thesis. They also interviewed dozens of reporters in China, Japan, and the United States, trying to assess how the California press handled news from China and Japan and why U.S. journalism standards prevented adequate coverage of events in the two Asian countries. They found that West Coast papers lacked permanent correspondents in China and Japan, and that the correspondents they did have reported to editors who were unfamiliar with East Asia. As a result, fabricated stories could go unchecked, and editors with no knowledge of China or Japan made unreasonable requests of contributors.

Mel had observed these problems firsthand when he was interviewed by San Francisco reporters upon returning from his year abroad.

"Not one asked about the background of war and its effects," Mel wrote in the thesis. "Each reporter pointed his questions during the interview towards eliciting responses which would give him a 'horror' angle for his story—as in the oft repeated question: 'Did you see anyone killed?'"

In their conclusion, Mel and Charlie outlined numerous problems that plagued journalists' coverage, such as their attempts to appeal to the demands of uninformed audiences; their biases based on their source networks, knowledge, and political preferences and the editorial policies of their publications; language difficulties; and censorship. Mel and Charlie wrote:

> Until Americans are educated to the Far East and supplied with a sufficient background to enable an intelligent interpretation of events, news of China and Japan will continue to be built around spectacular and sensational overt events. Only those stories which fit the general news pattern will find their way into print. The more subtle, yet far-reaching movements, [such] as the mounting class war

in China, will remain obscure to the American public. It will remain so until Americans either awaken to the fact that the Far East is no longer 8,000 miles away, or events in the Orient will prod the U.S. into action.

Mel and Charlie presented their paper at the Golden Gate International Exhibition in San Francisco, which was organized by Stanford president Ray Lyman Wilbur. A sort of complement to the World's Fair in New York, the Golden Gate International Exhibition focused on solidifying bonds among the nations of the Pacific Rim. When Mel, Shirlee, and another friend visited the exposition that summer prior to his presentation, they toured the expo's outsized pastiche of tourist kitsch, simplified presentations on Pacific cultures, and showcases of the latest scientific discoveries. Its highly touted features included a giant half-ton fruitcake baked in the Southern California enclave of Ojai with fifty dozen eggs and other outsized ingredients, a permanent burlesque exhibit called "Sally Rand's Nude Ranch," and the "fascinating story" of "SEX HORMONES," which "play a vital role in making woman what she is! In making man what he is!"

Cheesy displays aside, the exposition represented the height of New Deal optimism in a manner reminiscent of the utopian vision that Mel had laid out in that citizenship paper he'd written four years earlier, when he was starting out at Stanford. The event was an opportunity to present California as the heart of an idealized pan-Pacific economy just as the United States emerged from the Depression. The exhibition also showed off the *China Clipper,* Pan-Am's glamorous, silvery whale of an airplane, which flew regularly between Treasure Island and Hong Kong.

The Golden Gate International Exhibition took place at a time when some scholars and policymakers, especially those

involved with the Institute for Pacific Relations (IPR), an early and influential think tank cofounded by Wilbur, believed that Pacific Rim nations were becoming increasingly interdependent. The policy analysts and editors who attended Mel's presentation rewarded his fresh and potent perspective on Asian affairs with a clutch of introduction letters to important journalists, businessmen, and diplomats in China.

One of the sources Mel met while working on the thesis was Ray Marshall, the just-returned manager of the United Press's China bureau. Marshall now edited the syndicate's incoming cables in San Francisco. When Mel visited Marshall's Mission Street office, Marshall told Mel that he would make a strong recommendation to the United Press's New York office that Mel be hired to contribute from China. He even said he would urge them to try to pay Mel's boat fare to China, but told Mel that it would be worthwhile to go even if they didn't— which was likely because the syndicate was spending most of its money sending reporters to Europe.

Mel nearly fainted upon receiving such support from Marshall, though he knew a stable job wasn't guaranteed.

"It means that when I land in China, I am on my own," he wrote. "I will have the task of doing my best to interpret a force which is taking a toll of several thousand lives daily. Perhaps I won't do a good job. I don't know."

On top of Marshall's support and the letters he received from the Institute for Pacific Relations members, Mel was asked by the *San Francisco Chronicle*'s Paul Smith to send him feature articles from China for *This World,* the *Chronicle*'s Sunday magazine. If big news broke, Smith said the paper would also turn to him as its correspondent in Asia.

Mel knew this was a tremendous opportunity. Still, he had

to improve his Chinese in the few weeks left before he left California. His old friend George Ching, who lived in San Francisco, offered to tutor him. To help Mel meet more easily with Ching, Jonathan Rice, a friend from the *Stanford Daily* who also lived in the city with a number of other Stanford friends, invited Mel to room with him.

A few days after Mel made his presentation at the exposition, he wrote his mother with news about the commitment from the *Chronicle*. It was August 31, 1939, and probably not the best day for Mel to tout his ability to predict the news.

"Still looks like no war in Europe today," he wrote.

The next day Hitler invaded Poland.

Because of the outbreak of war in Europe, few people recall more positive events that were happening at the same time, like the Golden Gate exposition or the IPR's lobbying for pan-Pacific cooperation. Perhaps, as Mel wrote on the eve of his return to China, such optimistic initiatives had simply run their course. The world had changed for the worse, and it was Mel's job as a journalist to acknowledge that reality, though he argued that a journalist's commitment to accurate reporting could help achieve peace.

"World conditions point to troubled years ahead," Mel wrote.

> No matter which way you turn, revolution, civil war, world war it all means people dying and suffering. It is the primary task of the correspondent to portray a real picture of what he sees before him. Yet it is his job to serve his own group best. That is the job I want to tackle. A job which means success if just one iota of misunderstanding is righted. It means that the world is just that much closer to harmonious living.

Mel's first stop in China was a place rife with misunder-standing: China's great international metropolis, Shanghai.

After his crash course in Chinese with George Ching, Mel left for China in the third week of October 1939. Crossing the Pacific aboard the SS *President Coolidge,* he stopped in Hawaii, switched ships in Kobe, Japan, and even encountered friends from Lingnan during the journey. On the boat from Japan, Mel also made a crucial contact: Randall Gould, the charis-matic editor of the *Shanghai Evening Post & Mercury* and one of Shanghai's most influential journalists. Gould offered to intro-duce Mel around Shanghai and help him get acclimated in the city.

After arriving in Shanghai on November 7, Mel rented a room at the swanky $2-a-night Park Hotel (complete with three meals), which was next to a horse-racing track in the heart of Shanghai. This was far too expensive for Mel, and the guttural shouting of German guests in the hotel ordering around bellhops only increased his unease. Unfortunately for Mel, more affordable rooms were booked, so he needed to find either paying work or other lodging. In fact, he needed both if he was going to stay. Shanghai was not only a far more ex-pensive place to live than elsewhere in China, it felt culturally isolated from the rest of the country. Recent events were also making it a decidedly less comfortable place to live.

Shanghai had long been a hub for expatriates, in part be-cause foreign governments had enjoyed extraterritorial powers in the city for decades. Not only did these powers leave Shang-hai under the control of a council made up of foreign officials, but foreign residents were subject to their own countries' laws, not China's.

"But if you aren't British or French or American or if your country hasn't got enough gunboats it isn't so international," Mel wrote, referring to the many foreigners who came to Shanghai but were not nationals of countries that enjoyed extraterritorial powers. Paradoxically, among the most disenfranchised populations in Shanghai were Chinese nationals. And though Shanghai maintained much of its international identity when Mel arrived in 1939, in the two years since the Battle of Shanghai, Japan had consolidated power there and grown increasingly belligerent toward both the Chinese and Westerners.

"The Western world is being squeezed out of China," Mel wrote. "Their last opening wedges—the foreign concessions—are fastly becoming subject to Japanese pressure."

Even as the Japanese took over, Mel found Shanghai society distastefully out of touch. When he went to exchange money at the American Express office, the bright blue travel pamphlets inside always seemed disconcerting to him, especially when a stretch of cold nights hit Shanghai and he saw humanitarian workers piling the bodies of Chinese laborers who had frozen to death into their trucks. Shanghai, the people in it, and the way the local Chinese were treated strained Mel's patience to the point of anger. He said as much in one form or another in most of his letters.

"I hate to see the beggars (I'll see millions more)," he wrote. "I hate to see the rich kids in the cabarets, I hate to see the refugees, I hate to see the lousy foreigners in Packards and minks. Lots of money is being made now on the market and in business—but the Chinese peasant is taking it on the proverbial chin."

Shanghai wasn't the only place where Japan had increased its influence in China. At the end of 1937, Japan had attacked

Nanking, then China's capital, opening an unimaginably dark chapter in world history. For three weeks, Japanese forces committed acts as horrific as any others in the twentieth century's grim gallery of atrocities. Between 20,000 and 300,000 civilians were killed in Nanking, while thousands of women, perhaps even tens of thousands, were raped.*

Many journalists bore witness, including a *New York Times* reporter named Tillman Durdin. Reporting from Nanking in 1937, Durdin observed citywide looting, summary executions, enslavement of able-bodied men, rapes, and other crimes. In one of his most shocking accounts, Durdin said he saw 300 men lined up against a wall and shot.

After Japan conquered Nanking, Chiang Kai-shek's government retreated to Chungking, a distant, hilly city to the southwest. Meanwhile, a former ally of Chiang's, Wang Ching-wei (Wang Jingwei), made a separate peace with Japan. Wang set up a collaborationist government, the Reorganized National Government of China. It claimed to represent all of China, but in reality it controlled only the Japanese-occupied portions of the country and was subject to the occupiers' dictates.

Wang's underlings set up a network of spies and secret police in Shanghai's International Settlement and the French Concession. Often coordinating their work with Japan's secret agents and frequently enlisting the help of Shanghai's expansive criminal underground, these agents operated out of nightmarish 76 Jessfield Road—a feared house that Wang's enforcers used for beatings, flagellation, electrocution, and other torture.

Early in 1939, the Kuomintang government in free China

* Figures for how many were killed during the "Rape of Nanking" remain highly politicized and disputed, but the reality is that tens of thousands were massacred.

had infiltrated Shanghai's police network and assassinated a string of high-profile collaborators. Wang's shadowy alliance of criminals and secret police retaliated by cracking down in the city. This crackdown included threatening Shanghai's press corps.

Though the United States had not yet entered the war, such threats weren't new to American journalists in Shanghai, as the writer Paul French detailed in his *Through the Looking Glass.*

"Things went from bad to worse to deadly," French noted. Reuters reporter James Cox was murdered at a police station, and the *New York Times*'s Hallett Abend—whom Mel would soon meet—was assaulted at Shanghai's longtime press gathering point, the Broadway Mansions. Gould, the journalist whom Mel met just before arriving in Shanghai, was one of Japan's frequent targets. As a result of numerous attempts on his life, Gould took many security precautions, like keeping heavily armed bodyguards outside his office and traveling everywhere in an armored car. Mel wasn't terribly convinced about the usefulness of such precautions.

"The gunmen still get their newsmen," Mel wrote of the reinforced concrete guard booths and the "tanks" he saw outside of newspaper offices.

If Mel was at all frightened by the threats to journalists, he didn't say so in his letters. It's unlikely that he was. Instead, with Gould helping him make connections, Mel spent the better part of every day in Shanghai walking between news organizations to chat up editors, bureau chiefs, and correspondents.

He also spent considerable time with Abend, a Stanford alum who, as likely the highest-paid foreign correspondent in Asia at the time, was also an avid art collector. A longtime stringer for the *New York Times,* he invited Mel to lunch at his apartment after a referral from Gould. Over "an A-1 lunch," Abend showed off a collection of Chinese art worth thousands

of dollars. Mel bought some silk paintings from a dealer whom Abend regularly brought to his apartment, but he was most eager to discuss the correspondent's work. Aside from contributing to the *Times,* Abend regularly wrote for the *Saturday Evening Post* and other publications.

Aside from Abend and Gould, Shanghai's journalism community was dominated by what Mordechai Rozanski later dubbed the "Missouri Mafia," an influential cadre of reporters who'd studied at the University of Missouri School of Journalism. This midwestern school didn't just send a number of journalists to China—its faculty and administrators stayed intimately involved in graduates' activities in Asia even after they finished their schooling. Many journalists with ties to "Mizzou" also worked at Yenching University in Peiping, whose journalism department Mel had visited in 1937.

Only four days after arriving in Shanghai, Mel met a Chinese-born Missouri "Mafioso" named Woo Kya-Tang (Wu Giadang). Woo wined and dined Mel, urging him to work for the *China Press,* where Woo was managing editor. Even though Mel refused a job at the *China Press,* Woo, who had close ties with the Kuomintang, offered to work as Mel's agent. Mel also fielded offers to work at another paper, the *Shanghai Press,* and with the British news wire Reuters. But what Mel really wanted to do was get out of Shanghai and into free China.

To learn more about the mechanics of the news business, Mel tagged along at press conferences and watched how statements from Japanese, British, French, and American officials turned into headlines. He even once accompanied some reporters on a boat as they tried to intercept the visiting American ambassador for questions before he slipped past in the crowded waters of the Whangpoo (Huangpu) River.

"It's rather interesting hearing and seeing how the news ac-

tually breaks and finds its way into America," Mel wrote after one Japanese press conference.

While Mel scrounged for work in Shanghai, he wrote a biting essay contrasting Shanghai's selling points—its beauty, its modernity, its wealth, its internationalism—with the realities of municipal corruption, gunfights that the press never mentioned if Chinese were the victims, and tourists who marveled at Western-style buildings and gawked at the rickshaw drivers who tried to find them prostitutes.

In this essay, which was never published, Mel also skewered the sizable segment of Shanghai's international community whose members casually slung anti-Semitic slurs and stereotypes about the thousands of people who lived across Wàibáidù Qiáo—the Garden Bridge—a 105-meter-long steel-truss bridge over the Suzhou Channel, in Shanghai's Hongkew (Hongkou) district. Over the previous year, 17,000 Jewish emigrés forced out of Europe had found a home in Shanghai. World leaders had turned their backs on the thousands of Jews fleeing the Nazis. Conditions in Hongkew were cramped, however, and resembled the Jewish ghettoes many of its residents had left behind in Europe.

Mel did publish another piece. In it, his first bylined story from China—though he wrote under the pen name Mel Jack—Mel described walking through a crowded Shanghai neighborhood when he suddenly heard a little girl shouting in German.

"A few blocks more and I saw buildings displaying signs in German," he reported in the two-page feature for the *Los Angeles Times*'s Sunday magazine. "Delicatessens offering Yiddish foods, small markets, tailor shops, radio repairmen and dentists all offered their wares and services."

Only a year earlier, Mel wrote, Shanghai had been home

to only seventy Jewish residents, but as other ports around the world slammed their doors it fast became the last place accepting Jewish refugees. That welcome didn't last; by December 1939, Shanghai had begun to "pull in her welcome sign."

In his feature, Mel lusciously described every nuance of life in the vibrant, but strained, Jewish refugee community. "It looks hopeless," Mel wrote to his parents, describing the Jews' plight and the article while he was still trying to sell the piece. Aside from the hopelessness of these refugees' situation, Mel was fascinated by how strenuously they identified themselves, not just as Jews, but as Germans or Czechs or Austrians.

"How strange that nationalism was still fostered among people sent from their own countries," he pondered. "Could they get along living together in Shanghai? Could they make a living? If not, where can they go?"

Shortly after arriving, through Woo and his other contacts, Mel was referred to one of the most influential Missouri "Mafiosos" then working in China: Hollington Tong (Dong Xianguang). As vice minister of the publicity bureau, "Holly," as friends called him, was also an influential member of Chiang Kai-shek's Nationalist government. Mel, who'd admired a speech Holly gave on the Central Broadcasting Service (CBS) right after the Marco Polo Bridge incident in 1937, soon learned that Holly was the architect of much of free China's propaganda. His office wrote the government-sponsored news dispatches that were sent to wire services and newsrooms; after a government shake-up, it was also about to set up shortwave broadcasts from XGOY, the government-run radio station known as "the Voice of China."

Woo told Mel that the government was looking for someone to organize the operation at XGOY and write publicity as well. The job would put Mel in contact with some of the

most important people in China and let him see the day-to-day workings of the Chinese government from a perspective available only to a few. The job, which was Mel's if he wanted it, would give him a reason to leave Shanghai and move to Chungking, where the action was and where he could embed himself among a small but dedicated community of reporters.

"That's just the place I've been aiming at so all would be quite well should it turn out right," Mel said.

However, many of the journalists Mel had befriended in Shanghai warned him not to take the job. They thought the propaganda elements of it would kill Mel's dream of working for newspapers in the future. Others disagreed that it was a bad idea. Even though the position involved writing propaganda and paid poorly, the capital's allure—and the allure of being in free China—was difficult to resist. Besides, Mel hoped, a propaganda job didn't have to be permanent. Moreover, if he took the job, he'd end up in daily contact with the Kuomintang's inner circle and other high-profile sources. As Mel weighed the access and excitement of working in Chungking against the possibility of being permanently marked as a propagandist, the decision was made easier by the exhausting day-to-day life of Shanghai.

By Thanksgiving, when Gould and his third wife had Mel over for Thanksgiving dinner, he realized that he'd befriended more or less every American journalist in Shanghai. Regardless of what decision Mel made, they were all confident in his future.

"All seem quite anxious and convinced that I'll land something soon," he said. All of them, he added, had advice about each of his potential jobs.

"I'm darn choosey," he admitted. His other options included Woo's newspaper (Mel gave him some informal advice on how to improve it), an offer from Reuters that Mel thought would

also be propaganda-heavy, just in favor of the British, and waiting to see whether something concrete turned up with the United Press. He'd become familiar with the syndicate's Far East manager, so he felt confident about being offered a job, but it could still be a while.

Ten days later, Tong's office asked Mel again about the position in Chungking. At that point, Mel's biggest sticking point was the contract that the publicity bureau was asking him to sign. He wanted to be able to leave if a real journalism opportunity appeared. This was quite possible, especially because Mel expected the reporters he'd met in Shanghai to regularly circulate through Chungking, allowing him to maintain the network he'd developed. Finally, Tong's office relented and agreed to hire Mel without a contract.

"I am more than glad now to be about to do something no matter what the compensation," he wrote. "At least it's a living—and an interesting one."

Chapter 3

THE VOICE OF CHINA

Mel began his journey to Chungking on December 10, 1939. It would be a long trip. First he took a boat to Hong Kong, then a flight from there to the Kuomintang's capital. During the long voyage, Mel reflected on the complexities of the war in China and beyond.

His previous visit to China and now these first six weeks back there had helped convince Mel that the world was in the state it was because so many people were unable to look beyond their own situation. He insisted that if people paid more attention to the rest of the world, Hitler wouldn't have been on the march, Japan would have been kept from expanding into China, and labor disputes wouldn't be as hostile as they were in the United States. Mel also made it clear that he thought the situation in Asia was even more consequential for the world's future than the war in Europe.

"Japanese domination can spell only one thing—the East against the West," he concluded. "And no one can stop this revolutionary shift in Asia besides the United States. I don't know whether she wants to or should. But anyway it is now her problem. Asia is too close. The Philippines are too important now for us to ignore the Pacific."

During Mel's stopover in Hong Kong he visited Macau and

saw Marie and Carlos Leîtao. "The long line of Marie mothers and sons and daughters accorded me an appropriate welcome. That is I had plenty to eat." Mel also tried to contact Chan Ka Yik, but he had no response to the letter he had sent to his old roommate's home in Kwangsi.

Hong Kong was "full of uniforms," its harbor mined and blocked by steel netting. Prices were skyrocketing, but the hotels and nightlife were full of wealthy Chinese who "don't care who wins their war, don't follow the news." These people infuriated Mel.

"Makes me believe in purges," he wrote, but he added that "there are other sides to Hong Kong. Refugee camps, orphans homes, charity affairs to aid the soldiers."

The closer Mel got to Chungking, the closer the war seemed. But Mel was ready. He admitted that he missed home and its comforts before he left Hong Kong, but he was still looking forward to the trip. He felt that he would find more people who shared his perspective, and he was impressed by the colony's resilience after two years of war.

Finally, sometime between 2:00 and 4:00 one early morning just after Christmas, a China National Aviation Corporation (CNAC) DC-3 took off from Hong Kong with Mel aboard. He fell asleep, then woke around eight, just as the plane circled above a thick soup of fog and began its landing. Beneath, obscured by the clouds that always seemed to hang across its hills, lay Chungking.

In early 1940, Earl Leaf and T. K. Chang, the Chinese consul in Los Angeles, had an intriguing offer for a dentist in a small California beach town called Ventura. Leaf, who was also a former logger, sailor, and journalist, had heard that the dentist Charles E. Stuart was a world-renowned amateur radio "ham."

For nearly thirty years, "Doc Stuart" had been making his name known in amateur radio circles for his ability to contact people in some of the world's most remote places via short-wave. In this era, achieving clear signals over great distances, especially doing so consistently, still required considerable skill. Stuart's radio skills would be crucial to China as it tried to generate sympathy and support for its war effort in the United States. So Leaf and Chang asked Stuart to receive propaganda broadcasts sent from China, record them, and retransmit them to a Chinese news service with offices in four U.S. cities.

In a little room off the side of his dental office in downtown Ventura, Stuart and his dental assistant (and soon-to-be wife), Alacia Held, set up a miniature studio with radio receivers, headphones, a teletype machine, and even a device that could capture ten minutes of audio on each side of a twelve-inch record. There, Stuart would tune in to broadcasts from XGOY, the government-run radio station in distant Chungking, while Alacia set up recordings of each broadcast and transcribed every word spoken. Stuart would become both the primary link between China and the United States and the primary vehicle for the work Mel was about to begin in Chungking.

Aware that an American audience would have a difficult time understanding heavily accented English, especially over what was often a poor signal despite his radio expertise, Stuart asked his counterparts in China to hire an announcer who could speak the language clearly. Peng Lo Shan, XGOY's station manager and also an employee of China's Ministry of Information, turned to Holly Tong to find out whether Mel, the young American he'd just hired to work in his publicity department, could help organize the radio station. This idea had intrigued Mel ever since Tong's agents had approached him a second time in Shanghai, and he was finally able to start working shortly after his arrival that foggy late December morning.

In a highly political move, China's broadcasting service had been moved to the publicity bureau from another government ministry on January 1, 1940. Aside from running XGOY, the publicity bureau also compiled material for daily and weekly English-language news summaries, handled foreign correspondents, censored outgoing copy, and saw to other public affairs needs of the government.

Mel's first task with the publicity bureau was surveying its radio capabilities and needs. He quickly recognized the need that Stuart had mentioned: a clear-speaking American announcer who understood the U.S. radio audience.

"No one up here knows much about broadcasting, particularly the kind of programs to send to the U.S.," Mel wrote.

The United States, not China, was XGOY's target demographic. If XGOY could generate sympathy for the Chinese cause in the United States, it might be able to help sway public opinion and put pressure on the Roosevelt administration to assist Chiang Kai-shek's war effort.

Mel had a friend from Los Angeles who he thought would be a capable announcer, as well as a source of advice about broadcasting. They corresponded about XGOY for a few months, but the friend never came to Chungking. Thus, Mel became the announcer.

Aside from needing someone who understood the United States, XGOY had other problems. For one thing, it broadcast in thirteen languages besides English, so news copy had to be translated into each of these. Those translations were of varying quality. For another, there were any number of technical complications. And none of it mattered if, as happened more than once, someone forgot to flip the switch that made the broadcast go live.

Mel's job wasn't simply to assist at XGOY. He also helped rewrite newspaper and magazine copy originally written by

the publicity bureau's Chinese staff. He even was a ghostwriter for a column that a local bishop supplied to a newsletter called *McClure's*. From the beginning, Mel wasn't particularly charitable in his descriptions of some of the bureau's work that he had to rewrite. Much of it was unintelligible when it reached Mel, even though it had been written in English.

"Two of us retranslate these atrocities into a news story form whenever possible," Mel said. Moreover, many of the original stories were written by government ministers and other important Kuomintang leaders, or their advisors. Mel had to be cautious before he made any changes.

"Of course, there is the problem of face and toe-treading," Mel noted. "So when *certain* writers butch badly—that is permissible."

However, Mel added that he might have been somewhat exaggerating how bad the work was for good reading. He admired and respected his boss, Hollington Tong, the vice minister of publicity. Mel thought Tong was an active, good-natured official with a modern slant. He also liked the people he worked with, even if their work habits sometimes annoyed him.

"No one here knows exactly what routine means," Mel wrote that January. "Even getting your salary is rather confusing. I asked for some money since I was broke and low [*sic*] and behold a boy brought me a large envelope crammed with more bills than I know what to do with."

When Mel wasn't working, he was constantly exploring his new hometown by foot. Chungking was a makeshift metropolis perched atop a series of steep hills. It centered on a peninsula four miles long and a mile or so wide that thrust eastward into the junction of the Chialing (Jialing) and Yangtze (Chang Jiang) Rivers. Bamboo houses on stilts climbed up the hills, bunching up along the cliffs that rose precipitously from the banks of the Yangtze.

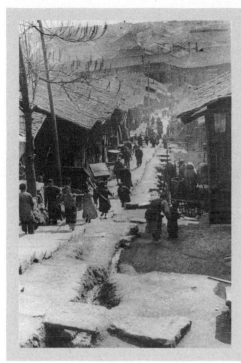

Chungking (Chongqing), China, and one of its many stone-step pathways. *Photo by Melville J. Jacoby. Photo courtesy Peggy Stern Cole.*

Central Chungking was divided into an upper city, a lower city, and flood-prone markets along the river. Before the war, merchants had traveled along the length of the Yangtze, the world's third longest river, to Chungking from places like Hankow, Nanking, and Shanghai. On the south bank of the Yangtze was a small foreign district inhabited by some of the city's foreign embassies, Christian missions, and major business concerns, such as Standard Oil.

Crossing the peninsula just west of downtown Chungking was a new road that had recently been renamed Zhongshan, in honor of the national hero Sun Yat-sen. Up Zhongshan, the Kuomintang's leaders convened at the Executive Yuan. Nearby were other government offices, as well as homes occupied by the Chiangs and other notables, including the Communist em-

issary Chou En-lai (Zhou Enlai) and the Nationalist spymaster Tai Li (Dai Li).

Chungking felt unfinished. By the time Mel arrived, its newly paved streets teemed with refugees from the conquered coastal cities, but much of the city still lacked modern roads. Once a key city in the ancient Bā Kingdom and located in the heart of Szechuan Province (Sichuan), Chungking had been something of a backwater in China for a while.

But then, as Mel wrote, "the 20th Century caught up to Chungking in two leaps and a bound." The first leap: in 1891 the English established regular steamer service along the Yangtze between Shanghai and Chungking. The second: in 1931 regular flights began from the coast to Shanhuba—the rocky airfield in the Yangtze's riverbed.

The bound? That was Chiang Kai-shek's announcement on November 20, 1937, that China's capital was moving from Nanking to Chungking, rapidly transforming the city into free China's center of gravity. As the historian Rana Mitter wrote, this transition was a key piece of the country's wartime strategy of trading space for time.

"Moving the entire government 1500 kilometers up the Yangtze River helped to consolidate ideas of a united China that spanned the whole of the country's landmass," Mitter wrote. Chungking was far inland, in the country's southwest. Though located roughly in the center of modern China, in 1940 it was considered the frontier.

China's government survived, but to resist an enemy as powerful, rich, and modernized as the Japanese, China also needed a thriving economy. When the Kuomintang moved its seat of power to Chungking, it orchestrated a massive relocation of Chinese industry and commerce. Entire factories were dismantled and floated on barges up the Yangtze from

Hankow. Railroads were laid just ahead of trains that carried boilers, refineries, and other industrial equipment into China's heart.

While the thick fog that clung to Chungking's hills kept Japan's bombers away in the winter, this was a city with its attention otherwise directed skyward. Chungking was the "most raided city in the world." Life seemed to revolve around the city's many dugouts—air raid shelters—tunneled into Chungking's many hillsides. These dugouts were often not glamorous. Many of the deep, damp tunnels were "often used for the wrong purposes" and consequently disgusting enough to convince Mel to carry a flashlight for his visits. The city's leaders still had to teach the city's many new residents to use them when the raids did finally come.

"Chungking is probably the world's most uncomfortable capital to live in," Mel wrote in "Unheavenly City," one of a handful of his unpublished stories from the summer of 1940. "A servant heats your bath water over an open fire, and by the time it gets to the tub, it's either cold or the air raid siren has sounded. A single chocolate bar is split a dozen ways, and American cigarettes are almost as rare as taxicabs."

New roads had been paved, but it was a city where most people walked. Few owned cars, and taxis were rare. Webs of stone staircases and steep, winding alleyways cut over the hills and between the bamboo-and-paper buildings perched on stilts along Chungking's cliffs. The steps were coated with muddy, slippery blankets of moss.

Chungking was a city of smells, of scents "evil and new— and yet intimately familiar and human," Carl Mydans would write later. Summers were stifling, damp winters were chilling, and everyone smoked the Three Castles cigarettes advertised in local publications as "Still My Favorite." Chungking's depri-

vations, squalor, danger, and inconveniences were myriad, yet the city got its hooks into nearly every visitor.

"Few foreigners desert Chungking without wanting to return," Mel wrote. "The set formula is to tell friends in Hong Kong what a hell-hole they are missing, and then to rush right back on the next plane loaded with only thirty pounds of clothes and bare essentials."

Chungking was simultaneously brand-new and decrepit. Fast becoming the "most bombed" city in the world, it was also the epicenter of the country for any serious journalist. Outside of Mel's work at the publicity bureau, Mel began to use the contacts he'd developed before leaving California to pitch reporting with his own name on it. He also acquired a Contax Model II camera, which he brought with him everywhere he went, shooting photos whenever he got a chance. He even sold some photographs to the Associated Press (AP). And after the *Los Angeles Times* published his article about Shanghai's Jewish community, he arranged to write more features, like one about the selection of the Dalai Lama for *This World,* the Sunday magazine of the *San Francisco Chronicle.*

In California, Shirlee, Mel's girlfriend from Stanford, had been keeping in regular contact with his mother. The two swapped news from Mel and tried to interpret what his brief, sometimes cryptic telegrams meant. (They spent a considerable amount of time trying to figure out the meaning of his cable address, "SINOCOM," which simply stood for "Chinese [Sino] Communications.") One thing, however, was readily apparent to them: the letters Mel sent from Chungking had a far happier tone than anything he'd written from Shanghai.

This may have had much to do with the community Mel had found at Chungking's Press Hostel. If Chungking was wartime

China's center of gravity, Mel and many other journalists in the city found theirs in the Press Hostel, a thin-walled structure of mud, bamboo, plaster, and stone that before the war had been a middle school.

After the government moved to Chungking, Holly Tong convinced H. H. Kung—possibly China's richest man, its finance minister, and Madame Chiang's brother-in-law—to finance $10,000 in upgrades to the school so that foreign reporters could live and work there. It was cheap and uncomfortable—water for baths had to be carried up by porters, and there wasn't much of it—but it quickly felt like home.

Maya Rodevitch, Melville Jacoby, Randall Gould, and Hugh Deane socialize outside of the Press Hostel in Chungking, China.
Photo courtesy Peggy Stern Cole.

Built into a small, grassy bowl between two ridges spanning the peninsula that gave shape to central Chungking, the hostel was within walking distance of key Kuomintang facilities and foreign embassies being built in the surrounding hills and valleys (though more were constructed in districts across the city's two rivers). Holly's own residence was near the Press Hostel, as were his offices and the studio of China's Central Broadcasting Service (which also had facilities elsewhere).

Mel lived in a small room with two large windows and whitewashed mud walls. He slept on a small metal cot with a hard, half-inch-thick mattress. There were a couple of end tables, a small desk with a lamp, some chairs, a dresser, and a washbasin. A forever-damp carpet covered part of the cement floor.

There was also an office that Mel shared with Maurice "Mo" Votaw, another Mizzou grad, who was on hiatus from teaching at a journalism school in Shanghai. Gaunt, with slightly receding, wavy brown hair and a mustache, Mo played a somewhat avuncular role for Mel and the other young journalists who haunted the Press Hostel.

"If you are a correspondent you live at the Chungking Press Hostel," Mel wrote. "It's almost like being back in a college dormitory. Meals, because of the 25-1 exchange in operation, cost you about two American dollars a month. You know, or at least think you do, more about everyone else's business than your own. Family problems nine thousand miles back in America are Press Hostel problems. Try and keep the contents of a letter secret, and your name is mud."

As they ate, slept, and suffered raids together, the other journalists came to feel far closer than mere colleagues. To Mel, the people he met at the Press Hostel—among them Till Durdin and his wife Peggy; Israel Epstein; Mel's old Lingnan friend Hugh Deane; the prickly, misogynistic Jack Belden; and the

woman Belden pursued, Betty Graham (another former Ling-
nan exchange student who in turn had an unrequited crush on
Mel)—became an extended family. Yes, the Chungking press
gang competed for scoops—indeed, foreign reporters came and
went with shifting assignments and shifting fortunes—and of
course bitterness and heartbreak occasionally crept into Press
Hostel affairs, but everyone who lived there shared a bond.

There were often light moments at the Press Hostel: pickup
basketball games and volleyball with Ministry of Information
officials or local kids in the dirt courtyard; the excitement of
chocolate bars and whiskey when someone returned from a
trip to Hong Kong; the time Mel sat fully naked—though stra-
tegically covered—in the hostel's bath and someone snapped
his somewhat miffed picture.

Denizens of the press hostel loved welcoming returning or
newly arriving correspondents with long, late-running parties.
When Randall Gould came in early March, Mel and another
friend set up a large dinner for him.

"Put on a pretty good feed and lots of rice wine—twenty-four
pewter jugs to be exact," Mel wrote.

Those jugs were hoisted by twenty-three extremely colorful
guests, who together represented the sort of cosmopolis that
Chungking had cultivated. Among Mel's invitees were a Polish
woman who worked for the League of Nations and was the
Chinese war minister's mistress; an American writer named
Helen Foster Snow (aka Nym Wales), who helped organize
the Chinese Industrial Cooperatives movement and was mar-
ried to the author Edgar Snow; Peggy Durdin; an unidentified
Bank of China advisor; and Theodore H. White, *Time*'s cor-
respondent.

"What a group we got here, too," Mel said. "Our press hostel
houses enough characters, but when we join the crowd from
the Chungking Hostel [a private lodging house where many

foreigners lived] then the fun begins—someone someday will write a book on Chungking society."

The day after the party, Gould borrowed an office car, and he and Mel drove into the countryside around Chungking. Fruit trees were beginning to flower, and Mel found the blooms a welcome relief from three months of the city's gray skies. The two reporters took a dip at a hot springs resort, shot photos, and visited far-flung government offices that had been scattered to avoid concentrated disruptions from air raids, which gave them a sense of how the government was responding to the constant attacks.

"It was quite a break for me to go along as gasoline is one dollar gold per gallon and people don't use cars too much," Mel noted.

Usually, the diversions were less adventurous. Once, someone at the Press Hostel got ahold of a full Japanese uniform, complete with weapons. They proceeded to dress *Time* correspondent Theodore H. White in the getup. When he had the full uniform on, "Teddy" grinned widely, a rifle in one hand, a pistol in another, a helmet on, and a Japanese flag sticking out of the sleeve of his long field coat.

The hostel felt like the center of an Edenic world, despite the horrors beyond the palm trees surrounding the hostel's grounds. It was an era that Teddy, a quick-tongued Harvard grad, later recalled as "those days in Chungking, under the bombs, when life was so fresh and everyone was so good and all things were so simple."

Among the friends Mel made at the Press Hostel, Teddy may have been the closest. The pair's friendship began right at the beginning of 1940, when *Time* magazine hired Teddy to work as its Far East correspondent and Mel took over Teddy's pre-

vious job at the publicity bureau. They bonded in early January, after taking a crowded bus with Votaw to the center of Chungking for a night out eating Cantonese food and theater-hopping between a Chinese movie they couldn't understand and a bunch of ancient, badly censored American newsreels.

Teddy and Mel were an unusual pair. Smirking Mel was tall and athletic, with soulful eyes and thick hair. Broad-grinning Teddy was short and slightly rounder, bespectacled, and balding. The former was an only child and the darling of a wealthy California family; the latter had lived leanly with his mother and several siblings in Boston. Mel was often quiet; Teddy was loquacious when his passions were aroused.

But both came from families with Jewish heritage, and each had a father who perished at a young age. Both men loved China immensely, but loved journalism even more. Each was brilliant in his own way. They were, as the author Peter Rand wrote, "soul mates" of a sort.

The men became fast friends as the war progressed.

"I don't know how, if ever, words can recapture the joys and happiness of deep, living friendship," Teddy later told the Durdins. "We carry so much around of our friends. It never leaves; it is the heat of Chungking, or the nights when the Japanese were raiding, or the restaurants and the good food; or the talking, most of all the talking."

Humidity suffocated Chungking. Mosquitoes infested Chungking. Buses' charcoal exhaust choked Chungking. Parties in Chungking flowed with roast duck, scallion pancakes, and rice wine as Japanese rebels, German Communists, and American military attachés mingled with adventure-seekers, mercenaries, and bohemians from the world's farthest corners. Outside these bacchanals, Chungking's cacophonous streets crawled

with beggars peddling broken tools and decrepit clothing and stinking of unwashed mothers trying to feed children defecating in the gutters.

For much of the year, heat enveloped Chungking, even in the middle of the night. The thick, sultry air was as ever present as the noise. Silence was a concept so foreign in this pop-up capital that the word could have been cut from dictionary pages and never missed.

Air raid season finally arrived as the weather cleared, and that brought the worst noise by far: the wail of air raid sirens. These were always swiftly followed by the urgent murmur of citizens rushing to dugout shelters. Then came the faraway drone of approaching bombers that climbed to a roar. This sound ebbed to a brief, eerie quiet, which, in turn, flowed away as deceptively distant blasts thudded above hundreds of feet of stone, "like suction cups plopping against water."

During attacks, the city's residents did what they could to play it cool. On these days, while approaching planes were still distant, Chungkingers watched the skies with detached interest. The attacks had become routine, and the underground shelters a part of daily life. Young lovers stole away in the darkness to kiss. Cooks prepped lunch boxes. Bureaucrats read the newspaper.

Such normalcy, if you could call it that, was possible because of an elaborate warning system. Spies near Japanese airfields reported bomber squadrons taking off to officials in Chungking. Local officials, in turn, estimated when the attacking sorties would arrive. While sirens sounded, a series of red paper warning lamps were hoisted onto poles atop the hills so that residents could gauge how long they had to get to one of the many shelters. When the first ball went up, they had two hours before the attack; the second came when the planes were within

one hundred miles; the final was raised just before the planes arrived.

Chungking's air defense system had created what superficially seemed like an orderly response to the raids, but those raids carved stark, deadly realities out of the city's resilient facade. After every bombing, residents emerged from the shelters to horrific scenes. Rickshaw drivers and *bang-bang* men—local porters who carried heavy loads up Chungking's countless stone steps—lay mangled in the street, their bamboo carrying poles and baskets scattered around them. Women's bodies were sprawled in roadways, bloodied skirts splayed in the dirt. Flattened buses smoldered. Flaming buildings burned. Smoke rolled into the sky and sank again into the city's many valleys.

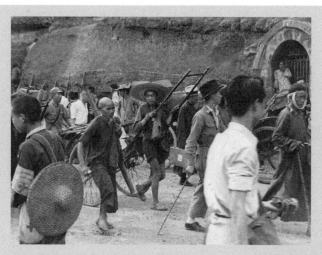

Crowds pack Chungking (Chongqing), China's, streets outside of one of the city's many dugouts, or air raid shelters. *Photo by Melville J. Jacoby. Photo courtesy Peggy Stern Cole.*

Many people, particularly the starving and sick, couldn't reach Chungking's shelters in time. It was their bodies that lay mangled in the streets, their bamboo stilt and paper-wall houses that burned most often, their children's wails that echoed on the city's stone steps long after the thunder of the raids ceased. It was these people desperate to sell one more handful of peanuts or bunch of tangerines just to survive who were, in overwhelming numbers, the war's victims.

While horrified by the bomb victims' experience, Mel wasn't in the same great personal danger. Air raid alarms came so frequently that he eventually tired of how they interrupted his work, but he could always reach a shelter. There he tried to steal moments with his typewriter to bang out stories, but more often than he liked he found himself in a dugout too crowded, dark, or loud to work.

Moments that Mel didn't spend in a bomb shelter were filled with the noise of the teeming masses, the conversations and lovemaking unmuted by the Press Hostel's paper-thin walls, the chatter of work, and the constant rattle of typewriters. Each morning, in front of a stack of radio equipment at XGOY's control center, Mel and other news announcers read morning briefings with measured voices, while out on Chungking's streets countless dialects pooled from China's four corners to this polyglot bastion, where they swirled—particularly in Cantonese, Mandarin, and Szechuanese (Sichuanese)—from storefront to storefront.

Mel also worked in close proximity to Chungking's rich and powerful. Located near Zhongshan and the government offices that surrounded it, the Press Hostel was built where it was so that Chinese officials could easily watch over the press but also so that journalists had easy access to Chungking's leaders while they reported.

"You get to know Chinese officials fairly well and that

makes you feel closer to the war," Mel wrote. "Gradually you find that you have more Chinese than foreign friends, and that makes you feel good. You think of yourself in the center of this great gyration of events."

Mayling Soong, the influential American-educated wife of Generalissimo Chiang Kai-shek, as photographed by Melville Jacoby.
Photo courtesy Peggy Stern Cole.

Newly arrived to this landscape was Sun Yat-sen's widow, Soong Ching-ling (Soong Qingling), who that spring had moved to Chungking and a three-story home only a quarter-mile away from the hostel. In age, Ching-ling was the middle of the powerful trio of "Soong Sisters." The youngest was Mayling—aka Madame Chiang Kai-shek—and the oldest was Ay-ling (Ailing), the wife of financier H. H. Kung, the individual who bankrolled Tong's Press Hostel project. Their brother, T. V. Soong, born between Ay-Ling and Madame Sun, was a former finance minister and businessman who would later serve as a special emissary to the United States.

Madame Sun's arrival marked the first time all three Soong sisters had lived in the same city since the start of the war. It was also one of the biggest political events in the wartime capital, as it signaled the height of cooperation between the Communists, with whom she sympathized, and the Kuomintang, whose leaders were intimately connected to her sisters and brother.

Mel was offered the opportunity to shoot pictures of the sisters' first tour of Chungking. He almost missed it while in the bath.

"Someone said for —— sakes get dressed, I was going out with Madame Chiang, Sun, and Kung," Mel told his parents. Mel had just sold his camera to Hugh Deane and hadn't yet bought a new one, so he grabbed Associated Press reporter Jim Stewart's camera and caught up with the sisters. He then traveled around Chungking with their retinue as they toured bomb-damaged areas, air raid shelters, and factories.

On the morning of April 17, Mel sat at a microphone in XGOY's studio near the Press Hostel across from the sisters, the three most important women in China. Getting them together on the radio was a boon for Chinese publicity, and for Mel's career. This day they were chattering together—in English, which they spoke to one another everywhere. Moments before the broadcast began, Ching-ling burst out in giggles. Soon her sisters started laughing as well. One of them looked at Mel and made a funny face. He lost it too.

All four were still chuckling at 5:40 A.M., as NBC's New York host broke in.

"Go ahead, Chungking," the announcer said.

Mel pulled himself together. In measured, almost stiff tones, he introduced the three sisters. His voice was distorted and

almost unintelligible because of the static, but back in their homes in San Francisco and Bel Air, Shirlee and Elza listened in wonder, thrilled to be hearing Mel's voice for the first time in months and proud of him for introducing such important figures to the United States.

"Thank you, NBC, and hello, America," Mel said. "Here in the Chungking studios of the Chinese International Broadcasting Station are three of the foremost women in China."

Mel continued by introducing each of the women by name.

"It is a rare privilege indeed to turn the microphone over at this time to Madame Sun," Mel said as Ching-ling composed herself.

"Quite a speech," Mel later joked in a letter about his sparse introduction. "Lousy as an announcer as I am, the whole thing was sort of fun. People say I usually don't sound so badly."

If he was not pleased with his announcing, Mel was even less pleased with the fact that both the end of Madame Chiang's speech and a closing announcement of his were cut off when the segment went overtime. However, when Mel saw Madame Chiang again later, she told him she was pleased with the broadcast, and with him. She promised to sit down for an interview in the near future.

"We are quite chummy now, you know," a charmed Mel wrote to his mother. "Always calls me by name and gives me a nice smile."

Mel's broadcast for the Soong sisters had been specially arranged with NBC in New York. On May 3, preparations were finally completed at XGOY for its own daily broadcasts from a new studio—this one safely dug into a tunnel deep beneath Chungking's hills, where it was protected from the city's constant air raids. At 4:00 A.M. each morning, Mel walked seven

miles west to XGOY's new station in the Shapingba district. After a breakfast of hot noodles, Mel broadcast the day's news roundup for Doc Stuart. Afterward, if he didn't have to help put out a fire from the constant squabbles between the station's engineers and its programming staff, Mel left to pick up the day's dope from sources around Chungking. That required walking up and down hills and stairs all over the city through thick, damp weather.

For a brief period of time, after broadcasts were shifted to late evenings, XGOY's main studio was out of commission and Mel had to use another transmitter. Doing so required leaving at 7:00 P.M. for a two-hour ride on the back of a truck or in a crowded bus to the other transmitter, which was far out in the countryside on Chungking's outskirts; then he got another two-hour ride back. This was all after exhausting days of reporting, air raids, and meetings.

"Not the easiest capital in the world to cover, Chungking presents a teasing array of difficulties to the correspondent," Mel once reported to an editor.

The reality of air raids usually kept Mel from getting more than one interview done a day before he had to find a dugout. Taking into account the time he had to remain in a shelter before the all-clear, it took too long to get between multiple meetings without a car. On cloudy days, however, Mel might have had time to take a sampan to the south bank of the Yangtze and the many foreign embassies, business outposts, and Chinese government offices located there. Then he would come back across the river. Faced with the steep stairways that led up the city's cliffs, Mel normally refused the Chinese peasants who offered to carry him up in a sedan chair in favor of gingerly negotiating the thousands of slippery stone steps himself. Recalling the embarrassment of riding across the Kwangsi countryside to the family compound of his Lingnan roommate

Ka Yik, Mel could bear neither the thought of twisting his
stocky six-foot-one frame into the chairs nor the cultural dis-
comfort of relying on the peasants' servitude.

"When you are climbing from one hill to another under a
blazing mid-day sun, you curse their steepness," Mel wrote in
"Unheavenly City." "A few hours later you are tucked away in
a tunnel running through the center of the same hill safe from
exploding bombs. You feel a five hundred pounder jar the hill
above your head and your jaw snaps shut. But as soon as you
can talk again, you remark to your neighbor how glad you are
for Chungking's hills, and thank goodness out loud that you
aren't in flat old London."

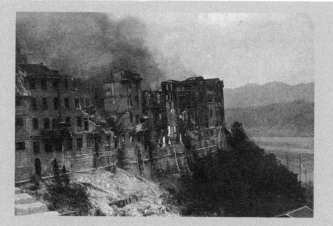

A building burns atop a cliff in Chungking
(Chongqing), China, following an air raid by
Japanese planes. *Photo by Melville J. Jacoby.*
Photo courtesy Peggy Stern Cole.

Atop the cliffs of Pipa Shan, one of Chungking's many hills,
Mel would stop to light a Three Castles cigarette and watch
foreign pilots "miraculously" ease huge CNAC DC-3s be-

tween several large mountains, through the thick, yellow fog blanketing the Yangtze, and down toward the airfield at Shan-huba, though he would never quite see them land.

"The field is rocky, unlighted and unmarked," Mel said shortly after he arrived in Chungking. "You can't even see it from the neighboring cliffs overlooking the water. Yet [the pi-lots] always miss the hills around here which they can't possibly see, and land safely on a field that appears when they are about fifty feet above the ground."

Mel loved being in Chungking, but as the year progressed he became disillusioned with his government job. As he skipped dinners to write news roundups or wrangle guests for upcom-ing broadcasts, he kept a good sense of humor about how hard he was working.

"See, I am earning my three dollars per week," he wrote.

Every day something angered Mel about the studio. An-nouncers at XGOY wouldn't rehearse or properly time their broadcasts before going on air. Some would yawn on mic. Others just didn't show up when they were supposed to.

"Feel that I will have done my duty," he wrote. "I can't stand such an awful lack of efficiency much longer."

Mel was also upset that the office had peasants working ev-ery day around the clock without any breaks.

"Makes me sore as hell," Mel wrote. He wasn't just upset about being a party to the exploitation, though that was part of it. Other laborers worked less. He was aggravated that this was one of many areas at his office where there didn't seem to be any sort of system or routine. He got so mad that he threatened to quit.

That got Tong's attention, and he sent word to Mel that he was so pleased with his work that he wanted to offer Mel a gold-based salary (which meant far stabler income given the rapid fluctuations of China's wartime currency). It was tempt-

ing, but Mel still wasn't sure. For one thing, he didn't know if he could continue working as a propagandist. Though by that point he'd had a few stories in the *Chronicle* and he had been getting some bites from other publications, he wasn't getting regular journalism work. Committing to work for the Ministry of Information would make newspaper work even less likely to come his way.

If Mel accepted such a deal, he would be able to afford to pay for Shirlee to come out to Chungking. He also thought it was likely that they would get married if she did, and though he was open to that possibility, he didn't think it was quite the right moment, especially because a wedding would have to take place far away from their families.

"On the other hand, should I return in the next year to the U.S. I will practically lose all I have built today, and I will come home unless Shirlee comes out," Mel wrote to his mother and stepfather. He told them he wanted to do the right thing, but he wanted their input too.

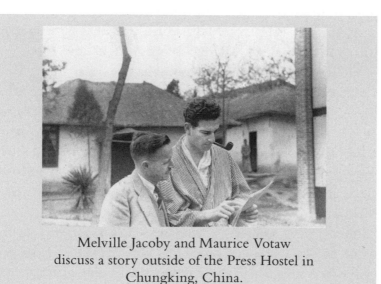

Melville Jacoby and Maurice Votaw
discuss a story outside of the Press Hostel in
Chungking, China.
Photo courtesy Peggy Stern Cole.

Shortly after Mel first indicated that he wanted to quit, Madame Chiang came through on her promise of an interview. Over the rare treat of fresh orange juice, they chatted for forty-five minutes. Most of what May-ling said was off-the-record. Mel put the slim bit of information he could use into a feature he wrote about her for the *Chronicle,* but in exchange for access to her, he had to show her the draft for her approval. Once she finally returned it after many delays, she'd censored it heavily.

"Very charming lady, but I would like to write what I could—instead of what I did," Mel wrote.

Even amid Chungking's charms, Mel developed complaints. For one thing, despite his profile of Madame Chiang, another of an influential advisor of Chiang's named W. H. Donald, and Mel's reporting on the new Dalai Lama's selection for the *San Francisco Chronicle,* a publication for which he'd long wanted to write, Mel had few opportunities to do his own reporting.

"Haven't done a doggone thing in writing articles," he complained. "Sick of turning out Sunday magazine trash and no time for much better stuff at the moment."

As early as February, Mel had realized that by nature he was "too critical to remain a propagandist" and that some of Holly's crew felt he was "too objective." Earl Leaf, Mel's China News Service contact in New York, also realized that Mel might actually contribute more as an independent reporter, so Leaf worked to connect Mel with outside news wires. Meanwhile, Teddy White was planning to take a trip and offered Mel fill-in work with *Time* and *Life* while he was away; in the end, however, the magazines didn't use any of Mel's material.

It may have seemed to Mel and other reporters that the world revolved around Chungking, but American newspapers still lacked sufficient Asian coverage. Throughout his stay in

Chungking, Mel had been corresponding with the Institute for Pacific Relations, whose influence had helped him find a job. John Oakie, the San Francisco Bay Region Division's secretary, told Mel that he was "delighted" that Mel was in a position to watch the events transpiring in Asia. Mel sent Oakie notes about political events in China, and Oakie was eager for more details now that the European war dominated headlines.

"The atmosphere between here and the Far East has been pretty murky since the outbreak of a really first class show in Europe," Oakie wrote. "There is almost no news coming through from China and the magazine output here is simply hash and rehash of old stuff, with a certain amount of addition or subtraction for wishful thinking and pessimism."

Mel wanted to help Oakie. He agreed that the papers should carry more material about Asia. It was his job to care about that. But he still paid attention to events in Europe. Indeed, Mel had long thought that what happened in Europe had tremendous effects on Asia, and vice versa. He was even thinking about leaving China for Europe, possibly as a volunteer for the Canadian or Free French air force, or as a Red Cross ambulance driver, which a group of his friends from Shanghai were preparing to do. Mel also thought about talking to the military attaché at the American embassy in Chungking, who had previously said that he could help Mel land a plum assignment in the Army Air Corps if the United States entered the war.

"I realize that would worry you both, but in the meantime I fear you worry here, too," Mel wrote to his mother and step-father.

So when France fell on June 22, 1940, Mel took note. Three days later, he was at a government office during an air raid. The office's dugout happened to be just below the French embassy,

and many members of the embassy's staff were taking shelter inside. Mel knew some of them. Everybody was depressed.

"They don't know which government they represent even," he wrote.

As Mel explained in a letter that day, he also had an eye on his future. France's surrender reminded him how much the news from Europe was dominating space in American publications, leaving few interested in buying his freelance stories about China. A more permanent job started to sound appealing.

There were still many reasons to stay. The United Press kept insisting that a job in Shanghai would open up by fall, and Hollington Tong's enticement of a gold salary for Mel to commit to a full-time position remained on the table. Meanwhile, Teddy White assured Mel that *Time* would have an opening come September and that Mel would get first dibs at the position. Chungking wasn't as easy a place to leave as he had expected, anyhow. Mel had come to love its flaws.

"Learning to bum cigarettes from visitors, enduring a cold water bath, eating only Chinese food, getting letters home by clipper, settling the world's problems over rice wine, and watching the Chinese in their tremendous efforts is all part of Chungking's fun," Mel wrote in "Unheavenly City." "You get to like it."

Mel had arrived in Chungking idealistic and eager, but it didn't take long for the city's inefficiencies and discomforts to get under his skin. Only now, as the summer progressed, did he begin to realize that in fact much of what was "wrong" with Chungking was, in a way, what was *right* about it.

"You damn a government bureau for incompetence and laugh at the city's bus system," Mel wrote. "Instead of marveling at the fact that the buses still run, you write home in your let-

ters ridiculing the wheezing old charcoal burning monsters . . . but all the time you have forgotten that the Chinese themselves are laughing about the buses too and a thousand other things that you don't see."

Chungking was hot. It was loud. It was squalid. It was crowded. It was deadly.

It was home. Chungking was home.

Chapter 4

THE HAIPHONG INCIDENT

*A*s the summer of 1940 stretched toward fall, the Chung-king press corps paid ever closer attention to the developments in Indochina, the French colony south of China that consisted of present-day Vietnam, Laos, and Cambodia.

After the Nazi takeover of France, Marshal Philippe Pétain assumed control of a newly formed puppet government located in the spa town of Vichy. Initially, Pétain took a hands-off approach in French Indochina, and so regional forces and colonial officials there were unclear how, or whether, to become involved with the conflict in nearby China. Pétain's capitulation to the Nazis worried Mel. German influence in France might shift French Indochina's relationship with Japan and China, and Japan's entrance into the Axis could also endanger Great Britain's colonies in Hong Kong, Malaya (Malaysia), and Singapore.

"I hope America realizes what a German win would do in the Far East," Mel wrote.

In January 1940—five months before France fell—Japan began a series of attacks on the Kunming-Haiphong railway. This railway connected Haiphong, a crucial port near Hanoi in what is now North Vietnam, with Kunming, a major logistical center in southwestern China. Using the railway, European

and American suppliers were able to transport fuel, ammunition, and other supplies through Haiphong to Kunming. With its war effort slowed by the grinding resistance of a China that made up for its lack of modern weapons with sheer numbers, Japan changed tactics that summer and accelerated its attempts to cut off this and other supply lines.

Even after the Vichy government was installed, France was not at war with either China or Japan. The colony had long profited from shipments of arms and other equipment to China. At first it worked to keep the Haiphong-Kunming railway open. But as ties among Japan, Italy, and Germany—which ultimately held Vichy's puppet strings—tightened, Indochina began absorbing further Japanese pressure.

With all that was happening in Indochina, and aware that the French colony's fate could affect the balance of power in Asia, Mel looked into reporting there. It seemed to him that reporting on the intersections between France's fall and Japan's rise might be a better use of his talents and passions than waking up at 4:00 A.M. to write news summaries only to have engineers bungle the broadcasts.

"As you can imagine with trouble about to brew in either Indochina or around Hong Kong, I am anxious to get out of here and see what's happening in the outside world," Mel wrote to his mother.

That July, Mel's decision was made easier when political jockeying at XGOY became so rampant that Mel blew up at the entire station staff. The station's engineers were acting like prima donnas and refusing to cooperate with the program staff, who worked closely with Mel. The constant friction made it impossible for Mel to get any work done. So he resigned, effective at the end of the month.

"Damn these politics," Mel wrote, not going into detail about the workplace political intrigues he cursed. "I really

fumed and stormed around here, and with the heat and all it wasn't very cool. Delivered several to-the-point lectures to some of these officials, hypocritical, inefficient little mugs for which I was thoroughly congratulated by my superiors."

Though Holly Tong felt powerless to do anything, because so many staffers at the station had family members who had tremendous influence in the Kuomintang's power circles, he was reluctant to let Mel leave. But Mel's mind was made up, and Tong understood why. Knowing that he couldn't compel Mel to stay, he finally accepted his resignation and wrote an encouraging letter praising him for his energy and work ethic.

"I feel that your initiative will take you far in whatever field of activities you may be engaged," Tong wrote. "Your willingness to work in all kinds of adverse circumstances is an asset for success. I shall follow your career with keen interest."

Just as Mel was resigning from Tong's employ, his friend Teddy White was preparing to leave for a reporting trip to Indochina and Singapore. Mel decided to go with him; then, if further news didn't break, he would head home (but he cautioned his mother in a letter that he would come back to Chungking if breaking news, like a cease-fire with Japan, occurred). Another reason he could be delayed in returning home might be an inability to buy a ticket; the United States had frozen Japanese and Chinese assets that summer, and Mel didn't know if he'd be able to withdraw money from his bank accounts while he traveled.

Mel expected that the connections he'd built in Shanghai would pay off with an assignment from the United Press. If that happened, then he could get a press pass to travel farther through Indochina than he could without one. He also imagined that he could keep writing features for the *San Francisco Chronicle* and *McClure's*. Moreover, Teddy had helped Mel get

in touch with *Life* magazine. Mel was bringing his camera, and he hoped to market his pictures to the photo-heavy weekly.

Early on the morning of August 10, Mel and Teddy took off on a DC-3 bound for Kunming, in Yunnan Province. A temperate town about four hundred miles southwest of Chungking, Kunming was also a logistical hub near China's borders with Indochina and Burma (Myanmar). Because roads connecting Kunming to these French and British colonies had not yet been blocked by Japan, it didn't have the same shortages as Chungking, though prices were still very high. Faced with the sudden abundance, however, Mel didn't care.

"You should have seen me walk down the streets and being amazed at being able to buy chocolate, canned milk, cigarettes, brandy—it seems to me everything," Mel wrote. "Guess there are things I have forgotten altogether."

The food was plentiful in Kunming, and the air was fresh, but Mel still couldn't believe that the long trip he'd started would eventually bring him back to the United States, though he didn't yet know quite when. Mel was thinking back on Chungking.

"Left Chungking on Sunday and miss it already," he wrote.

Mel spent the first part of his trip interviewing business, political, and military leaders in Kunming, writing up long summaries about their backgrounds and their assessments of where the war was headed. He'd done similar interviews with many key Kuomintang leaders just before leaving Chungking. Between the pages of a brown leather notebook, Mel penciled page after page of notes on topics ranging from the dynamics of Wang Ching-wei's puppet government in occupied China to the economic breakdowns of various provinces, to assessments

of the Communists, to pages-long backgrounds of Kuomintang military leaders.

But shortly after Mel and Teddy reached Kunming, Mel had to stop working altogether. He had contracted a case of malaria and ended up bedridden for a week. Teddy had a schedule to keep for *Time,* so he went ahead to Indochina without Mel.

On August 26, Mel had finally recovered enough to travel, and he began a three-day train trip to Hanoi on the rail line that Japan was trying to shut down. In fact, on his way back from Hanoi on the same railway, Mel would see trainloads upon trainloads of petroleum barrels and other supplies being shipped into China.

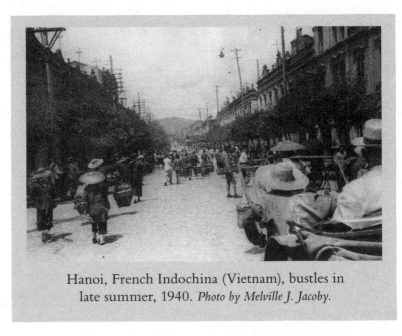

Hanoi, French Indochina (Vietnam), bustles in late summer, 1940. *Photo by Melville J. Jacoby.*

Hanoi wobbled between peace and war. Throughout the city, laborers busily dug air raid shelters even as the city's inhabitants attempted to maintain the routines of everyday life.

The city's leafy boulevards were lined with flower vendors. Streetcars chimed around corners as rickshaws raced by, pulling French colonialists in sun hats. Europeans still ate lazy lunches by Hoan Kiem Lake, but nearby businesses piled sandbags against their windows.

"It was quite exciting landing here and seeing a modern city with hundreds of cars, and street trams, and being able to buy at a fairly reasonable price anything I needed," Mel wrote to his parents at the end of August.

While Mel was convalescing in Kunming, *Life* had cabled Teddy asking him to see if Mel could do a photo story on the defense of Indochina. Now that he was in Hanoi, Mel wanted to interview General Maurice Martin, who had just taken over France's negotiations with the Japanese over Japan's incursions into Indochina. But the press was closely watched in Hanoi, and every telegram Mel sent or received was first examined by censors. If he wanted to do that story, he'd have to get the colonial officials' permission.

While he waited for permission to interview Martin and report in Indochina, Mel—who had finally caught up with Teddy—still had some recuperating to do from his bout of malaria. Reveling in the comfort of an electric fan, he wrote letters from the Hotel Metropole explaining that he would probably head home if he didn't get permission to do the interview.

Despite a doctor's suggestion that he not rush back into work, very soon after Mel reached Hanoi he started reporting again. Shortly after he arrived, at the beginning of September, Japan threatened to invade Indochina after a month of negotiating with Vichy officials. Japanese troops entered Indochina on the fifth, and Martin suspended negotiations a day later.

As the talks dragged on, Japan made more moves toward the

colony while other countries—particularly the United States— weighed the possibility of intervening. Robert Bellaire, a United Press manager in Shanghai, had learned that Mel was in Hanoi, so he asked him to start sending two-hundred-word summaries of the "hottest" news about the unraveling situation. Because of the expense of sending large amounts of material by wire, Mel would further break these brief summaries down into smaller messages.

While Mel worked on securing interviews, he prepared extensive background notes on Indochina, its neighbors, their political dynamics, the local economic climate, the history of the region, and the attitudes of the colonized Lao, Khmer, Annamite, and Tonkinese populations toward colonial powers. He envisioned these notes as useful material if he could get them out of Indochina—not a trivial matter given how heavily censored the colony was and how few ships were traveling from there.

In one set of questions Mel prepared for an interview, he focused on local history, culture, politics, and economics. Among the questions he wanted to explore was why Indochina didn't have a higher standard of living given its abundant resources. Posing the issue this way was mostly rhetorical; he was trying to assess how effectively France was managing the local economy and to what extent it was exploiting local populations. His questions drove to the core of power dynamics in Indochina as he attempted to zero in on who controlled important industries like oil and rubber, how influential local Communist groups were, and even why local rice farmers' crops seemed to be failing. He also asked questions about what the government was doing to move local populations away from subsistence farming.

"The French have given no thought at all to making this

country independent and industrial," Mel wrote at the conclusion of one piece.

Armed with these questions, Mel arranged interviews with high-ranking officials aside from Martin. Only four days after he arrived, he interviewed Admiral Jean Decoux, the Vichy-appointed governor-general of Indochina. The next day he met with the Japanese consul in Hanoi, and a few days later with another Japanese official.

"Anyhow, here I am really running around fast, liking the job immensely, doing my best, and hoping for [an] in with UP [the United Press]," Mel wrote in a letter to his parents.

Mel even pulled a hotel bellboy aside to get his impression of the political climate. The bellboy told Mel that Japanese officers and diplomats gave large tips, tried to play locals off against the French, and interviewed them about local Annamite questions. This tactic was successful. Many of the local Annamites were so incensed by decades of French abuse that they welcomed Japan, which had just announced its vision of a Greater East Asia Co-Prosperity Sphere—which ostensibly aimed to unite Asia against European colonialism but would actually replace foreign empires with a system run by and subservient to Japan.

On September 11, Mel began his twenty-fourth birthday with Teddy and another reporter in meetings with sources at the Chinese consulate. They then returned to the Metropole to celebrate Mel's birthday. Teddy, who was leaving for Singapore the next day, gave Mel a cigarette case and other "trinkets" as gifts. But there was an even better surprise waiting for Mel: a wire from the United Press asking him to formally sign on as a special correspondent based in Hanoi. They'd liked his earlier reporting and the initiative he'd taken to do it without a

commitment from them. The United Press was eager for more and would pay Mel $25 per week, plus expenses. In one letter, Mel said he had "worked like the very devil" to get the job, but then just a few lines later he turned more modest.

"Just a lot of luck and I'll be fired soon," he wrote to Elza and Manfred. He was worried that his French wasn't up to par and that he'd have to compete with high-ranking reporters from other newswires, but he liked the job, and he said he was working as hard as he could to earn the United Press's favor. Mel also told his family that he thought what he was witnessing was both history and a situation that would "determine the future" of Asia.

"If this really flares up properly it will be real copy and I'll have a swell chance to do some good," he wrote. "That's my hope."

There was one problem. Dick Wilson, the syndicate's Manila bureau chief, had already asked another United Press reporter named Pierre Martinpantz to correspond from Hanoi. This led to an awkward and uncomfortable working arrangement for both Martinpantz and Mel. Martinpantz could see everything Mel sent to Bellaire, and he got defensive and angry after Mel asked Bellaire how they were supposed to work together. Martinpantz worried that Mel was hired because he was getting pushed out, and he responded by obstructing Mel's work.

"In one way or another, he managed to block about every move I made, making it impossible for me to even get an interview unless on the q.t.," Mel wrote.

Bellaire had thought it wouldn't be a problem to have both correspondents in Hanoi. The two could complement one another's work, and if Mel went on a reporting expedition, the United Press would still have someone in Hanoi. The United Press would also pay Martinpantz for contributing to Mel's stories. It took a few weeks, but the two reporters were able

to smooth things out. In any case, Mel now finally had his in with a news syndicate. It was an uncertain, low-paying gig, but it was work in a place where there would be plenty of news. Moreover, Bellaire assured Mel that if major developments occurred in Indochina, he expected to be able to offer Mel a more attractive assignment.

Just as he had seemed to lighten when he finally left Shanghai for Chungking, Mel seemed similarly cheerful in the letters he wrote to his mother and Shirlee about this latest offer. Both of them noted his fresh energy. In one letter he sent to Shirlee, Mel proudly added a new title to his signature: "foreign correspondent, ahem."

Mel was excited about the new job, but it was chaotic. Twice a day he, the AP's Yates MacDaniel, and Archibald Trojan Steele, whom Mel had met in Shanghai, visited an English-speaking press liaison in Admiral Decoux's office. Taking pity on the American reporters, the liaison would verify or deny whatever rumors the reporters brought to him, then summon whichever official could comment on the news item they were working on.

"Sometimes that takes a lot of argument," Mel wrote to Bellaire. "At times we get categorical denials of things we may have seen ourselves."

It would then take hours for officials to censor and translate the reporters' write-ups, only to have another censor at the wire office chop them up again.

"Then maybe they go off," Mel wrote.

Mel claimed that he had good enough sources for plenty of good, ongoing beats, if not for the censors. He knew of some stories that were interesting but likely to stir up too much trouble to pursue. Unless he thought that they were absolutely vital, or that he would be scooped, Mel tried to save those until they would be easier to complete.

Matters weren't helped by the fact that Hanoi's cable office closed at 10:00 P.M., with no exceptions, and that every message sent by the press had to be translated into French. Even this wasn't the end of the government's intervention. In Hanoi, Mel couldn't see the American newspapers where his stories appeared (Shirlee and Elza were dutifully saving them for him), but he could hear them. A broadcast station in Manila would air announcers reading United Press copy. Mel could pick up its broadcasts in Hanoi, and he was not happy with how he was being edited.

"From the Manila broadcasts it often sounds like someone else is filing," Mel wrote Bellaire. He said that the misinformation resulting from poorly edited stories of his had put him on the spot more than once.

"The government here has listening posts, and I've been blamed on behalf of UP [United Press] for some pretty bad rumors."

At 5:45 one morning in late September, an air raid siren rang in Hanoi. Mel leapt from his bed and instinctively grabbed his camera. Preparing to head to a dugout as he'd done in Chungking, he ran instead straight into a wall.

"Then I opened my eyes and found out I wasn't at the press hostel and the door was behind not in front," Mel wrote.

There hadn't been a raid, but Hanoi seemed to be girding for war. On September 27, Japan began landing thousands of troops in Haiphong, the port city near Hanoi. Only five days earlier, Vichy had finally relented to the Japanese demands and Admiral Decoux had hammered out an agreement with the Japanese, but word didn't reach all of Japan's forces before they'd engaged in a brief series of skirmishes around Dong Dang in northeastern Indochina. The agreement was signed

the same day Japan entered the Tripartite Pact, which established the Axis alliance with Germany and Italy. The timing was not a coincidence.

Mel watched as Japan flexed its muscles in Southeast Asia. The crisis with French Indochina had emboldened the swaggering Asian empire, which seemed to enjoy pushing around a European power. Aside from cutting off supply lines to China and securing a better base from which to attack its enemy, Japan was now in striking distance of Burma, Malaya, and Hong Kong, all of which were British colonies. It was a busy period for Mel and his work, but it was paying off.

"Getting a few years of experience crammed down my throat in a few days," Mel wrote. Other correspondents told Mel that Indochina was the hardest place they'd ever worked. They had to cover the entire country, not just Hanoi. Everything was different from Chungking.

Where Chungking reporters' lives revolved around the crumbling Press Hostel, in Hanoi they converged at the Metropole, a once-opulent, Parisian-style structure on a leafy Hanoi avenue. Mel worked from room 229. Though he spoke enough French to get by and write copies of his news briefs for Vichy censors to review, he hired a translator/fixer, whose services took a big chunk out of his daily food and drink budget. With access to French officials not easily forthcoming, much of Mel's reporting, as was true for other journalists in Hanoi, happened at the Metropole's bar, where he gathered dope on the off-duty French colonialists, Japanese officers, American diplomats, and British businessmen who seemed to buzz about at all hours.

"Getting news means sitting in the lobby at least six hours a day buying people drink after drink, talking, hinting, smiling, etc.," Mel wrote. "I have again learned as in other places the value of friends."

Though Mel was enjoying the work, he began to feel like he'd been in Indochina for years. Despite Indochina's growing significance, Mel discovered that it wasn't easy to work with the United Press. The newswire's instructions for him weren't always clear. Matters got so bad that he wired Bellaire that he would leave for Hong Kong if the United Press didn't send a clear assignment or make arrangements for him to stay in Hanoi.

Meanwhile, covering Hanoi involved delicately negotiating Indochina's rapidly shifting politics. Mel had to work with French officials and Japanese officers, but he also knew that each stakeholder he contacted had agendas they had to protect. At one point in the beginning of October, the French invited reporters to follow Admiral Decoux on a tour through Saigon, Cambodia, and possibly the Thai border, but at other times colonial officials capriciously shut off access to French sources when they didn't like a reporter's coverage. Then, a week into October, Vichy used forced retirements to replace all its generals in Indochina, including Maurice Martin, who'd resisted Japanese pressure in September. The move signaled Tokyo's increasing influence in the colony.

Back in California, Shirlee was eager for Mel to come home, though she recognized what an opportunity his assignment in Hanoi was. In a letter she wrote to Elza, she noted that Mel expected the assignment in Indochina to last six weeks or so, though he had told her that he couldn't be certain how long it would last. The thought of Mel staying in Asia longer was bittersweet. She didn't want him to be away longer, but with it looking like the United States was getting ready to enter World War II, draft-eligible men like Mel weren't being allowed to leave the country. She didn't want to encourage him to stay away, but she also wanted him to be able to get as much as he could from being out of the country now that he was finally

making progress as a reporter. She even sent a telegram at the end of October urging Mel to "stick it out, dear."

Mel continued to write that he wanted to go home. He loved the work he was doing in Indochina, but he hated how uncertain his future was with the United Press.

"Though the pay and all is okay I don't like this week to week business any more and I want to make some definite plans," he wrote.

Still, it's clear that he wasn't in so terrible a hurry as he claimed. He had waffled on Shirlee in Chungking. At one point he talked about bringing her there, but at other times he told his mother that he couldn't even tell if it was a good idea for Elza to invite her down for a holiday, suggesting that he didn't really know where their relationship stood. Often he didn't mention Shirlee at all.

Mel started calling Shirlee his "fiancée" in wires to Bellaire and others, even though he didn't speak as concretely about marriage in his messages to his family. In one cable, he told Bellaire that he was interested in a permanent assignment only if he could bring Shirlee to Indochina, but that seemed impossible.

With war clouds continuing to gather, most Americans had evacuated from Indochina by the beginning of October. Regular shipping schedules had been suspended and the last passenger ship scheduled to leave Hanoi would sail by the second weekend of the month. Mel worried that he would have to hurry onto one of those last ships if he wanted to make it home. It hadn't helped that by then Shirlee had started "frantically querying" Mel on his plans.

After sending rushed telegrams of his own to Bellaire, Mel wrote a letter to him to clarify his position. He said that he was enjoying his work very much, but that he needed to know how long the United Press could sustain him.

"If there are chances of a future steady post of some sort I would like to remain of course," Mel wrote. He stressed again that he had been on his way home, "not only to get a wife," but to get domestic newspaper experience, most likely at the *San Francisco Chronicle*.

Over the next month, it became increasingly difficult for Mel to do his work. As Japan's occupation of Indochina continued, Vichy began clamping down on Mel. French officials weren't happy with the interviews he'd done with Japanese representatives now stationed in the colony, and they began using censors to stop his inquiries by slowing them down immensely.

"I have been told by numerous friendly officials that there is really nothing personal about the new restrictions and they all advise that I leave," Mel wrote to Bellaire at the beginning of November. "There are all sorts of complications. Police constantly looking over my room, a little man on a bicycle who follows me, telephone tapping—all of this of course applies to every foreigner in Hanoi."

The situation became so bad that in mid-November Mel complained to Charles Reed, the American consul in Hanoi, that the censorship was beginning to look like discrimination by French officials in favor of Japan's state-run Domei news agency. Shortly before Mel's complaint, Reed had asked Hanoi's governor-general to protect American property after Japanese soldiers occupied an American warehouse in Haiphong. The warehouse—which stored hundreds of barrels of oil—had been flying the U.S. flag when the Japanese troops stationed themselves there, completely disregarding signs reading THIS IS AMERICAN PROPERTY in English, French, and Vietnamese. Mel had tried to report on this, but French officials stopped his cable about Reed's complaint for a full day.

Japan believed that the North American syndicate was only a cover operation disguising a Chinese firm that was using the warehouse to import war matériel. Eventually, Japanese soldiers took down the American flag and blocked a ship from unloading supplies in Haiphong. This led Reed to order Robert Rinden, his vice consul, to investigate.

On November 21, Rinden went to Haiphong. Reed told Rinden to let Mel go along with him, as Mel wanted to shoot pictures of American property blocked by Japanese troops. That day a driver brought them to the warehouse, which was outside of Haiphong alongside the main highway, near the port.

When Mel and Rinden arrived, numerous Japanese soldiers were gathered outside of the warehouse. A U.S. flag still flew above the facility. Mel wanted to take a picture before it got dark, but Rinden wondered if they should come back another time with permission from the Japanese. Since French officials had issued Mel a photography permit, he told Rinden that he didn't think they'd get in trouble.

Turning off the highway, Rinden instructed the driver to pass the warehouse along a side road while staying a few hundred yards away from it. After passing it once, Mel asked the driver to stop, snapped three quick pictures of the warehouse, the U.S. flag, and the Japanese soldiers' adjacent tent, then told the driver to return to Haiphong.

Back on the highway, Rinden looked back and saw a large military truck filled with Japanese soldiers speeding up toward their car. He told Mel that he thought they were being followed. Mel didn't believe him. But when they reached the city, a group of Japanese soldiers blocked the way in front of them while the truck pulled up behind. Two soldiers got out, rushed over, opened the car's doors, and tried to force Mel and Rinden to get out.

Through a soldier who could speak English, an officer ig-

nored Rinden's consular ID, insisted that they had been spying, and demanded that Mel turn over his camera and destroy his film. Mel refused. The officer told Mel and Rinden to get back in their car, then ordered two of his soldiers to climb onto its running board while they drove slowly behind the truck to the city center. As the car passed the Hotel Europe, Rinden told the driver to stop, speaking French and hoping the soldiers wouldn't understand.

When the driver stopped, Mel and Rinden both jumped from the car and tried to walk to the hotel. Before they could, the soldiers surrounded them with their guns drawn. Rinden told someone to get the local French police, who tried to get the Japanese soldiers to let Mel and Rinden at least go to the hotel. The troops again blocked their way.

"The French police were unable to cope with this," Mel wrote to Consul Reed.

The Americans' pursuers wanted to take them to their headquarters, but Rinden refused. As a compromise, the French brought them to their own police headquarters, where a "Commander Fradin" admitted that he was more or less helpless. Another writer later recounted Mel's recollection of the conversation he had with Fradin:

> "Who is the sovereign power in this country," Jacoby asked him, "you or the Japanese?"
> "We are, of course."
> "Well, if you are the masters, how does it happen that we can be arrested on French territory by the Japanese?"
> The officer smiled sadly and answered, "When a man has lice in his hair, who is the master?"

Fradin tried to get Mel and Rinden to sign a statement that the Japanese actions had been justified, but Mel refused. Then

Fradin asked for Mel's camera. Mel surrendered it after asking Fradin to agree not to hand it over to the Japanese.

Mel and Rinden returned to Hanoi that night, with a French escort for their safety. There Reed lodged an official complaint with both French and Japanese officials in Indochina. Four days later, Joseph Grew, the U.S. ambassador to Japan, formally protested the incident to Japanese foreign minister Yosuke Matsuoka, calling it an "especially flagrant" violation that represented the latest in a "deplorably large number of incidents involving American nationals and the Japanese military in China."

After Mel's arrest—which Mel downplayed as a "foolish camera incident" in a letter to his family the next day—Japan would demand that the French expel him from Indochina. But first Vichy gave Mel a personal minder, a former Standard Oil employee named Daniel Armand de Lisle, who accompanied Mel everywhere he went for the remainder of his time in Indochina and worked as his "personal censor."

On Mel's first night back from Haiphong, he and de Lisle went to Hanoi's airport to meet Alice-Leone Moats, a *Collier's* magazine scribe who was flying up from Saigon. She was at the beginning of an around-the-world reporting trip that would also bring her to Chungking, Russia, and Africa. For the next two weeks, she, Mel, and de Lisle would travel all over Indochina together. But when Moats arrived, she was surprised to see Mel at the airfield. She had heard about his arrest right before she left Saigon and didn't know he'd already been released.

"By that time, however, the Jacoby affair had become an international incident and the French made out an order of expulsion," Moats later wrote in her book *Blind Date with Mars*. "Then, after thinking it over, they changed their minds. He was leaving soon anyway, and it seemed wiser to allow him to remain until his successor arrived."

Mel and de Lisle brought Moats from Hanoi's airfield to the Metropole. Despite its grand French Colonial architecture and the leafy, bucolic neighborhood where it was located, to the ever-judgmental Moats the hotel was a "dismal, grimy place with lumpy beds and limp curtains that looked so dirty I preferred not to touch them." Clearly, she was in for a surprise when she later arrived in Chungking and saw that city and its accommodation options. (Mel, coming from the other direction, found the Metropole immeasurably luxurious after eight months living in the Press Hostel.)

However, Mel's arrest amplified what Mel later called French Indochina's "stiffling [*sic*] atmosphere." For one thing, he was being followed. Shortly after the arrest, French police told Mel that agents loyal to Wang Ching-wei, the puppet leader in Nanking, were chasing him. Wang's henchmen had beaten and tortured numerous reporters in Shanghai, including Mel's friends Randall Gould and Hallett Abend.

Mel acquired a .45-caliber pistol to protect himself, though the precaution made him uncomfortable. His new status as a target also earned him a bodyguard, not to mention a "snoop" who followed him everywhere he went.

"The latter though is quite a distinction because even the diplomats have them now in Hanoi," Mel wrote, adding that it was remarkable "how low my opinion is of the French now."

Just after Mel's arrest, conditions were becoming tense along Indochina's border with Siam (Thailand). With his replacement for the United Press headed to Hanoi, Mel drove with de Lisle through Laos before meeting up again with Moats in Saigon, then traveling with both to Cambodia, where he would report on some of the border tensions. In Laos, he was struck by the sight of the "perfect blue sky," the elephants and

tigers, and the villages squeezed between the Mekong River and palm jungles.

"The trouble out there with modern planes and guns all taking part seems unbelievable," he wrote. It was December, and the French were happy with Mel's coverage of the Thai border, but the Japanese continued to pressure Vichy to expel him. Consul Reed reported to the State Department that the colony's secretary-general thought it would be wise for Mel to leave on the next boat, which was departing on December 26.

Mel lamented that he would miss Christmas. He admitted that he kept finding ways to stay away from home and said it "ruined his humor" that his return had been delayed so frequently. But Mel's actions don't seem to have coincided with his words. He was getting deeper into his story even as he told his family and Shirlee that he desperately wanted to go home. As much as he insisted he would try to buy the earliest ticket home and apologized for not writing enough, it was clear that Mel's heart was in Asia.

"Am terribly sorry because two months ago I would have bet my stamp collection that I would be home," he wrote. It's hard to believe he really wanted to go home, or at least, that he hadn't changed his mind.

"I must say that to date this trip to the Orient has been a good one, and I feel that the time has been well spent," he wrote to his mother. "I have a feeling that I'll be coming back again—just as I did four years ago."

By New Year's Eve, Mel was back in Hong Kong. He stayed at the Phillips House, a missionary residence where he'd often stayed during weekends away from Lingnan. In fact, four years earlier he had stayed in the exact same room while visiting Hong Kong for the same holiday.

In Hong Kong—which was becoming a sort of bookend for the transitions in Mel's life—he was happy to give up his pistol and reconnect with friends from Chungking. This was a particularly busy visit, full of meetings with friends and official contacts. The visits helped Mel show off his knowledge and experience to powerful figures. This Mel was a confident man far removed from the wide-eyed kid who had first visited Hong Kong four years earlier, and even the uncertain reporter who'd arrived in Shanghai a year previously without a job.

In Hong Kong he ate lunch with Ed Snow and Bob Neville, the foreign editor of a New York paper called *PM,* and went to parties hosted by Emily Hahn, the doyenne of *The New Yorker.* He had lunch with England's top spy in the region and with Hong Kong's chief colonial administrators. He also took tea privately with Madame Sun, with whom he now felt comfortable speaking candidly about the affairs of the nation that her husband had led out of monarchy just a couple of decades earlier.

Finally, during his last hours in China, Mel met with Madame Sun's sister, Mayling, the Generalissimo's wife. In this frank conversation about wartime strategy with the country's most powerful woman, Mel helped Madame Chiang develop an idea that would soon grow into one of the war's most romanticized fighting forces.

"Madame Chiang asked me if I'd be interested in getting an American volunteer air force, after I suggested it as the only solution to China's very weak position right now," Mel said. Soon the American Volunteer Group, or "Flying Tigers," the squadron of mercenary American flyers who fought the Japanese, was born.

In Hong Kong, Mel also received a letter from Mo Votaw, the professor with whom he had shared his office at the Press

Hostel in Chungking. Votaw told Mel that Holly had a plan to have Mel come back to work at XGOY if Mel wanted to. But he warned that Mel would have to temper his expectations until the engineering staff at XGOY got its act together. That, Votaw cautioned, would require getting the engineers to cooperate with the station's programmers.

"We thought of having a showdown with them, but finally decided it would mean more disruption than anything else, and more stink than good, so for the time being we must simply go on doing our best and hoping the others will see the light and be willing to do their best," Votaw wrote.

But Mel didn't want to accept that offer, at least not yet. Now he actually did want to go home.

As much opportunity as Mel was leaving behind in Asia, on New Year's Eve he finally began to come to terms with just how long he had been away from home. It had been more than a year since he'd first left for Shanghai, and many people awaited his return.

First, there was Chilton Bush, his professor and mentor back at Stanford. Bush had told Mel when they'd corresponded that summer that he thought Mel should write a book informed by his experiences in China, and that the Institute for Pacific Relations, he suspected, would publish it. He had seen Mel's career progress rapidly and knew he was on the verge of something significant. He told Elza as much after she wrote to find out whether Mel was making wise decisions for himself. Bush believed the United Press would go to great lengths to hire Mel as a regular contributor, not just as a stringer.

"He is extremely modest," Bush wrote to Mel's mother. "I don't think he has an inferiority complex, but is just modest,

which is a characteristic that makes him friends. At the same time he has an unusual amount of courage which speaks for itself in what he does."

Though Mel would return to the United States newly emboldened by his experiences in Indochina and Chungking, and do so with an established network of professional contacts willing to go to similar lengths, leaving Asia wasn't easy—not then, not when so much was possible for his future, in which "there are a thousand and one things that I could do."

Shirlee Austerland had also waited a long time for Mel to come back. She'd anxiously anticipated every bit of news about him throughout this long, dangerous year. Mel had left for China at the peak of their romance. The entire time he was there Shirlee wrote him *and* Elza frequently.

But paradoxically, now that Mel was finally on his way home, Shirlee—who continuously asked when he might return and whether she should come down to Los Angeles to be there when his ship arrived—suddenly decided she was done waiting for Mel. When the *Tarakan* reached Manila, Mel phoned Shirlee for the first time in ages. She told Mel that he had taken too long to come home. She ended things, gently but firmly.

In his letters and in person, Mel had easily expressed to his mother how much he loved and valued Shirlee, but he was never able to do the same with Shirlee herself. As much as Mel said he loved and missed her, the Chungking air had settled into him. For months he had put off deciding where Shirlee fit in his life. His great adventure through Indochina may have cemented his love of journalism and Asian affairs, but it only stretched the patience of Shirlee, who had tired of Mel's empty promises to return. By the time Mel finally did arrive in the United States—even before he made it to the mainland—he knew his love affair with Shirlee had disintegrated.

"I gave up a chance, in fact several chances out here, to come home and decide on Shirlee," he told his mother as he informed her that, when he contacted Shirlee, she had indicated—diplomatically—that things were over between them. Mel was "disheartened" that things turned out that way, especially because of the opportunities he'd just passed up, but, he said, "I'll be home soon and all will work out. One way or the other."

Elza, meanwhile, was the person Mel most looked forward to seeing in California. He didn't want a big scene when his ship arrived in Los Angeles. He was exhausted. The idea of his many relatives coming to greet the ship, then offering their opinions on his relationship and career prospects, was too stressful for him.

"Hope only you and MM [Manfred Meyberg] are meeting me—*Please* no family," he requested, underscoring "please" three times. "Also would be swell if the family didn't barge in the very first night so I could talk to you both."

Once he was on his way home through Manila, Mel wrote Elza a more candid letter. It was her birthday. He hadn't planned to miss the date for a second year in a row, and he admitted that he knew the toll his long travels must have had on her, not to mention what she must have felt when she heard about the arrest in Indochina and about other dangers he'd encountered over the past year.

This letter, as Mel indicated, was one of the most honest he'd ever written to her. "It seems so terribly long that I've written a letter like this to you, that I'm almost ashamed," he wrote.

And then on second thought I know you understand I am always thinking about you and a letter makes no difference anyhow.

There have been times during the past months when I've felt that I should come home. I know how reports of the Far East

must sound. But then again, I have always felt the whole world is so upset and that I'm so much better off comparatively, that we should just be grateful and nothing else.

There have been many times, of course, that I've been in some sort of danger, but I must say it doesn't bother me a bit. Particularly when I know so many others are facing the same things. I suppose I'm a full-fledged fatalist now—with a small measure of caution thrown in—(that's between us) . . .

Part Two

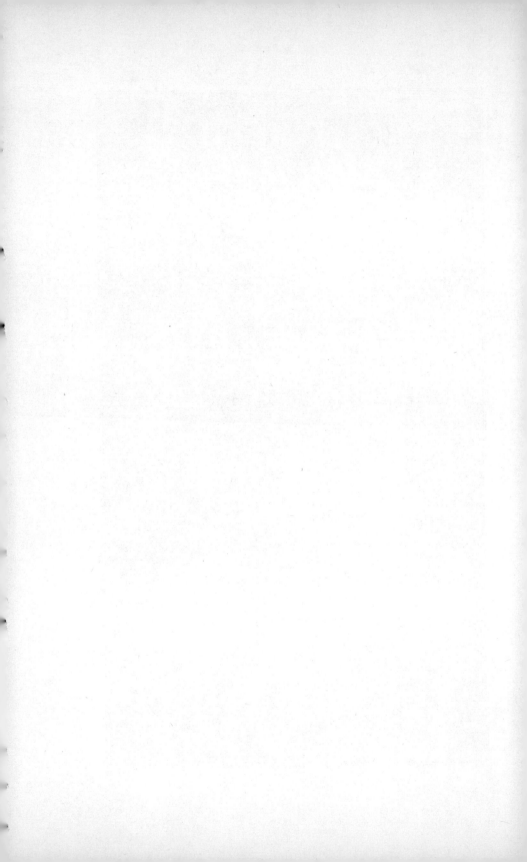

Chapter 5

A TRUE HOLLYWOOD STORY

Nineteen-forty-one was a fulcrum, dividing war and peace, history and modernity, West and East, uncertainty and direction, opportunity and frustration. It marked a boundary between two vastly different frontiers. Soon after the beginning of this pivotal year, for Mel as well as for the world, he was back in the United States searching for a career in journalism.

Mel arrived in Los Angeles on February 10. As happy as he was to see Elza, Manfred, and his dog Elmer, he was restless. His time in Chungking and then Indochina had shown him a world rapidly changing, and he had proven to himself that he was ready to report on those changes. Having lost Shirlee, Mel now turned his attention fully to his work.

A little over a week after returning, he spent an afternoon with the *Los Angeles Times* columnist Lee Shippey, who wanted to discuss Mel's experience in Indochina, especially his views on what Japan's increased influence there meant for the rest of Asia. The following Saturday, Shippey recounted their conversation in his "Lee Side o' L.A." column.

Shippey wrote that, according to Mel, "those who believe Japan is bankrupt, economically weak and almost exhausted by its war in China are merely wishful thinkers." While pillag-

ing much of China, Japan was teaching its children, Mel said, that "it is Japan's duty and destiny to rule all Asia and get the British, French and Americans out of that part of the world," as part of its Greater East Asia Co-Prosperity Sphere.

Mel then detailed for Shippey multiple examples of Japan's military advantages over China and its successes in Indochina. He also predicted the exact strategy that Japan would ultimately employ when it turned its military ambitions toward the Western colonial possessions straddling the Indian and Pacific Oceans.

"Jacoby says Japan will not stick its neck out but will certainly take the Dutch East Indies, Singapore and the Philippines when it sees the chance and only positive action by this country can prevent it."

Mel didn't remain long in Los Angeles.

"I thought that I would want to stay at home for a while," he wrote to Teddy White's mother in a letter a week after he returned. "But now I find that I am anxious to return to China."

Mel was so anxious to return to China that he left Los Angeles again only a week after he had arrived home, this time on a trip, first to San Francisco and then to the East Coast, in search of an opportunity that would take him back to Asia. It would be a trip full of reunions: with companions from his travels, with colleagues from his days in Shanghai and Chungking, with contacts he'd written to but hadn't met in person, and with dear friends from his Stanford days. One such reunion, which began as a simple phone call to a minor acquaintance from the *Stanford Daily,* would be life-changing.

Mel was busy as soon as he reached the Bay Area. It seemed like every hour he was at a different meeting. He met with

editors at the *San Francisco Chronicle* and the United Press, had lunch with his Stanford mentor, Chilton Bush, visited contacts in Chinatown whom his friends in Chungking had asked him to see, and secured a strong letter of recommendation to the president of NBC from a friend in the radio business.

While in San Francisco, Mel also met with friends, including his old chum John Rice, another Stanford alum who had worked at the *Daily*. Rice was the friend who hosted Mel while he was taking Chinese lessons from George Ching before he left for Shanghai in 1939.

Seeing Rice helped mute any residual sting Mel felt about Shirlee Austerland's decision to end their relationship. When they were at Stanford, San Francisco was a popular escape for Mel, Rice, and other students. On this visit, after Mel was done with his appointments, he ate dinner at John's apartment, and then the two of them set out for a night on the town.

It was like old times. During the reunion, Mel and John swapped stories about what their old friends were up to, and John was reminded of one of their former colleagues at the *Daily*. The question John asked Mel seemed insignificant at the time, but it began a chain of events that would do much more than help Mel quickly get over Shirlee.

Did Mel remember a woman named Annalee Whitmore?

Of course Mel did. She had been a copy editor and then an occasional night editor when he was a reporter at the *Daily* before he left for Lingnan, and she was famous at the paper for having become the first woman in eighteen years to serve as its managing editor. They weren't close, but Mel remembered Annalee. She had been a smart, no-nonsense editor when he was at the paper. The *Stanford Daily* had been only the beginning of her career. As John explained, she'd accomplished much more since graduating from Stanford. What was more?

She was deeply curious about China, the war there, and efforts to support the Chinese people, and she was eager to meet someone who knew more about the country.

In 1916, four months before Mel Jacoby was born, Anne Sharp Whitmore lay across the kitchen table of a farmhouse in Price, Utah. It was May 27, weeks after Anne's due date. Finally, there in the kitchen, Anne gave birth to her first child. She and her husband Leland compounded their first names and dubbed the twelve-pound baby girl Annalee. The first of the Whitmores' four children, Annalee took pride in her tabletop origin throughout her life. It was a story she told whenever she was asked about her upbringing.

When Annalee was a child, Leland Whitmore had worked at a bank. In October 1929, when Annalee was thirteen years old, the stock market crashed, destroying the financial sector and setting into motion the Great Depression. Annalee's father lost his job almost immediately. The Whitmores' money and social status vanished almost as quickly. Like countless other hard-on-their-luck families, the Whitmores moved to California. After a few months in Berkeley, they settled in Piedmont, another Oakland suburb.

Having lost everything in the Depression, the Whitmores had to work hard to scrape by after settling in California. Leland had been an amateur pilot before losing his banking job. At first he earned money selling real estate by flying clients in homebuilt airplanes over available properties. It still wasn't easy to make ends meet. Then, in 1934, as the Roosevelt administration laid out its New Deal policies, Leland Whitmore went to work at the newly created Federal Housing Administration (FHA), where he made a successful, lifelong career for himself.

Meanwhile, as Elza Meyberg had done a decade earlier in

Los Angeles, Leland and Anne Whitmore converted to Christian Science. This adopted faith buoyed the Whitmores' spirits in the lean times of the Depression. However, the religion never became a significant part of their daughter's life.

To help support her family, Annalee worked a series of summer jobs. In one office position she held during high school, she typed so hard and so long that by the end of each day her fingers bled. Though Annalee labored tremendously for her family, she still had fun. For a while she even dated Robert McNamara. The future secretary of defense was a fellow Piedmont High student.

Despite her family's challenges, and perhaps in part because of them, Annalee—who had an extraordinarily high IQ of 170—excelled in school and was a voracious reader. Family legend holds that at just five years old Annalee read Edith Hull's *The Sheik*. She decided then and there to become a writer. Whenever Annalee had a question as a child, her mother urged her to look for answers in a book. When she matriculated at Stanford in 1933, she earned the highest score anyone had ever received on the English A entrance exam. She was so far advanced when she began her studies at Stanford that she entered as a sophomore. Annalee maintained her commitment to academic rigor at the school and graduated as part of its Cap and Gown Society.

Annalee had been the first female editor at Piedmont High School's student paper. This was the first of many times when she was the "first woman" so-and-so. However, she was never motivated explicitly by feminism; she was driven instead by her passion for writing and language. At Stanford, Annalee joined the staff of the student paper, the *Stanford Daily,* where she started out reviewing plays and other performing arts.

"Eyes closed, expression intent, Mischa Elman last night justified all predictions regarding his second Stanford concert, ex-

ceptional power and depth of feeling setting this former child prodigy apart as a violinist of the first rank," opened Annalee's first bylined story in the *Daily*. In the piece, Annalee displayed the descriptive flourish she would develop throughout her career. Her style featured visual detail that may have seemed extraneous for a simple profile of a visiting musician, but brought to life a routine story that might otherwise have been overlooked.

Annalee's intricate description may have been a vestige of her uncannily accurate photographic memory, but at least on the fall day this article was published, her evocative style enlivened the *Daily*'s otherwise dull front page (with the exception of an uncredited football story that ran the same day in which the anonymous writer described fullback-turned-quarterback Frank Alustiza as "that chunky lad from Stockton with the questioning eyes.")

For her first year as a *Daily* reporter, Annalee wrote mostly arts and campus life stories. She also reviewed theater and film, at one point earning herself the nickname "Annalee 'New Theater' Whitmore." In fact, she was also a member of Ram's Head, a dramatic society whose members were chosen based on their participation in existing members' productions.

At the *Daily,* Annalee wanted to do more than simply trumpet her classmates' accomplishments. For example, Stanford's fall social calendar was highlighted by the annual "Big Game" pitting the school's football team against its rivals from the University of California at Berkeley, across the San Francisco Bay. In 1935, at the beginning of Annalee's junior year, she wrote a column dismissing the behavior of other women in the stands during the game against the Cal Bears.

"Why do supposedly intelligent women still gaze down, enraptured, at some thug in football clothes and say 'I do wish Tiny would send in Bill—he sits in my history section and has

the cutest profile,'" Annalee lamented, perhaps with a note of irony given that, after this article ran, she would date a football player named Bill McCurdy, mostly during her senior year.

Annalee was a unique woman who didn't like to do things to conform with those around her. At the end of her junior year, she was photographed with a group of other newly elected sponsors of Roble Hall, a Stanford residence hall. Seated in the front row of the photo, she shyly looked away from the camera. Her feet dangled from her chair, and she wore a bright print dress and cardigan combo that starkly contrasted with the plain, muted outfits worn by the rest of the group.

Though Annalee was once recognized as among the campus's best-dressed women—a *Stanford Daily* article noted that Annalee, presumably feeling more financially secure than she had at the beginning of the Depression, netted a dark green suit and a long coat with a beaver fur color that she wore "with brown accessories and a smart off the face hat" during a shopping trip to San Francisco—sartorial distinction isn't what makes the Roble photo so striking. Rather, her incongruous posture reveals a woman lost in thought and seemingly impatient with the photo shoot's ceremony. One might surmise that even in the spring of 1936, Annalee was destined for grander experiences and knew as much.

Annalee *was* photogenic, but she also charmed through less quantifiable traits. "Five feet three, with a neat eye-catching figure, she can wear a tailored suit, a G.I. uniform, even a pair of old jeans with the effect of extreme femininity," Shelley Mydans wrote. "But it is more than good looks. A better part of the charm lies in the tense, flattering concentration with which she listens to your conversation and in the breathless humming voice that spills out her quick answers."

Annalee was less interested in the artificialities of societal convention than she was in the thoughts, expressions, and contributions of her companions. Perhaps something outside the frame of the staged Roble Hall photo caught her attention. Whatever may have motivated Annalee to look away from the camera in that shot, it turned out to matter little. Soon after she was offered the sponsorship post at Roble, the student-led editorial staff of the *Daily* elected Annalee as one of two co-managing editors for the coming fall. She resigned her position at Roble in order to take the job.

In the fall of 1936—Annalee's senior year at Stanford—she served as the paper's first female managing editor in eighteen years. However, Annalee didn't outwardly seem to care much about her gender-role breakthrough; she was more interested in her actual job. Similarly, it appears that Annalee's commitment to her work at the *Daily,* rather than any intentional move to expand the paper's gender diversity, was what earned her the position. After all, when the paper announced its new management, it described Annalee's work for the paper and other campus activities over the previous three years as "indispensable."

"Extracurricular work on many committees and in many activities, together with a rapid, accurate judgment trained to sound journalism, make her the ideal person to handle the administration of the *Daily*'s news coverage," the departing editors wrote.

The same spring Annalee was elected to manage the *Daily,* she also led the revival of Stanford's chapter of Theta Sigma Phi, a women's journalism society now known as the Association for Women in Communications. Annalee was voted the group's president when it returned to Stanford in 1936.

Leadership wasn't what Annalee sought, but she sometimes found it anyway. As later explained by her daughter, the author

Anne Fadiman, she was "used to being the first woman to do 'x'."

Though both Mel and Annalee worked at the *Daily,* they rarely interacted. When he joined the paper, Annalee worked as a night editor. When she was elevated to her position as co-managing editor, Mel was off to China for his year at Lingnan University. He was still gone when Annalee graduated.

Despite her successes, Annalee found few career opportunities in journalism after graduating. Though she was determined to find work that capitalized on her intellect, her memory of the Depression and the Whitmores' economic struggles lingered. Annalee was afraid to be too picky in her job search, which led to a memorable encounter shortly after she left Stanford.

After graduating, Annalee went to work at the U.S. Agricultural Adjustment Administration (AAA). This was a New Deal program that addressed deflated food prices during the Great Depression. Farmers participating in the program were paid not to plant certain crops in order to help align supply and demand and drive up the price of farm products. Annalee took a $75-per-month secretarial position in the AAA's San Francisco office, which managed the program's public relations. The work itself wasn't terribly challenging or glamorous, but Annalee accepted it because she was concerned about being able to make ends meet if she hesitated too much before taking a job out of school. More importantly, it gave Annalee a chance to help bring to light the squalid conditions and hunger experienced by migratory laborers in California . . . or so she thought.

"In spite of her quick and very well-oiled brain, Annalee frequently leads with her heart, not in the conventional love

story—sense, but in the quantity of tense emotion she spends on causes her quick mind has found to be honest," Shelley Mydans later observed while discussing Annalee's job at the AAA.

Annalee had written about the AAA during her junior year at Stanford, in the *Daily*'s "Viewing the News" column, which analyzed current events. This piece contextualized the agricultural practices and climactic conditions that caused the Dust Bowl, which eviscerated Midwest farms in the middle of the 1930s.

"Travelers in the Middle West pass through mile after mile of land entirely covered by drifting dry soil," Annalee opened the April 1935 article. "Each dust-laden wind brings destruction to crops already hurt by drought, and each headline announces a new area hit by the storms."

Building off an interview with a Stanford economics professor, Annalee soberly argued that in order to reverse a long history of natural resource exploitation that had contributed to the destruction suffered across the country, Americans would need to rethink their history of individualism to pursue a policy of preservation. The brief piece underscored Annalee's early interest in social conditions and news that went beyond the trivialities of campus life.

Though Annalee was hired to conduct the government's work at the AAA, R. Louis Burgess, her supervisor, tried to pressure her to work on his own personal projects. Burgess wanted Annalee to write his memoir and ordered her to take his dictation and type up his in-progress book.

Frustrated that the menial work Burgess asked her to do had nothing to do with her job requirements, Annalee refused the assignment. At the same time, Burgess pressured Annalee not to focus on displaced people's accounts of Depression-era conditions in her reports on the AAA's work in California. He wanted to present a glowing picture of the government lift-

ing up the state's farmworkers. Since Annalee's own father had been forced by the Depression's upheavals to move his family across the country, the request particularly galled Annalee. Her reluctance to gloss over discomfiting stories—evidence, perhaps, of a journalist's instinct toward the truth—and her refusal to transcribe his memoir enraged Burgess. So Annalee quit.

No doubt Burgess, who would for years repeatedly accuse Annalee of having been "high strung," was a reactionary and a sexist, but the self-assurance and independence he rejected as moodiness on Annalee's part were among the traits that others most admired in her. If she didn't outright entrance the people she encountered, Annalee impressed them. *Life* photographer Carl Mydans later wrote that she "was electric; she was brilliant, bright, quick."

Though Annalee may have been pushed out of the Agricultural Adjustment Administration, it turned out to be a good move. Annalee was later quoted by the *Stanford Daily* as saying that she left the job because she was "bored with it." In any case, the PR spin that the job necessitated was anathema to a woman with her mind-set. She was, after all, someone who thought—and acted—like a "journalist through and through," as her daughter would one day say.

But as it turned out, something quite different beckoned: Hollywood.

The film *Andy Hardy Meets Debutante* opens with a close-up on the cover of *Snapshots* magazine. The fictional fifteen-cent glossy features brunette "Deb of the year" Daphne Fowler (played by Diana Lewis). As the camera zooms out, we discover that the rag rests on a pillow next to a slumbering, pubescent Mickey Rooney. Rooney grins, dreaming, the sequence suggests, of the starlets in his magazine. The next few scenes

introduce a teenage boy so obsessed with his crush that he cuts pictures of her out of household magazines to paste in the pages of a scrapbook fantasy collection disguised as a botany project.

So begins this "deathless classic" starring Rooney and Judy Garland, still riding the height of her *Wizard of Oz* fame. So also began the film-writing career of two Stanford graduates: Annalee Whitmore and Thomas Seller. Released in 1940, the film was a hit for MGM—and for Annalee's career.

As Mel Jacoby completed his thesis at Stanford over the 1938–1939 school year, Annalee was reassessing her career. After her abrupt departure from the Agricultural Adjustment Administration, she left San Francisco. Her parents had moved to Los Angeles, where Leland Whitmore had a new job with the Federal Housing Administration.

Annalee moved back in with her family, then turned her attention to Hollywood. It was a meandering path from government to studio work. At first, Annalee sought a job at Culver City–based MGM reading scripts, but competition for the position was so tight that she couldn't get an interview.

However, it turned out that while MGM had too many applicants for scriptwriting positions, the studio still needed secretaries. The idea of another secretarial position was initially anathema to Annalee, but she overcame her reluctance. A job anywhere at MGM was a foot in the studio's door, she realized. She applied for the position with an eye toward using it as a springboard back into her true passion: writing.

MGM tested the competence of its secretarial pool applicants by playing a recorded speech and having potential secretaries quickly and accurately transcribe it using shorthand. Annalee knew that the teenage summers she spent typing her fingers raw would help her handle the speed the job required, and she also knew that her years as a student reporter had honed her note-taking skills. And she had one more secret weapon:

a photographic memory. Back at the Agricultural Adjustment Administration, she relied on her tremendous powers of recollection to take dictation. But she didn't know shorthand.

"Annalee didn't know shorthand, but she didn't tell anyone," Hollywood columnist Sidney Skolsky later reported. "She had her own brand of shorthand."

This shorthand was so cryptic that later in her life it vexed even Annalee's closest colleagues. Her notes, Shelley Mydans wrote, "were a strange scrawling hieroglyphic, a secret code between Annalee and her quick pencil."

Secret code or not, Annalee took down the words she could in her own way. As Skolsky reported, she made up words in between the notes she transcribed, reconstructing the speech as closely as she could.

"She did it good enough to get a job," Skolsky wrote.

Yes, it was just a secretary's position, but she was in the door. After *Debutante*'s release, she told an unnamed *Stanford Daily* reporter that she felt lucky to get her original job at MGM, because the odds were "steep" against young writers.

"When I talk about odds, I mean the odds of getting inside a picture studio in the first place," Annalee said. "After you get in, the people are grand."

At the beginning, the job was as menial as the one she'd held with the government. Annalee even helped organize an office workers' union at the studio, and according to Shelley Mydans, MGM almost fired her for it. Her new job put her in close contact with massive names from literature and film. During her year as a writing department secretary, Annalee transcribed dictated scripts by the likes of F. Scott Fitzgerald—then in the last year of his life—and Oscar-winning screenwriter William Ludwig. Annalee also ran errands as an assistant to the writers. At one point, Fitzgerald enlisted her to buy a makeup compact for him to give to his daughter on her birthday.

Still, her superiors knew Annalee wanted to write, and as she herself said, she "never let anyone forget that." In fact, while Annalee was taking dictation and running errands for MGM scribes, she was also studying how they wrote. Annalee rarely passed on a chance to learn something new.

"I couldn't help but learn the technique of putting down words in movie script style," she told a columnist in July 1940. "I mean, I learned the mechanics of picture writing."

Late in 1939, MGM needed a project for Rooney and Garland after one they were supposed to do was postponed. Annalee overheard someone talking about the studio's dilemma while she was taking dictation. Sensing an opportunity, she started on her own script for the project when she went home that day. The following Monday morning, Annalee walked into the study with a complete draft of a new installment in the *Andy Hardy* series.

Based on a character adapted from a play by Aurania Rouverol (another Stanford graduate), *Andy Hardy*'s titular character was played by Rooney, while Garland also had a recurring role in the series. Annalee's treatment had parts for each. Ludwig had written three previous *Andy Hardy* installments; when Annalee showed him her script, he was floored by her initiative and its results. He urged her to turn the treatment into a full-fledged screenplay.

Seller, who graduated from Stanford two years before Annalee, started working at MGM a few months before she did. At Stanford, Seller had acted in several plays and written the winning entry in a one-act playwriting contest; later he wrote a play produced by a Palo Alto community theater. Like Annalee, Seller had been a member of the Ram's Head dramatic society at Stanford. Knowing Seller from that club, Annalee teamed up with him on the *Andy Hardy* script.

MGM green-lighted the story. Afterward, Ludwig urged

Annalee and Seller to enroll in MGM's school for junior screenwriters. They both breezed through the school.

"Their names are on the screen as the authors, their salaries already in substratosphere brackets, they both have long-term contracts, they're working now on '*Ziegfeld Girl*'—and if anybody claims there are no opportunities for youngsters in Hollywood, he's crazy," argued a *Stanford Daily* article about the school's two screenwriting alums.

The movie wasn't an intellectual masterpiece. "Daphne, the 'deb,' he decides, was 'just another milestone in my career,'" *New York Times* critic Bosley Crowther wrote of the film. "And so is '*Andy Hardy Meets Debutante*' just another milestone in this popular family series—a milestone to be welcomed, that is. But we can't help speculating upon how much they all look alike."

But this milestone was lucrative for MGM. The film cost MGM less than $500,000 to make, but it earned more than $2.6 million at the box office. To reward Annalee, the studio gave her a seven-year-long, full-time screenwriting contract, an assistant of her own, and an office. From that point on, she and Seller worked closely together as a writing team. They scribed other productions, such as *Honky Tonk* and *Ziegfeld Girl*. Their careers, it seemed, were made.

"Annalee Whitmore is a Hollywood product," wrote Skolsky, who regularly lunched with Annalee during her tenure at MGM. "Her career at Metro was a Cinderella story."

But this Cinderella was never satisfied for long. Annalee soon tired of writing formulaic vehicles for Hollywood's young stars. She had loved working at the *Daily*, and having watched global affairs deteriorate since her graduation in 1937, Annalee itched to return to journalism.

"She was at heart a newspaper woman and the world was full of big news," the *Stanford Daily*'s Mike Churchill would later write.

By the end of 1940, having learned how more than three years of war had ravaged much of China's civilian population, Annalee wanted to focus her writing on topics that might make a difference. As author Nancy Caldwell Sorel described Annalee's mind-set, "she found the prospect of seven years of Hollywood fluff when the real world was falling apart unendurable."

Annalee tried to go to Chungking as a correspondent. China seemed like a fertile land for writing inspiration, and so Annalee pitched an idea for a freelance story to *Reader's Digest,* hoping that if she had an assignment she could get permission to go there. The magazine accepted. Though Annalee was only a few months into her seven-year contract at MGM, she successfully made a case to the studio that a trip to China would also expose her to compelling subjects for future films.

So Annalee had MGM's support, but the prospect of a good story wasn't all a woman needed to get to China in 1941. The U.S. government, which also needed to be convinced to grant permission for citizens, especially women, to travel to an active war zone, wouldn't let her go. Because Chungking was an embattled city that endured air raids whenever the weather was clear, and because relations between the United States and Japan were rapidly deteriorating by early 1941, the State Department refused to issue Annalee—or any U.S. woman without guaranteed employment in China—the proper permits allowing her to travel there.

Annalee wasn't alone in this predicament. Around the same time, the State Department prevented Peggy Durdin from returning to Chungking, even though her husband, Till Durdin, had been allowed to travel to Shanghai for the *New York Times.* The promise of freelance publication—or apparently a studio contract—wasn't sufficient for consular officials. Without a job

or a proper sponsor in China, Annalee was stuck on the MGM lot.

But that didn't stall her interest in Chungking.

Annalee had one asset in addition to her work ethic and intelligence: her alma mater. As she discussed her frustrations with Seller and other fellow Stanford graduates, word quickly spread among the school's alumni community. At roughly the same time, Mel was on his way back to the United States from his eventful year reporting in Shanghai, Chungking, and French Indochina. The Haiphong incident had made headlines, and Annalee noticed them because she recognized Mel's name in the stories of his arrest.

Annalee's family had moved to Los Angeles around the time she started working at MGM. Living in Los Angeles's Miracle Mile neighborhood, her brother Jim made friends with a number of Mel's younger cousins, many of whom lived in nearby Hancock Park. In school he and Mel's cousin Peggy even attended the same "Opportunity Room" class. All these people knew about Mel's passion for China and the adventures he'd been having there, as he'd kept his family regularly apprised of his exploits. Jim Whitmore passed this information on to Annalee.

In truth, although Mel's name was familiar, it didn't generate much more than passing recognition for Annalee. He was an entire class year behind her, and they ran in different circles. Even at the *Daily*—where he started as a cub reporter when she was already on the editorial staff—they only occasionally interacted.

But Mel's adventures in Asia intrigued Annalee. Besides the arrest in Haiphong, Annalee learned about Mel's work in

China, his travels around the region, and his encounters with powerful figures in the country. If nothing else, Mel was committed to his craft and knew how to form influential connections.

Annalee soon learned that Mel and John Rice were close. She also knew John from the *Daily,* so she reached out to him to see if she could get an introduction. Mel sympathized when John told him about Annalee's difficulties getting permission from the U.S. government to travel to China. But he was also aware from his own experience in China that she would have a much easier time getting cleared to travel to the country if she had a concrete job to do there, not just one assignment. He wasn't even certain yet whether he'd be able to return himself. In any case, over the year Mel had been in China, he'd built up a deep network of contacts. Before he recommended any of them to Annalee, he wanted to get a better sense of her interest.

When John and Mel returned to John's apartment from their outing in the city, they called Annalee up. An instant rapport formed. On the phone, Mel promised Annalee that he'd make a few requests on her behalf. He was headed to the East Coast, so it would be some time before he was back in Los Angeles, but they made plans to meet for a drink and reacquaint themselves when he returned to town.

Before Mel could do much for Annalee, however, he would also have to figure out his own future. With no chance to rekindle his romance with Shirlee, and despite his closeness with his mother and stepfather, he did not feel anchored to California. Sure, he was probably feeling withdrawal symptoms from the adrenaline rush of war reporting, but he wasn't driven only by adventure-seeking instincts. Home was comfortable, but perhaps too comfortable. It was well past time Mel got serious about his life and his career.

Chapter 6

||||||||||||||||||||||||||||||||||||||

"I'LL BE CAREFUL"

*I*n 1941 a massive news operation whose publisher had deep ties to and passion for China, the nation's first broadcasting network, and the American arm of the Chinese News Service operation all had headquarters at New York's Rockefeller Center. A few dozen blocks east, at 150 Fifth Avenue, Lingnan University's board of trustees shared space with other Christian missionary schools and China aid organizations. New York was also one of two bases for the Institute for Pacific Relations (the other was in Hawaii), whose members had helped Mel find his footing as a journalist in China.

As a result of its concentration of wealth and media, New York City was an influential base for students of Sino–American relations, possibly even more important than Pacific-facing San Francisco or powerful Washington, D.C. In the spring of 1941, the city was about to add a multimillion-dollar fund-raising drive and relief operation to the list of China-focused endeavors it housed.

That spring, while Mel settled back into life in the United States, a panoply of powerful figures who would drive much of the next decade of U.S.-Chinese relations gathered in New York. They were summoned by Henry R. Luce, the tremendously influential publisher of *Time, Life,* and *Fortune* maga-

zines. Luce's parents were Presbyterian missionaries in China, and he had been born in the Chinese city of Chefoo (Yantai). Like so many other "mishkids," Luce spent the rest of his life enamored with China, and by 1941 he had begun aggressively advocating for American intervention in the country's war with Japan. Luce believed that a successful relief effort on China's behalf could help the United States win a battle for American civilization itself that couldn't be won solely through the use of force. Gaining the trust and confidence of China's hundreds of millions of people, Luce argued, should be a paramount goal.

"For they are the largest body of human beings whose friendship we can either gain or lose," Luce said in a speech that March. The United States, Luce argued, only had a few months to either gain or lose China's trust. "And we can gain or lose it not only by the wise use of our military or economic power but we can gain it perhaps even more surely by the art and practice of friendship."

Luce's speech outlined the interventionist philosophy behind the $5 million United China Relief fund-raising drive, which brought numerous humanitarian organizations together under one banner of American-Sino assistance. Begun on February 7, 1941, it aimed to bolster the beleaguered Chinese nation, particularly people in so-called free China, the portion of the country under the influence of Chiang Kai-shek and his Kuomintang Party. While it was obvious that United China Relief's aid wouldn't support Wang Ching-wei's Reorganized National Government of China—the Nanking-based puppet government that collaborated with Japan—it also wasn't intended to benefit Chiang's nominal allies in Yenan, the Communists. Ostensibly set up to benefit all Chinese people regardless of politics, the United China Relief drive would most benefit the Kuomintang.

B. A. Garside, a Presbyterian missionary who led the As-

sociated Boards for Christian Colleges of China, was United China Relief's executive director, though Luce provided the organization's momentum. In Chefoo, Garside had been a friend of Luce's father. Together, Garside and the younger Luce gathered a committee of thirteen heavy hitters to lead United China Relief's campaign committee.

Aside from Luce, the committee included the recently defeated Republican presidential candidate Wendell Willkie; the oil fortune heir, philanthropist, and internationalist John D. Rockefeller III (it was Rockefeller who'd staked the International House at UC Berkeley that inspired Mel's drive for a similar facility at Stanford); the novelist and Nobelist Pearl Buck, whose *The Good Earth* assessed pre-revolutionary Chinese village life; the presidential offspring and cousin and former Philippines governor-general Theodore Roosevelt Jr.; the Hollywood producer David O. Selznick; University of California president Robert G. Sproul; James G. Blaine, president of the Fidelity Trust Company, a Republican Party financier, and the grandson of a legendary former Speaker of the House; Eugene E. Barnett, head of the YMCA; New York Trust Company president Artemus L. Gates; William C. Bullitt, a former ambassador to the Soviet Union and France who had briefly served as the appointed mayor of Paris (Bullitt also worked as managing editor at the Famous Players–Lasky Corporation seven years after the start of its fruitful work at Mel's grandfather's barn); Studebaker president Paul G. Hoffman; and Thomas W. Lamont, a partner at J. P. Morgan who'd both helped negotiate the Treaty of Versailles and loaned $100 million to Benito Mussolini's regime.

Though the body was heavily weighted toward Republican Party figures, its three-member national advisory committee was chaired by Eleanor Roosevelt. The president's wife was joined in her advisory role by Buck and Mrs. James E. Hughes.

Most had previous personal or business ties to China. Given both Luce's and Selznick's involvement, participation in the organization was also an opportunity to burnish their public image.

All of this developed as Mel returned to the United States. He finally arrived in New York as United China Relief made its final preparations for "China Week," a series of dinners and other events that would celebrate the campaign's formal kick-off. Mel had last visited New York in the summer of 1936, just as he began his around-the-world trip to Lingnan. Now it almost seemed like the city—bustling with China-related events and activities—had donned a familiar costume to make Mel feel welcome.

But China Week was still almost a month away; until then, Mel had to keep up with the hectic schedule he'd arranged for himself. Regardless of his good timing with United China Relief, his goal was practical. New York was the heart of U.S. media, and he needed a job.

Mel adopted a strategy similar to the one he'd used in Shanghai. He hobnobbed with reporters, crashed news conferences, ate lunch at the Overseas Press Club (where he became a member), and met as many editors in New York as he could. He reasoned that one of them might be able to send him back to China.

First on Mel's list of meetings was Earl Leaf. The eccentric former journalist who'd helped locate the ham radio operator and dentist Doc Stuart was the Kuomintang's key propagandist in the United States. It was through Leaf's contacts that Hollington Tong had found Mel, and the two had been in touch frequently while Mel was at XGOY. Leaf offered Mel

a well-paying job opening a propaganda office on the West Coast, but Mel wasn't interested.

However, Leaf also found Mel a literary agent, Nancy Parker, and an agent to handle his photography, Paul Guillumette. Guillumette immediately tried to sell Mel's many photos of Indochina and Chungking. Meanwhile, Mel was excited that Parker also represented Madame Chiang and Carl Crow—the author of *400 Million Customers*—and he went straight from their meeting back to the Algonquin Hotel to type up summaries of possible stories that she might be able to place or help him develop further.

"Yesterday they were quite hopeful about me, but you never know what Monday will bring," Mel wrote after meeting the agents.

Mel also reconnected with Hallett Abend, the art-dealing *New York Times* correspondent who had helped Mel find his footing in Shanghai. The two had a lengthy discussion about working together. Abend would return to his position as the *Times*'s Far East Bureau head, and Mel would work with him, possibly covering Singapore and Burma.

"If something like that happened it would be the best spot in the Orient," Mel wrote. "But I'm hoping and he sounded optimistic."

Hallett Abend asked Mel to come with him to Washington, D.C., to meet his government sources. Abend went first, and Mel followed a few days later, about a week after he had arrived in New York.

Before he left for the capital, Mel had lunch with John Hersey. Hersey was *Time*'s Far East editor and the man who had hired Teddy White to work for the magazine. Teddy had suggested that the two meet. Hersey spoke highly of Teddy. He didn't have a job available for Mel, but he was willing to

have Mel contribute occasionally, as he had done for the *San Francisco Chronicle* the year before. As Mel left for Washington, he wondered whether he just might be able to make the offer from *Time* work if he combined it with other possibilities about which he was waiting to hear.

While in D.C., Mel met with officials from the State Department and had a long talk with General Robert Richardson, the newly appointed head of the army's public relations bureau. The visit gave Mel a chance to catch up with the now-married Harry Caulfield and two other friends from Lingnan, Ed Meisenhelder and Eugene Johnson. Now that all three worked with the government, Mel had even more sources he could plumb.

Interestingly, Mel also spent considerable time debriefing intelligence sections at both the Department of War and the Department of the Navy about Indochina and China. There is no apparent indication that he had been involved in any clandestine activity; rather, it seems likely that Mel was simply sharing his understanding of the dynamics on the ground in Asia. His depth of knowledge about Chungking and the Kuomintang was obvious, and his notes from his time in Indochina included day-by-day time lines of developments involving the colony and Japan, demographic and economic breakdowns of the various players in Southeast Asia, and background profiles of Japanese and French diplomats and military officers. The navy intelligence officials had a tentative commission for Mel if he returned to Asia, but he didn't want to make any decisions just yet.

He wasn't ruling anything out either. While Mel wanted work as a journalist, he knew that he'd probably have to join the military once war broke out. Making sure that he had opportunities with navy intelligence or other commands—he also said

he'd volunteer for the U.S. Army Air Corps immediately—was one way he could avoid service as a conscript. Still, he hoped that if he was a foreign correspondent on assignment, he could get an exemption from the draft and avoid the issue entirely. Whatever happened, it looked like the United States wasn't going to stay out of the war much longer.

"Everyone in Washington knows that we are in the war," Mel wrote shortly after the visit to Washington.

Mel returned to New York the following Tuesday night. Abend insisted that he still had an opportunity for Mel, but as much as Mel wanted to work for the *New York Times,* he was getting impatient waiting for further word. So he did what he'd always done: he arranged as many meetings as he could with newspapers, magazines, and radio networks.

Meanwhile, Mel's new agents were earning their commissions. *Click* magazine paid Mel $250 for twenty pictures he took of air raids in Chungking and a brief article, and it was interested in more work if he returned to China. *Asia* magazine asked Mel for a 2,500-word piece about the Indochina crisis for publication that May. *The New Republic* also asked for a story, but that one never panned out.

Returning to China was Mel's priority, but he didn't lack options in the United States either. Mel was surprised to discover that he wasn't getting many bites from the United Press. John Morris, the syndicate's Far East manager, and Dick Wilson, its Manila bureau chief, had both cabled the United Press's main office on his behalf and suggested that he be sent back to China or elsewhere in the region. The managers in New York didn't want to commit to anything, however, until something changed in the current stalemate between the United States and Japan.

They did, however, offer Mel a position in Sacramento editing cables coming in from the Far East. This offer promised more authority and more stability. It was tantalizing, and if Mel had wanted to grow up, this might have been the best way for him to do so. Sacramento certainly wasn't Chungking, but the opportunity was the first offer of full-time employment that Mel had ever received, and with his knowledge of China, he would be able to help address the problem he'd raised in his thesis—uninformed stateside cable editors—not to mention the problems he'd had with how his own stories from Indochina had been edited.

Mel still hadn't heard back from Abend about the *New York Times,* so he decided to take matters into his own hands. He decided not to take a job in the United States because if he did, he could just be quickly pulled into the army.

"Not so bad," he said, "but I still want to cash in on the last two years [of experience in China]."

Unwilling to keep waiting, Mel decided to act on another offer. NBC wanted him to work as a radio stringer in Chungking. The network would pay him $50 per three-minute segment. That alone wouldn't be enough to live on, especially because his workload would be inconsistent, though there was a chance, if he did well, that his reports would become part of NBC's regular news roundups. Still, he could always write and sell photos on top of the radio work.

"If I am going to make any real money out of the trip, it will roll in from pictures and articles, which I am trying to line up," Mel wrote. "Means walking the pavements all day besides doing all this other work. Personal contact. All is personal contact."

Fortunately, Mel had another offer. In January, Hollington Tong had written Mel assuring him that if he came back, as Tong hoped he would, he would try to smooth out some

of the working conditions at XGOY that had pushed Mel out of the station. Now, in New York, Earl Leaf and H. J. Timperley, the former *Manchester Guardian* journalist recently hired as Tong's primary foreign advisor, offered Mel a job in Chungking as an advisor at XGOY, where he would be transmitting his NBC broadcasts anyhow. They would also pay him a $100-per-month salary and provide a car for him to get from the Press Hostel to the radio station's underground studio. Finally, Mel wouldn't need to take a ship all the way to China: the government was willing to buy a plane ticket for Mel on board the famous Pan-Am *Clipper* from San Francisco.

Even with a salary from XGOY this time, it wouldn't be enough to live on. Fortunately, Hersey's offer to contribute to *Time* still stood. But at the last minute, the lesser-known *Newsweek* approached Mel with an offer to be its Far Eastern correspondent. Mel accepted. He'd be a stringer for the *Time* competitor, sending a few stories every week for a minimum of $20, and more if they published any of his stories.

"I took it instead of *Time* because I thought there might be more future," Mel wrote.

While Mel planned his return to China, Henry Luce and the unlikely cabal of powerful public figures behind United China Relief were getting ready for "China Week," a star-studded rollout of their fund-raising campaign. Using the threat of war and instability to gather support for the campaign, this extravaganza of public relations events and festivities throughout New York City would highlight various aspects of Chinese culture as seen through American eyes. The carefully orchestrated events would include galas, dinners, and lectures drawing audiences of celebrities, philanthropists, and politicians.

China Week also launched triumphalist newsreels that would

run in theaters nationwide throughout the summer. These films spread the celebration across the United States through blaring title sequences, dramatic narration, and images of the fighting in China. All of it highlighted the heroism of China's Nationalist armies while ignoring the Communist forces also fighting Japan.

Other China Weeks followed. Asking his constituents to "turn their thoughts to the needs of the Chinese people," the mayor of Baltimore proclaimed one for the week of March 2–9, three weeks before New York's. In May, New York governor Herbert Lehman declared a statewide China Week with platitudes about supporting democracy but included few official events. Other regions in the United States and Canada followed with similar celebrations, and the concept was repeated in New York the following year. By the end of 1942, United China Relief had raised about $4.8 million, just under its $5 million fund-raising goal.

After Mel agreed to return to his old job at XGOY, he soon learned that one of his responsibilities would be assisting United China Relief. Chiang Kai-shek wanted Wendell Willkie, who'd just lost the presidential election to President Roosevelt, to visit China. Mel was given a free ticket to the kickoff dinner and asked to pass along the Generalissimo's invitation to Willkie.

"So I'm a little shot doing big things," Mel wrote, and he didn't sound terribly pleased with himself. "A fine business this whole thing. I am disgusted at some people. Particularly some of the advisors to the Chinese government. What a racket they are running. And now I'm helping them too!"

But doing big things also gave Mel an enjoyable night out. As it happened, many people Mel knew from Chungking and Shanghai had shown up for the dinner. Even Randall Gould was there, as were two other writers Mel had befriended in

China: Ed Snow and Evans Carlson. And Mel had a glamorous date, one of the most famous Chinese women in America at the time: Lee Ya-Ching.

"She is very pretty and fell out of her plane once for a publicity stunt," Mel wrote. This was an understatement. Lee was a daredevil aviatrix who was arguably the most famous Chinese pilot, male or female. In 1935 she had parachuted into the San Francisco Bay after a training emergency, earning her membership in a select club of fliers known as the Caterpillar Club. But she was famous for more than that incident.

"In the decade before World War II, if you had asked anyone in China to name just one pilot, the answer you probably would have gotten would have been Lee Ya-Ching," wrote Rebecca Maksel in *Air and Space* magazine. The evening with Lee was just a dinner date for Mel, and part of his new association with United China Relief, but he enjoyed having such accomplished company. Indeed, while he was in New York, Mel wrote Teddy White a letter insisting that after his experience with Shirlee, he had no immediate interest in romance.

"Said Shirlee and I are on the best of terms and all that," Mel said. "But I am not going to get a wife now or for a long time. I am coming back across the Pacific. I hope before you get home."

Mel enjoyed the dinner, though he wasn't impressed by Willkie—or his own too-tight rented tux. That night Henry Luce also made a speech. He implored donors to support the Chinese cause.

"For [the Chinese] are the largest body of human beings whose friendship we can either gain or lose," Luce told the well-heeled diners at the Waldorf. "We can lose or gain their friendship in the next few months."

Playing a card commonly used in pro-China rhetoric, Luce lamented how year after year the United States continued to sell

arms and matériel to Japan even as Japanese atrocities against the Chinese mounted. Nevertheless, he insisted, China continued to have faith in the commitment of the United States.

"The Chinese people are interested in our power politics," he declared, leading to his speech's climax. "They are interested in our diplomatic maneuvers. They are interested in our military and naval strategy. But they are interested in something far, far more than all that. They are interested in us, the American people, in what kind of people we are."

Shortly after the China Week dinner, Mel returned to Washington, D.C. Now that he had work commitments, he needed a passport. He also needed to postpone the military draft again.

On March 11, just as Mel was leaving Washington after his previous visit, President Roosevelt had signed the Lend-Lease Act, which authorized billions of dollars of aid to the Allied powers, including China, and dramatically shifted the momentum of U.S. foreign relations. Back in the capital, Mel discovered, to his delight, that the State Department now saw his presence in China as an asset.

"State Department is exceptionally *pleased* about my going out and promises every cooperation," Mel wrote from Washington's Wardman Park Hotel. Shortly after the Department of State delivered its blessing, some of the connections Mel had made in other government departments also offered to help him out. "They feel it is definitely a part of our national defense program. I can't go into details. I have a connection in the Navy Department you will be proud to hear about—I think. If it works out."

=====

Mel's excitement over his return to China became difficult to contain, but he was also eager for another meeting, this one in Los Angeles: his drink with Annalee Whitmore. Speaking over the phone while he was in San Francisco, they had agreed to meet at a bar on Wilshire Boulevard, which was just a short walk from Annalee's parents' home near the La Brea Tar Pits.

On that first night, the two spent hours at the bar discussing China. By the time the night was through, they'd even begun brainstorming an idea for a movie about the conflict in Asia. After their meeting, Annalee began pursuing leads on agents who might be able to sell a treatment, though Mel, who'd grown up surrounded by Hollywood, was skeptical that the film would ever become something more than a wonderful idea.

Neither expected romantic chemistry when they finally met for cocktails. Mel was only recently out of his relationship with Shirlee Austerland, and Annalee was too focused on her work to think about romance; nevertheless, the meeting crackled with an intellectual energy so powerful that it precipitated intense physical and emotional chemistry. They quickly grew close, at least intellectually.

At Stanford, Mel had been too quiet to interest Annalee. Even though she was just four months older than Mel, she was a year ahead of him in school, and they had rarely spoken, in part because Mel was in China attending Lingnan during Annalee's senior year. Now Mel's confidence shone.

When Mel described China to Annalee, he spoke with such passion that it caught her by surprise. He'd experienced how many air raids and remained levelheaded throughout? He'd risked his life and freedom how many times to cover the belligerence against Indochina? He'd extended his work in Asia how many months, despite a worried family and an impatient

girlfriend? Who was this man who made his work the center of his life? And what was it about this place, this faraway place called Chungking, that made him want to go back so soon despite its discomforts, its deprivations, its dangers, and its incredible distance from home? Whatever it was, she wanted to find out for herself. And though she wouldn't immediately admit it, even to herself, Annalee soon realized that she wanted to see Mel again too. She'd broken off relationships with past partners because they hadn't stimulated her mind. Now here was a man who seemed to enjoy discussing the world with Annalee as much as she did with him.

Mel had known Annalee was interested in China before they met, and he quickly recognized the grip the country had on her imagination. Her independence and her interest in what was unfolding in Asia played a major role in his willingness to help her get to Asia to see the war for herself.

That night, an electrical current seemed to flow between Mel and Annalee. It was unlike any connection Mel had felt before. He'd dated in the past, and he didn't have a hard time talking to women. During his last semester at Lingnan, Mel had even toyed with the idea of marrying Marie Leîtao, his girlfriend in Macau, but that had been little more than a youthful lark.

Then there was Shirlee, whose affection for Mel cooled as he stayed in Asia for so long, despite what he thought was his love for her. At first Mel was lost, but he quickly realized that his reporting in China and Indochina had given him the opportunity he'd long awaited to define himself and pursue exactly the work he wanted. As high a priority as Mel had put on romance, it was clear that Shirlee would only play second fiddle to his work.

Annalee brought something entirely different to the table. She was an equal. She was fully herself, neither a woman who felt she had to prove herself and her capabilities to the men

around her nor a precious flower to be protected from those men. She cut through the bullshit. More importantly, she respected Mel and now found him attractive because of, not in spite of, his commitment to his career.

Before Mel left, he invited her to a United China Relief meeting. Then he drove up the coast from L.A. to Ventura, the small town where Dr. Charles Stuart received all of XGOY's broadcasts. Stuart had volunteered to organize the relief effort's chapter in his city, and Mel was eager to meet him in person. He brought Annalee along for the trip, so she was able to make her own introductions as well.

Annalee was capable of finding work on her own, but she also sought out Mel's advice. It had been made abundantly clear to Mel in New York that United China Relief would need a great deal of help. In early April, United China Relief publicity director Otis P. Swift had even written Mel's draft board in San Francisco on the organization's letterhead, urging its members to postpone drafting Mel because the committee was "anxious" to see him return to China.

"He is in close touch with the problems in [East Asia]," Swift wrote. "We feel that he will be most valuable in helping to coordinate American relief activities and to insure that they meet the actual needs of the Chinese people."

Aware of how invested United China Relief was in his return to China, and of the efforts that Leaf, Timperley, and the Kuomintang propaganda arm they represented were taking to convince him to return to his broadcasting role at XGOY, Mel knew he could parlay their assistance into an opportunity for Annalee. The afternoon he had lunch with John Hersey in New York he'd asked the *Time* hand to invite Annalee to dinner the next time he was in L.A.

Other Hollywood players were beginning to take note of China's crisis. In 1937 MGM successfully adapted Pearl Buck's

China-focused *The Good Earth*. Now Buck was one of United China Relief's initial leadership committee members, as was David O. Selznick, the former MGM studio head.

Though Mel had worked his connections to help Annalee, her own work in Hollywood impressed the power brokers. Word soon reached Selznick that a young scriptwriter at MGM wanted to immerse herself in the Asian situation and was asking around about relief efforts. Selznick knew that a skilled writer in China could energize the massive aid push that United China Relief wanted to organize. Perhaps this young, Stanford-educated woman was just the person to help.

Meanwhile, Annalee and Mel were growing so close so quickly that by the time Mel's departure neared, she came along on the Southern Pacific train he took up to San Francisco. The entire way they worked on their movie script.

"I have a hunch that it may sell, too," Mel said. "I guess I have more confidence in Annalee's work than my own."

At this point, Mel had his routine down in San Francisco. He had a great deal of business to conduct in a short period of time—appointments at wire service offices, visits to contacts in Chinatown, phone calls to editors in New York—but Annalee was happy to come along for his April 21 departure. The visits also gave her a chance to meet some of the United China Relief contacts Mel knew. She even met George Ching's brother, Teddy, who came to see Mel off on the American President Lines' SS *President Taft*. When that cool, dry afternoon he was scheduled to depart finally arrived, Teddy Ching wasn't the only one who was there to say good-bye. Annalee came too, and it was all Mel could do not to take her with him.

"Boat sailed at noon and I almost had Annalee talked into coming along."

Around the same time Mel set sail from San Francisco, Henry Luce landed at Burbank Airport, just north of Hollywood, fresh off the victory of the Lend-Lease Bill's signing and the launch of United China Relief. The publisher was about to begin a much-anticipated trip to China.

But before Luce continued north, he was driven to a brick colonial house perched above Benedict and Coldwater Canyons in the Hollywood Hills. It was Selznick's home—the producer had convened the Hollywood elite for another prong of the United China Relief rollout. Though a far more intimate affair than the dinner at the Waldorf in New York, the gathering collected the men who called the tune for the era's media. Its guest list was packed with Hollywood's most powerful producers.

Aware of himself as a man born in "old China," Luce spoke to the assembled moguls of Chungking and "new China," a place of "frightful and heartrending hardship" whose "story of unconquerable faith and fortitude" was one with which Americans were insufficiently familiar.

"It is partly because news, like the sun, travels from East to West," Luce said, appealing to his audience members' sense of themselves as culturally influential. "Hitherto the most notable exception to this rule has been the news of Hollywood. You people are, as you well know, big news—you are the principal traffic on the westbound course of news."

Luce believed that the story of China's "heroism" in standing on its own against Japan was a story that his audience's grandchildren would consider one of the greatest in history, one for the moguls to "rend as if our very lives depended on it—our lives and the happiness of our children's children." He was convinced that "by the year 2000 magnificent picture dramas will be derived from the episodes of this struggle."

Nineteen-forty-one was the pivot. It was in that year, Luce

insisted, that he and his peers were "determining that those future dramas shall spell out the triumph of the human spirit."

Before he left for China to see for himself where the drama now stood, Luce pulled aside one of the dinner's guests, Walt Disney. Disney was a natural fit for one of United China Relief's fund-raising efforts, the Campaign for Young China. The animator agreed to lead this campaign. Before he left, Luce sent a special message to a secretary at his New York office making sure she had noted Disney's commitment.

Henry Luce knew the dinner's attendees wanted their influence to continue west across the Pacific, but to sustain America's attention to the crisis in China, his relief organization would need for news of China's plight to travel back east across the ocean. United China Relief would need more than money. It would need a story to tell, and it would need people to tell that story, people who knew China and had connections and access there.

Mel Jacoby and his new friend, Annalee, were such people.

While Luce made the final preparations for his trip to China, Mel was sailing aboard the SS *President Taft* in first class—China's publicity bureau was paying for the journey—across the Pacific. Not even three months after he returned from his dangerous tour of Indochina, Mel was going back to Asia. He couldn't believe he was traveling again.

"Thanks for everything at home—still doesn't seem I'm headed back to China, guess it will take a bombing to wake me up," Mel wrote to his mother.

Mel would take the *Taft* to Honolulu. From there, he would fly across the Pacific on the *American Clipper,* one of the enormous flying boats owned by Juan Trippe's Pan-American Airways. The airline's *Clipper* routes were luxurious journeys

that cut weeks-long ocean crossings into affairs of a few days. (Though Mel flew on a plane called the *American Clipper*, his trip followed the route known by the same name as its sister plane, the *China Clipper*.)

Both *Click* and *Newsweek* had assigned Mel to cover his trip aboard the glamorous *Clipper*. Before he could, Mel had to clear his reporting plans with U.S. naval intelligence officers in Honolulu, who set constraints on what he could cover. So Mel got in touch with some of his navy connections in Washington, and they wired their counterparts in Honolulu to ask them to help Mel out.

"Friends are a great institution," Mel wrote.

Even before the security concerns, Mel was annoyed that he had been bumped from the San Francisco-to-Honolulu leg of the trip. Then he learned that there would be further inconveniences. His departure from Hawaii was delayed for two days, and he'd now be flying out with some of the same high-profile passengers who'd bumped him in the first place. Mel quickly discovered that among those passengers was Henry Luce, as well as the publisher's wife, Clare Boothe Luce, a playwright and future congresswoman who often contributed to *Life*.

"Not so good for the *Click* story," Mel wrote. "I'm afraid to have a rival publisher's face in the pics."

Mel was more than annoyed. He was angry that he had been kicked off the passenger list at the last minute for the San Francisco-to-Honolulu leg of the journey and that people like the Luces could so easily get permission to leave the United States when others couldn't. Despite his frustration, Mel remained professional enough to save his gripes for a letter home. He knew that his friend Teddy White worked for Luce, that *Time* had offered him stringer work in China, and that John Hersey was going to dine with Annalee to discuss a position for her with United China Relief.

On April 29, the night before Mel's departure upon the *Clipper,* Annalee wired Mel a bit of good news. Someone at MGM liked the screenplay the two of them were working on.

"She sure is a live wire," Mel wrote in a letter home mentioning Annalee's message.

> *If the damn thing does sell—if—and I get some money, the check will come to me, but half is hers.*
>
> *That's all except thanks again for everything and I'm already looking forward to home again. I'll be careful — love, mel*

With a roar and a shudder the *Clipper* lifted from Pearl Harbor on April 30. As gas fumes that would linger throughout the flight drifted through the cabin and its passengers started mingling, another reason for the security precautions became clear: the plane's passengers. If the United China Relief dinner Mel attended in New York had gathered some of America's most powerful philanthropists and business leaders, the *Clipper* manifest featured a spectrum of less widely known names that were nonetheless either incredibly powerful in 1940s Asia or about to make dramatic contributions to the course of World War II. Aside from the Luces, they included generals, spy chiefs and commandos, industrialists, and artists. The largest group was a party of U.S. Army Air Forces and Marine aviation officers headed to Asia to advise the Kuomintang's air forces, study Japan's strategy in its bombing raids, and plan air defenses in the Philippines. There was also a British businessman and onetime member of Shanghai's governing municipal council named Valentine Killery, who was leading a team on its way to Singapore to set up an ill-fated arm of the United Kingdom's clandestine spe-

cial operations network. And one woman on board the plane would become a lauded hero by helping to feed thousands of Shanghai's Jewish refugees.

Mel liked the plane's crew much better than its "motley crowd" of passengers. Most of the passengers were stuck-up, rude, and inconsiderate to him, especially the British passengers, "who think they own the ship." While the plane's captain helped Mel get photos, one of the Brits, Phyllis Gabell—who was secretly traveling with Killery to set up the clandestine unit in Singapore—threatened to sue Mel for taking her photo. The two American generals on the plane were more cooperative; one even tentatively agreed to go on the air with Mel in Chungking.

Eight thousand feet above the Pacific, somewhere between Guam and Manila, "really beautiful" cloud formations and blue waters rolled in from every direction. Only an hour or two of turbulence disturbed the four days of otherwise pleasant island-hopping from Hawaii to Midway, to Wake, to Guam, and then, finally, to Manila before most of the passengers flew on to Hong Kong.

Mel got a special treat during the flight: an invitation to see the crew quarters on the *Clipper*'s upper level.

"Only myself and two generals rated," Mel wrote. "Me to take some pics. The Generals to play around with the controls." Having those generals at the controls, Mel later reflected, "gave passengers their only rough bump" of the trip.

At long stops on Guam and Midway, Mel and Luce started talking. Because of their mutual interest in China, their talks meandered extensively. This was unusual given Luce's penchant for shutting down conversations on his own terms when

he decided he was done with them. Mel must have made a strong impression.

The *Clipper* landed in Manila on the morning of May 5. It was a Sunday, so there was little opportunity for Mel to see the people he wanted to see in their offices. He caught up briefly with Dick Wilson of the United Press, who'd been one of his editors while he worked in Indochina, and two other friends, but spent his short stay at the Manila Hotel doing little else. He didn't even have a chance to call Elza and Manfred, which he would regret when he was on his way to Hong Kong soon thereafter.

"My hectic stay here in Hong Kong is the initial real reminder that I'm back in the Orient," he wrote. Mel discovered, to his dismay, that flights from the British colony to Chungking were fully booked four months out. But Mel knew that "a certain group here"—meaning Kuomintang leaders and other VIPs— could always get a seat on the planes, and he used the pull he had with this group from his XGOY days to secure such a ticket. He'd be flying with CNAC on a special flight with the Luces.

Mel dined with Mickie Hahn his initial night in Hong Kong, bringing with him the first copies Hahn had seen in print of *The Soong Sisters,* her biography of the powerful siblings. She was one of "thousands" of other friends Mel met up with during his brief stay in Hong Kong. It was a busy, hectic visit that also included a stay at the city's best hotel.

"Never thought I'd come to that—did everything from order a belt for the Generalissimo to go to Madame H. H. Kung's for dinner last night, and tea yesterday with Mme Sun," Mel bragged. "Both of course interesting and all that but I'm a bit tired."

=====

As the sun comes up and the clouds clear, we look down upon a land of intricate and fairylike beauty. It is the land of the terraces of rice paddies and the land of thousands and thousands of hills, each hill terraced nearly to its top with rice paddies of infinitely varied shapes, some square, some round, but mostly like the sliver shape of the new moon, shapes within shapes until all but the wooded hill or mountaintop is full. It is the landscape which might have been dreamed by a child of pure imagination. The hills in Chinese paintings which seem quite fantastic are representative of those hills.

—Henry R. Luce, "China to the Sea,"
Life, June 30, 1941

For different reasons, Luce and Mel each felt a sense of homecoming as their CNAC plane descended past Chung-king's mountains toward Shanhuba. Luce—who was on his first vacation in two years—saw the embodiment of the newest chapter in the grand tale of the country where he was born. Mel was returning to the place that had given his life purpose, opportunity, and community.

Though there was a crowd at Shanhuba to see Luce and his wife, a sizable group of Mel's old Chungking friends also turned out to welcome him "home." Well, to welcome Mel and the seventy-seven pounds of "stuff" he lugged from Hong Kong along with him.

It was, Mel understated, "sort of good to be back."

So much had changed for Mel in the four months he had been away from Asia. He didn't have a permanent job, but now his prospects for secure work in journalism were strong. When he boarded his *Clipper* flight, he had been disgusted by the

preferential treatment granted to Henry Luce, yet by the time Mel arrived in Chungking he was not only impressed by the publisher, but the publisher had been impressed with Mel. In fact, it sounded from Teddy White like Luce was going to offer Mel a job with *Time* and *Life*. Indeed, Luce had taken a liking to Mel on the *Clipper* and cabled New York to inquire about him after they'd landed.

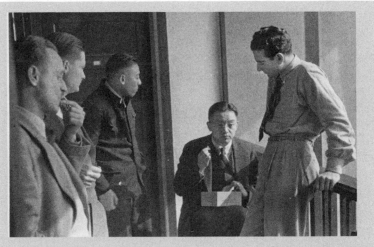

Maurice Votaw, Jim Stewart, an unidentified reporter, Ni-Nü Cheng, and Melville Jacoby share rare snacks on the balcony of the Press Hostel in Chungking, China.
Photo courtesy Peggy Stern Cole.

Chungking had also changed. Perhaps everything but the city's sodden air and slippery steps was different. The country was unraveling. On January 6, the day Mel had left Hong Kong to head back to the United States, a crisis that came to be known as the "New Fourth Army incident" had erupted, washing away the foundations—already eroding—of the United Front between the Communists and Nationalists.

Government troops had massacred thousands of Commu-

nist forces in Yenan, forces that had stayed behind after the Kuomintang ordered them to advance on Japanese troops to the north, a move that would have been suicidal for the Communists. Each side blamed the massacre on the other. The Communists believed that subordinates of Chiang Kai-shek had orchestrated the attack and that he later covered it up; the Nationalists alleged that the government troops were attacked and had returned fire out of self-defense.

As Teddy White and Annalee later detailed, Chungking "buzzed with rumors of an open breach, of an all out civil war." According to the two of them, the government troops who carried out the attacks treated the Communists they'd captured savagely.

"The New Fourth Army incident drew a line of emotional hysteria across all future relations of government and Communists," they later wrote. "In the beginning it had been a war of all China against the Japanese; now it was a war of two Chinas—a Communist China and a Kuomintang China."

When Mel arrived in Chungking that May, it remained unclear how matters stood between the two factions. One of Mel's reporting priorities would quickly become assessing whether the United Front that had been forged following the 1936 Sian incident could be salvaged or if indeed China's resistance was fracturing.

"The Communist-Kuomintang question is still an open sore," Mel wrote a month after his arrival. "No one knows exactly how things stand."

Still, just as he had done when he wrote calmingly to Elza about hysterical coverage of air raids, or even earlier, during the chaos following the Marco Polo Bridge incident, Mel told his mother that conditions in China weren't nearly as bad as rumored. Whether that was true for China as a whole, Mel discovered upon returning to Chungking that the same could

not be said of the places there that had felt most like home. The city's infrastructure was crumbling as the war dragged on, leaving the Press Hostel without electricity and consistent water supplies. It was also overcrowded—Mel had to squeeze in and share Teddy's room—and there were holes in the wall from nearby explosions.

"Aside from these minor points—everything is fine," Mel deadpanned in a letter.

Meanwhile, Holly Tong's radio operation was in shambles, which had serious consequences for Mel's stringing for NBC. The Japanese had pounded XGOY's facilities, and Mel discovered that Mike Peng, the station manager, was struggling to keep the station on the air.

But Mel now had an out: Teddy White, who was going back to the States with Henry Luce after the publisher's visit, suggested that Mel take over his duties for *Time.* After connecting with Luce on the *Clipper,* Mel felt comfortable taking the job despite his earlier belief that he had a bigger future at *Newsweek.* With the new position, Mel resigned from XGOY, happy that he would no longer be drawing a salary from the government, though he still volunteered to help keep the station's broadcasts on the air.

Helping XGOY stay afloat was hard. It meant working in darkness until 10:00 P.M. in a fifty-foot-deep dugout. With Chungking's electrical infrastructure in shambles, the station kept its equipment powered with batteries pulled from cars.

Mel spent much of his first week back in Chungking scouring the city for any piece of equipment he could use to whip the station into shape. He scrounged up spare batteries to power the station. He found extra vacuum tubes. Some nights Mel and XGOY's staff would even broadcast without lights in the studio.

Still, once the studio was on the air, the result was much the same as it had been a year before. XGOY's straining equipment sent Mel's voice through Chungking's souplike fog along radio waves that undulated for 10,000 miles to a little California beach town with a long wooden pier, hugged by dry, brownish mountains.

There in Ventura, on the sand a couple of miles south of the pier, tall rhombic antennae caught the signal and transmitted it through a nest of wires to a nearby Tudor-style home. (Doc Stuart and Alacia Held had moved their radio operation from their downtown dentist office.) Before seeing the day's patients, Stuart and Held carefully monitored the incoming transmission, recorded and transcribed the broadcast, then retransmitted it to propagandists and news outlets.

The broadcast closed with a familiar sign-off spoken by a young journalist from nearby Los Angeles.

"XGOY is signing off now," Mel said. "This is the Voice of China, the Chinese international broadcasting station, Szechuan China. Good morning, America, and good night, China."

Chapter 7

"NOTHING BUT TWISTED STICKS"

For most of the hot, suffocating day of June 5, 1941, there were no bombers above Chungking. There were no alarms. There were no screams. There was simply the background chatter of a busy Thursday.

Crews work to douse flames after an air raid in Chungking, China. *Photo by Melville J. Jacoby.*

But beginning at about 6:00 P.M. that night, the city's soundscape shifted. Alarms rang. Storefront shutters clattered closed.

Within an hour, eight Japanese planes roared overhead. Their crews opened bomb bay doors and showered Chungking with devices packed with kerosene and gasoline. Flaring across the sky, the bombs ignited the papery buildings that packed much of the dense city, replacing Chungking's daily noise with the crackle of flames.

"Fires lit the city and the sky above glowed pink and red," Mel wrote two days later in one of his first reports to David Hulburd, his new editor at *Time,* describing one of Chungking's most catastrophic nights yet. He had been on the south bank of the Yangtze during the attack.

When the first alert went up that evening, nearly 5,000 people had packed into the city's largest dugout, nearly a mile and a half long.

At first the city's air raid warning system indicated that the enemy was gone. But half an hour later, the warning signal returned. More planes were coming. Police shouted for people to return to the shelters. Most had noticed the signal themselves and were already running back toward the gates.

"In one giant shove they crammed, jammed their way back through the monster dugout's three entrances," Mel wrote. The weakest in the crowds stumbled, and the panicked crowds shoved forward over them even as more fell beneath their feet.

"The sweltering crowd grew restless after the bombs had fallen," Mel wrote. "Hundreds of them shoved towards one of the three entranceways for fresh air and a look-see."

However, the shelter's gates were locked, and guards wouldn't reopen them. A few minutes passed, and the crowds began crashing against the main gate. Its guard relented, and the crowds streamed out to watch their city burn.

Now the city heard bones and flesh crumple as people ran in every possible direction. They bellowed. They cried. They sobbed. They gasped for air in the choked tunnels and howled in pain as they clawed and bit at one another as they tried to break free.

"There was shouting and cursing as only China knows it," Mel wrote. "Women beating against those in front, children trying to find air. Scores went down to their death. As the sound of Japanese planes droning overhead came to their ears the shoving became even more intense and the bodies along the floor of the passageway more numerous. The excitement spread through the dugout like a swift breeze."

As the next round of bombs fell, those inside the dugout again panicked and surged back against the entrances. Waves of frightened residents rushed both into and out of the shelter, each stampede crushing the other. The guards were so overwhelmed that they locked the entrance gates again, trapping the frightened masses inside, leaving those within to claw, scratch, and shove at one another.

Two more waves of bombers attacked, drawing the crisis out for hours. As ever more people were crushed and asphyxiated, bodies piled higher. "Whole families went down into the damp, dirt floor tearing at each other," Mel wrote. "Body packed against body, walls of flesh grew."

Finally, by midnight, the raids were over. Elsewhere in Chungking people emerged from the dugouts with their children in their arms. Exhausted, but alive, they headed home and tried to get to sleep.

"Cars honked along the streets again, government people and big merchants came out of their better-made dugouts only half tired, half joking about being kept awake all night," Mel wrote.

But in the city center another two hours passed before the

public shelter's gates were opened. Its guards had fled. Once the gates finally were unlocked, few people emerged.

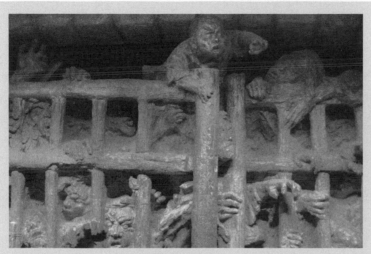

A museum exhibit at the Three Gorges Museum in Chongqing, China, re-creates desperate Chinese citizens caught in a stampede inside an air raid shelter during an attack on June 5, 1941. *Photo by Bill Lascher.*

"There were only a few faint cries heard inside," Mel wrote.

First local police and other authorities arrived, followed by Red Cross workers. They found bodies everywhere, some unmoving, a few still writhing.

"Most were dead," Mel wrote. "Like piles of leering, gasping sardines in a cannery, they were twisted and piled here and there along the dirt-floored dugout. A few arms and legs were twitching."

More than 4,000 people are thought to have died in the catastrophe. Blame for the disaster was spread widely. Starting within a day of the attack, air defense commanders were fired, foreign engineers decried shelter designs that limited air cir-

culation and lacked ventilation, doctors excoriated soldiers for not properly removing the bodies, and politicians called for the heads of the municipal officials who cut corners while building the structure.

The night after the attack, Mel and the United Press's Mac Fisher crossed the Yangtze River from the foreign district on the south bank to observe the recovery. On the sampan crossing the river, the reporters met survivors, one of whom had lost two brothers in the disaster. He claimed he saw Generalissimo Chiang Kai-shek burst into tears when he visited the dugout at 4:00 A.M., a scene that was widely reported elsewhere.

Once Mel reached the dugout, he pulled out his camera. At the main entrance, seeing dozens of masked Chinese soldiers carrying dead bodies from the shelter's black maw, he snapped a picture. On a nearby staircase he saw the dead still piled and sprawled where they had fallen an entire day before. He clicked the shutter again. Nearby, Red Cross workers threw the victims' corpses into a truck, and Mel took another picture. He saw a lifeless child crushed by the stampede and took one more picture.

Along with a multipage dispatch describing the catastrophe in excruciating detail, Mel sent the negatives of these ghastly images to his editor, who passed them on to *Time*'s sister publication, *Life* magazine. *Life* let Mel's photos do the talking and offered only a few paragraphs of explanatory text to contextualize the tragic images, which were accompanied in the magazine by a final, full-page print of a dead boy sprawled backward over a step, a little girl splayed nearby, both surrounded by dozens of other bodies.* Many of the bodies were half-naked,

* *Life* credits this image to an outside picture agency, but Mel's letter accompanying the negatives, as well as future letters, suggests that he took this picture. It's unclear if the final published image was a separate one

their clothes having been torn off in the frenzy to escape the stampede.

The story—Mel's first published contribution to *Life*—was a departure from the propaganda he had written for Holly Tong the previous summer. At a time when the Kuomintang struggled to keep control of this horrifying story, the report Mel sent with his photo negatives described the terrible scene he witnessed in far more vivid language than was usual for him and threaded a narrative reconstruction of the night's attack that re-created its horror without straying into hyperbole. Whereas in his master's thesis two years earlier he'd decried the "horror angle" in newspaper reports about the war's first days in Peiping, he was now witnessing and reporting a horror that was far too real.

The images also caused a stir among *Life*'s readers. One subscriber wrote to the magazine to decry its lack of "editorial discretion," saying no publication should print pictures that "degrade the human body." Another anticipated that his peers would take offense at Mel's pictures, and that was why he welcomed the decision to print them. "It COULD happen here," he wrote. Charles Kreiner, a reader from Baltimore, was altogether disbelieving. He claimed that Mel's shots were provided by China's publicity department and were the "fanciest piece of artificial nonsense" he'd ever seen. Kreiner wrote that he thought they were part of an elaborate propaganda scheme reliant on mannequins and sandbags for

from the one Mel described, as some images were shot similarly by multiple photographers. Additionally, the National Archives and Records Administration credits an identical photo to Carl Mydans, but Mydans was not in Chungking when this attack took place.

gruesome effect. *Life* couldn't allow such an allegation to go unchallenged.

"Reader Kreiner, like many another American, is refusing to believe the terrible facts of war," the editor responded, noting that Mel was there and saw the bodies. "*LIFE* vouches for the authenticity of the pictures."

In weeks to come, Mel's follow-up reporting only underscored how serious the situation was. The dispatches Mel sent David Hulburd were dense with accounts of the missteps and corrupt actions that worsened the catastrophe, story threads that were far too troubling for the Nationalists to contain. Much of that follow-up reporting would never see its way into print, but at this moment Mel was doing exactly what he'd set out to do when he first left for Shanghai after completing his thesis: he was documenting a nation and a city enduring a moment too important for the world to ignore. Now, as Mel began his career at Time Inc., he might be able to get the world's attention.

All summer long, Mel sent dispatches to *Time*. Fortunately, he had Teddy White in the magazine's New York offices both to help interpret the significance of his reporting to the publication's editors and to relay their messages and requests to Mel in a way he would understand. Already close friends, Mel and Teddy had established a sort of language between themselves common to people who work together in high-intensity environments. For example, shortly before the catastrophic raid on the downtown Chungking shelter, Mel began one letter with a note that indicated to Teddy that his message might be interrupted.

"Well, my friend, the ball just climbed to its place, and you know what that means," Mel wrote, referring to Chungking's

system of visual warnings to alert the city to imminent air raids.

Writing to Teddy also allowed Mel to vent in a way that he couldn't with his mother and stepfather. He could talk about the minutiae of his work and his experiences in Chungking with Teddy because Teddy understood the city and China.

But even with Teddy's advocacy, Mel wasn't completely comfortable in his new position. He knew he could have had a secure job back in Sacramento, so far from the bombs. He could have been a bureau chief for the United Press, filtering the war's news through the quiet of the Golden State's capital. But Chungking, where the "full weight of being a *Time* correspondent" was suddenly crashing down upon him, was anything but quiet.

"I must admit I haven't had the confidence in the moment I thought I had," he told his parents. "The job has me a bit worried. There is so much to do; and Teddy White did such a good job before me."

By the summer of 1941, America's neutrality in the China-Japan conflict had become little more than a charade, and a halfhearted one at that. That spring the United States had finalized its long-negotiated lend-lease program, which would provide economic and material support to China, Great Britain, and, eventually, the Soviet Union for their war efforts. Now goods and supplies were beginning to pour into China. President Roosevelt's handpicked advisor to the Chinese, Owen Lattimore, had just arrived in China. Indeed, Lattimore showed up in Chungking only shortly after the magazine he edited—*Asia*— published the analysis of the previous fall's Indochina crisis that Mel had written in New York that March. That story explained not only how Japan had maneuvered its

way into control of the French colony but how it had set the stage for the conflict to come.

Meanwhile, three of the American air defense strategists who had traveled on the Pan-Am *Clipper* with Mel had been spending weeks reviewing China's readiness for aerial warfare, as well as Japan's use of airpower. Their 8,000-mile tour of China was a poorly kept secret; indeed, the Japanese had chased the air mission's plane through the country. Often airfields and other sites they had visited were attacked shortly after they departed. Once, in Chengtu (Chengdu), the officers had to jump for cover in a nearby grave mound as a Japanese plane strafed an airfield.

Flown around China on a camouflaged CNAC DC-3 piloted by Chiang's personal pilot, Royal Leonard, the airmen were impressed by how their counterparts in China coped with such overmatched air forces. As Mel reported, they believed that if China had access to modern American planes or worked closely with the United States against a "common enemy"— which the strategists expected to happen—they could easily challenge Japan.

Combined with Lattimore's arrival, the airmen's visit made it clear to Mel that geopolitical circumstances were changing quickly.

"U.S. is pretty active here now in a big way," Mel wrote. "Really sending the stuff in. No fooling around this time."

Money, equipment, diplomats, and young journalists from L.A. weren't the only American arrivals in Asia in 1941. An elite force of American mercenary pilots was also beginning to pour into Rangoon, Burma, to train for escorting CNAC planes over the "hump" of the Himalayas. These pilots were the Flying Tigers, the mercenaries Mel had discussed with Madame Chiang before he last left Hong Kong. With the Flying

Tigers' arrival, increasingly favorable opinions of the United States circulated through Chungking, Mel noted. These new pilots would be a boon for China, especially since chatter about them also included rumors that they were bringing new planes. But that was all they were—rumors.

There was, however, one report to which Mel paid close attention. Two more people were on their way to Chungking: Carl and Shelley Mydans. After many delays in their flights, they finally arrived on June 13 aboard a DC-3 with an extra wing strapped to its belly. Mel, who'd rented a room from Shelley's mother during his last year at Stanford and received early photography advice from Carl, was eager to see them.

Two days after the Mydanses arrived, Mel took them to the south bank of the Yangtze River, where many foreign embassies and businesses were built on the hillsides with sweeping views of central Chungking. One of these buildings was the soon-to-be-vacated German embassy. (Having recently recognized Japan's puppet government in Chinese territory under its control, the Nazis were moving their embassy to Nanking.) To avoid being bombed by their Japanese allies, Nazi officials had draped a gigantic swastika atop the embassy. It was a relatively safe place to be during a raid, and Mel—who had first met German ambassador Baron Leopold von Plessen in Indochina—brought the Mydanses to its roof to watch the raid with a few other reporters who had come along.

"They got the view and a fair shaking, too," Mel wrote.

Some of Carl's pictures from the afternoon show the moment bombs blasted across the Chungking cityscape. Another shows smoke surrounding the *Tutuila,* a U.S. Navy gunboat moored in the Yangtze close to where an errant bomb hit. Other bombs fell near the U.S. embassy.

"Now that the shelter catastrophe has been forgotten," Mel noted wryly, "bombing talk in Chungking revolves around the question: Did the Japanese bomb the *Tutuila* on purpose."

Whether they had was up for debate, but Mel's comment acknowledged a sadder reality: Chungking gossip had already moved on from the June 5 tragedy, even as another forty people died in a poorly constructed dugout near the U.S. military attaché's office the same day the *Tutuila* was hit.

It wasn't just American facilities that suddenly seemed at risk. In early July, a bomb destroyed an annex to the Press Hostel that the reporters used as a mess. It also rendered the rooms of Till Durdin and some other reporters uninhabitable and blasted the roof off the main building.

"But aside from living conditions, correspondents found themselves battling something worse than a hard bed and no whiskey," Mel reported to Hulburd after he and the Mydans had returned from a trip. "The censorship since the end of last year gradually tightened until messages were always hacked to pieces, their guts gone, by the time they reached the cable offices."

Other branches of government were interfering with Hollington Tong, making it hard for the reporters to get a consistent message from the government. Inexperienced censors were cutting each reporter's messages in different ways. For example, the press conferences of the National Military Council's spokesman about recent battles were more than a week out of date.

Chungking's community of foreign correspondents had met that May to write a four-page bill of grievances to Chiang Kai-shek. That complaint covered censorship, government interference and confiscated mail, limited press permits, and other problems that made conditions for reporters worse

than "press elsewhere in the world." They also ripped into the widespread surveillance of reporters by secret police and other officials.

By June, Chiang responded to the reporters through Hollington Tong, assuring them that a resolution would come soon and that censorship would be loosened. The reporters, Mel said, were "not entirely satisfied with the answer." At first the censors loosened up considerably and government ministries appeared to be looking for better spokespeople, but the reporters adopted a wait-and-see attitude. Their gripes would continue throughout the course of the war and lead to the formation in 1943 of the Foreign Correspondents Club of China, an organization now based in Hong Kong.

Following Japan's signing of a non-aggression pact with the Soviet Union that April, it stepped up its campaigns across China. With the risk of war against the Soviets quieted, Japan could expend more energy against China in the hope of breaking that country's resistance before America's volunteer air force got set up. Mel reported that most of the fighting was concentrated in China's northwest, where Japan had established positions along the Yellow River, near T'ung-Kuan. Henry Luce, having visited the front lines himself, was eager for more on-the-ground material from there.

Mel also had to take into account the aftermath of the New Fourth Army incident. Mel's Kuomintang sources were publicly claiming that the 18th Group Army (another name for the Communists' 8th Route Army) was not contributing to the anti-Japanese campaign, even though his sources privately admitted they didn't have enough information about what the Communists were up to. There were no correspondents in

Communist-controlled areas. It took visits to the party's head-quarters in Chungking to get its side of the story.

"Correspondents take the Pirate brand cigarettes Communists offer, sip tea, and listen to [Communist Party] grievances which still follow the same patterns," Mel wrote. These grievances amounted to the absence of pay, munitions, credit, and direct communication from the central government.

In early June, Chou En-lai (Zhou Enlai), Mao's second-in-command and the Communists' liaison in Chungking, penned an editorial that he had a subordinate slip under the doors of each Press Hostel resident. The piece denounced Kuomintang censors for burying six different reports about the 18th Group Army's contributions along the Northern Front. Censors even tried to kill the official version of the piece, but now that Chou had printed enough separate copies for the correspondents to see, there was no way to actually do so.

Mel summarized for David Hulburd a series of guerrilla raids that the 18th Group Army was making against Japanese positions in northern China. This "heckling" was a big part of the Communists' strategy, but the Kuomintang had been suppressing reports about it.

When he was in Chungking that May, Henry Luce had learned for himself that the war seemed to be focusing on China's northwestern frontier, and he wanted the Mydanses to head there to shoot pictures and collect background for *Life* and *Time*. He also wanted Mel to go with them to supplement Carl's photos and Shelley's captions with his own writing and background.

Shortly after Carl and Shelley arrived in Chungking, they and Mel flew to Lanchow (Lanzhou), a city in northern China on the banks of the Yellow River. It was the Chinese terminus of a highway connecting the Soviet Union with China. The Japanese were dug in outside of the city.

Lanchow was dry. The outpost's adobe buildings and the broad straw hats of its residents reminded Carl of Mexico, an impression similar to Mel's when he visited Sian in 1937. Despite its strategic importance, Lanchow was a quiet, neglected-seeming place. Mel was surprised by its emptiness.

"The streets are drab and dusty looking and have for color only the occasional donkey rider, or a vendor displaying brilliant rows of big apricots, melons, peaches and pears," he wrote in a twenty-nine-page background report he provided to *Time* after the trip.

They arrived on June 19, Carl and Shelley's anniversary. After visiting the Lanchow front, they spent two hours looking for a bus to Sian. Finally a six-cylinder jalopy with a Russian-built chassis and Chinese-constructed body sputtered up to the bus station. It was falling apart and dirty, its upholstery torn up. Sixteen riders got on besides the reporters and Warren Lee, a government fixer who had been sent with them. Atop the rickety bus, ropes stretched willy-nilly across a mountain of canvas bags and other parcels. A license plate reading "3087" in large black letters hung crookedly from the rear bumper.

Lee had told curious fellow passengers that Mel and Carl were American "aviators," while he said that Shelley was a nurse. He had hoped to gain better treatment for his charges.

"What it *did* gain was constant request and expectation for Mel and me to repair their dreadful bus every time something went wrong," Carl noted. Assuming that if the "aviators" could fly a plane they were also skilled mechanics, the bus's driver—whose conveyance frequently malfunctioned—left Mel and Carl doing the bulk of the spark plug replacements and other repairs.

"Several times we successfully helped and each time the driver would start up and drive on before we had finished. To twist in a spark plug by hand and pound on it a few times with a hunk of iron was enough for him."

During the trip, the trio got shelled multiple times and stayed in a division commander's cave when they visited the front lines. During one multiday journey to Chengtu, Mel had to ride on the roof of a Red Cross ambulance, unprotected from the sun.

"My trip with Carl and Shelley to the northwest was exceptionally enjoyable although a bit rough and tumble," Mel wrote to his mother.

Four years after Mel had traveled with Harry Caulfield to Sian at the outbreak of hostilities between China and Japan, he was back in the country's interior. It was a completely different place. But it wasn't all hellish. Mel was particularly fond of working with Carl, whose stark, high-contrast photography captured moments of subtle human emotion, scenes full of action and activity, and grand landscapes with equal care.

One early Sunday morning, after a tire blew on their bus, Mel, Shelley, and Carl wandered up a hillside together to shoot pictures of the countryside. There were terraced hillsides, ancient forts in all directions, and shepherds with their flocks. Mel shot primarily in color, while Mydans, for the most part, stuck to black-and-white.

"Maybe I'm getting soft but I'll admit that the trip tired me for a while," Mel said. Still, he said, the Mydanses were "swell people to travel with," and he liked having an opportunity to learn about what it was like to work for Time Inc.

Two years earlier, when the Mydanses paid a visit to Shelley's mother at the same time Mel was living in the Smith household, he and Carl spent much time talking shop. Mel remained interested in photography even though he was primarily working as a writer. *Life* had used Mel's photos from the June 5 air raid shelter catastrophe, but only because the Mydanses weren't in Chungking yet. However, even though Carl was *Life*'s photographer on the trip, he generously helped Mel improve his

photography and discussed his techniques and equipment with the younger reporter.

"Working with pictures helping Carl Mydans has taught me more than a photo class," Mel said. "I really picked up some valuable tips, and fortunately he uses exactly the same equipment that I do. We shall be together for many months."

Carl told Mel that he had a good eye for shots but his technical skills could use some work. He also said that he'd benefit from more equipment, but since Mel used the same kind of camera as Carl, it wouldn't be as expensive as it would be to start from scratch building the $5,000 (in 1941 dollars) worth of equipment Carl used. Mel even was equipped to take color shots.

"Carl spends a lot of time coaching me on my pictures, which is quite a break since he is considered about the world's A-1 [photographer]," Mel told his mother in one later letter. The trio shared an office at the Press Hostel, and Mel found Carl and Shelley to be "really swell people and fun to work with."

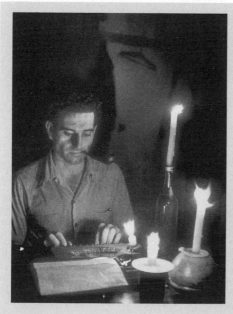

Melville Jacoby types by candlelight after the Chungking (Chongqing) Press Hostel was destroyed in an air raid. *Carl Mydans*/LIFE *Picture Collection/Getty Images.*

═══

July 7, 1941, marked the fourth anniversary of the war in China. The day before, while the reporters were still in Chengtu, the capital of Szechuan Province, Mel received a cable asking him to do an NBC broadcast to mark the occasion. It would pay $250. No planes were flying that day, however, and he had no other way to reach XGOY's Chungking studios in time for the broadcast. Instead, Mel spent two days running around Chengtu getting equipment and arranging interviews with officials. He then stayed up all night writing a fifteen-minute script.

To make sure broadcasts would reach the United States at prime-time hours and without interference from Japanese attackers, Mel had to get to the studio by 6:00 A.M. But the studio staff overslept, and the one person who showed up was incompetent. The broadcast failed, and Mel lost the $250.

"The whole thing has me annoyed considerably in as much as it would have been excellent publicity for China, and I did go to a lot of work when I could have been doing other things," Mel told his family.

On top of the censorship problems he and the other Press Hostel occupants had detailed in their letter of complaint earlier that summer, these logistical issues soured Mel on China. He began to realize it was no place to be a reporter.

"It is just too disheartening," he said.

Even worse news awaited Mel in Chungking. A day before the anniversary, a Japanese bomb struck the Press Hostel. It was a direct hit, and little was left of the building. Still in Chengtu during the attack, Mel lost all of the possessions he had in China, save one shirt and the clothes he wore on his trip.

The entire Press Hostel was flattened. It was left "nothing but twisted sticks and scattered stones."

Once Mel was back, he sat in the open air where his office

had been. By the glow of candles pressed into empty wine bottles and teapots, he typed at a low-profile Hermes Baby typewriter, a tobacco pipe pressed in the corner of his mouth as he stared at the page in front of him. The collar of his wrinkled beige shirt exposed chest hair the same shade as the stubble on his face. It was still 102 degrees at night. Firelight glinted off the beads of sweat that rolled down his face, but he had to continue working. There were still dozens of pages of notes from the Lanchow trip to type up, not to mention three weeks' worth of other work that had piled up while he was away.

As the summer progressed and the Japanese switched up their patterns for bombings, entire days were often spent wasted in shelters as alarm after alarm rang out. This made it particularly hard to get work done, especially because there was little time after ducking into dugouts to meet with government officials. Mel thus spent much of his time pooling his reports with the *New York Times*'s Till Durdin—with whom he also often ate at the home of Bertram Rappe, a Methodist missionary—because they could gather more news combined than they could individually.

"Collecting news is a big job now," he wrote to his family in early August. "I'm working of course against a dozen first rate men here."

However, Mel had Carl and Shelley on his side. They had been out when he wrote this letter. They returned just as he finished it, and Mel closed with a word of praise for his new friends and colleagues.

"I told you Carl and Shelley were good people—well, they just came back from a Russian Embassy dinner with their pockets full of chocolates for me," Mel wrote, repeating his frequent lamentation that Chungking's deprivations made chocolate a scarce commodity. "They knew I was crazy for some—sure good too."

Unfortunately for Mel, it wasn't clear how much longer he

and Carl would actually be working together, and unfortunately for the Mydanses, the sweets were about all they could secure from the Russians. Mel still was only provisionally employed by *Time,* and Carl and Shelley wanted to return to Russia, where Carl had shot the Soviet Union's 1940 war with Finland. But that night Shelley found out she wasn't likely to get a visa.

"Poor Shelley is disappointed as hell . . . I hope her visa goes through," Mel wrote.

Later that month, Mel told Teddy that the articles *Time* printed of his were looking more accurate than they had in some time. Clearly, this was Teddy's doing. But Mel continued to worry that the publication was making unrealistic demands regarding the photographs he submitted. For example, many of the shots Mel took of the tragedy at the public air raid shelter resembled ones that Till Durdin and Mac Fisher had taken.

"Of course I will try for exclusive stuff, but even Carl agrees that is hard on spot news breaks here," Mel wrote. "Damn near impossible. Thanks pal for sticking up for me. But I knew you would."

Even with the Mydanses in his corner, as September approached Mel worried about his standing with *Time.*

"As you must know I feel damn insecure and am wondering just what will happen to me in September," he told Teddy, asking for a frank note about his status. "Sure miss you Teddy. We all do, particularly when there are no speeches in little shambly cafes etc."

Once September came, Mel did receive a commitment from *Time.* One evening that month he checked in from the Chungking Club with a letter to Teddy. In its closing, he handed off the thin rice paper sheet to Carl and Shelley Mydans.

The couple—still hoping to receive clearance to travel to the Soviet Union but feeling ever more doubtful—dashed off

a paragraph to their Chungking friend, who was now working in the very New York offices where they had met and fallen in love.

"Say hello to everybody for us and don't dislike New York too much for we shall all be back there with you one day," they wrote.

As the summer drew to a close, Mel turned his attention back toward Annalee. They had been corresponding as she looked for a job that could bring her to China. Mel started to worry that she wouldn't arrive in time to be of much use to United China Relief, which was beginning to wind up its fund-raising drive, and that she'd need some freelance work to pad the job. In his letters to Annalee, he'd told her how hard it was to get assignments, and he felt guilty about pressuring her. He knew she'd been hung up back home by her troubles getting a passport.

"However, I'm sure she will make out all right," he said in a separate letter to his parents. "She should have come at the beginning of the summer. Not so late. But then, she couldn't help that."

||||||||||||||||||||||||||||||||

"HE TYPES ON THE DESK,
AND I TYPE ON THE DRESSING TABLE"

"I'm giving up this whole career," Annalee said.

It was August 1941, and Annalee was having lunch with Sidney Skolsky, the Hollywood columnist who regularly dropped in on Annalee and other writers at MGM for studio dope he could use for his column.

This time she wanted to dish about herself: less than a year after her script for *Andy Hardy Meets Debutante* helped her break in at MGM, she was planning on leaving the studio and going to China. The revelation shocked Skolsky.

As self-assured as ever, Annalee looked at Skolsky and erased from his mind any suspicion he harbored that he'd misheard her.

"I'm going to China," she repeated, telling him—as she'd told others—that she couldn't ignore the mounting stories of starvation, suffering, and illness while she kept writing meaningless Hollywood movies.

"I'm very interested in their fight," she continued. "I may have a story for you. If I do I'll let you know."

After *Debutante,* Annalee earned writing credits on *Honky Tonk* and *Ziegfeld Girl,* and that afternoon she was in the middle

of her adaptation of a story for her fourth film, *Tish*. (She was also shepherding the screenplay she and Mel wrote together.) Skolsky was surprised to hear that Annalee would suddenly set aside MGM after she'd worked so hard to get a studio writing job, but in a later reflection, Skolsky realized that Annalee hadn't actually given up on telling stories.

"The story of Annalee [Whitmore] is still being written and she is helping to write it," Skolsky wrote. "She knew what she was saying when she told me 'I may have a story for you.'"

After Mel left San Francisco that April, he and Annalee continued to correspond. First they talked on the phone during his stopover in Hawaii. When he reached China, he wrote her about his *Clipper* journey, then about how Chungking had changed in the months since he'd been away. As the summer progressed, he described the work he picked up at *Time*. His letters entranced Annalee. She paid rapt attention to each tale he sent from China and read everything of his that was published. China was on fire, and Annalee wasn't going to be satisfied sitting thousands of miles away, writing movies about teenage boys' romantic follies.

What Annalee and Mel did not discuss as publicly was their own romance. Each of them was attracted to the other, sure, and they'd talked about the idea of having a relationship more serious than the few dates they'd gone on while Mel was in California. He had even half-jokingly invited her along when he left from San Francisco that April. Still, neither of them was comfortable with a commitment so soon after meeting.

"I admit we'd talked about it, but we both felt we had known each other too short a time to even begin deciding," Annalee wrote to Mel's parents.

Still, with that summer's air raids worse than ever and Chung-king's infrastructure falling apart, Mel goaded Annalee about how it was too dangerous for her to come to Chungking.

"Chungking was no place for a woman," he wrote her, knowing the comment would raise her ire. Then he scrawled a note at the bottom of the letter: "P.S. Hurry up."

But the State Department continued to frustrate Annalee's plans. In late May, her passport application was denied again, and her doubts that the trip would ever happen were renewed. She was, on the other hand, optimistic that the script she and Mel had written together in California would succeed. (Mel seemed to think that too was wishful thinking, but by the start of 1942 MGM would green-light the story.)

But then, in August 1941, leaning on Mel's link to Luce and her own Hollywood connections, it looked like Annalee had a job secured: United China Relief wanted her to manage its press relations in Chungking. At Mel's suggestion, Elza Meyberg invited Annalee to her house for dinner with Doc Stuart—the Ventura dentist who received all of Mel's radio transmissions—Earl Leaf, and H. J. Timperley. By the time dinner was over, they'd sorted out the particulars of Annalee's job at United China Relief. She just needed to wrap things up at MGM, which agreed to give her a one-year sabbatical.

On August 12, Annalee's sabbatical began, and she set off on the MS *Granville,* a Norwegian-captained, Chinese-crewed freighter bound for Asia. Sailing from Los Angeles to Manila and then Hong Kong, she would spend much of the trip reading *Richfield Reporter* news summaries while relaxing on the ship's deck so that when she arrived she would be as up to date as she could be about the war. She also assessed her fellow travelers, whom she described in detail to her screenwriting partner Tom Seller.

"Passengers are about evenly divided between missionaries

and infidels," Annalee determined. "I drew a missionary for a cabinmate, but she's been fine."

Indeed, the presence of the missionaries served Annalee well. One of the "most rampant" among them struck a deal with her: if she quit smoking, the missionary would teach her Chinese.

"It practically killed me for two days, but now I can say 58 sentences suitable for any occasion through my nose very professionally, and the Chinese crew actually understands," Annalee bragged.

"It takes brains to learn shorthand in an hour and Chinese in a month," Shelley Mydans later recalled of her friend. "But it takes more than brains to utilize these hastily acquired talents. It takes charm. And Annalee has a lot of that, too."

By the end of the long trip, Annalee felt like the journey's star.

"Maybe people are right about what the Orient does to you," Annalee pondered. "There are so many nice men and so few women that between mirrors you feel like Hedy Lamarr. Haven't powdered my nose since I got on the ship and I feel devastating, so you can tell the situation's extreme."

Aware Annalee was finally on her way to him, Mel wired friends of his in Manila and Hong Kong asking them to welcome Annalee when the *Granville* arrived in each city. Annalee's stopover in Manila was four days long, so she had plenty of time to dance and eat lobster at the four-story, Art Deco Jai Alai stadium that she found "more fantastic than any MGM production," as well as to accompany the Chinese consul to a reception for a Filipino university president. Annalee remarked that despite five miles of mined harbor in Manila, the Philippines didn't seem nervous about the war.

"Last month's jitters, after Japan moved into Indo-China, have all left, evidently," she wrote.

Annalee reached Hong Kong on September 18. After a few days running errands for Mel and getting to know some contacts there, it was finally time for her to continue to Chungking. One couldn't easily fly there, because Chungking was located deep in China's interior, and Japan controlled China's coastal cities and the airspace above them. So one had to slip past patrolling Japanese planes.

This meant flying out of Hong Kong early in the morning or late at night under cover of darkness. CNAC dispatched Royal Leonard—the same pilot who had flown the American air officers' junket in June—to fly Annalee to the capital. Leonard, who had become a good friend of Mel's over the summer, invited Annalee to sit up front in the CNAC plane's copilot seat. Eager to show off to his young, attractive passenger, Leonard made an unscheduled landing on a rice paddy in Kweilin (Guilin) so Annalee could see the famous landscape there of steep, eroded limestone formations known as karst. The plane ended up stuck in the mud. Leonard and Annalee had to get locals to pull it out with water buffalo, and their trip was delayed several hours.

On the morning of September 23, Mel and his professor friend from the Press Hostel, Maurice "Uncle Mo" Votaw, got up early to meet Annalee at the Shanhuba airfield. When she didn't show up, Mel was worried. He'd had no word of the delays. Anything could have happened. The plane could have crashed, or it might even have been shot down. But finally, a few hours later, Leonard's DC-3 appeared and touched down on the gravel runway.

Once Annalee finally arrived, she, Mel, and Uncle Mo crossed back to central Chungking on a sampan. At the north bank of the Yangtze, they discovered that Mac Fisher and the Mydanses had all come down from the Press Hostel to greet Annalee.

Carl shot dozens of photos as the cheerful group stepped

across the cobbles on the banks of the Yangtze toward Chung-king's cliffside stairs. All five reporters grinned unconsciously. Mel draped a slightly oversized dark suit jacket and an overcoat across his arm. The dark material contrasted with his friends' light clothing. Shelley turned toward Mel, chatting, with a coat over her own arm. Mac, in a white shirt and khakis, and Mo, in white pants, a striped shirt rolled to his elbows, and a white jacket across his arm, each gripped cigarettes between their lips, holding them at almost identical angles as they listened to Annalee tell a story. Wearing tennis shoes, socks, and a knee-length beige dress, Annalee looked completely at ease with her new colleagues.

Two cameras were draped around Annalee's neck, and she clutched a purse under her left arm. Apparently her promise to her missionary cabinmate hadn't lasted: in her right hand she held a cigarette of her own. (She had more to give out; fresh Western cigarettes were precious commodities.) It was simultaneously clear that war wasn't far off—Mel's uncharacteristically loose-fitting suit gave away how little he was eating—and that these five friends felt instantly at home with one another.

Conditions in Chungking were unraveling. That summer's air raids had been more punishing and indiscriminate than ever before. They had finally seemed to taper off at the end of August, but the day before Annalee was scheduled to arrive, Chungking heard its first air raid alert in a month. It turned out to be a false alarm, but it was enough to make people jittery again. Meanwhile, the Kuomintang's censorship was increasing while access to government ministers, military officers, and other sources was disappearing. Inflation also ran rampant, and the cost of food was skyrocketing.

"Nobody eats those good crisp ducks now," Mel told Teddy White in a September letter.

Much to Mel's delight, though, Annalee had brought what

seemed like an entire pharmacy along. CNAC typically restricted passengers to only twenty pounds of luggage, but Mel had arranged for her to bring excess baggage on his behalf so that she could pick up some things he needed in Hong Kong, especially after he lost all but two of his shirts in the Press Hostel bombing. Elza had also sent her off with gifts for Mel, so Annalee ended up packing very little for herself. Among the items Annalee brought were chewing gum, vitamins and calcium supplements, Band-Aids, and a nice pen. There was $25—precious U.S. dollars—that Elza sent as a belated birthday present. And Mel was grateful that Annalee had also picked up clean shirts, new socks and underwear, and even a suit for him in Hong Kong.

"Gee, it was just like Xmas and I got your nice letter and card, Mom," Mel wrote. Annalee filled the rest of her duffel bag with one dress, paper and sheets for carbon copies, and anything else she thought she'd need for a year.

The Press Hostel reconstruction wasn't quite done, so Mel brought Annalee to Chialing House, a residence financed by H. H. Kung. Named for the river whose confluence with the Yangtze shaped Chungking's distinct geography, the three-story hotel—Chungking's "best"—stood on a cliff on the north side of the peninsula.

"Best" was a relative term: Chialing House was also more or less Chungking's *only* hotel. Its roof was full of holes from air raids. One of the few refrigerators that existed in Chungking at the time was in the Chialing's kitchen, but it had stopped working that June, just in time for the city's blistering summer. The hotel lacked running water except, one newspaper account joked, when it rained. Nevertheless, Mel spent the first few nights at the Chialing with Annalee. Then he brought her back to where he had been staying at Bertram Rappe's mission

compound while they waited for the Press Hostel to be reconstructed.

In his letters to Annalee, Mel may have masked some of Chungking's wartime circumstances to make the place sound irresistibly adventurous, but Annalee immediately discovered that she'd landed in a decrepit city, albeit one that in 1941 maintained a romantic atmosphere of wartime resilience. She said as much four decades later, recalling a time before rampant corruption had fully infected Kuomintang ranks:

> The Nationalists were living in mud and bamboo shacks. They were the most heroic, intelligent people. They were making do with nothing. Living conditions were terrible, the city was filled with rats, the food was dreadful, bomb craters everywhere. Everything was slimy, cold, wet, and mildewed. In the summer, the humidity was high and bugs flourished. There were spiders four inches across on the walls of your room. The press hostel had just been bombed. When they rebuilt it, it was just one story, built of bamboo and mud with whitewash on the outside and oiled paper for windows, a wooden floor. All the water had to be carried up from the Yangtze River in wooden buckets and we had one little tin basin of water a day to bathe in, that's all. The rats chewed our boots and through the telephone wires at night. They ate our soap. But though it was most uncomfortable physically, it was absolutely inspiring mentally. It was a great year!

The day after Annalee arrived, Mel brought her back down to the Yangtze, where they crossed to the south bank so Mel could take her to lunch at the Chungking Club. He even wangled cars to get her around town that day. She had it easy that

first day, as he was honest enough to report in a letter that day to his parents. "So far she has only seen the good side of life here." But Annalee's first day wasn't easy just because she didn't have to walk everywhere or because she ate relatively posh food. Also getting her off to a good start was the fact that everyone Annalee met liked her, and not just Westerners.

"Chinese all seem to like her very much and it looks like she will do fine," Mel wrote that day. He added that Annalee seemed a lot like Shelley Mydans. Shelley, in turn, was very well liked by Mel's Chinese friends, who agreed that she and Annalee were similar.

After getting Annalee situated, Mel got her to work. Earlier, Luce had asked him to work up press releases and other publicity material that the publisher could use to promote United China Relief. Indeed, one of the reasons Annalee was hired was to keep Mel from being overburdened by this work. In any case, she was eager to get started, and her arrival coincided with a big publicity coup for the campaign.

For three months, far to the west of Chungking, an expedition led by David Crockett Graham had been searching through Szechuan's forests for a giant panda cub. That summer, thirty men equipped with dogs and nets scoured the forests along the edge of the Tibetan plain for a panda. They ended up finding two.

The expedition had been orchestrated by United China Relief, which hoped to fly a panda on the Pan-Am *Clipper* and exhibit it to crowds on stops throughout the Pacific and North America, then finally bring it to the Bronx Zoo as a gift from Madame Chiang and H. H. Kung to the children of the United States.

Throughout the twentieth century, both China's National-

ist regime and its later Communist rulers employed a strategy known as "panda diplomacy." The charismatic black-and-white bears became powerful tools for cultivating China's image in other countries, and Madame Chiang realized that panda diplomacy could generate sympathy in the United States—and raise much-needed money for United China Relief.

It had been Mel's job to ensure that the expedition was formed in the first place. Then he had to manage the expedition's publicity and make sure the panda was actually delivered. Once the panda was captured, Mel had to arrange *Clipper* flights and other logistical details, like hiring people to build a special cage for the bear. He even had to make sure that the panda received bamboo shoots native to Wenchuan, as Graham believed that one reason pandas had a high mortality rate in captivity was because of radical changes in their diets. Other risks included elevation changes and infection, and all of them were details to which Mel paid close attention. If the pandas died, he could have easily been made the fall guy. All of this had been a headache for Mel to deal with while he was also trying to report for *Time* and handle his broadcast duties.

Immediately after Annalee arrived, Mel passed the panda job on to her. She wrote a script for the radio broadcast announcing the panda's capture on the second night she was in Chungking so the news could be announced on XGOY first thing the following morning. Annalee's script had to play up the difficulty of the panda's care and champion Dr. Graham's adventures to find the bear. Of course, writing the story came naturally to Annalee, and the news was a triumph for United China Relief.

"From obscurity to overnight world fame—that's the fate of the rare, half grown, giant panda just found near Wenchuan after a more than three month search," Annalee's script opened.

But this publicity coup was far from the biggest event of the

day, at least not for Mel and Annalee. The day was only going to get more exciting after the 6:30 A.M. broadcast, when the panda story was aired by XGOY.

Time's staff—especially Henry Luce—were impressed with Mel and his work, and now Luce wanted Mel to take the helm of *Time*'s Far East bureau. This opportunity promised a multi-tier pay raise, official status as a *Time* employee, and relocation to Manila.

Until that point, cash-strapped Mel had officially been a stringer for the magazine, even though it consistently published his work through the summer. (*Life* had also used Mel's work, especially his pictures of the air raid shelter catastrophe in June.) The new position meant a chance for stable employment, but it also meant he would be leaving China once again, sacrificing all the contacts he'd developed in Chungking. He would also have to leave Annalee behind in a war zone.

But how could he say no? Finally, his career in journalism was taking off. Mel was all too aware of what a bumpy road he had traveled to the gates of Luce's empire. Now inside, he had advanced quickly. It had hardly been a year since he quit XGOY. His arrest in Haiphong and travels through Indochina and Southeast Asia were still fresh in his memory. Only this past spring, Mel had pounded the pavement all over New York and Washington, D.C., desperately trying to find a job, any job, that would bring him back to Asia. He'd gambled against the United Press's offer of work in Sacramento precisely because he thought he could find better work where the action was. And through all this he'd found Annalee and fallen in love with her, and she'd fallen in love with him, possibly because of the drive he'd shown.

Now the new boss was showing so much faith in Mel's reporting that he wanted him to be *Time*'s primary eyes and ears in Asia. What's more, Mel would be the Far East bureau chief

just as ongoing saber-rattling between the United States and Japan intensified. No one asked anymore whether war between the two Pacific powers was likely; instead, pundits debated when it would start. When the first shots flew, it would be Mel's job to witness them on behalf of Luce's publications, and Manila was likely to be at the center of the action.

Even though taking this job meant leaving behind both Annalee and the city where Mel had built his career, Mel and Annalee nevertheless decided that he should accept Luce's offer. Annalee, meanwhile, was in no hurry to leave Chungking so soon after arriving. *Time* would still need a stringer in Chungking, and Mel considered Annalee for the position, but she was too busy writing copy for XGOY's Voice of China broadcasts and doing other work for United China Relief. She felt she had a job to do. Even though she didn't have a contract, she wasn't about to walk away from her responsibilities. So Mel offered the stringer job to the AP's Jim Stewart, to whom he also offered his radio work with NBC.

Annalee had transitioned easily into her job at United China Relief. Hollington Tong loved her and found her work invaluable. He was so impressed with her work that she was swiftly introduced to Madame Chiang.

Both Madame Chiang and the Generalissimo himself welcomed Annalee warmly. She was certain that China's powerful couple "did all they could" to entertain her and make life in Chungking easy for her because of how fond they were of Mel. But in fact, as Mel later heard through the grapevine, it was Annalee herself who had impressed Madame Chiang. It was rare to make the kind of impression on Madame Chiang that Annalee did. Aside from being China's first lady, Mayling was also a powerful, highly recognizable figure in her own right. Among other endeavors, she claimed much of the responsibility for the New Life Movement—a government-promoted cultural

drive that sought to improve public life in China. Among the many "virtues" the New Life Movement prescribed for China was "We Will Not Smoke." This message appeared on public signs throughout Chungking.

The first time Annalee visited Madame Chiang's house for lunch, her hostess sat down, lit a cigarette for herself, and offered another to Annalee. Having seen all over Chungking the stern admonitions from the New Life Movement not to smoke, Annalee refused. When Madame Chiang asked her why she'd refused, Annalee mentioned the signs.

"Oh," Madame Chiang replied. "That's for the people."

Annalee took the incident in stride. In a sense, Mayling's behavior wasn't much different from the people Annalee had worked with at MGM.

"She was no more arrogant than the movie moguls Annalee had known in Hollywood, and she grew rather fond of [Madame Chiang]," the author Nancy Caldwell Sorel wrote of the encounter. Soong Mayling was so impressed that she asked Annalee to be her speechwriter and handle her publicity.

Annalee wasn't eager for Mel to leave, but she relished her work. It gave her more than just a chance to write. She felt like she was doing work that mattered, and besides, she'd gone through so much to even be able to come to Chungking. On a visit to a "warphanage" outside of the city for children orphaned by the war, Annalee privately noted the wretched conditions these orphans faced. Still, she played and laughed with the children when she and Madame Chiang visited them. Later she would write about how little difference the warphanages seemed to be making for the children.

In early October, as Mel was finishing his preparations to transfer to Manila, he and Annalee found themselves running late

for a reception honoring a visiting missionary. Normally they would have walked there, but to pick up time, they hired two rickshaws to get them to the reception more quickly.

As their drivers ran madly through Chungking's steep streets, dodging crowds, rubble, and bomb-blast potholes, Mel yelled out above the clamor:

"Say, will you marry me?"

"What did you say?" she yelled back.

"I said, 'Will you marry me?'"

Annalee said nothing.

Mel kept asking, and Annalee still didn't respond. Finally, they arrived at the event and joined the receiving line. After they'd found a spot to stand, in between other guests, Annalee turned, directed her attentive eyes at Mel, took a beat, and said just one word: "Yes."

Whatever chemistry may have existed when Mel and Annalee met in Los Angeles that spring, and despite their flourishing correspondence, Mel had kept his romantic interest close to his vest all summer. But as their letters continued and Annalee's move to Chungking became a reality, it had been clear how anxious Mel was for her to join him. Later he'd claim that he hadn't even been certain privately whether he was attracted to her, though that seems unlikely given that Annalee had ridden the train up to San Francisco with Mel to see him off. By now, in any event, it was clear that the fire Mel and Annalee had ignited in that Wilshire Boulevard bar where they brainstormed scripts had spread across the Pacific and climbed the hills between the Yangtze and Chialing.

"I wasn't sure about myself and about Ann and having made a mistake before, tried to profit by experience," Mel wrote while he was on his way to Manila. "Hence I said nothing to

anyone, Ann included. But after Ann was in Chungking a few days again I was sure of myself and now she is coming to Manila early in December and if fate doesn't interfere I guess I'll be married in Manila."

Mel told his mother and stepfather that they weren't to circulate the contents of his letter. In fact, perhaps one of the most significant details of Mel and Annalee's romance was how little they chronicled it before they were engaged. Given Mel's frequent letters to his parents and friends like Teddy, and how candidly he admitted ambivalence about his work and his frustrations with XGOY's operations and the complications of working for the Luce empire, Mel wasted precious little ink on his hopes for romance with Annalee. Was it just that his failed relationship with Shirlee had made him more cautious and he didn't want to get anyone's hopes up, least of all his own? Or did the matter-of-fact way he wrote when he did discuss Annalee mean he was secure in his prospects with her?

"I don't want you to think that I or Annalee was holding out on you in LA about our intentions," Mel wrote to Elza and Manfred two weeks later. "Because I had not made up my mind at all or even mentioned anything about getting married to Annalee. I helped her to get out but did not encourage her very much. For which I have had my ears beaten down slightly. Only slightly and I shall rule with an iron hand henceforth. Maybe I shouldn't have put this in writing."

Annalee hadn't been any more open than Mel about the possibility of romance. After the engagement, she would insist that she didn't come to China to marry Mel. But romance had been brewing, even if they'd thought it could wait until both had settled into their jobs. Then Mel and Annalee learned that *Time* was sending him to Manila.

"It seemed altogether different when he was transferred the

week after I got there, though," Annalee said in a note to Mel's parents. "This war is certainly complicating a lot of things!"

Still, Annalee couldn't come with Mel to Manila right away. She wanted to work at least a couple more months in Chungking because she needed the time to make an impact in the job she was doing for Madame Chiang. Aside from Annalee's basic sense of professional loyalty, both she and Mel believed that the work she had started in Chungking could make a difference for China. She tentatively agreed to join Mel in Manila by December 10. They could wed as soon as she got there.

Another factor was that leaving so soon after she had established herself could jeopardize the work she'd begun in Chungking. Given how hard it had been to get permission to go to China in the first place, not completing the work might make it even harder for her to get travel clearances in the future, let alone more work. Yes, Annalee had been swept up by her unexpected attraction to Mel, but it wasn't because of him that she had left her cushy position at MGM. She had made a commitment to being in China and learning as much as possible about the country and its struggle to survive a draining war. She wasn't the kind of woman who would abandon a professional commitment just because a man wanted to get married. Mel wouldn't necessarily have wanted her to leave Chungking anyhow. He was attracted to her mind, her work ethic, and her passion for China.

Still, both were thrilled at the prospect of marriage, and once they'd both told their parents, they told them to freely share news of the engagement widely. Mel even called Elza and Manfred from Manila, where easy access to a phone was a surreal experience for him. Mel also wired Teddy White

and *Time* separately, as he did Earl Leaf, the Chinese News Service's representative in New York. Annalee cabled her parents. She also wired the Meybergs to tell them how happy she was and to thank them for the congratulations they had wired to her. Mel was beside himself with gratitude, especially because Elza and Manfred had heartily endorsed the marriage.

Everyone was thrilled. A few weeks after he told his family, Mel came back from a party and found a stack of congratulatory letters from members of his father's, mother's, and stepfather's extended families. That was all in addition to the telegrams he'd already been sent, all of them so complimentary that Mel said he felt embarrassed.

"Let them compliment Annalee, that's okay," he wrote before slipping in a key parenthetical. "(Look at the choice she made. What brains.)"

Mel's eleven-year-old cousin Jackee Marks even wrote a poem about the pending nuptials. The verse acknowledged that the wedding might occur during a war that even a child could anticipate.

"Here comes the bride and groom / Although the bombs drop boom!," the poem began. It closed similarly: "So know although / The subs are under and the planes overhead / There'll be two more people sleeping in a double bed."

On October 2, Mel left Chungking for Manila. Once again, he was going by way of Hong Kong, where he planned a six-day stop. As each of Mel's stops in Hong Kong had seemed to be since he attended Lingnan, this was a busy, gluttonous, and joyful layover. Holly Tong had business he wanted to conduct in Hong Kong, so he came along with Mel for that leg of the

trip. Every night, it seemed, Mel and Holly "went on a spree for beer and beer and beer and lobster and prawns, and oysters and double of everything good until 4:00 a.m."

But while Mel and Tong ate and drank, they also heard a great deal about Annalee, as Mel told his parents in a letter home from Hong Kong.

"Amazing what a swell impression Ann makes everyplace," Mel wrote. "My friends down here in Hong Kong who entertained her are all crazy about her."

Like Annalee, Mel was dedicated to his job, and he'd just been given a tremendous break. He had sought full-time journalism work for years. Moreover, the new position at *Time* would ultimately be good for his marriage. The realities of married life that Mel saw on his horizon only made the new job—and its secure, increased salary—more attractive. As much as Mel understood his and Annalee's professional commitments, he was eager to marry quickly.

"I have been trying to hurry her, but she won't be hurried," he wrote from Manila. "She wants to finish some work first."

Anxious that if war broke out, travel between China and the Philippines would be cut off—it was already a complicated journey involving perilous flights—Mel nudged Annalee to leave Chungking as soon as she could. Still, he continued to understand her commitment to her work, and both of them were willing to wait.

"Naturally I wanted Ann to leave right away with me," Mel admitted once he was in Hong Kong on his way to Manila. "But we both felt that she had a job to do, although she is under obligation to no one."

Holly Tong also told Mel how pleased he was that Annalee was staying to work in Chungking. Tong wrote Mel repeatedly about how much everyone in his office liked Annalee and her

work. Aside from Madame Chiang, her sister Ay-ling—H. H. Kung's wife—had also taken a strong liking to Annalee.

"A good thing you are taking her away from Chungking right away because Madame Kung has a strong liking for her and her efficiency plus," Tong told Mel, somewhat confirming Mel's earlier joke that Annalee had better come to Manila before "they really tie her down."

When Mel wrote home to tell his parents about his engagement, he took care to stress the importance of Annalee's sense of professional independence. Yet he knew his proposal must have seemed sudden given how rapidly his relationship with Shirlee Austerland had crumbled less than a year earlier, and given the role his work played in ending that relationship.

Elza didn't seem too concerned. She later told *Time*'s John Hersey that she "couldn't conceive of a more suited person" for Mel. The couple had much in common, Elza explained, in that "both are of tremendous depths of love for humanity and interest in China and, as you know, they are together writing."

Though Mel was disappointed that Annalee wasn't coming right along with him to Manila, he appreciated the break from Chungking life and felt more energetic than he had in a long time. Aside from indulging in Hong Kong life with Holly Tong and "millions" of other friends he had there, Mel worked hard, wrapping up multipage briefings for *Time* to send out on the *Clipper,* writing letters, and putting together a ten-minute broadcast for NBC about the fighting outside of Changsha, the capital of Hunan Province, where, after a Japanese drive, Chinese forces came back and encircled the attacking Japanese troops, achieving their first major victory of the war.

While Mel enjoyed the comfortable living in Hong Kong as a break from Chungking, when he finally reached Manila he

found the modernity and creature comforts of that city unsettling. With Hong Kong, even though the British weren't yet fighting the Japanese, everyone seemed to be getting ready for war. Manila, on the other hand, appeared peaceful, and life was surrealistically leisurely. To be sure, it was an uneasy quiet, as if Manila was also waiting for war, but the city's many luxuries and its nervous calm made for an unfamiliar reality for Mel to negotiate after his second straight summer in Chungking.

"Everything is completely strange and foreign to me here, and you have to sit around sipping cocktails and hire cars and all that," Mel wrote. He didn't find himself well suited for the artifice necessary for Manila's politics and social schmoozing.

"The job here in Manila scares me to death," he admitted. "Not like China where everything comes to me so easily and naturally."

Manila was relatively comfortable in part because the Philippines was a commonwealth and still effectively a U.S. colony. "The government of President Manuel Quezon was completely subordinate to the office of the U.S. high commissioner, Francis Sayre, and the economy of the entire archipelago carried a 'Made in USA' label," CBS reporter William J. Dunn later wrote.

Dunn described Manila as "the Pearl of the Orient." Indeed, many American expats relished the very characteristics that Mel found stultifying. In some eyes—possibly those with colonial lenses—the city was the Paris of the Far East. Tree-lined grand avenues built during the near half-century of American occupation, airy but shaded arcades, and vast plazas invited the pedestrian ease of late imperialism. Even as tumult roiled in nearly every direction, in the fall of 1941 Manila seemed peaceful.

But the peace was chimeric. Only six years earlier, a revolutionary movement—the Sakdalistas—had tried to overthrow

U.S. rule, shortly before the United States and the newly established government of Manuel Quezon signed an agreement promising the Philippines independence by 1946. This tumult represented only the latest incident in centuries of conflict and colonization.

As early as the fifteenth century, Muslim sultans from Malaysia and Indonesia began expanding into the Philippines, an attractive prize to outsiders. Around the same time, Chinese pirates regularly plundered the region. Then came Spain.

Ferdinand Magellan arrived in the Philippines in 1521, during his fleet's circumnavigation of the globe. Magellan established the Philippines' first Catholic church and began nearly 400 years of Spanish occupation, before being killed by a *datu*—a member of the region's ruling class—named Lapu-Lapu. Despite Lapu-Lapu's ensuing hero status, the Philippines had still not shaken Europe's hand from its throat by the twentieth century. The U.S. defeat of Spain in 1898 only transferred the islands from the clutches of a descendant colonial power to an ascendant one.

Though American propaganda cast the Philippines as a loyal partner, its population was hardly passive.

Mel worked hard to keep his mind off how much he missed Annalee. Though his new position came with a raise and official status as a *Time* employee, it wrenched away all the stink and beauty and adrenaline of Chungking. The visceral experience of a capital under constant bombardment subsided, replaced by an anxious cycle of socializing and politics.

Mel felt dizzy from all the rushing around he was doing. He likened it to times in the past when he'd rush back home to get a million things done at once before taking off again to who-

knew-where. In Manila, he couldn't use the same excuses he'd used in Chungking for not getting things done.

"You have to get things done quickly and efficiently," Mel wrote. "You can't blame anything on bombings or slow Chinese or anything."

Mel's new post consisted of "a very gay and artificial and very expensive life." One night in September 1941, he spent $40 to take a group of army officers out on the town, though he won some of the money back betting on the races with his guests. At the time, Mel's salary was $250 per month, but three-fifths of that figure paid for his small hotel room on the sixth floor of the Bay View Hotel. Though Manila wasn't cheap, *Time* did cover Mel's other expenses, plus he had the raise he received when he took the new job, and he had another pay bump to look forward to in January. Meanwhile, being in the publishing titan's employ made it easier for Mel to develop sources among high-level officials.

"Fortunately the name of Luce behind me helps," Mel wrote. "In fact the doors just swing open."

But maintaining those sources required going on expensive outings. He also had public relations duties on behalf of the Luce empire, giving speeches and mingling at civic clubs.

"So much contact work in this business," he told his parents. "Meeting big shots, impressing them, and getting their confidence in 10 easy lessons that it's getting to be a routine struggle."

Mel needed to nurture relationships with U.S. Army and Navy officers, Filipino military figures, and government officials. Though he may not have liked the glad-handing, Mel transitioned comfortably from officers' clubs and diplomatic receptions to shared cigarettes with enlisted American soldiers and Filipino reservists. He also befriended shipping magnates,

businessmen, and assorted other characters, such as Amleto Vespa, a "screwball" former Italian spy who invited Mel to his map-plastered Manila flat for rambling conversations about Axis strategy in Asia and the Pacific. H. J. Timperley, the China News Service rep who worked with Earl Leaf, wrote the introduction to Vespa's 1938 book, *Secret Agent of Japan,* the movie of which was filmed in Chungking in 1940, when Mel first worked in the Chinese capital.

Aside from cutting ties with his contacts in Chungking and dealing with the politics of working in Manila, Mel also had to give up most of his broadcasting. NBC said he could continue to contribute, but the network already had a full slate of reporters in Manila. Opportunities for Mel to report on the radio were infrequent.

But Mel appreciated the access he had in Manila, even if he felt out of his element there. He was also comforted that many of his friends were surfacing in Manila. Meanwhile, neither his cabled reports to *Time* nor his private communications were censored the way they had been in Chungking.

When Mel was preparing to leave Chungking, he'd written about his promotion coming with a second raise on top of the one he'd been given at the end of August and the promise of a third raise in January. He was also getting a bigger expense account that would cover most of his living costs in Manila, and in Manila he'd be able to keep in better contact with his family because the mail went more regularly and he had access to phones.

"And still I [*sic*] rather be in Chungking where things are happening," he wrote.

In Manila, where things weren't happening, Mel groused that others saw him as a spectacle simply because he'd come from Chungking. Any mention of the city was met with oohs

and aahs. Westerners still untouched by war were curious about the Chinese capital's constant air raids, but almost as quickly as they asked what it was like to endure such frequent bombings, they lost interest, returned to their drinks, and resumed the usual society gossip that pervaded Manila.

Mel didn't lose interest in the war. In his first two and a half months in the Philippines, he collected news, constructed personality backgrounds, assembled political roundups, and analyzed war preparations. He crammed these reports into hundreds of pages of detailed cables he sent to Hulburd, who used these reports as the basis for weekly news roundups. The magazine's editors picked the best or most interesting items, rewrote them, and ran them without bylines. Though most in *Time*'s huge audience in America didn't know it at the time, Mel was their only link to what was happening in China—and their window into the buildup for war in the Pacific.

As Mel and Annalee's wedding day approached, the letters he wrote to his parents in California suggested that he was anxious about his upcoming nuptials. In one note, he asked his family to "advise to last detail" what a ring should cost. Possibly before they could respond, and despite Manila's rising cost of living (though the residents of Manila acted like war wasn't on the horizon, rapid inflation in the Philippines in the fall of 1941 reflected economic insecurities about the conflict in Asia), Mel spent $746—three months' salary—on two rings. Even though Annalee had told him not to buy even one, he wanted to give her both an engagement ring and a wedding band.

One of the rings was a jade and "platinum affair with just a bare outline and simple design." The other featured a square-

cut one-and-a-half-carat diamond head with small diamonds branching off its platinum mount.

"Looks like half a milk bottle it is so big," Mel told his parents when he bought it.

Mel even bragged to his family that he bought the rings "Grandpa style" by haggling the jeweler down 20 percent. Even with the bargain, Mel felt a pinch. But ever the romantic, he wanted to provide Annalee with some semblance of a normal engagement.

Getting the engagement ring to her was another challenge. In Hong Kong, Mel met with Bill Dunn, who was headed to Chungking on assignment from CBS, and entrusted him with delivery of the ring.

"It was my only time I played Cupid," Dunn wrote, "and I mentally saluted Jacoby. . . . Talented and well-informed, [Annalee] would prove a valuable source of information for a reporter new to the scene."

The plan was still for Annalee to join Mel in Manila, but Mel was growing concerned that she wouldn't make it before war spread beyond China. The fighting there was getting worse, as was the antagonism between the United States and Japan, leaving Annalee with fewer and fewer opportunities to find safe passage from Chungking to the Philippines. Each day Mel grew more pessimistic about "Washington's too obvious appeasement gestures" with the Japanese.

Mel also had to obtain a marriage license, a headache in Manila. He described the ordeal as a comedic goose chase.

"You ring up everyone in town," Mel described. "Then you quit and ask someone who refers you to an office. You ring that office and after getting the room boy to speak takalog [sic] you get someone to speak English. Then he speaks at you to the effect that you can't get married and why get married when it

costs ten pesos for the papers when a common law wife is just as good and besides you can leave her if she is no good."

This story, wildly embellished, went on and on. There were closed government offices to visit, multiple forms to fill out and send to embassies, and bureaucrats to bribe. At every office someone else asked a variation of the "why get married . . . common law wife is just as good" question until Mel, having been sent back to the first office he had gone to, finally said he was getting a justice of the peace and didn't want a big wedding.

"And he says why didn't you say so in the first place marriage is a great thing," Mel wrote.

When Mel wasn't running around in circles trying to find a marriage license, he often took in the vista from his room at the aptly named Bay View Hotel. Over the tops of the trees lining Dewey Boulevard, Mel's gaze fell toward the southwest and the grayish-blue waters at the mouth of Manila Bay, which stretched across the horizon. Beneath the water's surface were miles and miles of submerged mines. U.S. destroyers and submarines carefully negotiated them, while smaller inter-island freighters ferried loads of rice and fruit between the capital and the rest of the Philippines.

Occasionally, Mel tracked Pan-Am's giant, silver-bellied Boeing 314 *Clippers* as they crossed the sky, their whalelike hulls and slender pontoons gliding into the harbor during stopovers on their transoceanic journeys. Each *Clipper* flight between the United States and Hong Kong promised mail, supplies, and new visitors.

Soon, Mel hoped, one of those flights would carry the woman he planned to marry.

As October turned into November, Mel's attention turned to a more vexing matter: transferring the pandas that had been caught in Wenchuan to Manila. They were due to arrive on November 16, and Mel was responsible for finding a place for them to be stored and cared for.

"I've been going wild again over the Panda situation," Mel told his parents in a mid-November letter, a day before the bears were due in Manila. "I've had to do everything from hire station wagons, to finding places for them to stay, to getting special kinds of bamboo and sugar cane flown down from the provinces on a chartered plane. What a business. People phoning all the time wanting to see the animals, or borrow them, sell insurance, an air conditioning plant, grape juice and everything imaginable."

Even Annalee was roped into the chaos that seemed to surround the panda hunt. After she reached Chungking, much of her early work had involved preparing Madame Chiang's speeches about the bears, which had been brought to the home of Bertram Rappe—the missionary Mel had stayed with after the Press Hostel was bombed—after they reached Chungking. There they were placed under the watch of armed guards. Annalee, who found the bears incredibly cute but the source of many headaches, wrote scripts about the pandas for XGOY's broadcasts and proposed press releases about the hunt to find them.

Meanwhile, Mel was far from the only reporter told to relocate from China to the Philippines. Since Manila was an American possession and the entire U.S. Asiatic fleet was based here, this was the country's principal stronghold in the Pacific. Like other industries, the islands had long been the base for U.S. news organizations' operations in Asia, and many had located their bureaus there. As the prospect of war with Japan neared, it seemed likely that the first phase of the fighting would begin in the Philippines, so newspapers and broadcast

networks wanted their reporters to be in the commonwealth when that happened.

On November 14, an Associated Press reporter named Clark Lee met a Japanese source of his in a bar in Shanghai, where Clark was based. The source had a tip from the Japanese colonel who was his country's spokesman in Shanghai. Clark had recently reported that it looked like Japan was preparing internment camps in barracks outside of Shanghai. Through the source, the colonel warned Clark that if he didn't want to be interned in these camps once a war started, he should leave in the next ten days. Clark redoubled efforts he had already begun to find either an escape to Chungking or passage on one of the last few freighters left in Shanghai. Finally, he secured the last free cabin on a Dutch ship, the SS *Tjibak,* and left for Manila.

Born in Oakland, California, Clark was nine years Mel's senior. He was, as Mel put it, a "tall, dark, husky, handsome, experienced newsman," and he had spent the past three and a half years reporting from Shanghai. Before going to Shanghai, Clark had been in Hawaii for two years. There he met and married Lydia Liliuokalani Kawânanakoa, a Hawaiian princess. She had come with Clark to Shanghai, but she left in August 1941, in part because of an earlier warning from Japanese officers who suggested that a possible war with the United States would make it impossible for her to flee.

Clark had also reported from Japan and in the battlefield, where he had accompanied the Japanese army and even ridden in one of their planes. However, he wasn't a Japanese apologist, and he had often reported critically on Japan's actions in China, thus earning himself the threat of imprisonment the colonel had made that night. Indeed, Clark's writing was far more jingoistic than Mel's. Mel's work was certainly patriotic, but he wasn't as melodramatic as Clark, who sometimes seemed to trade facts for color.

Still, Mel was impressed by Clark. The two met shortly after Clark arrived, and Mel suggested to David Hulburd in a cable that he "watch his stories."

From the edge of Pan-Am's facilities along the southern arc of Manila Bay near the Cavite shipyard, Mel watched a Boeing 314 cross the sky. It was Monday, November 24, 1941, just three days before Thanksgiving.

Annalee was on the plane. As it landed she spotted Mel at the water's edge, clad in a gleaming white suit, white shirt, and yellow tie.

"I could see him when the plane landed in the water, and it seemed like hours until they pulled it up onto the beach," Annalee later wrote to Mel's parents.

Finally, the *Clipper*'s pilot cut the aircraft's engines. The plane coasted the last few feet to the dock, where its passengers disembarked. Annalee barely had time to say anything to her fiancé. After they embraced, Mel ushered her to a waiting car, which drove the ten miles from Cavite to Manila, turned right off Dewey Boulevard onto Padre Faura, then stopped at the Union Church chapel a couple of blocks away. Mel strode confidently up to the church, while Annalee, wearing a white nylon dress printed with palm trees, ukuleles, pineapples, and leis in green, yellow, and red, linked her arm in his, smiling widely, a broad-brimmed yellow hat tucked under her other arm. For a couple who never expected romance, it was as dreamlike as any fairy tale.

"It was just like I'd always hoped it would be," Annalee wrote.

Carl and Shelley Mydans were there, as well as Allan Michie (a *Time* reporter about to transfer to England, Michie was also the author of *Their Finest Hour*) and the Reverend Walter

Brooks Foley. As soon as the couple arrived, the small procession gathered in an intimate reception room off the chapel decorated with white flowers and green drapes. Carl served as Mel's best man; Shelley was Annalee's matron of honor.

Reverend Foley performed the modest ceremony. Mel had always dreaded large, formal weddings. He had looked for a justice of the peace to officiate, but most of the ones he found spoke little English and held ceremonies in nipa huts—small stilt houses with bamboo walls and thatched roofs made from local leaves.

"The morning I came he found Reverend Foley, who was a short blond near-sighted angel, full of extravagant plans for choir chorales and processionals and borrowed bride giverawayers," Annalee wrote.

Annalee may not have wanted a big to-do or an ostentatious ring, but she clearly couldn't restrain her delight at the occasion itself. Her smile did not subside throughout the ceremony. Her hands gently clasped Mel's as they exchanged vows, and she looked intently at her husband, her eyes grinning and warm. For his part, Mel couldn't mask the pride on his face, nor his joy.

Within an hour of Annalee's landing, she and Mel were married. After their wedding, they wrote letters to their families. In one, Annalee insisted to Mel's parents that she didn't go to China to marry Mel, but she "couldn't think of a better reason" to have gone.

The celebration continued at the Bay View Hotel, just a few blocks away. Gathered in the lobby were many of the couple's friends who had also transferred to Manila from Chungking, as well as others Mel had met since arriving. Those who couldn't be there sent their congratulations. Everyone, from Annalee's colleagues at MGM to Henry and Clare Boothe Luce, to all the Press Hostel residents, to the entire staff of XGOY (which also aired a brief item about the marriage), sent their good wishes.

"General MacArthur about knocked me over the other p.m. congratulating me," Mel wrote. "Admiral [Thomas] Hart's staff nearly shook my hand off."

There was a portable phonograph setting the tune with jazz standards and popular big band recordings. In between songs, the newlyweds ducked into a corner of the lobby where they took turns placing long-distance phone calls to their parents in Los Angeles and Maryland. And then they danced into the night. War was on the horizon and could arrive any day, but that evening it could have been a million miles away.

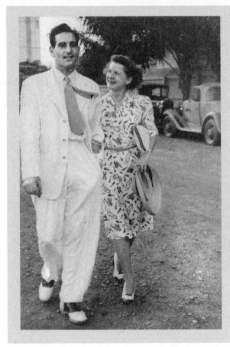

Annalee and Mel Jacoby moments after their wedding in Manila, the Philippines, on November 24, 1941. *Photo courtesy Peggy Stern Cole.*

For a brief moment after the wedding, Mel and Annalee were able to escape the demands of reporting and the high-stress atmosphere of war zones. It didn't matter that they hadn't had the traditional wedding Madame Chiang had originally

wanted to throw back in Chungking. Or that all of their things—including most of Annalee's clothes—were on a ship that would end up diverted to Singapore when the war started. The two young reporters were in love.

"He types on the desk, and I type on the dressing table, and we both feel awfully sorry for the people next door," Annalee told Mel's parents.

Slipping away for a brief honeymoon, Mel and Annalee drove up the slowly rising slope that led to the village of Tagaytay, forty miles to the southeast. Long a tourist destination, Tagaytay stretched along a ridge atop the many-fingered, horizon-spanning Lake Taal. The lake filled the crater of a massive shield volcano.

At its heart, a dusty, brown volcanic cone had built up after long-past eruptions. Within that cone was yet another small lake. This geologic matryoshka doll, the placid lake surrounding it, and the steep, verdant canyons beneath the ridge stretched below newly built Taal Vista Lodge. Constructed by the Philippines Railway just a few years earlier, the hotel's faux-Alpine lodge was its centerpiece. However, the Jacobys shacked up in one of a handful of small private cabins just west of the lodge. Overlooking the north ridge of the lake, the electricity shut off at night and the faucet dripped, but Mel and Annalee were in love and happy to be able to escape—if just for a weekend.

Even though they were honeymooning, the Jacobys weren't quite alone. Tied up next to their cabin were the two baby pandas that Madame Chiang had entrusted them to look after until John Tee-Van, the vet who would take them back to the Bronx Zoo, arrived from China.

News of the pandas' presence had spread quickly through Tagaytay, and they drew spectators, though not the huge crowds they'd drawn in Chungking. Even Clark Lee and the AP's Russell Brines were swept up in the commotion. While

on their way to explore war preparations in the southern reaches of Luzon, Lee and Brines stopped briefly to visit with the newlyweds and offered "unnecessary and unheeded advice" on caring for the pandas.

China's leaders not only sent the pandas as gifts to the United States but also made luxurious offerings to the Jacobys upon their wedding. Annalee's and Mel's friends and contacts in China sent a bevy of luxurious and stately gifts. These included gold and silver spoons, an "exquisite" red satin blanket from Madame Kung, elaborate vases, and piles of greetings from all the journalists at Chungking's Press Hostel.

Hollington Tong sent a gift of gold worth hundreds of dollars because he hadn't been able to arrange the "Red Sedan" wedding he and Madame Chiang had hoped to throw for Mel and Annalee in the Chinese capital. Such a traditional ceremony would have involved drummers, fine clothing, and an elaborate palanquin for the spouses. Alas, war made such a celebration impossible. Mel was embarrassed by the gift anyhow, and his conscience couldn't let him keep it.

Despite the panda-related annoyances, the intermittent services at the cabin, and a persistent rainstorm, the Jacobys were not dismayed.

"The running water worked only at intervals, the electricity blinked on and off all one evening, and it poured, but it was still the most wonderful honeymoon anyone ever had," Annalee wrote.

INFAMY

housands of miles from Manila, as Mel and Annalee exchanged vows, a fleet of Japanese ships gathered in a harbor in the southern Kuril Islands. Around this time, an order from Admiral Isoroku Yamamoto circulated among the ships collecting in Tankan Bay, and on November 26—two days after the wedding—the armada left the bay, bound for Hawaii.

The next day, the U.S. War Department informed General Douglas MacArthur that negotiations with Japan were crumbling. When the general ordered the forces under his command to full alert in preparation for an invasion, Mel and Annalee were forced to return to Manila from Lake Taal.

The SS *President Coolidge* was docked at Manila's enormous Pier 7, preparing to sail to the United States. With all the signs of war, civilians from all over Asia had been clamoring for space on the *Coolidge*. Among Mel and Annalee's friends headed back to the United States on the ship were CNAC's Royal Leonard, *Time*'s Allan Michie, Dennis McEvoy—a writer who had been a friend of Annalee's before she went to Chungking, where Mel met him—and John Tee-Van, who had spent so much time coordinating with the couple about the pandas that Mel and Annalee had grown incredibly fond of him. Tee-Van car-

ried his special cargo aboard the *Coolidge*. Finally, after worrying about the bears for so many months, Mel and Annalee watched as the pandas were loaded into specially constructed steel cages on the ship's deck.

"We saw the boat off and took a long, relieved breath to see the pandas actually leaving, after all we've both gone through with them," Annalee wrote.

In a saccharine coda to the panda saga, United China Relief arranged a naming contest for the bears after they arrived at the Bronx Zoo in 1942. It was another piece of the panda diplomacy effort, as publicity about the pandas was used to garner sympathy for United China Relief in the United States. Specifically, in a calculated effort to get donors to support the campaign's projects related to war orphans, the pandas were presented as a gift to America's children. Newspapers around the United States asked their readers' children to suggest names for the pandas. The daughter of a Columbus, Indiana, newspaper editor submitted the rather uninspired winning entries: "Pan-dah" and "Pan-Dee."

While the Jacobys were relieved not to be responsible for the pandas any longer, they hardly had an opportunity to relax. Manila teemed with anxiety. Though the Americans didn't know the Japanese fleet was steaming toward Hawaii, everyone paying attention knew that war was likely any day.

MacArthur's press aide, Lieutenant Colonel LeGrande "Pick" Diller, organized a small party for Mel, Annalee, Carl, and Shelley at the Manila Hotel on December 5. Though it was clear that Diller valued his friendship with Manila's press corps, he also wanted to prep them for the chaos many expected any hour, let alone any day.

"We did have such a good time, and they were such fine people," Diller later wrote of the meal.

It wouldn't be accurate to say that Diller, fellow press officer Lieutenant Colonel Sidney Huff, or other military leaders coddled the press. Still, it's clear that MacArthur's staff wanted to cultivate relationships with the writers and photographers of *Time* and *Life*. The right "optics" would be crucial for maintaining public support in what could be a long, grueling commitment in the Pacific, and Luce's empire had the era's most accessible lens. Regardless, Diller and Huff didn't have to convince reporters why war seemed inevitable. By this point, anyone could easily trace the line that had led to the current crisis.

After Japan expanded its influence in Indochina—as Mel had witnessed while stringing for the United Press—it set its sights on Thailand, Britain's colonies in Southeast Asia, and the Dutch East Indies. Nervous about Japan's growing dominance of Asia, the United States slapped a series of embargoes on the empire. By July 1941, MacArthur had been called out of retirement to command newly combined American and Filipino armed forces, the latter of which were undertrained and lacked modern weapons.

Over the course of the first few months of 1941, the United States—then still officially neutral—and Britain had developed a "Europe First" strategy focused on defeating Germany while limiting their efforts against Japan. Rather than send new resources to strengthen the forces under MacArthur's command, the nearly bankrupt Philippines had been left to defend itself even though it wasn't independent and the country couldn't afford to equip and train its own soldiers. As the historian Eric Morris described it, "That was a polite way of saying that the Philippines would be abandoned to the enemy."

As war neared, the Philippines' newly reelected but largely

powerless president, Manuel Quezon, and other officials complained to Washington about their vulnerabilities, but little changed. MacArthur secured thirty-three new long-range B-17 bombers, but that was far from enough; in any event, their late acquisition would soon prove moot.

War was a near-certainty, but Thailand, not the Philippines, emitted the "surest scent of action, after which comes Burma," Mel believed, and it was in Burma that General Claire Chennault's group of mercenary pilots—the Flying Tigers—were finishing training. Fresh with news from newly arrived sources in Manila, Mel urged his editors to be prepared to break the fighting group's story.

Something was coming, and Mel knew it.

On December 6, Mel informed David Hulburd that he was going to start sending reports by cable rather than over radio broadcasts. The latter were too easily intercepted, and Mel's messages contained confidential information. Mel understood how dangerous conditions were becoming in the Pacific. His notice to Hulburd about the cables might have been the last message he sent before war began.

Communication lines with Hong Kong were silent.

Radios tuned to Bangkok broadcasts received dead air.

Wireless communications with the United States carried only static.

The streets outside the Bay View were empty.

The morning of December 8, 1941, was deceptively quiet.

Then the phone rang.

It was Carl. Pearl Harbor had been bombed. A newspaper slipped under Carl's door declared the news in bold headlines. Mel didn't believe his colleague, so he looked at his own paper

and "saw some screwy headline that had nothing to do with Honolulu."

Still doubtful about what Carl had told him, Mel returned to bed, but he couldn't fall back asleep.

He called Clark Lee, who confirmed the news.

There had been ever-more-frequent Japanese flybys of the Philippines in the preceding days, but still, the news was a shock. "We'd known about the Japanese flights, all the other signs, but we didn't quite believe it even out there," Mel wrote.

While Mel was on the phone with Clark there was a knock at his door. He hung up and heard another knock, heavy and insistent. Mel found Carl standing outside the hotel room door, already dressed and ready to head into the city.

That World War II would be fought, and won, in the skies was clear early in the conflict. Though Japan delivered its first blows at Pearl Harbor, more than 6,000 miles across the Pacific from the Philippines, it followed its opening act with devastating raids on two airfields—Clark and Nichols Fields—in the Philippines. Two squadrons of B-17 bombers, dozens of P-40 fighters, and other planes were destroyed, eliminating much of the matériel that had been sent at MacArthur's request.

Despite the news of the attacks in Hawaii nine hours earlier, the planes had been left in the open while their pilots ate lunch nearby. Flyers didn't receive warnings of the approaching Japanese planes until they were almost overhead.

"By noon the first day, pilots were waiting impatiently on Clark field for take-off orders to bomb Formosa," Annalee wrote, referring to the Japanese-occupied island now known as Taiwan. "Our first offensive action had to wait for word from Washington—definite declaration of war. Engines were

warmed up; pilots leaned against the few planes and ate hot dogs."

Twenty minutes later, without warning, Annalee wrote, fifty-four enemy bombers arrived, delivering a brazen, devastating raid on Clark Field that crippled an already underprepared American garrison.

These raids sparked a decades-long debate about who was responsible for the blunder, but whoever should be blamed, the United States lost fully half of its air capacity in the Philippines in this one devastating first day of the war.

"MacArthur's men wanted to fight—but most of all they wanted something to fight with," Mel wrote in a flurry of cables he sent *Time* following the war's commencement and the airfields' decimation. Unfounded rumors of convoys and flights of P-40s coming to join the fight began almost as soon as the attacks subsided. They would not cease for months.

On that morning, Manila's Ermita neighborhood was quiet. Mel arranged a car for the *Time* employees to share. Together they raced up Dewey Boulevard, to Intramuros, the walled old-town district that had been Spain's stronghold during its 300-year occupation. When they reached the U.S. Army Forces in the Far East (USAFFE) headquarters at 1 Calle Victoria, they found MacArthur's driver, who had arrived early in the morning, asleep in his car.

"Headquarters was alive and asleep at the same time," Mel wrote. MacArthur's staff was weary-eyed but busy as they girded for war. Within hours, helmeted officers carrying gas masks on their hips raced back and forth across the stone-walled headquarters, stopping only briefly to gulp down coffee and sandwiches. The general himself was his usual bounding self, striding through the headquarters as staff and other wit-

nesses confirmed reports of attacks throughout the Philippines. Mel and Carl were concerned about their jobs. Would wartime censorship clamp down on their reporting?

"The whole picture seemed about as unreal to USAFFE men as it did to us," Mel later wrote. "We couldn't believe it, and MacArthur's staff had hoped the Japanese would hold off at least another month or so, giving us time to get another convoy or two in with the rest of the stuff on order."

This hesitation, of course, was partly to blame for the devastation that occurred that day and the unsettled footing with which American forces fought during the brutal months to come.

Meanwhile, deep-seated racial prejudices kept many Americans from believing that Japan was capable of carrying out the attacks.

"Those days were eye-openers to many an American who had read Japanese threats in the newspapers with too many grains of salt tossed in," Mel wrote. "They still couldn't believe the yellow man could be that good. It must be Germans; that was all everyone kept saying. We were just beginning to pay for years of unpreparedness. The shout 'It's Chinese propaganda' had suddenly lost all traces of plausibility."

Regardless of who was to blame, U.S. forces reeled.

Manila was quiet even as chaos engulfed the headquarters, where a scrum of reporters waited for updates. Rumors flew beneath the shady trees of Dewey Boulevard, rippled up the Pasig River, and raced past the storefronts along the Escolta.

"The whole thing has busted here like one bombshell, though, as previous cables showed, the military has been alert over the week," Mel wrote.

As the realization of what had begun set in, Manila residents rushed through the city, withdrew cash from banks, stocked up on food, and bought as much fuel as they could before ra-

tioning was ordered. Businesses quickly transformed basements into bomb shelters. Sandbags became scarce. As would happen all over the United States, local military rounded up anyone of Japanese descent, whether they were Japanese nationals or not. The Philippines waited for war.

Mel and Carl had little choice but to file blindly. Unable to contact wire service offices in either Asia or the United States to ask what material their editors wanted or needed, they were on their own.

"Manila had been a city of hell the first fortnight of war," Mel wrote. "If it wasn't planes overhead in the day, it was the flare shooters at night whose rockets struck panic."

But neither Mel, Annalee, nor Carl succumbed to that panic. During the run-up to the attacks, Mel had rewarded *Time*'s confidence with ceaseless reports on the tense atmosphere gripping Manila. After the attack, he accelerated his reporting, setting to work on round-the-clock summaries of the war's progression. His reports were shaped by observations of conditions in Manila, regular press conferences at MacArthur's headquarters, and visits to the war's front lines to witness the fighting himself.

Shortly after the war began, Mel and Carl drove three and a half miles southeast of the Bay View to Nielson Field, the headquarters of the Far East Air Force. There, Mel got his initial in-person glimpse of how chaotic the Philippines' air defenses were.

"The hopeless confusion and the gestures when reports of enemy planes came over were depressing," Mel wrote. "No one could do anything about them."

During his visit, Major Reginald Vance asked Mel if he would like to ride along in a reconnaissance plane. Of course he would. Mel loved flying, and he knew his editors in

New York would love a firsthand report of flying over the war zone.

Vance grabbed a .30-30 rifle and threw it at Mel.

"You're the gunner," Vance told Mel.

Mel wasn't going up in some state-of-the-art plane. He was about to fly in a puddle jumper that couldn't go faster than 150 miles per hour.

Just as Mel was about to sit down in the two-seater recon aircraft, Japanese fighter planes swooped overhead.

"And I was saved of the experience of being a gunner," Mel wrote. "The puddle jumper was what we had left to fight the war with."

On December 21, Japan began landing tens of thousands of troops at beaches along Lingayen Gulf, on the northwest side of Luzon. The next day, after an unexpected air raid, Mel drove with Joaquin Canuto, a Red Cross doctor, to northern Luzon to witness what was happening on the front lines.

At first Manila was chaotic. Mel wrote that he passed residents pouring out of buildings following the raid as young, boyish cadets marched into the streets for new assignments. As soon as he and Canuto passed the city limits, the chaos vanished.

"The Manila countryside suddenly looked peaceful, field after field of rice being harvested by farming peasants still unconcerned with the [Japanese] approximately a hundred miles distant by air and only rarely straightening their bent backs to glance casually at the planes flying over," Mel reported to David Hulburd. Daily life appeared to proceed as usual in the villages and farms they passed except for when military cars sped by up the highway and planes flew overhead.

Soon the road passed through thick patches of jungle. The farther north they drove, the more signs of war appeared. People were camouflaging their cars with palm fronds. Men were riding atop buses as airplane spotters. There were military checkpoints. Villages even competed for the business of passing troops at their gas stations and repair shops.

"The strangest sight was the big colorful billboards enroute showing pretty girls beauteously advertising perfumes, cigarettes, etc., like any American highway," Mel wrote.

After visiting the army's staging area for the Luzon front, Mel headed west to Lingayen. Low-flying Japanese reconnaissance planes frequently passed overhead, and Mel had to stop and hide by the side of the road, unsure whether strafing fighters might follow. By the time he reached the city of Dagupan, Mel could feel the ground shake as Japanese ships shelled American positions farther north. The shelling had scared away almost everyone in the city except for a few of its police and nurses and its mayor. Though Dagupan's residents had abandoned the city, those who remained were committed to their positions; each time a plane flew above the city center, the remaining police tried to shoot it down with their .38-caliber revolvers.

"Dagupan looked like a ghost city, everything alive yet no inhabitants," Mel wrote. "I could see food on the plates in the houses, overturned chairs and tables."

Mel continued to Lingayen's coast. He passed huts with still-open doors and clothes-strewn streets clearly abandoned in a hurry.

"I found some dungaree-clad Filipino soldiers and was giving them cigarettes and chocolate when suddenly two big silver Japanese seaplanes flew over, circling low," Mel reported. "I took cover with the soldiers, who were overjoyed that an American should visit them, saying: 'You Americans are very good to us.'"

The soldiers were eager to meet Mel and curious about his press pass. After the officer in charge brought Mel to an overlook from which he could see a cluster of Japanese transports and other ships, Mel returned to his car. Before he left, Mel watched as the soldiers shook their rifles at the enemy seaplanes, which continued to circle "like hawks, slowly hunting prey."

Mel cabled straightforward daily updates as well as flowing, literary dispatches describing the Filipinos' resistance and the dramatic acts of heroism he witnessed every day, but regardless of what form his reports took, one message persisted and amplified over time: the Philippines needed America's support, and the U.S. forces stationed there needed reinforcements. As Mel wrote to Hulburd:

> *The story of the battle of the Philippines, someday told fully, will be a story of American indecision in the Pacific. Another few weeks' leeway and we would have been strong enough in the air to face the present odds. The Japanese had the most complete dress rehearsal of the Philippines attack. . . . The hue and cry from the front is to hell with cheery words from home and give us some planes which'll enable us to stop the enemy cold.*

As the attacks dragged through their first and then second week, nerves frayed throughout Manila.

"The same sunrise is glowing, and the sun sets over Manila Bay after a fortnight, but everything else is changed," Mel wrote in an evening dispatch after the combined disruptions of Daylight Savings Time, nightly blackouts, and war-weariness had caused palpable changes in the Philippine capital's atmosphere.

"Manila no longer appears like a Florida resort, the men in white sharkskin, the women gaily decked," he reported in the December 18 dispatch. "The men are in checked suits, the

women dressing in slacks with uncoiffured hair. Correspondents have long since shed coats and ties. Uniforms are now commonplace."

A "people's army" of sorts was forming, with shop owners arming themselves with .45s, women donning Red Cross uniforms, and everyone carrying gas masks. Fear had prevailed the first few days of the war, but it dissipated in favor of more "professional" conversations about day-to-day preparations. Women and children began moving into hotels and other large buildings known to have shelters. Horse-drawn carriages carried evacuees into the country. Profiteering leveled off.

With prospects unraveling in the capital, the idea of remaining became ever less attractive to Mel and Annalee. Bombers loomed by day. At night, every sound and light sparked panic, especially among Filipino guards and soldiers armed for the first time in their lives. The city's residents were nervous, but, as Mel captured in one report, they still held out hope that the United States would come to their rescue:

> *Manila nights were like the battlefield; a thousand shadow fights raged. An electric sign would mysteriously beam out in the blackout and a hundred bullets would sing by it . . . You couldn't go on the streets at night without a half dozen bullets splattering nearby. And all the time from the little groups at the bars, or working 24 hours a day in the Red Cross, or guarding bridges, came the same thoughts—the convoy will get here soon. The American navy was on the way—South.*

But because of the "Europe First" strategy—and in the Pacific, a focus on defending Australia—no salvation approached from over the horizon. On December 8, Japan hadn't just attacked Hawaii and the Philippines; it had bombed Hong Kong

and Singapore and invaded Malaya and Thailand. In Shanghai, the illusion of a free city-state ended as Japanese forces occupied the International Settlement.

Nineteen forty-one marked the third straight Christmas that Mel spent separated from his family. But at least this year he had Annalee and their adopted family of fellow reporters to share what semblance of a celebration they could muster.

The holiday began quietly. That morning, Carl and Shelley visited the Jacobys in their room at the Bay View. Around a small tree on the room's desk, the foursome opened presents together.

That night all four went up the street to the opulent Manila Hotel, where Clark Lee was staying. Until the previous night, MacArthur had been staying there as well. In its lobby, the Jacobys and the Mydanses met Clark and other members of the press corps for a subdued holiday dinner of turkey and champagne.

Clark had just returned from a four-day journey to Luzon's front lines, where he had continued on his own after Mel returned from Lingayen. During that trip, both reporters had to dive in ditches to avoid dive bombers. Later, Clark found himself stuck in the middle of a firefight. As the bullets flew, he had abandoned his car. He then hiked along steep cliffs and hid overnight with indigenous Igorot populations, barely avoiding land mines as he negotiated tree-knotted jungle trails. Now Clark was planning another dangerous journey.

After Christmas dinner, as his Associated Press colleague Russell Brines shared a dance with Annalee, Clark pulled Mel aside and warned him that they should flee Manila. The Japanese were drawing ever closer, and Clark knew the Philippine capital would not be safe for the reporters when they arrived.

U.S. forces were already shifting their operations to Bataan—
the jungle-blanketed peninsula to the northwest—and Cor-
regidor, the fortified island at the mouth of Manila Bay where
the military had moved its command center. And the Japanese
were drawing ever closer to the capital.

Mel may have thrived amid Chungking's wartime excite-
ment, but he was also conscious of the dangers of war. In
China, he often wrote his mother to assuage her worries for
his safety. But now Mel faced more acute risks. In Chungking,
danger approached mostly from the skies. That threat, as horri-
ble as it was, was fairly predictable, given the Chinese capital's
ingenious system of lamps and human spotters, as well as the
regularity of the bombings. Although many bombs had now
also fallen on Manila, and would continue to fall, the greatest
fear came not from the skies but from the specter of Japanese
troops marching through the city's streets any day now. This
threat was something different.

"The ugliness of war rained down in great sheets like it had in
China and Indochina, and the Americans learned for the first
time to take it—and not as neutrals," Mel wrote.

A day after the holiday, MacArthur, unable to hold the cap-
ital, declared Manila an "Open City," leaving it undefended.
MacArthur hoped this move might spare the city the kind
of destruction and brutality that urban warfare had already
brought to China and Europe. The general crafted the Open
City declaration to limit civilian casualties by signaling—
through radio broadcasts, newspaper headlines, and banners
strung between buildings—that the Americans would no
longer fight to control the capital. But the Japanese either
missed the signals or consciously refused to heed them, and

bombs continued to fall on Manila from planes emblazoned with the Rising Sun.

"There are no uniforms on the streets, no rush of tanks, army trucks, no military police guards at night," Mel wrote. "The [Japanese] bombers flying over are not meeting a single anti-aircraft burst and are calmly circling and crisscrossing over the city, picking objectives as if in practice flights similar to Chungking."

Morale in the city plummeted, but Filipino citizens wore much braver faces than their American counterparts. Many Filipinos resented their capital's abandonment and wanted to fight, Mel reported. But as the Japanese grip on Luzon tightened, nearly three million Filipino civilians fled from their country's cities and towns in search of safety amid the thick jungles that covered Luzon's hills and mountains.

Meanwhile, thousands of Western civilians who worked for American businesses and government offices were left behind in Manila. The country was ultimately overseen by High Commissioner Francis B. Sayre, not its recently reelected president, Manuel Quezon. Both Sayre and Quezon, as well as their families, were evacuated to Corregidor, leaving Claude Buss the only representative of the high commissioner's office left in the city.

In angry meetings with Buss, American men demanded that their wives and children be evacuated to Corregidor but were told that the fortress island lacked sufficient beds and provisions. The more vociferous among the civilians insisted that they'd arm themselves and resist the Japanese occupation without the army's help, but each time Buss told them to go home, pack bags of supplies for possible internment in concentration camps, and "just wait."

The reporters were less restive, but they were anxious.

On the day MacArthur's forces began withdrawing from Manila, Mel was among five reporters—one from each of the major news outlets operating in the city—who were invited to Corregidor to continue covering the fighting with the American forces' blessing. But the military wouldn't allow them to bring their families. None of the reporters could agree to abandon spouses and children they'd brought to the Philippines— least of all Mel, who wouldn't leave Annalee behind again. They needed another plan.

Before the war, both sides of the Pasig River had been lined with watercraft that could have served as escape vessels. But in the weeks following December 8, most of the boats had been bombed by the enemy; the rest had either been sabotaged or commandeered by the U.S. military.

"The last two weeks in Manila were the worst," Annalee wrote. "The Japanese were getting closer; we knew Mel would probably be killed if they got him; and every way of getting out failed as soon as we thought of it."

That the Japanese knew about Mel's previous work with the Chinese government he was certain. They no doubt also knew that his earlier reporting hadn't portrayed Japan favorably. Mel's many graphic photo essays and narrative accounts had revealed the ghastly toll that the empire's bombs had exacted on Chungking. His arrest in Haiphong a year earlier had briefly stirred the pot already simmering between Japan and the United States. And in early 1941 Mel had followed up his arrest with a damning report in *Asia* magazine outlining Japan's occupation of Indochina and anticipating the country's designs on the rest of the continent.

If the Japanese had a blacklist—and Mel was confident they did—there were many reasons his name was surely on it. Annalee's likely was as well, given her work as a speechwriter for Madame Chiang, not to mention her connection to Mel. Like

other American civilians remaining in Manila, the Jacobys couldn't count on protection from the American government. They were also certain that if they were captured, they would be killed immediately.

"China days had taught us the meaning of Japanese black-lists," Mel wrote.

Rumors of such blacklists ran rampant among the journalists. Neither Mel nor Annalee trusted that the enemy would grant them any lenience just because they were reporters. In fact, before the attacks at Pearl Harbor, Mel had received ominous warnings about his reporting from Japanese diplomats in the Philippines.

Whenever Mel, Annalee, Clark Lee, and the rest of Manila's press corps were not reporting on the battle for the Philippines, they were dissecting possible escape options. At one point, Mel and Clark plotted an overland journey to Bataan, but it soon became clear that such a trip would be impossible. Every bus in Manila had been requisitioned by the army to handle its massive realignment of forces, which were congesting every road to Bataan. As soon as these roads were cleared, the army blew up the bridges leading from Manila.

For a time, it looked like the Jacobys would be able to leave Manila aboard a British freighter bound for the East Indies, but the freighter was bombed the night they planned to leave. (Japan's quick conquest of the Dutch East Indies, Malaya, and Singapore after Pearl Harbor may have rendered such a trip pointless anyhow.)

Then it looked like Annalee and Mel would be able to escape with Carl and Shelley Mydans via another ship. General MacArthur granted permission for all four to board the *Mactan,* a hospital ship bound for Australia, but after the reporters'

bags were packed and in a car, the U.S. State Department tele-grammed to say civilians could not be allowed to board. If they were, the *Mactan* would lose the protected status guaranteed by the Hague Convention. Shortly before it set sail, a consul from neutral Switzerland even inspected the *Mactan* to make sure the Red Cross had kept to these international guidelines. The Mydanses and the Jacobys were stuck.

Time, of course, was also invested in their escape, and Henry Luce weighed in on the foursome's decision-making. On the day after Christmas, Luce cabled Mel to tell him that *Time* (read: Luce) wanted the reporters out of Manila if possible, but before deciding one course of action or another, Luce in-structed, they should consider their own safety and ability to continue reporting in the future.

"Congratulations to all for magnificent work," Luce closed his December 26 message. "We look forward more big jobs in Pacific all regards."

Prior to Pearl Harbor, Mel had befriended representatives of the Dee Chuan Lumber Company. The company had been founded by a recently deceased Chinese Filipino business ty-coon who used his riches to help support the Kuomintang in its fight against Japan. After the outbreak of war between China and Japan, Dee Chuan helped organize a boycott of Japanese goods in the Philippines and other resistance efforts. After his death, his sons took over the company but kept his name.

Three weeks into the war, Mel got in touch with represen-tatives of Dee Chuan Lumber. Together they scoured Manila's waterfront and the Pasig River for a craft Mel could use to get out of the Philippines. They identified a freighter that was then moored in the Pasig, which spilled into Manila Bay just up

Dewey Boulevard to the north, past a foreigners' golf course and the old walled city. The freighter might be able to make the 2,000-mile journey between Manila and Australia. The shippers outfitted the vessel with enough food and diesel fuel to take a crew and passengers, including Mel and Annalee, the entire way.

"I was scared then—afraid of getting caught, and afraid of trying to sail through the Japanese Navy outside Manila," Mel told his editor at *Time*. "I told Carl and Shelley but they didn't want to come with us."

Carl and Shelley were the closest thing to family the Jacobys had in Manila. Just as Mel looked up to Carl, the couple inspired Annalee. But neither the Jacobys nor the Mydanses realized the full extent of the massive realignment of American and Filipino forces to Corregidor and Bataan. A week after Mel had arranged for the tug to be left in the Pasig, he and Annalee made their decision to escape. But then Mel discovered that the tug had been taken by members of the retreating U.S. Army. Without a boat available, it appeared almost certain that the reporters would be stuck in Manila.

Escape by sea would be treacherous enough, but given the U.S. Navy's widespread mining of the harbor, any boat without an expert navigator familiar with the mines' locations was doomed. The waters were also crowded with the hulks of bombed or sabotaged ships that had sunk just beneath the waves or still smoldered on the harbor surface. Escape by land was no more promising.

"None of us knew about the Bataan maneuver until New Year's Eve," Annalee later told CBS's Bill Dunn, adding that bridges were being blown up on every side of the city that night as Japanese patrols neared.

With their options for escape slim, most of the Manila-based

reporters resolved to remain in the city despite the looming possibility of Japanese conquest. For many, the prospect of internment was more appealing than attempting to survive treacherous seas or jungles rife with snipers, booby traps, and other hazards. Some reporters even believed that if the press remained, the Japanese might keep them under house arrest at the Bay View for the duration of the conflict.

Others, however, didn't trust Japan to act humanely if they rounded up the reporters. Four years earlier, when Japanese troops captured Nanking, they unleashed savagery shocking even compared to all the other horrors of World War II. Tens of thousands of civilians were killed and raped during three weeks of terror in Nanking. The perceptions of Japanese brutality held by the close-knit foreign press corps were shaped in part by accounts from their close friends in Chungking who had witnessed the "Rape of Nanking."

The Jacobys, the Mydanses, and many of the other reporters at the Bay View were friends of Tillman Durdin, the *New York Times* reporter who had been in Nanking, and they didn't want to find out whether the Japanese would behave in Manila as they had in that city.

New Year's Eve 1941 arrived with Japanese troops "just a stone's throw" south of Manila. U.S. General Hugh Casey's engineers were among the last in the city. They were tasked with destroying anything of value behind the retreating American forces, beginning with RCA's radio transmission facilities.

"The same thing happened in a thousand places in and around Manila that morning," Mel wrote. "Bridges, radios, warehouses, everything went up with a noise that sounded

to the people like bombing and sent them jittering into the street."

With their fate uncertain, Manila's press corps gathered in Mel and Annalee's sixth-floor room at the Bay View. Thirty-two reporters packed into the tiny space to debate the merits of an escape and discuss what might happen if they were to be captured or placed under house arrest.

Clark Lee had no interest in waiting for a Japanese roundup. He was determined to attempt escape.

"Anything to stay out of their hands, even if it's only for a few hours longer," Clark said.

For days, Clark and Mel had been poring over maps of the Philippines and assessing updates on Japanese positions while they proposed, and subsequently rejected, dozens of potential escape plans. Now as midnight—and the Japanese occupation—drew ever nearer, Mel began forming a new plan.

Most of the American forces—and their vehicles—were converging on Bataan; perhaps the Jacobys could make their way there, then try to find another boat that they and anyone who wanted to join them could take for a perilous journey from the Philippines to Allied territory.

"By the time we'e [sic] finally decided to get to Bataan there was almost no way of getting there," Annalee wrote. "We thought there might be a small chance of watching for a dark night and getting away before the end came."

While the meeting at the hotel went on, Mel left to scour the nearby waterfront for any boat somehow left behind. Disorder reigned at the docks. Looters were clearing out warehouses while the few remaining American army and navy forces sabotaged oil tanks and other key facilities. The Japanese were still a morning away, though Mel was certain that he saw some of their scouts in plainclothes bicycling amid the crowds. He did

his best to ignore the mayhem while he searched for anyone willing to risk a trip through the mine-laden bay with reporters on board.

Sifting through the masses, Mel found Captains William Hastings and Chet Judah, two American merchants he'd met previously. Their small inter-island ship, *La Florecita,* was nearby. The U.S. Army Transportation Service (ATS) had been using it for days to tug ships out of the Pasig River to draw bombers away from the city. Now, laden with ammunition and other supplies intended for Bataan, the vessel—also owned by Dee Chuan Lumber—was the last boat left afloat in Manila besides the hospital ship *Mactan.*

Mel told Hastings that neither he, his wife, nor Clark Lee thought it was safe to stay in Manila. Hastings and Judah were preparing to run the tightening Japanese blockade after delivering their cargo to Bataan; they might be able to bring others with them. Hastings told Mel to stay close to a phone. He'd call when it was time to go.

Leaving the dock, Mel raced away from the port, along Dewey Boulevard and back to the Bay View to deliver the news. The correspondents crammed into his hotel room were still debating whether they should try to escape. Some still held tightly to the belief that if the press remained together as a group, they'd be treated fairly by the Japanese. Or they could go to Bataan.

But nobody knew how much resistance the American and Filipino soldiers were putting up against the Japanese on that peninsula. Many of the reporters thought it was needlessly dangerous to try to reach Bataan. Some guessed that total defeat—on Bataan and throughout the Philippines—might come within the week, while others believed the country might hold for a short time longer than that.

"It still seemed better to have that week than to sit still and do nothing, especially with the blacklist hanging over our heads," Mel wrote. But few thought the U.S. would last much longer on the Bataan Peninsula. That meant a risky escape there could amount to nothing.

Back in the hotel room, Mel told his companions about *La Florecita*.

"We're going to run the blockade," he told his colleagues. "Annalee, Clark and myself."

Nobody accepted their invitation to join. Not even Carl and Shelley Mydans, who had also rejected earlier plans to escape by boat. The Mydanses wavered at first, but the Jacobys weren't able to change their minds.

"Carl and Shelley decided to stay, hoping to be alive after two or three years of concentration camps," Annalee wrote, noting a few lines later that the Mydanses continued to try to convince the Jacobys to stay, "thinking we'd surely be killed, but we were sure Mel would be killed anyway."

Nobody in the Jacobys' Bay View Hotel room came to their decisions easily, and the choices the couples made to either escape or stay behind would forever haunt both the Mydanses and the Jacobys. In an exhaustive history of women journalists who covered World War II, the author Nancy Caldwell Sorel provided a compelling analysis of what all four may have thought that fearful night:

It is often the case that when danger threatens, even when the risks are apparent, people do not heed and leave while they still can. Journalists are a special case: the story, and the glory, belong to those who stay. Neither Carl Mydans nor Mel Jacoby gave serious thought to quitting Manila until the choice had narrowed to hazardous escape

or internment, and although the Smith and Whitmore families may have urged their daughters, both in their mid-twenties, to return home while they still could, those daughters, reporters themselves as well as wives, did not consider that option. Both experienced the intensified romantic feeling and marital connectedness that danger elicits. Both loved their husbands deeply.

Mel hated the thought of leaving the Mydanses behind after everything they'd survived together, but, he realized, "I guess that's in the game now."

Ultimately, of the thirty-two journalists gathered in the Jacobys' room, all except Mel, Annalee, and Clark Lee opted to stay. (Later that night, the United Press's Frank Hewlett found a Chevrolet and drove to Bataan with Nat Floyd of the *New York Times* and Curtis Hindson of Reuters; they barely made it past a series of bridges before U.S. Army engineers demolished them.) The rest left to gather their families. They would return later that night to set up cots in the Jacobys' room and exactly one floor below in 520, the Mydanses' room.

That afternoon, when Mel left for the docks to look for a boat, Clark Lee rather absurdly returned to the Manila Hotel and its barbershop for one last haircut. He also stopped at a lackluster New Year's Eve dinner hosted by relatives and went to the USAFFE's now nearly vacant headquarters to confer with remaining officers about whether any alternative possibilities for escape had emerged.

While Clark was gone, Mel and Annalee made their own preparations. As early as Christmas Day, the Jacobys had packed a knapsack to be ready if they had to make a quick departure. There was room in it only for a camera and some plain, sturdy

outfits. Preparing the bag was heartbreaking. They had to leave behind their lavish wedding gifts and tributes from Madame Chiang, her sisters, and other Chinese elites, as well as from dear friends. Bamboo and silver vases, embroidered satin blankets—all of them were priceless, but they couldn't spare even an inch of space.

They might be living out of their bag for months, if not years, to come, so each ounce was precious. While they waited to hear from the crew of *La Florecita,* Mel and Annalee finished packing the bag; with their destination uncertain, they filled unused space with canned food and a couple more pieces of clothing.

Besides most of Mel's photography equipment, they also abandoned hundreds of dollars they had deposited in a Manila bank, much of which family had given them as wedding gifts.

Then there were the notes. Six hundred typewritten pages' worth. Mel's notes were a voluminous record of three years of reporting: they traced his path—and the war's—through China, to Southeast Asia, and finally on to the apocalyptic scene unfolding outside his hotel room in Manila. They were proof—documentary evidence of everywhere Mel had been, every detail he had recorded when he dissected China's political and economic climate, every analysis of military strategy he'd prepared, all the sources he'd met, even all the intimate, confidential reflections on the U.S. and Filipino preparedness for war he'd gleaned in the weeks preceding Pearl Harbor. Much of his documentation underscored how woefully unready the American forces were for battle in the Philippines.

The notes had to go.

Mel and Annalee went to their hotel room's tiny bathroom. Its curtained window cast a greenish light on the couple as they tried to burn their notes in the toilet and sink. The room filled with smoke.

One floor below, Carl and Shelley Mydans were doing the same. The rumors about approaching Japanese troops were becoming more urgent. The latest had the enemy just two hours away, in the town where Mel and Annalee had celebrated their brief honeymoon a month earlier.

Mel came down to Carl's room. After they continued to struggle with flushing their notes, they decided to try the hotel's furnace. Another journalist in Manila, Royal Arch Gunnison, later wrote that this might have been a dangerous decision: anyone seen burning documents just before an occupation might be suspected of being a spy destroying evidence. Nevertheless, Carl and Mel decided to take that risk. Mel went upstairs, where he and Annalee stuffed their notes into a pillowcase. Then he raced back down to Carl's room and together the two wordlessly ran to the basement.

The door to the furnace room was locked. Mel started ramming the door with his shoulder. Finally, both Mel and Carl kicked at it. The door crashed open, echoing in the basement. They scrambled through a cluttered storeroom and found the growling furnace. Carl grabbed its door with his pillow to protect his hand from the heat. Without speaking, both men threw their notes into the flames.

Most events in life don't sync up with calendars. But somehow Mel's life repeatedly returned to moments like this when history converged all too perfectly with his own doings. Now everything he and Carl had experienced was condensed into a space consisting of the six floors between their cramped, smoke-filled bathrooms and this hot basement, dark except for the furnace's glow. A meticulous note taker throughout his life, Carl couldn't stomach watching months' worth of his notes burn. Mel had already started considering one day writ-

ing a book about China, but now he watched everything he'd worked toward for most of his adult life go up in flames.

Neither Mel nor Carl spoke, not even after they made sure their notes were gone and each had returned to their wives and their rooms. It was as uncomfortable a position as any of the four had found themselves in, and neither the Jacobys nor the Mydanses would verbalize why.

For the rest of their lives, this moment would haunt them and cloud their recollection. Never would they be able to flush away the memory of what they had done. Barely two years had passed since Mel first met Carl. They'd since shared an intimacy of the sort that usually only exists in foxholes and bedrooms, but that night the basement of the Bay View felt more like a crime scene.

Once back upstairs, Mel called Clark Lee and told him to get back to the Bay View in case Captains Hastings and Judah showed up. When Clark arrived, the trio once more tried to convince the Mydanses to join the escape, but their friends still refused. The argument intensified. Suddenly, as if punctuating the debate, a flash as bright as day lit the room. The windows shook tremendously. Great black columns of smoke roiled into the sky to the north. The departing American forces had just blown up the city's central gasoline reserves across the Pasig River.

"Annalee supplied the adjectives," Clark wrote. "'Stupendous, terrific, colossal, terrifying, magnificent, overwhelming,' she gasped."

Aware that this was likely to be the last night they were together for some time, the reporters decided that a farewell toast was in order. Unfortunately, they couldn't find any booze. Annalee and Shelley had poured all their liquor out, fearful

of rumors about how "berserk" Japanese soldiers would get if they got ahold of it. Without a drink to share, the Jacobys simply sat with their colleagues in their darkened hotel room and watched Manila go up in flames. There were fires in every direction.

At 10:30 P.M., the sharp clatter of a ringing telephone cut through the hotel room's anguished quiet. Captains Hastings and Judah were downstairs. *La Florecita* was ready. If the Jacobys wanted to get out of Manila, they couldn't wait any longer.

Burning embers rained from the sky as the captains' car sped up chaos-engulfed Dewey Boulevard to Pier 7, just next to the Manila Hotel. As soon as they arrived the sailors and reporters ran from the vehicle to *La Florecita*. The small freighter's crew already had the engines turning. Flames from torched warehouses spread along the horizon. Somewhere in the distance, additional fuel reserves were sabotaged. Their thunderous blasts punctuated the moment.

Clark boarded *La Florecita* first. Mel and Annalee followed, hand in hand.

They leapt aboard the boat just before it chugged into Manila Bay. Almost as soon as the ship—a ten-year-old, 364-ton cargo boat—had pushed off, the dock exploded behind them, dynamited by the few American soldiers lingering at the pier. Sparks fell across the deck of *La Florecita* as it threaded its way through the bay's hazardous waters. The reporters watched through the ensuing fire's glow as the last fleeing Filipinos pulled whatever they could use from the warehouses of their crumbling capital.

At one minute after midnight, Mel, Annalee, and Clark stood on the ship's deck, illuminated only by the moon and firelight from the city. The explosions and cacophony of a collapsing nation had given way to the darkened waters' quiet. Safety remained a long way off.

Still, Clark was optimistic.

"Soon we'll be in the Indies, eating good food," he told his friends.

The boat bobbed in the middle of the bay, its bridge dark. The new year may have arrived, but there was no champagne to mark the occasion. The only thing the reporters could find to drink was a bottle of applejack produced by a member of the crew. Passing the bottle around, the reporters and the ship's crew wished each other an unenthusiastic "Happy New Year."

"We could just barely make out their faces in the reflected light from Manila's great pier area throwing clouds of smoke and leaping flames a half-mile high behind us," Mel wrote.

They still didn't know where they were headed: the jungles of the Bataan Peninsula or the fortress of Corregidor. Either choice meant threading the bay's minefields, and they knew that if they tried to escape to the open ocean, the Japanese navy lay in wait just past the harbor's entrance. They were at the mercy of Captains Hastings and Judah. Wherever the sailors decided it was safe to anchor was their destination.

Part Three

INTO THE BLACKNESS BEYOND

Flames towered above Manila Bay as the new year dawned. Twenty-six miles away from the Filipino capital, *La Florecita* bobbed in a channel. On one side was a jungle-covered peninsula, on the other a rocky island. As 1942 began, Mel, Annalee, and Clark woke on the freighter's deck to the wail of air raid sirens.

South of the bobbing ship rose Corregidor, a wriggling mass of rock that stood sentinel over the sea. To the north, a verdant carpet of palms and banyans climbed the slopes of Mariveles Mountain, which spanned the horizon and dominated the Bataan Peninsula.

Corregidor was shaped like an arcing comet with a tail. "Topside" was the higher-elevation plateau—the comet's head—which housed anti-aircraft and artillery batteries, barracks, a parade ground, and other facilities, most of which had been pummeled in air raids that began two days earlier. "Middleside"—the lower portion of the head—housed more barracks and what had served as the army's hospital until the facility was transferred to a massive tunnel complex beneath Malinta Hill, the limestone mount where the island's "tail" began. Behind steep Malinta, the skinny two-and-a-half-mile "Tailside" was where the island's small airfield, the navy's ra-

dio facilities, and some officers' houses were located. Sea-level "Bottomside" connected head and tail; it housed three docks on its north side, a power plant, and a small barrio that was home to civilian laborers who worked on Corregidor.

Seen from certain parts of Corregidor—like Battery Grubbs, one of the artillery installations on Topside—Bataan, with Mariveles gently sloping into the South China Sea, presented an almost romantic vista when coupled with pink-and-orange sunsets. The rugged crags of Bokanita Pass at the peninsula's southern tip and the sharp, triangular rock of tiny La Monja Island west of the pass framed a scene that at any other time might have been found on vacation postcards. Mariveles's magma chambers had long since ceased their fury, but during the four weeks of war so far, violence had erupted beneath the canopy of Ipil-ipil, yakal, gum, and apitong trees that climbed the mountain's slopes.

It was still dark when *La Florecita*'s crew lay anchor off Bottomside's North Docks. Since they served as the loading terminal for transports headed to Bataan, the docks were a natural target for Japanese bombers. Captains Judah and Hastings had hoped to reach Bataan to deliver ammunition but hadn't made it. Now Mel, Annalee, and Clark had to act quickly. Remaining on the open water in broad daylight was out of the question. The embattled peninsula to their north was likely to be the first target for the approaching planes.

Mel had passed up offers to relocate to Corregidor a few weeks earlier. Now it was also a likely target, but it was close, and its many fortifications promised shelter. Later the group could figure out how to get back across the channel to Bataan, where the real battle—and thus the real story—was under way. For the time being, they just needed to survive the day.

The sky was clear, and the sun was rising. The reporters

struggled to deploy *La Florecita*'s lone lifeboat. Finally freeing the dinghy from the ship, they rowed toward Corregidor's North Docks. It took on water and nearly swamped before they reached the docks. The planes were coming closer.

"We scrambled up and raced for a dugout, and we came out an hour later to find ourselves under arrest," Annalee wrote.

As the reporters argued with the U.S. military police who'd arrested them for arriving unannounced at what was essentially an island-wide fortress, another air raid siren wailed. MPs and arrestees alike scrambled into the dugout. Everyone waited for the raining bombs' characteristic thuds and trembling to end. They would repeat this dance all day as Japanese planes pounded Corregidor with a heavy series of attacks, and its moves would become familiar as the raids continued for the next week.

Japan began an aerial siege of Corregidor on December 29, resumed bombing on New Year's Eve, and continued the onslaught through January 6 before shifting its attention—temporarily—to the forces gathering at Bataan.

"That was our introduction to Corregidor," Mel noted.

The night before, while still at the Bay View, Mel had called Lieutenant Colonel Diller, General Douglas MacArthur's press aide, to discuss his plan to sail aboard *La Florecita*. Diller told Mel that he "couldn't exactly stop" him and Annalee from landing in Bataan, hinting that MacArthur and his subordinates wouldn't try to keep the reporters from coming.

"MacArthur, he said, understood my position with the Japanese and was 100% sympathetic," Mel wrote.

Nevertheless, the military police didn't treat the reporters lightly at first. They were highly suspicious of their sudden

appearance. After all, as Clark later noted, "the M.P. book had no provision for two civilian men and a girl in a military area in wartime."

In comparison to other Western powers' colonies in the Pacific, the Philippines had been relatively accepting of the U.S. presence—but this attitude wasn't by any means universally shared by its people. Domestic and foreign fifth columnists existed throughout the islands, as they did across Asia and the Pacific. In the Philippines, many groups were suspected of collaborating with the Japanese empire. The most prevalent were followers of Benigno Ramos's Ganap Party, which had grown out of Ramos's Sakdalista Party, an anti-American group that had been defeated in an early 1930s drive for independence for the Philippines. Ramos had fled the Philippines, but he returned when the Japanese invaded. Now his followers were widely known to be rooting out anti-Japanese resistance throughout the Philippines and otherwise assisting Japan, whose Greater East Asia Co-Prosperity Sphere vision of kicking the Americans out of Asia appealed to the Ganaps.

There had also been decades of Japanese immigration to the Philippines, and many Americans suspected that some of these immigrants had been forewarned of the attacks. Clark himself had reported that Japanese civilians in Manila were packed and ready for internment when American soldiers came for them, suggesting, he argued, that they knew to be ready before the war began for U.S. soldiers to come for them. Others thought that German and Spanish priests, of whom there were many in the heavily Catholic Philippines, were suspect. Germany was Japan's Axis partner, while Spain, though officially neutral in the war, helped supply its partner in the Anti-Comintern Pact, which targeted Communists, and Francisco Franco's government had worked closely with the Catholic Church.

Collaborators were accused of signaling high-value targets to bombers, sabotaging American and Filipino supplies, and spreading propaganda. It is unlikely that the military police suspected Mel, Clark, or Annalee of such activities, but nerves on Corregidor were jittery after three incessant, pounding weeks of war. Anyone who showed up unexpectedly was at least worth looking into.

Regardless of suspicions, Corregidor and Bataan were strained. The highest-ranking U.S. military and civilian officials in the Philippines had all relocated to Corregidor, but even they struggled to get Washington to commit to a supply convoy and reinforcements for their now-encircled forces. War Plan Orange Three, a strategy developed before the conflict began, had called for six months' worth of supplies for 43,000 soldiers on Bataan, plus reserves for 10,000 more for Corregidor. Before Manila fell, the army's quartermaster corps had coordinated a massive movement of supplies by barge and land.

By January, there were almost twice as many troops on Bataan, around 83,000. Another 12,000 people were on Corregidor. (That number was probably slightly lower when *La Florecita* arrived, as the number of personnel on Corregidor rose as U.S. forces were pushed off Bataan.) In addition to feeding, healing, and inoculating their troops, U.S. commanders also had to consider the needs of 25,000 civilian refugees scattered throughout Bataan. Even under the best circumstances, supplying these numbers would have been a Herculean task. These were far from the best circumstances.

Feeding just three additional mouths on Corregidor could prove a headache, as would housing even three more bodies in the claustrophobic tunnels dug beneath the island's surface. While extensive, these shelters would become ever more crowded as barracks and officers' quarters on the island's surface

became targets and as more than 1,000 hospital beds lining the concrete walls of one set of the side tunnels—or "laterals"— filled with injured and sick soldiers.

It took hours—interrupted many times by additional raids— before army brass who knew the reporters vouched for them. The reporters recognized many of the people they saw as they rushed in and out of shelter, and fortunately some of these people recognized the reporters.

"The Rock [Corregidor] was teeming with faces, many of them familiar, most of them more than friendly," Mel wrote. "Soldiers and officers seemed glad to see someone from the other world."

Mel sought out Pick Diller and stressed that he had planned to go to Bataan but with bombers approaching that morning, their boat had brought them here to Corregidor. They could get on the next ferry off the island, but they were curious if the freighter they'd provisioned back in Manila for an escape and left in the Pasig River might be available. Diller and the reporters spent all day asking around.

Everyone was so busy running in and out of shelters that night fell unexpectedly. Though the reporters would have to sleep on a trolley platform, they were no longer treated as intruders, or even as a distraction. Instead, they were welcomed warmly on Corregidor by officers and enlisted men alike.

"During the night a dozen soldiers came by smiling and offering the three of us anything and everything from a place to bath [sic] to whiskey without soda," Mel reported.

"One soldier sat by us the next morning until we awakened and asked if we wanted coffee. A cook from a nearby enlisted men's mess sent a breakfast invitation. They were on three meals a day then."

Such generosity was memorable, for over the next four months the siege of Corregidor and Bataan would tighten ra-

tions further and further. Soldiers would be limited at first to half rations of about two meals a day, or 2,000 calories—and they often received even less—and then they would turn to slaughtering the Philippines' endemic, oxlike carabao for food. Later, their pack mules, horses, or anything else they could get their hands on would become sources of food as conditions on Bataan worsened and supplies dwindled.

The garrison at Corregidor requisitioned *La Florecita* to ferry supplies to Bataan almost as soon as the reporters arrived. With the boat now unavailable, if the reporters wanted to go farther than Corregidor, they would have to find another way.

Dusty and crowded Corregidor was not an ideal home for Mel, Annalee, and Clark. Each had work to do. They had news to report and stories to tell, and they wanted at least to get to the front lines on Bataan. They weren't motivated simply by a desire to scoop their competitors or to get their names on front pages; to them, their mission was covering the war.

Telling the story of the conflict and the people waging it was the best way the trio could serve their country. After all, Mel had already avoided the draft multiple times, in part by reasoning that he could make more of a contribution to the war effort working in the Pacific as a reporter—still at the battle's front lines but behind the keys of his typewriter instead of the trigger of a gun.

Fortunately, General MacArthur believed the same. Just weeks into the war, MacArthur's command already stood accused of insufficiently preparing for the Japanese attacks, leaving the USAFFE limping and ragged. On top of the onslaught, the USAFFE's leadership felt neglected by Washington, which also seemed to pay little attention to the broader Pacific fight. In addition to War Plan Orange Three's guidelines for the Pacific,

the U.S. military's overall war-fighting strategy, Rainbow Five, prioritized defeating Hitler in Europe over fighting Japan.

On January 14, U.S. and British leaders wrapped up three weeks of meetings in Washington, D.C., known as the "Arcadia conference." It was the first time British Prime Minister Winston Churchill and President Roosevelt had met in person since the United States entered the war. At Arcadia, the two countries committed to Rainbow Five, also known as the "Europe First" strategy. This made it clear to those stationed at Bataan that no convoy would be coming. Just as Arcadia concluded, MacArthur sent a four-paragraph communiqué to his forces saying that it was impossible to retreat further. The message opened with a promise he'd never be able to deliver:

"Help is on the way from the United States. Thousands of troops and hundreds of planes are being dispatched," he wrote, imploring his troops to hold the line until the reinforcements could fight through.

"It is a question now of courage and determination," MacArthur continued. "Men who run will merely be destroyed but men who fight will save themselves and their country."

Indeed, while other Western colonies in Asia quickly fell, the Philippines continued to fight back against Japan, even though its defenders fought without sufficient bullets, food, or fuel for whichever vehicles hadn't been destroyed. It may have been a heroic resistance, but despite what the hopeful rank and file continued to believe, there was no convoy steaming across the Pacific to rescue them.

Given their access to the front pages and covers of major publications back in North America, the six reporters operating on Corregidor presented these forces with the only voice that could be heard across the vast ocean that separated them

from the United States. Suddenly the reporters' bylines were appearing next to "With USAFFE in Northern Luzon" in the dateline. These five words would define Annalee, Mel, Clark, and the others. A simple attribution for procedure's sake carried a weight that wouldn't be understood by the people who read them.

"It is a matter of fact phrase but it means a world turned upside down," Annalee told her readers in *Liberty* magazine, "a world where a chocolate bar is more unusual than death; where quiet is only a prelude to explosion; where the United States is 8,000 miles away; where Manila, just across the water, is enemy territory."

They call it "Pacific," Clark Lee would later pointedly note, but he and his companions quickly realized this place was anything but.

For now, Corregidor was the reporters' home. Cleared to stay on the island and given accreditation from the military, the trio were little fettered in their work as they set out to report firsthand the U.S. entry into the war. Accreditation opened the door to many opportunities for them, including the chance to ride along on supply trips from the North Docks to the Bataan Peninsula, where the couple would see the kinds of horrors that had transformed Bataan into what Annalee called a "subdivision of hell."

According to a War Department field manual issued later that month (though no doubt never distributed to Corregidor), accredited reporters were permitted to accompany fighting forces into the field and report on the spot. Their reports were subject to wartime censorship, military law, and other restrictions, but they also had wide freedom to talk to soldiers, travel aboard military vessels that had extra space, and use available

radio or other transmission facilities (with some restrictions). Accredited reporters would receive the same medical treatment as soldiers if injured, and if they were captured, they could expect Geneva Conventions protections as prisoners of war, provided they carried appropriate certification. They were differentiated from "visiting" correspondents, who were given permission to visit only on specifically outlined itineraries and to publish their reporting only after their visits.

"Pressmen are allowed to visit any front or headquarters at will, writing mainly feature color, background, personal experiences stories," Mel reported for the journalism news weekly *Editor and Publisher.* "Most of the correspondents have done everything with the troops except fire guns or fly planes."

Newly outfitted with army-style uniforms whose arms featured an embroidered *C,* for "correspondent," Mel resumed his work for *Time* and *Life.*

"In Bataan the troops fight with their backs to the sea-wall and no longer wear clean shirts but have learned to eat the thick Bataan dust, lick gritty teeth and take blood," Mel wrote in a dispatch to *Life* that was reprinted in the *Field Artillery Journal.* Such evocative details and candid accounts of the soldiers' desperate resistance—Mel relayed firsthand narratives from Bataan and Corregidor that appeared regularly in *Life* on top of his own reporting—shocked the American public. As a result of Mel's work, Americans already demoralized by Pearl Harbor now saw the mess unfolding in the Pacific.

"The pictures of Bataan wounded were wonderful in timeliness to really give people the jolt and realization of suffering that is being endured over there by our boys, Americans and Filipinos, and those valiant women, our nurse corps," read one letter to the editor that appeared in *Life.*

As Mel had envisioned before the war began, he and Annalee worked as a team much as the Mydanses had done in China,

the Philippines, and elsewhere. Annalee helped compile Mel's dispatches to Luce's magazines, but she also wrote some of her own and continued an assignment she had arranged in Manila: writing highly descriptive features about the war for *Liberty*, a five-cent weekly magazine that competed with the popular *Saturday Evening Post*. In one blow-by-blow of the first days after the outbreak of war, subscribers read Annalee's visceral descriptions of air raids, closed schools, desperate evacuees, and bloody attacks on railroads. In another, she described new recruits, among whom were former doormen as well as Harvard Business School grads.

"Now they've gone through weeks of constant attack," she wrote.

> *And constant attack is an empty phrase that conveys nothing of the hellishness of shrieking, blasting shells and shattered bodies, of dive bombing, of strafing machine-gun fire. Those words mean more when you've discovered what just the whistle of shells overhead or the boom of bombs can do to a most durable stomach, or seen how a machine-gun bullet changes a human leg.*

The Rock offered scant refuge from the pummeling air raids. Corregidor was a bomb-blasted island prison for an American and Filipino force with nowhere to turn. Civilian and soldier alike suffered Corregidor's dangers and discomforts. No one was spared the threat of the enemy's constant bombardments, and everyone shared the fetid conditions of the dark, moldy, stinking network of tunnels just east of the dock where *La Florecita* had landed.

In this war of aerial terror, these tunnels carved 300 feet beneath the limestone of Malinta Hill were the island's most important facility. There was a central 1,400-foot-long, concrete-

reinforced tunnel with dozens of parallel spurs off either side, plus additional U.S. Navy and hospital tunnels. During the war, these tunnels housed General MacArthur's command center, overworked medics and nurses, stores of ammunition and equipment, mess halls, and living quarters.

For the better part of the 1930s, Filipino laborers in the U.S. Army Corps of Engineers had built the complex, digging through a hillside knotted with jungles. The trees dripped with moisture from the tropical humidity, and countless leeches crawled across their damp, tangled branches. A day's labor left the workers covered with the parasites. Cursing the leeches, they howled, "*Malinta,*" a Filipino term that roughly translates as "many leeches." The term attached itself to the project, and by the time it was finished the tunnel and the mountain above were both known as Malinta. The soldiers who arrived on Corregidor also discovered the leeches, as well as the bats, bullfrogs, and skittering hermit crabs that infested the tunnels.

Now that MacArthur's forces had retreated from Manila, Malinta had become the military's nerve center in the Philippines. The general and his commanders were forced to prosecute the war in this underground maze, surrounded by frightened civilian families and hundreds of sick, wounded soldiers.

The same morning that the American reporters arrived at Corregidor, a Filipino counterpart and friend, Carlos Romulo, showed up on the steamer *Hyde*. Romulo had won the 1941 Pulitzer Prize for his coverage of Southeast Asia, which, much like Mel's, had warned of the coming war. The two identified with one another for their shared insight on Japan's ambitions. After war broke out, MacArthur tapped Romulo to coordinate the "Voice of Freedom," a pro-American radio program broadcast from Bataan's jungles. On Corregidor, Romulo would grow even closer to Mel and Annalee.

When Romulo reported for duty at Malinta, he was shocked by the tunnel's putrid odor and its desperate conditions. Soldiers found anywhere they could to sleep and squeezed into corners of the concrete floors, between ammunition cases and one another's boots. Romulo took note of their exhaustion, of how the soldiers slept through the noise and shaking of bombs and other activity. Instead of scantily clad women, Romulo wrote, these soldiers pinned pictures of American fighters and bombers to their makeshift bunks.

"They were the sweethearts these fellows wanted to see!" Romulo later recalled.

These soldiers desperate for even a few minutes' sleep and perhaps a dream of B-17s and P-40s flying over the horizon were joined underneath Malinta by dozens of government officials and VIPs, including the Philippines' president, Manuel Quezon. And many of the officials who had been evacuated to Malinta were not there alone; some had brought their wives and children with them to the fortress. How long anyone would remain—civilian or military—remained unforeseeable.

"We were of all ages, and of differing tastes and habits," wrote Amea Willoughby, one of seventeen occupants of the "ladies' lateral," a spartan dwelling that housed at least seventeen women and children who had been evacuated from Manila.

Amea was married to Colonel Charles Willoughby. He would soon become MacArthur's chief intelligence officer, but at the time he was an assistant to Francis B. Sayre, the U.S. high commissioner in the Philippines. In 1943, with the war still waging, Amea Willoughby would describe how life in the lateral flattened its inhabitants' social divisions.

"In a design for living that afforded no privacy, or even the luxury of modesty, we could not hide from each other the little faults and traits of a lifetime," Willoughby wrote. "We were

stripped of social artificialities along with the outer props of prestige and material acquisitions."

Like their male counterparts, the women crammed into the hot, stifling tunnel slept on double-decker cots and ate in a noisy, stinking dining hall shared with officers and wounded soldiers recovering at the underground hospital. The women were married to men who before the war had been the Philippines' power brokers—the lateral's residents included Quezon's wife and teenage daughter—and most were ill prepared for the island's tough conditions.

Many of the women, Willoughby noted, needed time to shake off their shyness amid the "overwhelmingly masculine" environment on Corregidor. However, there was one ladies' lateral resident who barely flinched at the conditions, thus earning Amea Willoughby's admiration: Annalee Jacoby.

Annalee had no interest in waiting around helplessly while Mel went about his work. She wanted to report too. But Corregidor officials first assigned Annalee to a cot in the ladies' lateral with the other civilian women. She strenuously objected; she wanted to live with Mel and Clark, who were given cots on the porch of Commissioner Sayre's house, located on Tailside. (Sayre and his family had relocated to a space inside Malinta.) In order to remain officially accredited, however, she had to accept the assignment.

Annalee, despite her slight, 100-pound frame, adapted quickly to conditions on the island and made only one token nod to femininity while on Corregidor: she still pinned her dark brown hair up in bobby pins after a shower to set it into a wave.

"That was her only concession to doing anything feminine and time consuming," her daughter, the author Anne Fadi-

man, relayed decades later. "Particularly during the war, she looked down on women who were fussing about."

To Willoughby, Annalee may have been small, but she was "eloquent of self-reliance and capability," not just some loyal bride tagging along on Mel's adventures across Asia. She was an independent woman who drew upon her own memories of the Depression to figure out how to survive despite Corregidor's scant resources. As Anne Fadiman later recounted, Annalee had no patience for "frilly, helpless" women.

On Corregidor, Annalee, like the island's four other accredited reporters, wore an army-issued khaki uniform. She wanted to be seen by the rest of Corregidor and Bataan's otherwise all-male press corps, as well as by the military and government officials there, as just another reporter.

"We were impressed, and some of us were envious, of her arm band which said PRESS and by the fact that she went everywhere on The Rock with her husband," Willoughby wrote.

She went nearly everywhere Mel went, but not because she was anxiously tagging along with him. She was working, taking trips with Mel across the channel to Bataan to visit field hospitals or going to the gun batteries on Topside to meet the men operating the artillery. She faced many of the same dangers these men faced and wasn't any more afraid of bombs or artillery than anyone else on the island. In fact, she looked forward to excitement her entire life, but she wasn't observing the war for the thrill of it: Annalee had a job to do, and she couldn't do it if she was shrinking away in a stinking, noisy tunnel. More often than not, that job involved writing about the "little things" that were this war's most depressing elements, like "the soldier who comes up asking if anybody's heard about his wife and baby in Manila."

Food wasn't all Bataan lacked. U.S. policymakers had declined to reinforce the Philippines' air combat capabilities, leaving Bataan's skies defended by a patchwork of twenty planes in various states of disrepair after the raids on U.S. air bases early in the war. Some of them were old Filipino army trainers. Some were converted puddle jumpers. There were four beat-up P-40 fighters and a few P-35s.

Led by Brigadier General Harold H. George, a forty-nine-year-old former World War I ace, this "Bataan Air Force" nevertheless helped provide breathing room for the American and Filipino soldiers fighting in the jungles beneath. Known as "Pursuit Hal" to differentiate him from another general with the same name—Harold L. George, or "Bomber Hal," who led the Air Transport Command during the war—George had been promoted on Christmas Eve, when he took over the 5th Interceptor Command and was given responsibility for Bataan's air defenses. This included the approximately 5,000 U.S. Army Air Forces personnel and 600 or so Filipinos under George's command, most of whom, lacking planes to fly or service, were given rifles and turned into infantrymen.

Thus constrained, Pursuit Hal orchestrated a campaign of "courage and ingenuity" from secret airfields hidden by Bataan's ubiquitous foliage. Taking off from airfields that stood out "like water in the desert against the jungles" when fellow soldiers saw them, each flight was "almost a suicide mission." Were there but more planes available to the pilots on Bataan, Mel wrote, he was certain, given what George had done with the few available to his command, that the flyers could hold off the Japanese long enough to reinforce Bataan and Corregidor. Like most of his sources, Mel believed that wresting back control of the Philippines would give the United States a base from which it could "bomb the living daylights out of Formosa" [present-day Taiwan], which the Japanese empire had trans-

formed into a major stepping-stone of its own for control of the Pacific. The dream of reinforcements sailing for Bataan, about to arrive any day, was the fantasy that kept the forces fighting despite their pitched battle.

"The patch of sea spanning outward from the bay is the path by which they will see their convoy steaming in with planes, food and guns," Mel wrote of how desperately the Bataan defenders wanted to believe that help was indeed steaming in.

In reality, no convoy was coming, and Japan's blockade limited shipping of ammunition, food, and medical equipment from other Philippine islands. Still, in one dispatch to *Time,* Mel tried to speak for the soldiers he met on Bataan.

"Since the troops at Bataan are unable to send mail now, they ask that the following, adopted as typical, be sent: Dear Mr. Roosevelt; our P-40 is full of holes," Mel wrote, using a description for the plane that Annalee would later use to headline a magazine article about Bataan. "Please send us a new one."

Meanwhile, the blockade confined Mel, Annalee, and Clark to Corregidor's cramped, increasingly wretched conditions.

Mel and Annalee tried to make the best of the situation. Corregidor was "not the best place in the world for a honeymoon," Annalee conceded, "but we were so glad to be alive and still free that it didn't matter."

Almost everywhere Mel and Annalee went on Corregidor they were surrounded by soldiers, officers, medics, and the small group of civilian VIPs and support staff who had been evacuated to the island. The couple stuck together as much as they possibly could, but there were usually twenty or so other people around at all times. During their first week on Corregidor, Annalee said, they only had two minutes alone together,

and that moment of privacy was rudely interrupted by a Japanese bomb that forced them to find cover with the masses.

Another time, on Bataan, a large formation of Japanese bombers flew overhead, prompting what Annalee later called her favorite memory of Bataan. Her daughter Anne Fadiman would recall the incident as told to her by Annalee:

> Both threw themselves on the ground, Mel on top of Annalee. As the bombs began to fall, Mel, who was known for his dry sense of humor, said, "Remember, dear, it's all in your head." (Though Mel was Jewish and Annalee was descended from Mormons, both had been raised by mothers who had converted to Christian Science.) Annalee remembered the two of them shaking with laughter as the ground around them shook from the bombing.

While newspapers would soon print stories about the honeymooning reporters dodging bombs on Corregidor, the second day they were there they made news for another reason. When the United States was less than a month into its showdown against Japan, Hollywood gossip columnists announced in blaring letters that MGM had begun production on a new film, with Ruth Hussey attached. In their January 2, 1942, column, Louella Parsons and Ronald Reagan, then a gossip columnist, announced plans for the film, dubbed *War Brides* and based on the screenplay that Mel and Annalee had written that past spring. Parsons and Reagan were sufficiently impressed with the project that their item about *War Brides* got top billing in the column, edging out news about an adaptation being made of a stage play called *Casablanca*. As it turned out, *War Brides* was never filmed.

Crowded and embattled conditions like those on Corregidor were not unfamiliar to the Jacobys. So strong was their

memory of Chungking that the couple almost found comfort
amid Malinta's dank, stale-aired tunnels shuddering with ev-
ery bomb blast. As horrible as this war had become, it had
been on the bomb-ravaged streets above the Yangtze that the
romance Mel and Annalee began in California flourished into
love. Now here, on the hills overlooking the Bataan Channel,
the drone of approaching planes, the wail of air raid sirens,
the ensuing thunder of bomb upon bomb, and the staccato of
anti-aircraft cannon responses provided the sound track of a
deepening love.

Mel and Annalee's connection was strengthening, but for
others Bataan and Corregidor felt ever more separated from the
rest of the world. For most soldiers in the moldy tunnels and
bloodied dust of the Philippines, day-to-day survival was more
important than grand strategy. In 1942 few felt as alone as U.S.
soldiers felt on those islands in the Pacific, and there was no
relief in sight. On Corregidor and Bataan, "there could be no
Dunkirk," as Annalee wrote.

"In this war there's no sending back to the rear for replace-
ments or supplies—this is war without a rear, with Japanese
on all sides, long-range guns in all directions, planes overhead
everywhere," she wrote. "Ten thousand refugees have poured
down from Bataan's mountains. They can't escape bombs and
shells—there's nowhere to go."

Radio was the one technology that kept Corregidor from total
isolation. The navy's high-power wireless system linked the
island with Washington, D.C. The reporters' accredited status
allowed them to cable dispatches to their publications through
the system, but they couldn't use it to send personal communi-
cations. However, they were able to transmit and receive a few
select messages through high-ranking personnel authorized

to access the radio system. In mid-January, for example, U.S. High Commissioner Francis Sayre sent a secret message to Secretary of State Cordell Hull on Mel's behalf.

In a message that was to be passed on confidentially to his employers at Time Inc., Mel asked Luce to get the War Department to authorize the army to pay him $500 to cover expenses for what might become a long absence. Through Sayre, Mel also asked Hull to have Luce inform his family that he and Annalee were safe. Four and a half years after Hull had been compelled to assure the mother of a friend of Mel's that her son and Mel were not in danger in Peiping as it came under siege, the statesman again became the messenger for reassurances about Mel.

Mel's radio message also informed Luce and his deputies that the Mydanses had remained behind in Manila. Mel's successful escape was stunning news in New York, but his editors weren't allowed to publicize his location. They could only say that he was "with the United States Armed Forces in the Far East." A week later, David Hulburd sent a coded message back through Hull, to Sayre, for Mel.

"We have informed your families and are delighted that you are well and in good hands," Hulburd said. Hulburd added that Mel's most recent two cables were "magnificent." He also asked Mel for firsthand reporting of the fighting to provide to *Life.*

The first of Mel's cables to Hulburd, sent on January 18, described a typical day of bombing for the Luzon forces. Despite Mel's tremendous access to Corregidor's generals and high-profile politicos, the report focused on the Filipinos working as nurses, barbers, and cooks on The Rock. While on the island, much of Mel's reporting depicted the everyday Filipino laborers who endured the conditions there and on nearby Bataan as

steadfastly as the infantrymen, pilots, and sailors more com-
monly thought of as heroes. Mel's second "magnificent" dis-
patch told a darker story. It told of conditions in Manila, which
must have haunted the Jacobys, who knew their friends were
there, somewhere.

Exhausted nurses take a brief moment of respite to
bathe while serving on the besieged Bataan Peninsula
in the Philippines. *Photo by Annalee Jacoby.*

It was a working honeymoon of sorts for a man and woman
who loved their work as much as one another. Together the
Jacobys compiled hundreds of reports chronicling everything
they'd seen so far of the war. Some reports described surgical
techniques in open-air hospitals, profiled Bataan's nurses, and
introduced the various pets adopted by soldiers stationed on
Corregidor, among other subjects. Others described the tiny,
cobbled-together air force led by General George. A few dis-
cussed the couple's own adventures.

Most of the reports made their way to Mel's editors at *Time*.

Others became the grist for Annalee's stories in *Liberty*. A few shaped contributions from both for *Life*. Many would end up unpublished.

"On Bataan, Mel soon began to realize all of the aspirations the *Time* editors had had for him," a biographical pamphlet from Stanford would later recall. "He was the first reporter to go behind the Japanese lines. He got the story of the American and Filipino men and boys who were doing the fighting and he told it well."

Because both *Life* and *Time* were owned by Henry Luce (as was *Fortune*), Mel's work ended up in both publications. Given the probability that Carl and Shelley had been captured, Mel was now the only source in the Philippines that *Life* could count on for its photo spreads. For Americans at home, *Life* provided many of the most powerful images of World War II, and it is no exaggeration to say that Melville Jacoby was responsible for many Americans' first glimpse of the savagery on Bataan.

Just past a workshop deep in the Bataan jungle, where a mechanic was tying twine around the engine of one of Harold George's airplanes, Mel heard static drifting through the trees. Then he heard a voice. Then, through the telltale crackle of radio waves being tuned, Mel suddenly recognized words. They weren't chattered by American boys waiting for bombs. They weren't mixed into the Tagalog-English argot a few Filipino scouts spoke nearby. They weren't the curses of an injured soldier screaming as a medic applied iodine to an infected wound.

They were . . . the sales pitch of a Jell-O commercial. What Mel was hearing was the tail end of the February 15 episode of *The Jack Benny Show*.

Even on Bataan, American forces could tune to KGEI. Set up by General Electric, this international shortwave station broadcast from Treasure Island in the San Francisco Bay; its programming was meant to boost the morale of troops deployed in the Pacific. (Coincidentally, KGEI was where Shirlee Austerland, Mel's ex-girlfriend, now worked.)

It sounded like home, and it was simultaneously tantalizing and depressing. By the third week of February 1942, most of the forces on Bataan were down to half rations. Many had even less food as supply lines got cut off. The ad for Jell-O at the end of *The Jack Benny Show* was torturous.

"We hear KGEI so know what's going on at home except Jack Benny and Crosby sound funny in Bataan Jungles," Mel wrote.

Four days after this particular broadcast, Mel was finally able to write a brief letter home to Elza and Manfred to let them know that he and Annalee were okay.

"So much to write but nothing to say except we both think of you all the time and wish we could hear from you," Mel wrote. "But you know the rules on personal cablegrams by now I'm sure and Mr. Luce must keep you pretty well informed. In fact I'm afraid we are about the only ones out here who's [sic] movements are really recorded by cable back home."

Of course, the exigencies of war meant that Mel could tell his family little of substance about the war fighting he witnessed on Corregidor and Bataan, or even where he was. Instead, he told Elza and Manfred Meyberg about the surreality of hearing popular music on the Philippines' tropical front lines, thanks to KGEI. Mel also told his family that he lamented leaving the Mydanses behind in Manila and tried to assuage his parents' fear for his safety. He assured them that he and Annalee

were well, and that on The Rock they'd even run into college friends and other acquaintances from past lives.

"Ann is fine and swell—hasn't been doing much writing on her own but helping me," Mel wrote.

Annalee's family received a similar message, and over the next few months her mother, Anne Whitmore, and Elza Meyberg corresponded with one another to discuss what few details they had received. Meanwhile, the families put on a brave public face, often using humor to mask any anxieties.

"Annalee will be able to talk herself out of anything but a direct bomb hit," her sister Carol Whitmore told the *Stanford Daily*.

Aside from Mel, Annalee, and Clark, there were three other journalists on Corregidor: Curtis Hindson of Reuters, the *New York Times*'s Nat Floyd, and Frank Hewlett of the United Press, who would later coin the term "The Battling Bastards of Bataan" with his poem of the same name. Though the reporters didn't precisely think of each other as competitors, they continued vying for scoops from Bataan and Corregidor. They put days' worth of work into stories, in part because of the navy's word limits, and for each reporter that work paid off only "if he [could] get a daily dispatch through," as Mel reported in a dispatch describing the reporting conditions.

"There is keenest rivalry amongst the press, particularly between the association representatives [the AP's Clark Lee and *New York Times*'s Nat Floyd], who don't trust each other, both swearing they didn't have a dispatch through for weeks," Mel wrote.

"Correspondents usually try to find out others' itinerary at the front, then beat the other one to a story."

Some writers have claimed that MacArthur used Mel for his own ends. It's true that *Time*'s and *Life*'s New York–based ed-

itors doctored Mel's and other reporters' copy for political and sensationalist ends to make MacArthur and others look good. Ample evidence exists that Mel did admire MacArthur, but the general was far from the only voice calling for reinforcements in the Pacific and a rethinking of the Europe First strategy.

Mel based many of his dispatches on candid admissions from the enlisted men and officers pinned down in Bataan's jungles. He and Annalee could easily have never ended up reaching Corregidor in the first place, though it is true that MacArthur's press officers' familiarity with the couple made it easier for them to stay on the island once they had arrived. However, one of the key reasons Mel and the other reporters wanted off Corregidor was expressly because their 500-words-per-day radio limit constrained their reporting. With no way to get the entire story out, no guarantee that a dispatch would be received, and no way to know whether it would be accurately edited even if it was received, Corregidor fast became a 1,735-acre prison. Whether or not MacArthur had influenced coverage on Corregidor so far, the general was about to involve himself in Mel's story.

General MacArthur's six-foot frame bounded about his cramped, makeshift headquarters beneath Malinta, making the room—only 15 feet wide, but 160 feet long and full of desks, chairs, phones, maps, and other equipment—seem even smaller than it was. It was February 23, 1942, and at a rare moment when Annalee wasn't present (she was elsewhere in Malinta), the general asked Mel and Clark a simple question:

"Do you want to go now?"

MacArthur suggested a promising and straightforward, if risky, plan: a blockade runner that had just reached Corregidor from Cebu, a still-unoccupied island 350 miles to the south-

east, would sneak past the Japanese at night and hide out by day as it island-hopped back to Cebu. There they could either try to find another boat out of the Philippines or, if necessary, hide in the jungles until it was safe to flee. MacArthur would send them with a letter authorizing military support, as well as grenades and pistols.

Dangerous as it may have been, it was probably the reporters' last chance to leave Corregidor. MacArthur may have been eager to have three fewer mouths to feed and beds to provide, but he also believed that if Mel, Annalee, and Clark escaped, their coverage could help pressure the U.S. government into taking the fight for the Philippines seriously. MacArthur believed that the journalists' unhindered reports to their news outlets could stir enough interest back in the United States to pressure policymakers to send relief to his beleaguered troops. After all, those troops had already lasted much longer than anyone expected, despite their meager supplies.

Half a world away, President Franklin Roosevelt delivered a fireside chat urging the nation to maintain its resolve. The radio address marked the first time the White House made public its Europe First strategy, and it didn't sit well with Americans enraged by the attacks on Pearl Harbor.

The very next day Americans also learned that around the same time Roosevelt was delivering his speech pressing the United States to prioritize the drive against Hitler, a Japanese submarine had surfaced off the coast of California and shelled an oil field just north of bucolic Santa Barbara. The oil field was surrounded by little more than patches of sagebrush and some live oak stands and a few frightened horses, so the damage was nil. Still, the wounds from Pearl Harbor were raw.

This was the first attack on the continental United States since the end of the Civil War, nearly three-quarters of a century earlier. Though the shelling was an attack of opportunity

by the submarine's captain, not part of a larger assault, it rattled the nation and stoked fears that an assault on the West Coast was coming.

Earlier on the day Roosevelt publicly defended the U.S. government's lack of reinforcements for the Philippines, he secretly ordered MacArthur to leave the Philippines. Roosevelt wanted the general in Australia to serve as Supreme Allied Commander in the South Pacific.

MacArthur, Mel wrote, "must have been boiling" inside, especially after having just promised the forces under his command that reinforcements were coming. In January, Roosevelt's State of the Union Address had pledged that the United States would produce 45,000 combat planes in 1942 and 100,000 more the following year. MacArthur knew that not a single one of those planes would be made available to the U.S. forces in the Philippines. Roosevelt's evacuation order, meanwhile, reinforced existing perceptions that MacArthur had abandoned his responsibilities when he issued the Open City declaration in Manila and took shelter on Corregidor. Now the general would either have to defy Roosevelt's orders or leave behind the tens of thousands under his command—even as they lacked the supplies necessary to maintain their fight—and confirm those perceptions that he was a coward.

Still, Roosevelt's order came as no surprise. Since the beginning of the year, American submarines had been secretly spiriting away crucial documents and millions of dollars' worth of gold that had been brought to Corregidor when Manila was evacuated, and the subs had also taken key officers and civilians from Corregidor. By the end of February 1942, the subs had helped 200 people escape in an effort to limit losses from what many privately acknowledged was inevitable defeat. But MacArthur's troops held on in Corregidor and Bataan for far longer than other Allied strongholds in the Pa-

cific. They might have survived for even longer had they been properly supplied.

But they were forced to fight with few resources, and inevitably defeat loomed for the "Defenders of Bataan."

Two weeks before he would finally evacuate, the general paced through his cramped command center, explaining the escape he'd arranged for the journalists. Never letting his grip slip from his long, black cigarette holder, he stopped moving only to issue orders to subordinates.

The plan for Mel, Annalee, and Clark would require them to piggyback on a secret mission that was already under way to smuggle supplies past Japanese lines of control to Bataan and Corregidor. Without a convoy to reinforce Bataan and Corregidor, conditions had been worsening daily. Though the United States still controlled much of the Philippines, there were few routes available to get supplies from unoccupied islands past the Japanese blockade.

Japan had yet to invade the Visayas, a group of islands in the central Philippines. One of those islands, Cebu, had become the primary staging point to transfer on to Corregidor and Bataan the food, ammunition, uniforms, or other matériel that came from the other islands or from farther away.

The U.S. Army Transportation Service still needed ships to get those supplies past Japan's blockade and into Bataan, so Major Cornelius Byrd of the ATS searched Cebu for private ship captains willing to smuggle supplies for him. There were two things he needed for the mission to succeed besides their willingness: a boat small enough not to attract too much attention from a distance, and a boat that didn't burn coal or diesel, because their exhaust would be easily spotted by Japanese patrols.

One of the many small vessels that regularly traveled between the various Philippines islands would be ideal.

The first ship Byrd identified for the Corregidor supply mission was a 700-ton inter-island freighter called the *Princesa de Cebu*. The *Princesa* successfully pierced the blockade and arrived off Corregidor in the dead of night on February 21, two days before MacArthur called the meeting with the journalists. Though the ship brought as much food as it could carry from Cebu, it was still a tiny vessel. The smuggled rations could feed the troops on Bataan for only two days—which was far from what was necessary to substantially maintain their resistance.

The *Princesa* was the central piece in MacArthur's plan for the journalists. He had arranged for the *Princesa*'s crew to take Mel, Clark, and Annalee on their journey back to Cebu. Amid Cebu's relative calm, the journalists could seek another boat or a plane to transport them the remainder of the way to the safety of Australia. While the general may very well have seen the reporters' safe escape as an opportunity to get the word out about Corregidor's pressed conditions, it was a spontaneous plan, not part of the *Princesa*'s original operation. The plan could still put the reporters and everyone else involved at considerable risk.

MacArthur spent an hour with Mel and Clark. While describing the plan, the general frequently interrupted himself to explain his interpretation of how Bataan and Corregidor mattered to the larger U.S. fight and to share his analysis of the strategic situation in the Pacific. Finally, however, the general stopped pacing and looked at the reporters one more time.

"Get rid of your khakis, arm yourselves every time you make landfall, and travel only at night," MacArthur advised.

Then he looked at his chief of staff, Major General Richard K. Sutherland.

"Dick, make arrangements immediately," he ordered.

Sutherland gave Mel and Clark each a .45-caliber pistol, a grenade, a rifle, and a small amount of ammunition. He also gave them copies of a letter with MacArthur's signature instructing any American forces they encountered to render whatever aid they could to the escapees. Though carrying firearms could have endangered the journalists and would normally be inadvisable for war correspondents, this was an extraordinary circumstance.

MacArthur turned back to the reporters, his cigarette between his lips, and shook their hands.

"I believe you will make it," he said. Then he looked at Mel. "Say goodbye to Annalee for me."

As soon as he left MacArthur's office, Mel found Annalee in the ladies' lateral. The couple then headed to MacArthur's personal quarters so they could bid farewell to the general's wife, Jean, whom they'd befriended over the six weeks they'd been on Corregidor, and the MacArthurs' four-year-old son, Arthur.

Though MacArthur's own order to withdraw was a closely held military secret, many of the officers circulating through Malinta's tunnels appeared to know something was up. As the Jacobys left the tunnel and made their way to the North Docks, they exchanged glances with many of the friends they'd made.

"We could say goodbye to but a few officers, but there were some seemingly knowing nods from friends who must have known we weren't just bound for the Bataan front to get more stories," Mel wrote.

Just before they left, the Jacobys ran into Diller and Huff. Both press officers knew of the reporters' escape plans. They had a bottle with them. As they said good-bye, Diller poured a round of drinks.

"To our next drink," they toasted.

As Mel prepared to leave—he and Annalee carried only small packs and reluctantly left their typewriter behind—he also made one last radio dispatch.

"I will be very busy on an important story for the next few weeks, so don't query," he radioed Hulburd, closing the cable with the telegraph code reporters used to communicate that a dispatch was completed and that further information was not on its way: "This is message thirty."

Hours after the toast with Colonels Diller and Huff, Mel and Annalee crossed the two miles to Bataan and wandered the network of tree trails hidden beneath the jungle's canopy one last time. By this point, the two were familiar enough with the paths that they could follow them without a guide. They sat down beneath a thick knot of banyan trees near the shore to absorb their last moments on the peninsula.

"We sit by the side of a Bataan roadway waiting," Mel wrote. "Our visions of past months of war are vivid, clouded only momentarily during this waiting by thick sheets of Bataan dust rolling off the road every time a car or truck races by. We wonder for a moment when we will return—and how."

Finally, escape was in sight. At dusk, a launch would arrive to take the Jacobys to the *Princesa de Cebu*. That ship, they hoped, would then slip past enemy patrols at the mouth of Manila Bay and carry the reporters through the Philippines—possibly even farther across treacherous, Japanese-controlled sea-lanes and on to refuge in Australia, thousands of miles to the south.

Through a pair of binoculars borrowed from a soldier on the Bataan coast, Mel peered south toward Manila. He could see the rising sun of the Japanese flag fluttering over the Manila Hotel, the same place where he'd had his last Christmas dinner,

where Annalee had danced with Russell Brines and Clark Lee had urged Mel to flee the Philippines. He knew that Carl and Shelley were somewhere beneath that fluttering crimson-and-white banner. A reliable confidential source had told Mel that the Mydanses were among the thousands in captivity at Manila's Santo Tomas University, which the Japanese had turned into an internment camp. However, it had been a month since that report.

That day Mel and Annalee felt as "impregnable as the mountain," almost invincible "for the first time in this war." Finally, they were leaving, Mel wrote, recalling people and moments from his six weeks on Corregidor and Bataan. Leaving everything. Leaving General Douglas MacArthur. Leaving the general's trusted lieutenants, who had become their friends. Leaving the scores of men they'd met at the front whose stories had yet to be told. They were leaving all of them behind, "most of all the scared Pennsylvania soldier who ran the first time he heard [Japanese] fire but who braved machine gun fire the second time to carry his officer off the field."

As the Jacobys walked along the tree trail, a Jeep carrying two officers skidded into the dirt. The noise and dust shook Annalee and Mel back into the moment. They stood up and greeted the officers. It was the first time Mel really registered the weariness on the faces of those fighting in Bataan. Despite the fatigue in their eyes, neither officer mentioned their exhaustion. Instead, they chatted casually, sharing rumors and battlefield legends until the soldiers finally drove off a few minutes later. Mel and Annalee again turned to thoughts more hopeful than the soldiers' exhaustion. Like thoughts of ice cream sodas. Could they ever taste as good as they imagined?

Finally, the sun began to set. It was time.

The couple ran back toward the shore along the tree trails. One path led to the last American planes remaining in the Philippines, the rickety trainers, a couple of obsolete fighters, the P-40 so "full of holes." The planes were hidden next to an airstrip that resembled a hiking trail more than a runway.

Mel and Annalee were barraged by memories at each turn. They passed anti-aircraft batteries, a motor pool, a machine shop, even a bakery (though one that had never had bread to bake) and a makeshift abattoir where first caribou, then mules, then even monkeys were slaughtered for the soldiers' meals.

Across the narrow channel from Bataan, Clark Lee had finished wrapping up his own affairs on Corregidor, and now he was waiting for the Jacobys at the same dock on the island's north side where the trio had come ashore on New Year's Day. He did bring a typewriter, as well as a razor, a toothbrush, and a change of clothes.

The *Princesa* approached at dusk, slowly steaming westward. They boarded and were greeted by four British and two American civilians who had received field commissions after fleeing from Manila to Bataan. They had boarded the *Princesa* from a separate launch earlier. Among them was Lew Carson, a Shanghai-based executive for Reliance Motors hired by the army to help manage its motor pool, and Charles Van Landingham, a former banker who escaped to Bataan on a tiny sailboat on New Year's Eve. Also a contributor to the *Saturday Evening Post,* Van Landingham was struck by how deceptively peaceful the green jungles of Bataan looked as he left:

"It was hard to realize that under that leafy canopy thousands of hollow-eyed, half-sick men stood by their guns, fighting on grimly in the hope that help would come before it was too late," Van Landingham wrote.

Its lights dark, the *Princesa* slowly made its way into mine-laden Manila Bay. Huge searchlights on Fortuna Island scanned the sky above the island as its "ack-ack" guns—anti-aircraft artillery—fired at Japanese bombers. The darkness gave way momentarily to the glow of the guns' tracers, which lit the passengers' faces. Then night returned across the ship's deck.

From Corregidor, a searchlight swept the coast in front of the *Princesa*. A small, fast torpedo boat appeared and led the ship through the mines, barely visible but for the path carved by its wake. The craft was skillfully piloted by Lieutenant John D. Bulkeley, who provided a few minutes of covering fire while guiding the *Princesa* toward the mouth of Manila Bay. Then, in a final farewell gesture, Bulkeley flashed the torpedo boat's starboard light and roared back to Bataan, leaving nothing but darkness in his wake.

Night on the Pacific washed across the *Princesa*. Only the distant flash of Japanese artillery punctuated the dark. The ship's two masts bobbed beneath what Mel's eyes found to be a "too bright moon." This was the same moon the soldiers on Bataan prayed would descend quickly, lest even a quick glint of its light across a shining service rifle's barrel draw a sniper's bullet. Now the moon cursed the *Princesa*. The nearby shore was dark, but everyone aboard the *Princesa* knew it crawled with enemy forces. They silently watched the passing islands. Each lurch of the ship tied the passengers' stomachs in a "tight feeling."

A crew member snapped a chicken's neck. The reporters jumped at the bird's sudden, loud squawk.

It was just dinner, but everyone crossed their fingers.

"Sure, we'll make it," someone said. "Easy."

All three reporters rapped their fists on the wooden deck.

Nobody slept. Everyone kept watch, fearful of missing even the briefest moment of movement. Finally out of Manila

Harbor, the ship maneuvered toward the southeast and crept through the darkness along Batangas, on the Luzon coast south of Manila.

Thousands of miles, countless inlets and islands, circling recon planes, even submarines and destroyers dispatched by the Philippines' new conquerors lay between the reporters and safety in Australia. They spoke little. Instead, they reflected privately on the soldiers they had met on Corregidor and Bataan, the onslaught both places had endured, and their own good fortune so far.

"We talk very little sitting on deck now. We are remembering MacArthur's men, how hard it was to finally leave, how lucky the three of us are. We'd gotten through the [Japanese] before," Mel wrote. "Everything we've known the past two months is swallowed in blackness beyond."

FALSE CONVOY

On February 24, 1942, a battle group led by the USS *Enterprise* attacked Wake Island. The same day, Allied forces led by British general Archibald Percival Wavell began withdrawing from the island of Java. And in Los Angeles, California, anti-aircraft gun operators saw what they thought was an invading plane, panicked, and shot more than 1,000 rounds of ammunition at bombers that were not there.

Residents of a village in the Philippines watch anxiously as the *Princesa de Cebu* approaches during its flight from Corregidor. *Photo by Melville J. Jacoby.*

That morning, along the northeast side of the Philippine island of Mindoro, the secluded bay of Pola was quiet. A small ship, the *Princesa de Cebu,* was anchored a few hundred yards from shore. On board, its crew and passengers ate a slow breakfast of canned corn beef. There was even time for watery coffee.

A small river led from the middle of the bay into a mangrove swamp. Small clumps of buildings with walls and roofs made of dried palm fronds were wedged between the river mouth and a hillside rising from the west side of the bay. A beach ringed the entire bay, and behind it and the structures rose a wall of slender trees.

No signs of life in the village were visible. The morning was deceptively peaceful. No artillery boomed. No bombers roared the morning awake. One hundred or so miles southeast of Bataan—though the *Princesa* had sailed a longer course through the darkened waters to get there—the awakening world on Mindoro seemed "luxurious."

The morning sun cast the surrounding jungle's trees in so many different shades that some broad fronds seemed almost yellow; others displayed the luxuriant green of a deep forest, while still others sparkled in emerald. Carabao lumbered through nearby fields as egrets lazed on their backs. Bright and blue, the sky stretched from the foothills of Naujan Mountain across the bay's lowlands toward prominent Mount Dumali and bathed Pola in sultry heat.

No sooner had Mel, Annalee, Clark, and the other passengers emptied their tin coffee mugs than a distant engine's whir pierced the morning calm. The whir came closer and grew into a sputtering racket as a small plane appeared high above the boat, circling in the sky.

Everyone on the *Princesa* was certain of the plane's identity. It looked and sounded just like a Japanese reconnaissance plane

with a loud engine that flew over Corregidor and Bataan every morning, photographing defenses and identifying artillery positions before air raids.

"Photo Joe" they called it. Joe may have been on his way to set the scene for another pummeling of Corregidor, but the fact that he was circling above the bay wasn't encouraging. Barely out of Corregidor, had the *Princesa* already been spotted?

There was no time to waste. The pilot might have already radioed his headquarters. A squadron of Japanese planes could arrive any second and annihilate the *Princesa*. It wouldn't be safe to be on board the boat until the sun set.

"Two Japanese cruisers were sinking everything afloat in Philippine waters and bombers were getting the ships the destroyers missed," Annalee wrote.

Mel and Clark grabbed the pistols and grenades that MacArthur had given them on Corregidor as everyone jumped into a rowboat and paddled toward shore.

As the group reached shore, they could see that the buildings along the bay front were empty. Pola looked like a ghost town. The only sign of life was a fat pig scampering across the dirt road between the vacated buildings. Had the village already been abandoned? Had a Japanese landing force invaded Mindoro and rounded up the villagers?

Suddenly, just as the launch came near shore and pulled alongside an empty *banca*—a small outrigger canoe—the village sprang to life. Dozens of people emerged at once from the trees. The villagers and the city's constabulary had kept a close eye on this mysterious ship when it arrived overnight. As soon as someone saw its launch headed toward the shore and their village, they'd alerted the town and everyone raced into the jungle without even closing their front doors.

Once scouts at the jungle's edge saw the dinghy's American flags, they raced back toward shore. Clad in khaki shirts and

white shorts, a few villagers—many of them children—were led by a police captain gripping a sawed-off shotgun. The newcomers remained wary at first, but soon relaxed. Smiles spread across the Filipinos' faces. Most kept a keen eye on the weapons attached to Mel's and Clark's belts. Mel watched a conclusion form in anxious eyes.

"You're the reinforcements, finally come from America!" a voice shouted in English. It was the town's mayor, a schoolteacher and former commonwealth official. He welcomed the visitors.

It was a heartbreaking exclamation, but the Jacobys and their friends couldn't correct them. They didn't know yet who else might be on the island. They would have to be discreet if they were going to make it out of the Philippines without being captured. Just being on a freighter had already made it hard enough to stay hidden. In any case, there wasn't time for small talk until they knew that Photo Joe wasn't coming back. As they stepped onto the sand, the reporters anxiously scanned the sky.

Then one of the British businessmen they were traveling with blurted out that they weren't reinforcements. They'd only come from Bataan. The crestfallen mayor seemed to deflate when he realized what the Brit was telling him.

Mel, Annalee, and Clark were stunned that their companion had spoken so clumsily. Rumors spread fast among the villages peppering the Philippines—millions of Filipino civilians had fled Manila and other cities to the jungles after the Japanese occupation began. Some among the millions, though not all, were surely hangers-on of the Sakdalistas who assisted Japan's fifth-column work. Should they or other spies be hidden among the Pola villagers, or if they knew a boat full of Americans escaping Corregidor had slipped past the Japanese blockade, they might inform Japanese forces. This threatened

not just the *Princesa* and its passengers but the entire blockade-running operation.

Though the townspeople were disappointed to learn that there wasn't help coming to the Philippines, they welcomed Mel and the *Princesa*'s other passengers. They had been listening to Carlos Romulo's "Voice of Freedom" and other broadcasts about the war, and they were eager to learn more about how it was progressing. To Mel, the questions were "eager." To Clark, they were "embarrassing." To Annalee, they were constant.

"We heard the same thing over and over—'We love America. We want to fight. We want to help fight. But when are the American planes coming?'" she wrote.

As Pola's residents welcomed their Western visitors, their children raced to their homes and the jungle and returned with gifts of coconuts and bananas. By that time, the sun was high. Whether Photo Joe had seen the *Princesa* or not, there was nowhere safe for the travelers to sail until the sun set again, so the mayor invited the group to lunch.

"We stuffed ourselves with this welcome change from the corned-beef hash of Bataan, and then spent the day sleeping in the shade of the tall palms," Van Landingham wrote.

Wine flowed readily, and the reporters' hosts toasted and boisterously cheered the United States. Praising "MacArthur, Bataan, and America over and over again, always pointing to their bolos significantly," the Filipinos showed their eagerness to take up the fight alongside their rank-and-file American allies holed up on Corregidor and Bataan. "They are waiting for the convoy from America too. It is the same on every island."

After the meal, Mel took numerous pictures. As he did, Annalee sat down next to an outdoor upright piano, surrounded by a dozen or so women from the village. A grinning little girl in a polka-dot dress played an impromptu concert. Occasion-

ally a teenager sat down to play alongside the girl. While Annalee watched, smiling, one of the other Americans sprawled in a nearby chair, looking relaxed. For at least this instant, life won out over war. Mel captured the afternoon in his lens.

As the sun began to set, Mel, Annalee, Clark, and the rest of the passengers on the *Princesa* returned to the ship. Now that it was getting dark, they'd be safe from bombers and Photo Joe. They sailed around a knot of land east of Pola, then turned southward into another night.

The Philippines comprise 7,000 islands—about 2,000 of which are inhabited. Each night, the *Princesa* sailed from one to another. Cebu was only 200 miles or so away from Pola, but the ship had to inch carefully through the islands. Each day its passengers disembarked on the closest shore and waited until they could continue their journey the following night. Each leg of the trip was relatively short. After the *Princesa* left Pola, it crossed the Tablas Strait to the island of the same name, then continued south along its western edge to sheltered Looc Bay, a journey of about eighty-five miles. There the group found a few bottles of the Philippines' ubiquitous San Miguel pale pilsen beer.

"It was warm, but tasted like champagne!" wrote Van Landingham.

Though they had to wait until the skies darkened to sail further, the night brought no relief. Mel, Clark, Annalee, and everyone aboard the *Princesa* took turns as the ship chugged through the night. The jittery lookouts imagined an ocean of dangers. "Each little fishing boat we passed might be a [Japanese] patrol boat," Mel wrote. "Countless fires on the islands where farmers were burning their fields were possibly signal fires. The fires bothered us most."

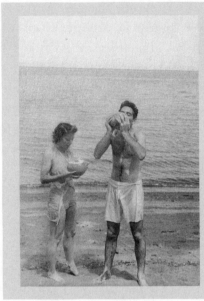

Unable to sail by day, Melville and Annalee Jacoby eat coconuts and swim in the Pacific while waiting for the next phase of their escape. *Photo courtesy Peggy Stern Cole.*

As frightening as each night was, the days began to seem like a tropical, if absurd, vacation. In the mornings, there was little to do besides eat, drink, and swim. They reveled in left-behind cases of San Miguel. There was always the fear of being spotted, as they had been that first morning, but the days lacked the uncertainty that accompanied each dark night.

"Every night on the ship we thought we'd die before morning," Annalee wrote. "But every day was a wonderful vacation ashore eating eight meals and swimming in makeshift bathing suits."

Annalee cut a polka-dot dress into two pieces, tied half of it across her chest and attached the other piece around her waist with a safety pin, creating a hand-made bikini. Mel repurposed his white boxer shorts into swim trunks. They let the warm inter-island waters wash the war from their bodies, if only for a moment.

Like thousands of newlyweds to come, they spent these

mornings splashing in the Pacific and laughing. Using bor-
rowed bolos, they sliced coconuts open. As the ocean splashed
around their feet, they lifted the fruit with both hands and
drank thirstily of the translucent juices spilling over their lips.
They lingered, smiling together on the shore, Annalee's clothes
clinging to her curves, Mel's soaked chest hair matted against
his skin.

Hundreds of Filipinos just like the ones in Pola greeted the
ship as it slunk through their country. At nearly every stop,
villagers waited on the top of portside steps or at the edge of
beaches. Eager and curious to meet their surprise guests, most
of them, especially the kids—wearing Mickey Mouse and Pi-
nocchio sweatshirts—were joyful hosts. If any of the people
they met were Sakdalistas, neither Mel nor Annalee seemed to
know. Instead, the couple felt welcomed, and they felt a shared
sense of purpose.

Despite the questions that Filipinos had for Mel and Clark
and Annalee, their lives at first seemed to proceed as normal.
The Philippines would suffer tremendously during the war,
and Filipinos' daily lives were about to be violently disrupted.
The Pola residents' anxiety when they first sighted the new-
comers reflected their fear of what might have been on the way
and what the *Princesa*'s arrival could have signified. Each village
seemed to have heard a different rumor about Japanese soldiers
raping and pillaging their way through Luzon. Nevertheless,
until whatever was to come actually arrived, life on the unoc-
cupied islands could proceed much as it always had. They had,
after all, been subject to U.S. rule for decades, and before that
for hundreds of years under Spain.

"They are short on food," wrote Mel, pumping up the
pro-U.S. propaganda as he continued. "Shipping has ceased

entirely. They have no currency, and no trade, but they are willing to wait. They have been raised by Uncle Sam and they are as good movie fans as the average American."

This is not to say that the villagers were not preparing for war. In each place the *Princesa* stopped, Filipino men proudly displayed their long, sharpened, machete-like bolos. In others, eager recruits clamored to join up, even though they were underprovisioned.

"You see a band of newly organized soldiers wearing blue denims; they have seen pictures of machine guns but never touched one, they've been taught how to use an army grenade but all they have is a Coca-Cola bottle filled with powder filched from a [Japanese] mine which broke loose and floated nearby," Mel wrote.

Rather than run from the Japanese, who seemed impossible to escape, many Filipinos continued to paddle bancas into placid waters and spear fish until the nets full of their catch sagged. They continued to welcome friendly newcomers with wide smiles and platters overloaded with ripe green mangoes and bananas and to nudge their shy, smiling children to play the piano for unexpected guests. The sun shone and the breeze laconically tousled the palms, the pleasant weather contrasting with the thorough unpleasantness of war.

Idyllic waters lapped at the edge of each bay, but on nearly every shore anxiety still filled the faces of the villagers whom Mel and Annalee encountered. In each place the *Princesa* stopped, people desperately hoped the ship was the spearhead of a convoy; to a person, each time, they deflated when they realized the ship and its passengers were all alone.

Nearly every villager seemed to have a story to share with the traveling reporters, harrowing accounts of looted villages and

farms, townspeople forced into hard labor, and sisters, mothers, and daughters raped by the invaders. One town's residents told of Japanese neighbors who lived quietly in the community for years, then vanished when the war started, as if they had been preparing for an invasion since they arrived.

In another village, the reporters heard, hundreds of people who had never seen an airplane came out to watch a squadron's approach and were killed by bombs. Filipinos on the island of Masbate described how American miners had been rounded up, tied to poles, and carried off by the occupiers. The Filipinos often implored their powerless visitors to send them arms so they could carry out guerrilla raids on the Japanese. All the boatload of journalists could do was promise to tell their story.

Filipina villagers entertain Annalee Jacoby during her escape from Corregidor. *Photo by Melville J. Jacoby.*

On the third day of their trip, the group came ashore at Estancia, a small village on the northeast corner of the island of Panay. Clark wrote that he, Van Landingham, and Lew Carson hired a local driver to take them to the city of Capiz (present-

day Roxas City). The three were amazed that they could buy Coca-Cola and chewing gum and newspapers there, and that one of the two girls they offered rides to along the way had just won a beauty contest.

"We had forgotten there were such things as beauty contests and beauty parlors," Clark wrote.

But fear returned that night. First, two Japanese planes flew low over Clark and the others as they returned from their expedition to Capiz. Then, at dusk, as the *Princesa* prepared to leave Estancia, Mel noticed a German priest taking note of them as they left port. While Clark and Van Landingham worried about bombers, Mel worried about signal fires.

As soon as the *Princesa* pushed off, a huge fire erupted on the hill behind the ship. Suddenly, the sky lit up as another fire ignited in a straight line across the bay. Everyone had been certain they were signal fires similar to what collaborators working with Japan had used early in the war to guide Japanese planes to American airfields and other targets. This would be their tensest night yet.

"Fine. Travelling. Love. Annalee."

On February 27, this concise telegram showed up in Bethesda, Maryland, where Annalee's parents now lived. The overjoyed Whitmores dashed off a letter to Elza and Manfred Meyberg, their new son-in-law's parents.

"I'm so happy and grateful I can hardly write," Anne Whitmore wrote. "Won't it be wonderful when we get our next cable telling where they're going? I do hope it's home."

In Los Angeles, just after 10:30 that morning, the Meybergs received a similar note from Mel. All either family had known up until then was that their children were safe, that they had made it to Corregidor, and that they were somehow able to get

word through the State Department to Henry Luce, who had passed word on to the Meybergs through David Hulburd.

The telegram had been radioed from a place called "Cebu." On the sheet the Meybergs received, someone had penciled "Below Luzon," as if that person had just looked up where Cebu was located. That same day, four days after leaving The Rock, the *Princesa* arrived at Barili, a small port on the west side of the twenty-two-mile-wide island about 350 miles southeast of Corregidor. No bomber had seen the German priest's signal fire and attacked the *Princesa*. No enemy destroyer had intercepted the ship as it crept around the island of Negros toward Barili, roughly 100 miles away from Estancia.

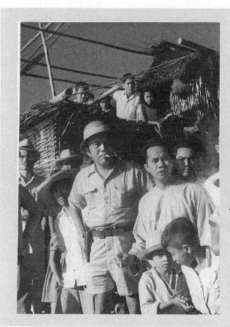

Filipino men look out to sea from the shore of one of the islands visited by Melville and Annalee Jacoby during their escape from the Philippines. *Photo by Melville J. Jacoby. Courtesy Peggy Stern Cole.*

Cebu was still under American control. In Barili, after disappointing the mayor with the news that they weren't reinforcements, Mel, Annalee, and Clark found someone to drive

them over the mountain spine that ran along the length of the island, then north along its eastern shore. They drove past cattle, rich farmland, and even stocked food stores. It was difficult to believe what they were seeing after six weeks of deprivation and violence on Corregidor and Bataan.

"With its sugar plantations and fruit trees and homes with bright-colored roofs, the island looked like the most beautiful place we had ever seen, and the most peaceful," Clark wrote. Finally they reached Cebu City, the provincial capital, where they found a small American garrison and some sense of normalcy.

But bad news arrived in Cebu as well. George Rivers, one of the businessmen on the *Princesa*, had fallen ill with dengue fever and was getting worse. Lew Carson and the British passengers who had joined from Bataan took Rivers straight to Cebu's hospital. At first, the medical attention seemed to make a difference. Rivers's illness began to turn, and he left the hospital. But he had been weakened by the disease. On March 5, less than a week after they arrived at Cebu, the Brighton, England–born Rivers succumbed to a sudden heart attack. He was thirty-three years old.

While Rivers's friends said farewell to their companion, the Jacobys and Clark Lee got back to work. Thanks to the letter of introduction that MacArthur wrote before the reporters left Corregidor, military officials on Cebu granted the reporters access to the island's wireless transmitters. They were able to use these to assure their families that they were okay. But lest they tip off the Japanese to the blockade-running operation if their messages were intercepted, they couldn't provide many details. The messages carried location stamps that said they were on Cebu, but they couldn't describe the details of how they made it off Corregidor, which islands they'd stopped at on the way, how long they might be on Cebu, or where they might go next. Such details might also risk the lives of hospi-

table islanders like the ones who'd welcomed them in Pola and on other islands.

At first, the war felt distant in Cebu City.

"Cebu brought back memories of Manila just before the invasion," Van Landingham wrote.

Whereas Corregidor's Topside cinema had been bombed out, Cebu's movie theater was still functional, though the two films it showed were months old. There was one bar still open in the city, though only a few cases of whiskey and yet more San Miguel beer remained on hand.

These businesses were closed from 10:00 A.M. to 3:00 P.M., when air raids were most likely. The scattered customers who came to them lived in the canyons surrounding Cebu. About seventy American civilians—mostly businessmen—had abandoned their jobs as representatives of Western concerns based around the island and escaped to the relative safety of the city's canyons.

"There was an air of impending disaster," Van Landingham wrote. There had already been air raids of strategic targets on nearby islands. Two enemy cruisers were known to be prowling the waters of the Visayan island group. It was only a matter of time before Japan invaded Cebu.

Cebu's American residents left behind golf courses and beach clubs and made spartan new homes out of makeshift hillside shacks. Some of them joined the soldiers stationed on the island, as civilians from Manila had done on Bataan, but the rest rarely left the hills. The city's streets felt ghostly and were mostly deserted, with the exception of the few people who slipped into town for supplies or drinks.

"It is amazing to see Americans having cocktails before dinner so close to Bataan and Corregidor where we had been, yet

feeling that the [Japanese] would come in momentarily," Mel wrote.

Wedged between beaches and the island's hills, Cebu might have been called a sleepy town under different circumstances. Despite the town's somnolent character and mostly empty streets, after all the thatch-roofed villages and nipa huts, not to mention bamboo hospitals, dust, and tunnels, Cebu City seemed, to Clark, "as big as New York, even though it [has] only one five-story 'skyscraper.'"

That "skyscraper" would briefly house Mel and Annalee. Major Cornelius Byrd of the U.S. Army Transportation Service lived in the building's penthouse apartment. Byrd had organized the blockade-running effort that sent the *Princesa* to Corregidor. He invited Mel and Annalee to stay in his apartment for the first few nights after the *Princesa* arrived. This gave Mel and Annalee some semblance of a return to the honeymoon that had been cut short by the war's arrival.

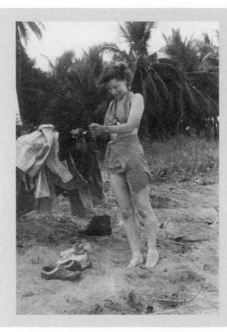

Annalee transformed one of her outfits into a makeshift bikini to use while fleeing Corregidor. *Photo by Melville J. Jacoby.*

From a base known as Camp X, Colonel Irving C. Scudder commanded U.S. forces on the island, such as they were. Scudder gained command of the island in January, after General William F. Sharp departed for Mindanao. Scudder was left in charge of a garrison known as the Cebu Brigade, which consisted primarily of incompletely trained Filipino troops and a cobble of antiquated defenses, the most prominent of which was Fuerte de San Pedro, a triangular stone fort built 200 years earlier by the Spanish to repel Dutch pirates and other attackers.

Aside from the fort's rusty guns, there were few other defenses to speak of. As threatening as Cebu's defenses may have seemed half a century earlier, they would now likely be inconsequential for the modern Japanese ships sailing somewhere beyond the horizon. Soldiers and civilians alike knew this, and any approaching boat rattled Cebu residents, who were as "jittery as race colts."

Two days after the *Princesa* arrived at Cebu, Mel saw that they had good reason to be so jittery. Early on the morning of March 1, spotters saw two large, dark shapes unexpectedly appear off Cebu's harbor. It immediately became clear that these were the two Japanese ships that patrolled the inter-island waters of the Philippines. Converging on Cebu on their way south toward an operation off the island of Mindanao, the ships—the 532-foot light cruiser *Kuma* and the 290-foot Ōtori-class torpedo boat *Kiji*—detoured toward Cebu and opened fire on the city's docks. The shelling destroyed three inter-island transports docked at Cebu, the *Regulus,* the *Lepus,* and the *Legazpi.* According to various histories, more than 300 people died in the attack. No doubt as a result of censorship concerns, neither Mel, Annalee, nor Clark made any mention of the attack; Carson would later mention it briefly in a private letter. Van

Landingham would include the attack in a story about his trip through the Philippines, but he sanitized the attack's damage.

"One [shell] struck the old Spanish fort," Van Landingham wrote. "Others fell harmlessly into the bay."

As in Manila Bay, scuttled ships littered the seafloor off Cebu, while the ruins of sabotaged oil facilities stretched smoldering across the marshy expanse of flatland just north of the port. All the bridges into town had already been demolished, leaving the lightly undulating road between Liloan and Cebu City one of the capital's few access points. On the island's only airfield, the Americans had intentionally torched the remaining airplanes to keep any resources out of Japanese hands.

Cebu was the end of the line for the *Princesa,* which would continue its operation smuggling supplies to Corregidor and Bataan. Its passengers would need to find another way off the island. Thus, their energies turned to brainstorming yet again how they might flee to safety. As the Jacobys settled into their "honeymoon suite" in downtown Cebu, Byrd provided a car and a driver to Clark, Van Landingham, and Lew Carson. The trio drove fifteen miles northeast of the city, past a series of lagoons, to the Liloan Beach Club. There they made a home for themselves as they waited for another ship to visit the island. After a few days on their own, Mel and Annalee joined their traveling companions at the clubhouse.

The beach club's "postcard beauty" comprised a sliver of sandy beach lined with swaying palm trees hugging a crescent-shaped bay. In front of the club, silt deposited by the Jubay River created a six-meter-deep shelf that turned the water a dusty but turquoise-tinged brown. About 500 meters from the shore the waters darkened to sapphire right where the seafloor dropped 600 meters beneath the surface.

Roughly in the center of the crescent, the plaster-coated clubhouse looked whiter than possible in the March sun. The blazing lightness of the club's walls stood out above the tropical waters, the building's Spanish-colonial-inspired balustrades too elegant for the harsh conditions of this war and its arched windows an indication of a time now vanished. The club's sprawling patio and second-floor deck provided deceptively idyllic vantage points overlooking Liloan Bay. The club felt as if it sat on the edge of the world, but its view was hardly relaxing: the same shelf that stretched placidly under the surface of the bay made the cove a perfect landing spot for potential invaders, whose ships could anchor right at the nearby drop-off.

The danger was so great that the island's defense also required vigilance from the Liloan Club's new inhabitants. Each of the people staying at the club volunteered for two-hour shifts to stand watch over the bay. Should a vessel approach, they'd not only be able to alert a nearby contingent of Filipino scouts, they might also get a jump-start on an escape before word circulated that Cebu's tranquillity was nearing its end.

Given as much privacy for their "honeymoon" as the group's constant vigilance could afford, Mel and Annalee combined their watch shifts once they finally joined the others at the club. Clark, Van Landingham, and Carson slept on the beach club's porch, while Mel and Annalee slept in the main building. When they were on watch, Mel and Annalee stayed up together for hours. Savoring the chance to be together alone after six weeks of cramped confines on Corregidor and the frightening journey aboard the *Princesa,* Mel was reminded by the warm breezes of his mother's home in Southern California and her prizewinning gardens. As he had done when the raids on Corregidor were at their worst, Mel described Elza's

gardens to Annalee. He didn't spare a detail. The descriptions were as vivid as Mel could make them, and Annalee felt like she was walking in the gardens with him as he talked.

During the day, the Jacobys joined their traveling companions in swimming, playing golf on a vacant course nearby, and talking to the locals. One afternoon, the Jacobys, Clark Lee, Lew Carson, and Charles Van Landingham were the guests of honor at a feast in the Liloan Beach Club's dining room. After the meal, dozens of local Filipinos crowded around the lunch table, laughing and telling stories with the reporters and one another. It was during boisterous moments like these that Mel felt a sense of camaraderie and kinship with the Filipino people that reminded him of how he had felt in Chungking.

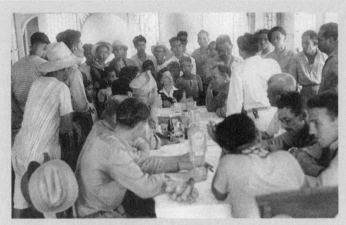

Residents of Cebu, in the Philippines,
share a feast at the Liloan Beach Club with
Annalee Jacoby and other passengers from the
Princesa de Cebu. Photo by Melville J. Jacoby.

Along the beach in front of the shuttered, arching windows of the beach club's faux-Spanish facade, the night was both

welcome and feared. On the one hand, it held Mel and Annalee together. The night, the sand, and the quiet rumble of the ever-crashing sea felt like their own private world. The ocean's murmur matched the murmur in their chests. After so many months of racing beneath foreboding skies, they absorbed the quiet and one another's presence, for once sharing words not with the rest of the world but only between themselves.

On the other hand, danger surrounded them. The moon was too bright for comfort, and their eyes forever scanned the sea for the hunters sure to come.

"The moon rising, shadows, lights, everything kept us on edge," Mel wrote.

In New York, Mel's editors knew little more than what his family had heard after he arrived on Cebu. Annalee had also sent David Hulburd a brief message on Mel's behalf saying that they were "progressing as rapidly as possible" and asking whether they wanted Mel to prepare a report for *Life* on his trip (they did). Mel sent one more brief message two days later, but then there was nothing. Even when the reporters were on Corregidor, Hulburd and his staff had usually had a vague sense of what Mel and Annalee were up to. Now there was only silence.

Meanwhile, on Cebu, Mel, Annalee, and their friends attempted to repair a captured Japanese fishing boat, imagining that they could use it for an escape in case another friendly vessel didn't arrive. If they couldn't fix the fishing boat and the situation became dire, their only choice besides trying to hide on Cebu—which didn't seem realistic—would be to take their borrowed car to the other side of the island, convince a local to row them away in a tiny, rickety banca, and gamble on surviving the vast Pacific, now an enormous war zone.

Mel and Annalee continued to gather notes for their report-

ing, but they couldn't send any dispatches from Cebu. (The wireless station on the island was only capable of sending brief messages.) Hundreds, thousands of words remained unwritten. Dozens of rolls of film remained undeveloped. Countless letters and cables remained unsent. There was so much to say that they couldn't put on the page, and there had been so much more lost to the fires of the Bay View's furnace back in Manila.

While he was in Cebu City, Mel bought a secondhand typewriter so that he and Annalee would have one to use. Mel's "new" typewriter was a Corona Four manufactured in 1930, its black metal frame emblazoned with gold-colored DuCo lacquer. With little to do besides wait for an opportunity to escape and keep watch for the Japanese, and with Annalee there to help and collaborate, Mel began writing a book. First he wrote a long dispatch about what they had experienced since leaving MacArthur's bunker nearly two weeks earlier. Then he started writing about what Manila had been like on the day of the attacks on Pearl Harbor and Clark Field, the events immediately preceding them, and the way those events played out in the Philippines. He also wanted to go further back, to situate the current battle in the broader conflict he'd watched emerge since he was at Lingnan five years earlier. He wanted to illustrate the thread that led from the Marco Polo Bridge incident through to the Pacific war, but with three years of notes in the Bay View's furnace, Mel had to write from his and Annalee's recollections. Nevertheless, he was grateful he had Annalee's photographic memory to help him reconstruct later events.

In the dispatches Mel wrote for *Time* and *Life* while he worked on the book, he reported the conditions he had witnessed on Corregidor and Bataan, as well as the accounts he'd gathered from villagers on the many stops between The Rock and Cebu. He hoped to describe the situation well enough to convince the American public to insist on aid for the Philip-

pines, and his dispatches described the Filipinos' eagerness to fight the Japanese.

Mel and Annalee had no way to know it yet, but Luce's deputies in New York had already transformed some of the reports they had sent from Corregidor into published stories. One was a narrative describing scenes from the Battle of Bataan—"Our launch works slowly into Mariveles landing and everyone quickly scrambles out," read one of its lines. Another was a first-person account dictated to Annalee by Captain John Wheeler, who commanded the cavalry regiment of Filipino scouts and Americans that fought a delaying action during MacArthur's retreat to the embattled peninsula. Then there was the epic "Corregidor Cable No. 79," which was published by the *Field Artillery Journal* through a special arrangement with Time Inc. It described many of the characters fighting on Corregidor and told their stories, including an account of three "boys" from Salinas, California, whose tanks were ambushed the day after Christmas and who then spent five days hiking through enemy territory back to Manila, one with a rivet from his destroyed tank lodged in his throat.

"All kinds of men make up MacArthur's Army—all John Does and Juan de la Cruzes who have learned to improvise, adopt [Japanese] tricks, and stick it out," Mel had written.

Other memories remained vivid without notes or Annalee's memory. Manila. The people they'd left behind. Two people in particular haunted the couple: their imprisoned friends, Carl and Shelley Mydans. Mel and Annalee still only knew what they'd learned on Corregidor. They knew that the Mydanses were alive and safe, but they also knew from intelligence reports that reached MacArthur's staff that many of the prisoners didn't have enough food.

"We keep thinking about them now," Annalee wrote. "If only they'd come!"

A week into March, a 5,500-ton cargo ship with blue masts and a gray hull docked in Corregidor. Its arrival was a shock, but a welcome one. The vessel, the *Doña Nati,* had brought food, small arms ammunition, and medical supplies all the way from Australia. It took two days for work crews to unload the ship. Built by the De La Rama shipping line, the *Doña Nati* was one of three ships that had successfully slipped through Japanese blockades from outside of the Philippines to deliver much-needed supplies to the islands.

"Some of the most courageous and ingenious people of this whole era were the blockade runners," Rear Admiral Kemp Tolley wrote of the *Doña Nati*'s crew and their counterparts on other smuggling ships.

At first, Cebu was to be the logistical hub for supplying bases around the Philippines, using resources from nearby islands. But then, as the Japanese blockade tightened, U.S. strategists had to look beyond the Philippines for supplies. The closest Allied territory with any kind of resources that could be made available was Australia; Cebu became a base for processing shipments from there before they were sent to Corregidor, Bataan, or islands in the Visayas that the Japanese hadn't yet occupied. But getting from Australia to Cebu involved traversing enemy waters.

The United States therefore needed to entice into service ship captains with vessels capable of making the long, dangerous journey past Japanese-controlled islands and shipping lanes, not to mention patrolling ships. In February 1942, two officers who had been staked with $10 million to disperse among any merchant sailors willing to attempt a trip arrived in Australia. Only ten ship captains answered the call. Of these, seven crews mutinied and forced their captains to turn back before entering dangerous waters. Just three made it all the way, one of which was the *Doña Nati,* captained by Ramon Pons.

Pons had led the *Doña Nati* from Manila on December 8, the day the war started. Colonel Alexander Johnson of the U.S. Army had requisitioned the ship that January and offered Pons four months' salary for him and his crew just to attempt the journey to Cebu, with a bonus of nine months' salary if they returned safely. Pons, who had been blacklisted by a Spanish social club in Manila with pro-Franco sympathies, gladly agreed.

At 4:00 A.M. on March 10, 1942, just three days after the *Doña Nati* arrived, Lew Carson was on watch when he saw a group of soldiers race past the Liloan Beach Club with .30-caliber rifles at the ready. Beyond the soldiers, Carson saw the faint outline of a ship turning toward shore at the mouth of Liloan Bay.

Carson woke everyone else up. Within minutes, a car arrived from the city. An army officer got out and warned the group that they had better pack up immediately and come back to the city. Fifteen minutes later, the group arrived in Cebu and went to Major Byrd's "penthouse."

Over breakfast, Byrd told Mel, Clark, Annalee, Carson, and Van Landingham that word had reached Cebu that a Japanese destroyer was spotted on its way toward the island. The spotters estimated it would be in range of the port by noon. It was 10:15 A.M. when Byrd delivered the news. Crews were still unloading the *Doña Nati* when the ship was seen, but now Pons was preparing to leave.

The approaching cruiser could have been a lone ship on patrol that just happened to pass near Cebu, but it was just as likely that reports had reached Japanese officials that a boatload of Americans had slipped out of Corregidor and were sailing south, calling on the tiny villages peppered across the islands. Perhaps the cruiser now steaming toward the island had been sent expressly to look for those escaped Americans. Or the

many Japanese recon planes that crossed the Philippine skies may have spotted the *Doña Nati* and alerted its base about the plump target. And there was one more possibility that was just as frightening: the incoming ship might have been the vanguard of a Japanese invasion force preparing to capture Cebu.

Whatever the reason the ship was on its way toward Cebu, none of the former passengers of the *Princesa* wanted to stay to find out why. It seemed as though the *Doña Nati* would be the last viable transport the Americans could trust before the invaders arrived. But sailing aboard the vessel carried enormous risk; the De La Rama Steamship Company originally built the *Doña Nati* for transpacific shipping. At 423 feet long, it was the largest vessel around—and thus an easy target for ship-to-ship shelling, as well as any bombers that might also be bound for Cebu.

Another report came saying that the Japanese ship was now just an hour away. There was no more time to wait. As if echoing their New Year's Eve escape from Manila, Mel, Annalee, and Clark ran from Byrd's building and across the park that separated it from Cebu's waterfront to reach the *Doña Nati* as it prepared to cast off. The ship's engines were already churning the water and about to push the ship away from its dock. Because the ship had been in port for only a short time, its crew hadn't had a chance to fill the ship's hold with ballast water to replace the unloaded cargo. Without the ballast, it would be an unsteady ride, especially at high speeds.

Mel, Annalee, and Clark knew that remaining on Cebu was a dangerous prospect, but some of the officers at the docks shouted, as the group ran for the vessel, that with the tall, spindly cargo masts on its foredeck and a three-deck-high superstructure topped with a large smokestack, the *Doña Nati* was

too big a target for a safe escape. The vessel would not only have to maneuver out of port quickly but thread the narrow channel that separated Cebu from Mactan Island and the shallow submerged marshes surrounding it.

"Don't be damn fools," an officer yelled, insisting that they'd never make it out of the bay alive. Mel, Clark, and Annalee hesitated as Carson and Van Landingham ran aboard the *Doña Nati*.

"Come on, Mel," Clark pleaded. "This could be our only chance."

The Japanese cruiser was no more than an hour away from Cebu by that point.

Captain Pons argued with one of the dockside officers about his orders. If he reversed course and headed back to Australia unannounced, any American ship he encountered might not recognize the *Doña Nati* as a friendly ship and sink it on sight. But his vessel would be Cebu's biggest target if he stayed. His only defenses were two 50-millimeter cannons and a small deck gun that the army had installed and manned with six soldiers.

Pons's argument with the land-side officers bought time for Mel, Clark, and Annalee. Byrd told them that he would send a motorboat out with the ship; if the Japanese cruiser arrived before the *Doña Nati* made it a safe distance from Cebu, they could jump and the boat would pick them up, but for now, the reporters couldn't dither any longer. It was time to go. Now. They ran toward the ship just as Pons ordered his crew to cast off the ship's moorings and pull up its gangplank.

Doña Nati's crew still hadn't pulled up its cargo nets. As the ship pushed away from the docks, Mel, Clark, and Annalee grabbed the nets and began climbing aboard. With its cargo hold empty, the ship bobbed and lurched. The reporters clung to the nets as the crew pushed the *Doña Nati* into full steam.

The ropes swaying in their hands, they finally climbed up the side of the ship as it pushed into the waves and away from Cebu.

The *Doña Nati* shuddered as it steamed ahead. The engineer was pushing the ship to try to pick up more speed without the cargo or the ballast. With the Japanese cruiser getting closer, the *Doña Nati* had no time to spare if it was going to escape. The Japanese ship was approaching from the south. If the *Doña Nati* sailed north it could gain time, but that wasn't a guaranteed escape. Even if the Japanese ship didn't shell the *Doña Nati,* it was feasible that enemy bombers might also be on their way. Only clouds could keep such a large ship hidden, but the heartbreaking blue of the clear wartime skies spread as far as the reporters could see.

Catching their breath, and bruised from the climb up the *Doña Nati's* sides, the reporters donned life belts that they would keep on the entire day. Clark sat "cross-legged, cross-fingered and cross-armed again." For the third time in as many months, he, Mel, and Annalee set sail toward unknown waters.

Unbeknownst to Captain Pons and his passengers, while the *Doña Nati* left port, a quick-thinking reserve navy officer in Cebu sent a wireless message to headquarters in Corregidor. The message described the ship, its passengers, and its course. With any luck, Rear Admiral Frank Rockwell, who commanded the remaining naval forces in the Philippines, could warn the rest of the Pacific Fleet that the ship was bound for Brisbane and shouldn't be attacked by American vessels patrolling the South Seas.

While the rest of the American officers garrisoned on Cebu fled the docks in case the approaching Japanese cruiser shelled the island, Captain Pons steered the *Doña Nati* straight across

the channel, then struggled to turn the ship north around nearby Mactan Island. Pons threaded the ocean liner first through the barely half-mile distance between Cebu and Mactan, then around the reefs and mangrove forests along the latter's north shore.

Mel checked his watch. It was 11:30. Spotters had estimated that the Japanese ship they had seen would arrive by noon.

By then the *Doña Nati* had received no further word of the cruiser, and the reporters ate lunch as their ship steamed east around the island of Bohol. At 3:00 P.M. their radio picked up a broadcast from Cebu reporting that a ship had shelled the city, hitting several smaller vessels at the port, then departed for the southeast—the same direction the *Doña Nati* needed to head to get out of the Philippines. They hoped that they were in the clear, since the cruiser and the *Doña Nati* had first gone in separate directions.

Every little fishing boat the *Doña Nati* passed on the journey stood out "like a brick chimney, giving us a chill." That afternoon, after the ship passed the north side of the island of Bohol, someone spotted a camouflaged ship near the Canigao Channel. The *Doña Nati* needed to pass this ship as it steered around the island of Leyte and out of the Philippines. The other ship looked to be anchored, but Pons was unwilling to get close enough to identify the vessel. Then, as the sky darkened, a Japanese recon plane circled above and sped off.

All the fear of bombers and destroyers returned. No planes came, but that probably meant that a cruiser was waiting to catch the *Doña Nati* if it tried to sail through the Surigao Strait, on the other side of Leyte. So Pons steered his vessel farther north to hide in an inlet along the coast of Leyte, near the village of Inopacan.

As he searched for shelter, Pons dispatched one of his officers to shore in a motorboat to investigate the ship that had

been spotted. About an hour later, the officer returned with word that it was not an enemy craft but the *Anhui,* another blockade runner. It had foundered on a reef in the night. The ship carried a Chinese crew and a shipment from Australia of guns, ammunition, mortars, and pepper to make rotting meat palatable.

The next morning another recon plane flew above the *Doña Nati*—Pons later said they had been "circling like buzzards"— then sped off. Gambling that by appearing to head north he could draw the enemy cruiser from Surigao to another strait north of Leyte, Pons continued in that direction at first, then turned back southward. When the *Doña Nati* again reached the *Anhui,* a launch arrived from the other ship asking Pons to help tow her off the reef, and Pons agreed. But it was getting dark, and they had to wait until dawn, when the tide would be high enough.

That morning small craft arrived from Cebu City to help unload the *Anhui* and update Captain Pons on the route he was to take once in the Pacific. Finally they could get under way, but Pons waited until sunset before directing the *Doña Nati* between Leyte and Mindanao, then turned north to continue through the Surigao Strait.

"To me, the trip that night through the strait was the most exciting part of our voyage," Van Landingham wrote.

Fearing they would suddenly find themselves caught in the Japanese cruiser's searchlights, the *Doña Nati* emerged from the strait around three in the morning. Suddenly, with thousands of miles of the Pacific stretching toward the horizon, the reporters had reached the open ocean. They had escaped the Philippines, but now there would be no more shelter.

Finally free of the islands, the *Doña Nati*'s journey at first drifted into monotony. Despite all the excitement that had colored their last months, doldrums became common. Mel and Annalee spent their days sunbathing, writing, and reading old copies of the *True Confessions* and *Amazing Adventures* magazines that were scattered about the ship. A few crew members had ukuleles and other musical instruments. During one of their island stops before Surigao, a monkey had found its way onto the *Doña Nati*. Watching a crewman chase the creature around and around on the ship's deck was a respite from the boredom.

All the while, the thrumming of the ship's engine provided a constant sound track to nervous days that drifted into inky nights and back again. Often, the only other sound was the low, constant gurgle of the sea bubbling in the *Doña Nati*'s wake.

The ship began to feel like it was the only place in the entire world, which seemed to end just beyond the white waves churning alongside its hull. At sea in the tropics, when there is nothing more to see besides more ocean, the sun takes center stage. It becomes more than an incidental presence, one that doesn't simply warm the body but scorches the sky and everything beneath it. It roasts the skin so deeply that it seems to bake both the soul and the mind. Everything beneath the all-encompassing blue cooks in its heat, until the portions of a ship's steel deck shadowed beneath the vessel's bulkheads become the only refuges.

If a trip like Mel and Annalee's had occurred under any other circumstances, the air might almost have been described as cozy. The Earth spun beneath the brilliant blue until its ever-present star vanished beneath one last blast of pink and orange and purple brilliance across the horizon. Night followed swiftly. In this somewhere that felt like nowhere, the March

night wrapped around the body as warmly and softly as a fleece blanket.

After so many hours at sea, however, the rolling repetition of the *Doña Nati*'s journey and its close quarters took a toll on the ship's passengers. On that anxious night when the vessel passed through the Surigao Strait, Mel and Clark began bickering about something inconsequential. The debate continued into dinner. Its subject wasn't important enough that anyone remembered it, but as Clark later wrote, it was the first time he and Mel had disagreed about anything since they left Manila.

As Clark described the fight, their bickering turned to yelling. Soon, they were goading one another to throw the first punch. Neither wanted to be the one to hit the other.

"Go ahead," Clark taunted. "I can lick you even with one broken hand."

An amateur boxer since college, Mel snapped. He delivered a left hook to Clark's jaw. The men wrestled across the deck of the ship, trading blows. They each got good hits in, but did no major damage.

The fight lasted all of five minutes. It was as if it needed to happen just to relieve the tension. When it was over, they stood up, shook hands, and said nothing more about the scrape.

When the *Doña Nati* passed through Surigao, it lost whatever sense of protection the islands had provided. Though it may have shaken one Japanese cruiser, others, perhaps even submarines, might be chasing it. And before the *Doña Nati* would be safe, it would have to cross Japanese-controlled shipping lanes.

Captain Pons told Clark Lee that the *Doña Nati*'s journey would get more dangerous each day until March 18, give or take a day. Pons told Clark that was when he estimated that his ship would pass the convergence point for Japanese shipping lanes between the Dutch East Indies, New Guinea, and a shal-

low lagoon known as Truk, where the Japanese had built their most important naval base in the South Pacific.

"Hearing the captain talk about trouble on the 18th, we all began to expect it," Clark wrote. "When the 18th finally came we stayed on deck all day, watching the sea and sky. The unbroken circle of sea around us had come to be all-important. As long as nothing appeared we were reasonably certain to stay alive."

The Japanese navy wasn't the only worry. If the *Doña Nati* didn't encounter an entire enemy convoy, the blockade runner might still run into an American raider mistaking it as an easy target.

Skirting New Guinea, Pons's crew swept the *Doña Nati* far eastward into the Pacific along the equator, almost as far east as Fiji, then hooked the ship back south toward Australia. Eventually they passed "right through a hornet's nest" and traveled as close as a half-hour's flight from Japanese-held islands. During this portion of the trip, whenever they were awake they took their life belts with them in case they had to suddenly abandon ship. At night they slept in their clothes with the life preservers within arm's reach. They kept their pocket notebooks and identification papers accessible enough to toss into the sea if it looked like they were about to be captured.

Four days out of Surigao, the *Doña Nati*'s lookout saw a ship. Worried that it was an enemy cruiser, Captain Pons ordered his crew to switch direction at full speed, back southwest toward Rabaul, a Japanese base northwest of New Guinea. Pons was trying to make it look like the *Doña Nati* was a Japanese ship. The vessel's top speed was fifteen knots, but Pons's engineer was able to push it to seventeen and a half knots, enough to shake the other ship.

The following night they spotted a light on the horizon. Pons and his crew waited for it to approach, but it didn't seem

to shift position. Mel and Clark paced back and forth across the deck all night, and Annalee filed her nails down to the quick, but there was no further sign of danger that night. Indeed, the next day their radio picked up a report that Allied forces had launched a large attack on a Japanese fleet at Rabaul a few days earlier.

On the other side of the world, meanwhile, David Hulburd and the rest of the *Time* operation had begun to worry about Mel and Annalee. Two weeks after the short messages from Cebu, no further word had arrived in either New York or California. An understandably anxious Elza contacted Hulburd and asked whether he had any further information.

He did not.

"I only wish I could give you more information than you already have as to Mel and Annalee's plans and destination," Hulburd wrote to Elza. She had forwarded Annalee's initial telegram to him, and in return Hulburd explained that "love exboth" had meant "love from us both."

"So surely they are together," Hulburd presumed. "Where they are headed for is anybody's guess, but I feel that they are much safer at Cebu than they would be at Bataan."

On the morning of Saint Patrick's Day, an American aircraft carrier, the USS *Lexington*, and its battle group were sailing east across the Pacific, somewhere beyond the Solomon Islands. The ships were returning to Pearl Harbor for repairs and resupplies after participating in the attack on Rabaul.

In accordance with the navy's readiness procedures, the fleet sailed with its lights darkened. At 6:22 A.M., Ensign Joseph Weber, the officer on watch, logged a report that routine air

patrols had spotted an unknown ship sailing about forty miles away from the fleet. Half an hour later, the *Lexington* changed course, but kept a watchful eye on the unidentified vessel.

At the same time, after a few days of quiet, Clark suddenly jolted Mel out of a *True Confessions* story right when he was about to read the titular admission. A formation of eight warships was matching their course. The *Doña Nati* didn't dare approach to investigate whether the vessels were friends or foes. It was unlikely that the ships were American because they were so close to Japanese shipping lanes and Japan's South Pacific bases. The flotilla appeared to include an aircraft carrier and other vessels. Not one ship broke formation toward the *Doña Nati*.

The reporters speculated that they'd encountered a fleet of damaged Japanese ships headed home for repairs after the attack at Rabaul. It was true that the reporters had seen ships headed home, but what they didn't know at the time was that they'd seen the *Lexington* and its battle group.

As the *Lexington* traveled on, the passengers of the *Doña Nati* eased into the cautious placidity of the featureless Pacific. Mel turned to the typewriter he'd purchased on Cebu and began writing a letter to David Hulburd, his editor at *Time*. "With little to do but shake in my tennis shoes," Mel opened his letter, which brought Hulburd up to date on the events he'd witnessed in the Philippines since the December 8 attacks.

"Whether I'll ever arrive at a point where this letter can be mailed is a matter of fate," he began. "So far we've been scared plenty but very lucky—and I'm knocking on wood."

As Mel wrote, it became clear that what was appearing on the page was more than a letter; it could be the beginning of his book. What Mel began was a detailed, multipart narrative of the war so far. He would eventually share it all, he said, "at least all I can tell now."

Mel's book began in Japanese Indochina, moved to the "proving ground" in China, then went on to the diplomatic skirmishes of the past four years and the private reflections that others had shared with him about the entry of the United States into the war. Mel gave Hulburd a day-by-day, blow-by-blow accounting of the Pacific war so far, interweaving the larger story with detailed descriptions of individual units and personalities and with accounts of his reporting and movements as well as Annalee's, Carl's, and Shelley's.

Mel's prose in this draft retooled some of the descriptions he'd composed for his dispatches for *Time.* There were countless horrors that Mel recalled as he composed his book, but he wrote surrounded by a world that could still present moments of beauty.

Around 8:00 P.M. that same night, back on the *Lexington,* Ensign Weber assumed watch as the sea again vanished into darkness and the aircraft carrier again changed course. Little out of the ordinary had happened on the ship since Seaman Second Class Peter S. Runacres broke his left ring finger while removing a shell from a gun during a drill.

Then, shortly after Ensign Weber's shift began, a bright streak shot across the constellation of Leo. For the next three hours, meteors blazed across the skies to the northwest, performing a celestial show for anyone who happened to sail across that fearful expanse of ocean. Perhaps that night, after Mel stopped typing, he looked up and saw the same meteors. Perhaps he shared the sight with Annalee, Clark, and the rest of the *Doña Nati*'s passengers.

The next morning, Pons's engineer spied two specks quickly approaching the *Doña Nati*. They didn't change course. Suddenly, one disappeared, while the other grew larger on the horizon. Everyone's first suspicion was that the first was a submarine diving to continue in stealthy pursuit. Mel grabbed what he'd written the night before and again prepared to throw his recollections overboard.

Then dark rain clouds engulfed the *Doña Nati*. By the time the storm passed, one distant vessel still hung on the horizon, but the squall had bought time for Pons to alter his course, allowing the *Doña Nati* to circle behind the approaching ship. It was no longer gaining on the *Doña Nati*.

Mel noted that none of the Filipino sailors panicked. No one even reached for a weapon. Instead, the crew steered the ship wide around the threat. By nightfall they'd lost sight of both vessels. If there had been a submarine, it hadn't revealed itself.

The following day brought no sign of either distant ship. That night was almost relaxing. Crewmen played guitars and ukuleles, "singing their version of American jazz tunes, vintage 1930."

As the *Doña Nati*'s passengers finally found a moment to relax, *Time*'s staff in New York only grew more anxious. There was still no word from Mel or Annalee. Neither Hulburd nor Luce nor the Meybergs nor the Whitmores had heard anything.

"I wish I knew where they are now," Hulburd eventually wrote to his colleague F. D. Pratt. Pratt was preparing materials to be mailed to subscribers with the next issue of *Time,* and he'd asked Hulburd to give him an update on the status of the magazine's reporters around the world.

Hulburd did know that Carl and Shelley Mydans were alive

but still prisoners at Santo Tomas University in Manila. Shelley had been appointed a room monitor, and they were both believed to be getting at least a subsistence diet. However, Hulburd knew nothing more about Mel and Annalee than that they'd fled on the *Doña Nati.*

"The Jacobys are having just about the most hectic and exciting honeymoon anybody ever had," Hulburd wrote.

Around the same time, Elza was receiving notices that the draft deferral Mel had requested in November was about to expire. Obviously, there was no way he could report, so she asked Hulburd, as Mel's supervisor, to respond to the draft board. When he did, Hulburd explained that Cebu was the last place he knew Mel to be.

"I wish to inform you that he is now some place in the Pacific on his way, we hope, to Australia," Hulburd wrote.

Back on the *Doña Nati,* radio news kept the reporters guessing how close Japanese convoys might be. Stories about new bombing raids at Bataan and Corregidor offered dark reminders of where they'd been. Late in their journey they heard that MacArthur had made it to Australia. Later they would find out that the general's dramatic escape was led by the same man— Bulkeley, now a captain—who had shepherded the *Princesa* away from Corregidor.

"We had come far enough to know that help can go through—the Japanese Navy can not cover the entire ocean, making us feel in a small way that our trip takes on significance and is helping our friends in Bataan and Corregidor," Mel wrote.

Finally, in the relief this news brought, the reporters broke a promise they'd made not to talk about what they hoped to do when they reached Australia. Someone mentioned what he'd

eat first. Tentative thoughts turned to imagined glasses of cold beer or the thought of putting on clean clothes. Soon everyone began chattering like kids on Christmas Eve.

But first they had to finish their journey.

Clark began staying up all night, hoping he'd be the first to see land, but he fell asleep. Then, on the morning of March 27, Mel saw it. He yelled out Clark's name. Clark woke with a start. He swore as he ran out to the deck rail to see. Sure enough, there it was. Australia. Brisbane to be exact.

As the *Doña Nati* approached the port, an Allied bomber roared past overhead. This was the first time in months that a plane flying overhead didn't alarm them. Indeed, the Americans' hearts swelled. The numerous U.S. ships and military vehicles the *Doña Nati* passed as it sailed up into the Brisbane River cheered them even more, as did a boatful of smiling people who greeted the ship's arrival.

"Our first glimpse of the country was the friendliness of the boatload of laughing men and women waving at us and our American flag, then the smiling doctor who came aboard a few seconds and gave us a handshake in welcome," Mel wrote a few days later.

Before stepping off the *Doña Nati,* Mel stopped to say good-bye to the crew. The ship's engineer smiled conspiratorially. Mel inquired why the engineer was so pleased with himself. Just as soon as the vessel had pulled alongside Brisbane's docks and he'd shut off the ship's engines, he told Mel that one of its pistons had cracked. All the strain he'd put on the *Doña Nati* pushing the ship beyond the cruising speed it was designed for had finally destroyed the engine.

"ALMOST TOO GOOD TO BE TRUE"

D avid Hulburd was just about to send his memo to F. D. Pratt about the fate of *Time*'s reporters when the wireless machine at *Time*'s Rockefeller Center headquarters clattered and buzzed. Before Hulburd sent his memo, someone pulled a message from the machine and yelped excitedly. It had terrific news. Mel and Annalee were safe.

"No details yet, but what a trip they must have had from Bataan and Cebu," Hulburd scrawled in blue letters that looped across the bottom of the memo. The news was a PR coup for *Time*.

Then at the pinnacle of its popularity, *Time* cast itself as the nation's most turned-to source for news about the war. Whatever private relief Hulburd and his colleague felt about Mel and Annalee's safety—aside from personal concerns, Time Inc. had taken out a $25,000 life insurance policy on Mel when it hired him full-time—the memo he wrote to Pratt became a valuable marketing document. The magazine's circulation desk saw an opportunity in the news of the Jacobys' arrival in Brisbane.

When *Time*'s next issue came out, the magazine's sales staff cleverly packaged subscribers' issues with copies of Hulburd's memo, complete with a facsimile of his excitedly scrawled note about the Jacobys' escape. The young couple were becoming

standard-bearers, representatives of the risks to which Luce's troops would go to bring stories from the war back to U.S. shores.

Their families were understandably relieved by the news as well. "Both Fine Address Lennons Hotel Plans Indefinite," read a telegram Mel and Annalee sent together to Mel's mother and stepfather. Mel followed up a day later with: "I hope you were not too worried, Mother."

Shortly after the *Doña Nati* limped into Brisbane's harbor, Australian immigration officials recorded the names "Melville Jack Jacoby" and "Annalee Whitmore Jacoby" on alien registration forms. Asked how long they planned to be in Australia, the couple, uncertain themselves, left no answer. Instructed to declare the purpose of their visit, the Jacobys wrote simply, "war coverage."

After escaping Corregidor himself, Douglas MacArthur had established headquarters in Melbourne, nearly 900 miles southwest of Brisbane. Following heavy defeats in the Philippines, Singapore, Malaya, and the Dutch East Indies, the Allies were regrouping in Australia. With them came much of the press corps covering the Pacific Theater.

The couple seemed less certain about how to answer another required question on the form. Asked to list the names and addresses of friends or family in the country, they wrote: "General Douglas MacArthur. Lennox Hotel?" As reported on the form, they carried $700 in U.S. currency and claimed to be in sound mental and physical health

After filling out the forms, Mel, Clark, Annalee, and Lew Carson walked to the docks and hailed a taxi. Every single hotel in the city was booked, Clark reported. They were filled with American pilots. Finally they found a room at the Lennons Hotel. Clark suddenly remembered that he'd offered to buy a round of drinks if they made it to safety.

Annalee and Mel each wanted a Tom Collins, but before gin, soda, and lime, they had to attend to a more serious matter: advocating for Carl and Shelley Mydans. The Jacobys had last received information about their friends' condition when they were still on Corregidor. The very first message they sent to Hulburd was that the Mydanses were okay but might not have enough food.

Two days later, Mel, Annalee, and Clark flew from Brisbane to Melbourne, where they planned to visit MacArthur's headquarters, then get to work. Ten thousand feet over Australia, the landscape seemed strikingly ordinary. The rows and rows of houses lit up beneath the plane for the world to see—their occupants unconcerned by the now-distant prospect of air raids that Mel and Annalee were so used to—were real.

"In Bataan at night, sentries always barked at soldiers carrying guns with glistening barrels that might be seen by enemy snipers hidden in the nearby trees and bushes," Mel wrote aboard the plane, reflecting on the sight. "Our only light in Bataan came from the Moon and then the men prayed it would go down fast. Tonight at 10,000 feet over Australia we can look down upon rows of houses lit up—it's an amazing sight to us and hard to believe it's real."

In Melbourne, they went straight to the Menzies Hotel. Like the Manila Hotel earlier, Menzies had been turned into MacArthur's headquarters. After the reporters showed up, word quickly spread around the hotel that they were safe. General MacArthur himself came to welcome them to Australia. Mel wrote about the broad, welcoming smile the general flashed.

"I knew you'd make it, Mel," the general said.

There was a bet to pay off. Six weeks earlier, back in Corregidor's nest of tunnels that last day before their long journey,

Pick Diller and Sidney Huff—now full colonels—had shared a toast with Mel and Annalee, convinced that they'd make it through the Pacific alive. That day they'd gambled on the reporters' chances. If they did indeed make it to Australia safely, the reporters owed Diller and Huff a champagne toast. Mel and Annalee were happy to pay up. It was a joyful encounter at a time starved for such moments, and the celebrations continued well into that night.

Diller and Huff arranged a reunion of sorts in the Menzies Hotel lobby. Nearly all of Mel's friends from Chungking—the "old gang" from his Press Hostel days—had trickled into Melbourne from every corner of Asia and the Pacific to report on the next phase of the war following the fall of the Philippines. Familiar faces—including Till and Peggy Durdin and Bill Dunn—appeared, and many of them told adventurous escape stories of their own.

There was one more familiar face in Melbourne: Theodore White. Teddy had just returned to the Pacific front from New York. The sight of Mel's old friend from Chungking days was heartening. Then Mel introduced Annalee to Teddy. He was instantly smitten. Meeting her and seeing Mel were twin highlights of an assignment in Australia that was already uplifting for Teddy.

"I found, you know, when I went home [in May 1941] that almost all of my old friends had ceased to mean anything to me," White later wrote about being in Melbourne.

> *And suddenly when I got back into the newspaper gang in Australia I found that these were my people in a very intimate and peculiar way. And most of all, my people were the boys who had been with me in Chungking—the old gang.*
>
> *Till Durdin and his wife turned up after a series of miraculous escapes in Melbourne. And then Mel and Annalee turned*

*up after their super-miraculous escape from Corregidor, and
there we were all of us, the old gang in Melbourne again, in our
intimacy and friendship.*

Riveted by his friends' escape from the Philippines, White
imagined Mel and Annalee could make quick work of the book
they had started, and he cabled two Random House editors he
thought might be interested in their story.

"*Time*'s Corregidor correspondent Melville Jacoby just ar-
rived here after miraculous escape with hair-raising stories
Philippine campaign which I believe make superb book ma-
terial," White told Random House's Bennett Cerf and Robert
Haas.

Mel and Annalee were as heartened as Teddy was by the
sight of so many old friends, but in all the familiar faces two
were noticeably absent, the two who they may have most
wanted to see: Carl and Shelley Mydans, who couldn't share
in this reunion.

"There are a lot of familiar faces in our group missing,"
Mel wrote. "Some are captured, the rest just dead. Then we
remember the men we left on Corregidor taking it on the chin
and our food doesn't taste quite so good. And our friends in
Manila—maybe they're hungry."

Mel had brought to Australia his and Carl's photographic film,
a godsend for *Life*. The photos gave readers an unprecedented
perspective on the battle of the Philippines.

"Unbelievably in months when Hong Kong, Singapore, Java
and Rangoon fell, a small body of Americans and Filipinos
held their ground against an enemy who elsewhere appeared
irresistible," *Life*'s editors wrote in the opening of "Philippine
Epic," a thirteen-page photo essay composed of Carl's and

Mel's images from the Philippines. "*LIFE* had not expected to see pictures of these men and their battle until after the war."

The piece opens with a shot that Mel took of General MacArthur, black cane in his right hand, strolling out of the Malinta complex deep in conversation with General Sutherland, his chief of staff. On one side of the image a few Filipino scouts and American enlisted men watch the generals, awestruck.

A roughly chronological arrangement, the piece begins with Mydans's images of the Philippines' first anxious days of war—well-dressed civilians gathered in air raid shelters, sandbagged bookstores, and the arrest of Japanese civilians. It then erupts with a two-page spread of flame- and smoke-filled pictures of the bombed Cavite shipyard near Manila, burning oil tankers, and a firefighter carefully laying three bodies side by side, bodies identified as his own wife and children.

The series then shifts from Mydans's stark depictions of Manila's first taste of war to Mel's hectic escape. The photos here, capturing scenes from both Bataan and Corregidor, were the first images most Americans saw of the battle in the Philippines. They show the frenetic activity of MacArthur's headquarters in the Malinta tunnel complex under Corregidor and the operations aboveground, the rubble and destruction wrought upon Filipinos' daily lives in places like the small village of Mariveles, and the resilience and desperation in Bataan's jungles, which "made the Bataan fighting anything but trench warfare.

"It resembles old time American Indian fighting," the picture's caption explained during an era when Western militaries were still acclimating to guerrilla tactics. "Both sides frequently find substantial groups of the enemy inside their own lines. Warfare is an unceasing game of stalking and being stalked."

There are pictures of Marines, "Filipino Joe"—the generic

term for unspecified Filipino enlisted men—and wounded soldiers recovering in open-air base hospitals on Bataan, as well as a series of intimate glimpses Mel caught of VIPs relocated to Corregidor, including General MacArthur, President Quezon, and their families. There is even one photo of an exhausted-looking Annalee.

The series closes with what might be considered a hopeful image. In the full-page picture, Arthur MacArthur—the general's four-year-old son—stands in overalls on Corregidor. One hand grips a closed Chinese fan. In the other, the boy clutches a small stuffed bunny, with a cautious, almost imperceptible smile.

All the comforts of a major city far removed from the war seemed to Annalee "too good to be true." She said as much in a letter to Elza and Manfred Meyberg. Even the opportunity to actually do that, to write a simple letter to her in-laws, was a surreal luxury.

Mel and Annalee made a home for themselves in room 311 of Melbourne's Australia Hotel. Mel spent much of his time fielding offers from publishers for "This Is Our Battle," the book he and Annalee began drafting aboard the *Doña Nati*. It wasn't pure journalism. From Australia, Mel characterized the work baldly and somewhat uncharacteristically as a "propaganda book" and promised Hulburd a "lengthy story" about the battle that broke out in the Philippines on December 8, 1941.

Even as the Jacobys settled into Melbourne, they knew a new hell was enveloping the place they'd just escaped. On April 9, months of resistance in the Philippines had come to a jarring halt at 12:30 P.M. when Major General Edward P. King reluctantly surrendered Bataan and its defenders to Japan.

"At last Bataan fell," began an April 20, 1942, *Life* story accompanied by photos from Mel and Annalee of tin-roofed hospitals, gangrenous wounds, and "valiant" nurses who served at soldiers' sides. "Its defenders had won for Americans four precious months in which to strengthen the worldwide fronts. White and brown, they had done the job like Americans."

Soon the horrific Bataan Death March would begin. One of the darkest moments in U.S. military history, the march killed between 7,000 and 10,000 Americans and Filipinos. Tens of thousands more ended up in terrifying Japanese prison camps and the "hell ships" that transferred the prisoners between camps. In Melbourne, long before the specifics of the march came to light, the sadness of the surrender was already felt.

On Bataan, the scene was horrific. Withdrawing troops set fire to fuel stores. The passengers on ships withdrawing across the channel to Corregidor quivered beneath the covering fire blasting over their heads. And then, just as the moment's trauma began to set in, the peninsula rattled violently.

This was not a continuation of the attack; rather, a series of earthquakes had erupted across the Philippines. The nation sat, after all, above subduction zones at the western edge of the Pacific Ring of Fire. Many of its islands' most notable features—Mount Pinatubo, Mount Apo, and Lake Taal, for example—were volcanos (even Mariveles was a dormant volcano), and with a volcanic landscape come earthquakes.

Geology does not rest for war. Nature does not take sides.

Australia felt the day's symbolic reverberations.

"If ever men were grilled to lead a fight for their country through sheer hatred, it is these," Mel wrote. "They know they are slated for bigger jobs, but in their hearts most of them wish they were with the rest of the gang."

In Australia, Mel and Annalee felt the same mixture of sadness and anger almost anyone who had seen Corregidor and

Bataan felt: Why had these outposts been left to wither in the heat of Japan's invasion? Where were the reinforcements promised so long ago? Where was the convoy?

"In Australia we saw again the pilots who had left Corregidor by submarine," Annalee wrote in an article that appeared later that year. "They were bitter. They had come out so they could go back to help their friends, and they still had nothing to go back in. Their comrades were still eating mule, still waiting for planes, still facing a not-too-gentle Japanese capture."

Though Mel now discussed the urgency of the Philippines' plight, as he began writing "This Is Our Battle" he also wove the situation in China into his narrative. From the first moment *Time*'s staff received word that the couple was safe in Australia, word spread about the adventure they'd had.

Meanwhile, the Jacobys did what they could to catch up with the real world and begin to enjoy married life.

"Being married is wonderful," Annalee wrote. "We're probably the only two people who were actually happy on Corregidor."

Mel and Annalee had themselves escaped death, injury, and capture, but they did not flee the Philippines unscarred. Australia was not home. In fact, Mel didn't even write home for two weeks after he and Annalee arrived in Brisbane; only in the unsettled realization of what had happened in Bataan did he write a letter. Melbourne may have been a reunion, but it was an uncertain one marred by the absence of friends.

"It's hard to get used to all these temporary luxuries," Mel told Elza and Manfred when he finally wrote. "We are living in a comfortable false security now."

Mel wanted real security. He thought about home, and an

image came to mind of his parents' home in Bel Air. Then and for decades to come, Elza and Manfred's house was known for its elaborate floral displays.

"Your telegram about the flowers in the garden at home made me want to tell Mr. Luce that I would come, but I don't think it's smart right now."

After Mel and Annalee arrived in Melbourne, *Time* wanted him to write up his escape. He composed a 4,000-word account that he sent as soon as censors cleared sensitive details about the route they'd taken, who helped them, and what their blockade runner looked like.

Weeks after sneaking out of Corregidor and months after their New Year's Eve escape, Mel and Annalee had lost everything except the $700 that remained in their pockets, but they had made it. Still, their future was uncertain. The army draft—for which Mel's employers at *Time* had already twice arranged deferrals—again loomed. Meanwhile, the publishing offers continued. The couple had to make a decision. They could abandon frontline journalism and return to the United States to complete the book. But if they did, Mel risked being drafted (though he wasn't completely opposed to joining the service as an officer). Meanwhile, despite Annalee's accreditation as a correspondent, if she returned to the United States, the government might still prevent her from getting another passport to leave the country.

Mel and Annalee thought instead about returning directly to Chungking, where conditions were worsening. They knew that city's rhythms well. They thought perhaps they could even continue to cover the war from China as husband and wife, the way the Mydanses had done before everything changed in the Philippines.

But with the Japanese and Americans battling across the Pacific, getting back to China wouldn't be easy. Even if the Jacobys made it to Chungking, they'd have each other, but they wouldn't ever be safe or secure. Bombs would continue to fall all around them, and the possibility of a Japanese victory would always loom.

Mel and Annalee's escape had been undeniably dramatic. It also made for a wonderfully upbeat story after the United States endured the Pearl Harbor attacks and the fall of the Philippines. Almost as soon as the Jacobys reported from Brisbane, the producers of the *March of Time* radio series set to work on an episode that would dramatize the escape while informing listeners about the state of the resistance in the Pacific.

For the last five minutes of the show, CBS planned a live radio linkup with Mel. Mel didn't want to be the focus of the piece, however, so he offered to get someone who'd served on Bataan. He turned to Brigadier General Harold H. George ("Pursuit Hal," who had led Bataan's air defenses). *Time* told both Mel's family and George's, and they (and Annalee's family as well) were ecstatic about the chance to hear their voices after so many months. But when the announcer broke in after the melodramatic and sappy dramatized depiction of Mel and Annalee's escape, he was unable to reach Melbourne, disappointing the families.

Instead, the announcer read a cable that Mel had sent to his *Time* editors describing General George, who lauded the American fighting forces in the Philippines when Mel interviewed him.

While Mel arranged the *March of Time* broadcast, General George prepared his own next mission. On April 22, Lieutenant General George Brett, the newly appointed commander of the Allied Air Forces for the Southwest, ordered Pursuit Hal to rush at once to Darwin, a port town in northern Australia. Darwin had been bombed repeatedly following an intense raid on February 19, and it looked like it was about to become the next flash point in the war. As described by Colonel Allison Ind—George's assistant and chief of intelligence at the time—Darwin mattered not just because it represented a possible foothold for the Japanese on Allied territory; it was also close to enemy positions on the island of Timor—300 miles away—and in the Celebes, a group of Indonesian islands another few hundred miles farther away, where Japan was massing its forces for what many thought was an upcoming invasion of Australia.

"Indeed, it was a case of plugging the threatened break in the dike with bare fingers," Ind wrote. "There was little else, should the flood pressure increase."

General George was to assume command of the U.S. Army Air Forces in Darwin. Pursuit Hal, the army hoped, could translate his expertise from defending Bataan amid such pitched odds to leading a far better prepared defense of Darwin's skies. The order energized General George, and his clearly defined mission left him a "changed man."

"This metamorphosis was characterized initially by a furious burst of energy and planning," Ind wrote. "He was happy. Here was action. He was a man of action. Here was field service. He loved field service. Waves of rank at a main headquarters depressed him. Again he would be with his men fighting a war on a tooth-for-tooth basis, only he insisted that it be three-teeth-for-a-tooth basis, '—or you aren't winning this war!'"

Following his aborted *March of Time* broadcast, Mel learned

about General George's order to transfer to Darwin. A battle was brewing, and a story. Preparations for the defense of Australia would provide the kind of heroic narrative of U.S. resilience that *Time*'s editors craved. Because he knew the general, because he had seen what the pilots under his command had done in Bataan, and because he had long been interested in aviation himself, Mel realized that he was uniquely positioned to tell such a story, and he began reporting a series of dispatches on the Army Air Forces's mobilization in northern Australia.

General George invited Mel to come along to see the preparations firsthand. Even though this meant traveling across Australia so soon after the trip through the Pacific, the trip's distance didn't seem to faze Mel, who told Clark Lee that it was little more than a "short hop" to see a few airfields. Whatever Mel called it, the 2,300-mile trip would take two days one way. George planned multiple stops along the way to inspect and show off the string of air bases the Allies were hastily constructing across the continent. As Ind recounts, the general was enthusiastic about Mel joining him.

Two days before Mel's trip, he and Annalee cabled her parents in Maryland. The Jacobys were excited to check in with the Whitmores, including their dog, and to report that Annalee had sold another story to *Liberty* about Corregidor. The dog, reported the *Evening Star* in Washington, D.C., was included in the family's reply, cabling, "Woof."

Before Mel left Melbourne, he dined with Carlos Romulo, newly arrived from Bataan and now General MacArthur's aide-de-camp and a press assistant. Mel identified with Romulo first and foremost as a fellow journalist, but also as a representative of the nation Mel was coming to appreciate as much as China. He told Romulo about how scrupulously he had noted the

conditions he witnessed on his and Annalee's voyage through the Philippines.

"The natives hailed us as deliverers, as if we were gods because we were Americans," Mel told Romulo at dinner. "When I think of the loyalty and the abiding, simple faith the Filipinos have in America and realize we haven't lived up to it. . . ."

Mel trailed off, but Romulo perceived that his interest in opening American eyes to the Philippines' dire situation was sincere. It echoed Mel's concern for China, and though by that point Mel felt deeply for the Filipinos, he also thought about that first home of his in Asia, and the people there. As far away as he may have been from the Chinese people, he couldn't forget them.

Mel would leave with George on April 27. On the night of April 26, Colonels Diller and Huff arranged a dinner at the Australia Hotel to formally celebrate the Jacobys' safe escape. The entire press gang present in Melbourne came for the celebration. Yes, the lines between soldier and correspondent were blurred, but the intimacy shared by source and subject was understandable.

"[Mel and Annalee] had been through everything with us and we understood each other so well," Diller later wrote to Mel's mother.

In the hotel lobby, joy spilled forth from the table of reporters and press officers with whom they'd survived so much. So raucous was their laughter that it leapt into the camera lenses, and so happy were the reunited friends that the photos these lenses captured still seem to chatter nearly three-quarters of a century later. In one, Teddy White gesticulates across the table, his face beaming while he makes a point. At his side, Annalee, her hair in curls for the first time in months, can't stifle a laugh. Colonel Diller crumples in smiles on Teddy's other side.

In another shot, across a table covered with potted succu-

lents, Mel smirks mid-bite, still wearing his khaki correspondent's uniform and a brown coat but now filling them out better than he had when he'd first arrived at Brisbane. Next to Mel, Peggy Durdin gazes across the table and gestures toward her mouth as if adding description to the story.

The gang from Chungking and Manila all knew how precious a night like this had become in this pounding of a war. Almost everyone, Mel noted, "had narrow escapes from Singapore, Burma, the Indies." Now those who made it to Australia gravitated toward one another.

These were old friends. Permanent friends. Friends who would carry this moment together always, whatever "always" meant.

As the feast rolled on, the correspondents' party continued up the stairs. Diller, Huff, Peggy Durdin, the Jacobys, and Romulo packed the room of the United Press's Frank Hewlett.

Mel and Annalee were reminded of that other gathering five months earlier, on New Year's Eve, in Mel and Annalee's Manila hotel room. But now fear was replaced by joy. Mel sprawled across Hewlett's bed, eagerly prodding Romulo to describe his own hair-raising escape from the Philippines.

"Tell us the story, Carlos," Mel insisted. "Tell us how you made it out, and don't spare a thing. Tell us about the anti-aircraft fire."

It was clear that Mel had already heard the story; everyone had. But as the "last man out of Bataan," Romulo's story was already legendary beyond the Philippines.

"And the earthquake," Mel said. "Tell us everything."

Mel wanted every earthshaking detail of Carlos's escape from Bataan. Mel's own escape didn't lack theatrics, but he couldn't get enough of Romulo's tale. After all, what did it lack? An amphibious vehicle converted into a rattling plane,

enemy fire, even the minute-long temblor that shook the earth right as the plane took off. This was a year of great escapes. None of the reporters packed into the room wanted the story, or the night, to end.

Soon the soldiers would return to battle, and the reporters would go back to covering the war, but this moment of warmth imprinted itself in Romulo's mind, as it probably did for the other reporters. These were the kind of friendships forged only in chaos. Their bonds were solidified amid rock-hewn tunnels, bomb blasts, and blood-soaked jungles. Just for one night, the war was a million miles away. The party continued until all hours. For the moment, every reporter in that room was safe, home, and full of love.

Still, darkness hovered just outside the frame.

"We heard of unspeakable mass cruelties and individual cases of torture," Romulo wrote in his diary. They were aware of reports of hundreds of Filipino soldiers dying each day as they were marched from Bataan and of "sick and ragged" Americans marched through Manila to a prison camp. When Corregidor finally fell a few weeks later, Romulo wouldn't be able to bear the news, especially about what might have happened to the seventy Filipina and American nurses remaining at the fortress.

"We tried in headquarters not to wonder what happened to those girls," Romulo wrote. "I have seen the faces of our greatest soldiers grow white when they speak of Corregidor."

And then there were Carl and Shelley.

Two thousand miles away, Mel knew that they were still alive but that, like their fellow captives, they were hungry. As Mel and his friends celebrated, the Mydanses witnessed horrors in captivity yet unimagined by those who escaped the Philippines.

"I hope something is being done regarding the exchange of

correspondents," Mel wrote. "We cannot eat or drink without thinking of them."

The next morning Mel set out for his trip north with General George. Annalee accompanied Mel to the airfield. On the tarmac, Colonel Ind, George's intelligence chief—who carried an almost romantic appreciation of the war, his superior officer, and the year that had transpired since he and Pursuit Hal left the United States on a special assignment to the Philippines— filmed the departure preparations with a 16-millimeter movie camera. Ind continued to record Mel and Annalee as the child of Hollywood and the MGM screenwriter embraced and kissed good-bye.

Shortly after the couple's lips parted, Mel walked to the nearby Lockheed C-47 and boarded with George and Ind. Across the plane Ind noted the "manly, handsome and virile features of Mel Jacoby, alight with the prospect of an action assignment."

At 11:16 A.M. on April 27, 1942, the C-47 took off.

April 29, 1942, was Emperor Hirohito's birthday, and a Japanese national holiday. Two thousand miles north of Darwin, the guards of the Santo Tomas prison camp in Manila forced their captives into a humiliating celebration. Carl Mydans recorded the day's events in the tiny journal he kept.

Across the bay from Santo Tomas, Japan's pilots paid tribute to their emperor with a punishing attack on Corregidor. The day was "especially dark" on the island, Second Lieutenant William Hook and Juanita Redmond, an army nurse, later told Annalee after their own escape from Bataan and Corregidor.

The first wave of bombers appeared over Corregidor at 7:30 A.M. and then they "never stopped," Hook and Redmond told

Annalee. Wave after wave of bombers arrived, some diving to attack the gun positions atop Malinta, the rest going for other targets. The Malinta hospital's occupants could feel the mountain's walls shuddering in the concussions. At one point, spotters counted as many as 100 explosions per minute.

That same day, two days after leaving Melbourne, George, Ind, and Mel approached Batchelor Airfield, a small base just south of Darwin. They had picked up a fourth passenger the day before, a British officer headed to Darwin.

Hastily constructed Batchelor offered just two runways and arid fields of scrub brush.

This stop wasn't on the mission's itinerary, and Ind asked George—who had relieved pilot Joseph Moore so he could have a spin at the controls—why he was landing. George reminded Ind that he needed to let off the British "hitch-hiker," but the Brit interjected, saying he wanted to go to Darwin, not Batchelor.

"All right, fine, it's one on me," George said. "But as long as we're here, let's have a quick look around the station before we push on."

To Mel, Batchelor Field was another detour in an itinerary full of them: Corregidor, then Cebu, and now this. And here he was alone for the first time in months; Annalee was 2,000 miles away in Melbourne, waiting for her husband to finish his trip with Pursuit Hal.

It was strange for them to be apart after such a long and intense shared experience, but Mel couldn't ignore a golden assignment like this, and she wouldn't have wanted him to. After all, he had witnessed the fall of the Philippines, felt the thud of Japanese bombs ceaselessly pounding above the dank depths of Chungking's air raid shelters, and spent his first years of adulthood in a war-ravaged landscape far across the sea from his California home.

As the C-47 landed, two officers from the base drove a Jeep across the tarmac to meet the visitors. Late afternoon sun baked the plane as it taxied toward a round parking space alongside the airstrip. Its passengers, eager for fresh air and a chance to stretch their legs, stepped out and walked toward the Jeep.

Across the runway, two pilots—a veteran of the Philippines campaign, Lieutenant Jack Dale, and Lieutenant J. W. Tyler, a newly transferred recent flight school graduate—prepared two Curtiss P-40E Kittyhawk fighters for twilight maneuvers. Dale and Tyler taxied their planes onto the runway, turned, and lined up alongside one another. It was standard procedure to take off in pairs. Dale's plane was on the right, Tyler's on the left. The pilots pushed their throttles. Engines roared. The P-40s raced west down the gravel runway.

Next to the C-47, Mel stopped to light a cigarette. So did the general. He was a fan of the Kittyhawks and had seen what his pilots could do with the few ramshackle, earlier model P-40s they'd had access to in the Philippines. George was eager to champion them. Mel had first learned to fly in Hong Kong during his Lingnan years and had considered joining the U.S. Army as a pilot after his first freelancing stint, so he ate up the chance to discuss aviation with the general.

The 49th Fighter Group had only just received its Kittyhawks a month earlier. Though it would soon be surpassed by the P-51 Mustang in wartime mythology, at the time the Kittyhawk was the latest iteration of what was then the most advanced American fighting machine. Thirty-one feet two inches long, with a thirty-seven-foot, four-inch wingspan, the plane could reach speeds of 354 miles per hour. It was a powerful plane made famous in China by Claire Chennault's Flying Tigers.

Dale's and Hazard's planes sped toward takeoff alongside one another. They quickly neared the end of the runway. Ty-

ler's P-40 slipped slightly behind Dale's. Suddenly, the aircraft wobbled as it crossed into the slipstream of Dale's fighter. Tyler strained at the flight stick but could do nothing. His fighter lurched out of control, then careened off the runway. It shot across the airfield, barreling toward the plane that Mel and George had landed in.

Chaos erupted.

Everyone who had just deplaned from the C-47 leapt out of the P-40's path. In one instant of torn steel and twisted machinery, the smaller plane slammed into the C-47. The impact's force knocked two of the larger plane's engines from its wings and sheered its cockpit from the fuselage. Shrapnel and various aircraft parts flew into the sky and rained across the landing strip.

One witness saw bodies thrown as far as twenty yards away, landing among the reeds growing around the transport's parking spot.

Meanwhile, the impact flung the still-powered propeller of Tyler's fighter off the plane's nose. Continuing to spin, it raced straight toward Mel. He tried to leap away, but the air blade sliced through his thigh, across his upper body, and into the base of his head, severing his femoral artery and snapping his cervical vertebrae.

As Mel collapsed, one of the fighter's wings slammed into the landing party, which included Lieutenant Robert Jasper, one of the base officers who'd come out to welcome General George. Chunks of metal flew from the wing's landing gear and shattered Jasper's skull. Then Colonel Ind saw the general. He lay crumpled on the tarmac a few feet away. The general was breathing and could speak, but he would succumb to his injuries within a day.

Jasper ultimately survived, but there was no hope for Mel. In an instant he was gone.

Colonel Ind recounted the event later:

Mercifully blinded by the limitations of our human vision to the future of even a few seconds, we could not know that upon this seemingly unimportant point the fates of all of us were spinning down faster and faster on a fine pivot that would shatter with the impact and fling the debris into an eternity of separation during mortal time.

Without a doubt, that pivot delivered a sudden, senseless conclusion to five months of nonstop adventure and drama. It was a decidedly meaningless end to a life quickly becoming monumental, even in its brief twenty-five years.

For the first time in its history, *Time* lost a reporter in the line of duty. Stanford University lost a treasured alumnus. The people of China and the Philippines lost a friend. A family in California lost a beloved son and cousin.

And a young woman waiting at a Melbourne hotel for her new husband learned that he wasn't coming home.

SOLDIER OF THE PRESS

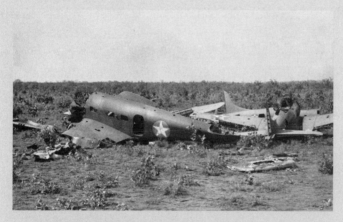

Wreckage of the C-47 and P-40 aircraft
involved in the crash at Batchelor Airfield that killed
Melville Jacoby.
Australian War Memorial.

*E*arly in the morning of April 30, an urgent message arrived for Elza Meyberg at the Sir Francis Drake Hotel in San Francisco, where she and Manfred were staying during the Oakland Flower Show. It contained forty-seven words of all-caps brevity:

MEL FLEW DARWIN MONDAY WITH GENERAL GEORGE
STOP PLEASE BE AWFULLY BRAVE TOLD TODAY BOTH
KILLED WHEN SECOND PLANE OUT OF CONTROL
CRASHED INTO THEIRS STOP KEEP HOPING AGAINST
HOPE LATER REPORT WILL DENY BUT NO CHANCE
STOP WILL CABLE ANY MORE DETAILS ALL MY
DEEPEST LOVE

ANNALEE JACOBY

Annalee's note seared beneath the Pacific along the telegraph lines from Australia to California, its words finally burning into the heart of her mother-in-law of all of five months. It carried the message Elza had feared for half a decade.

The message was perhaps more debilitating than the already unimaginable impact of news of her only child's death because Elza received it so soon after she was told Mel and Annalee had made it safely through so many trials. With the news just a few weeks earlier of the *Doña Nati*'s arrival in Brisbane, Elza had thought she no longer had to worry about receiving the kind of horrific message now burned into the brown, flimsy sheet in her hands.

Mel—her one and only son—had traveled 2,000 miles under the cover of darkness to avoid capture. He had braved the front lines of this horrible war in order to tell other mothers about their sons' bravery. He had survived scores of bombings and weeks under siege on a claustrophobic island so his country wouldn't ignore this distant battle as it had ignored so many others. But now he lay mangled and lifeless in some outback hospital.

A day later, word of Mel's death made its way through Mel's family. Peggy Stern and her sister Jackee, Mel's cousins, learned

about the tragedy when they met their father after school. Like their four other cousins, they were understandably crushed by their older hero's death and the strikingly unfamiliar sight of their father crying openly. They would always remember Mel and the day they learned he was gone.

The next day an army transport flew Mel's body back to Melbourne, where Annalee waited at the airport, a twisted reflection of the moment Mel had stood at the Cavite shoreline five months earlier, that beautiful day when he swept her from the *Clipper* and took her to the wedding chapel.

Base personnel back at Batchelor Field had rearranged Mel's gruesomely mutilated body. But Annalee was furious about the doily-like covering that had been placed over her dead husband's head to obscure his ghastly wounds. She was furious about the dressing, furious that his body had been disturbed or altered in any manner. She wanted him to appear as he did when he took his final breath, however horrific the sight might have been.

"She just wanted to see him," her daughter Anne Fadiman later said. Annalee hated that Mel had been made up unnaturally, as if she was too fragile to see him simply because she was a woman, especially after surviving so much danger and witnessing so much horror without flinching.

That morning, a day after Mel's death, business was unexpectedly brisk at Adrian's florist shop. All day American military officers—General Douglas MacArthur's staff included—foreign correspondents, and diplomats crowded the florist's shop at No. 3 Australia Arcade. Dozens and dozens of flower arrangements were sent to Annalee, who was grieving at the nearby Australia Hotel.

Mel's service, held at B. Matthews Funeral home on May 1, resembled a military funeral. His coffin was draped in a flag, and officers attended in uniform. After the funeral, Mel's body was brought to Springvale Crematorium and incinerated. Teddy took his ashes. Flown in a plane by a friend Mel had made on Bataan, Colonel Joseph Moore—the pilot who had taken Mel and General George to Batchelor Field—Teddy scattered Mel's ashes over the waters of Melbourne's harbor.

"Mel's career was as brilliant as it was brief," White wrote. "When he died, he was one of the greatest of U.S. war correspondents. He was more than that, one of the most magnificent men and trustworthy friends I have met anywhere."

As time passed and the sting of Mel's death faded, Annalee would remember their romance warmly and recognize how valuable their experience together had been for both of them. They were risk-loving people who would always be twenty-five in Annalee's mind. She could remember Mel forever as her twenty-five-year-old husband who had thrived on their adventure together.

As Annalee's daughter Anne later reflected, "I think that those last weeks of his life were probably among the happiest."

"When we heard that Mel was gone there was a fog of gloom over Melbourne," Teddy White told Mel's mother when he finally felt able to pick up a pen to write her. "You could have ladled it out with a spoon."

Mel's death was particularly hard on Teddy, whose recent years had closely tracked Mel's. Teddy spiraled into a depression following his friend's death. He waited weeks to write his own family, afraid that he would "infect" his letter with depression that would then spread back home to Boston. Finally, one afternoon in mid-June, Teddy, on his way to a *Time*

assignment in India and perhaps China, was on board a ship in the middle of the Indian Ocean.

Now attached to the U.S. armed forces as a correspondent for *Time,* Teddy was chasing a story about the Allies being caught off guard by the Japanese attacks when so many people—including Teddy, most journalists, and especially Mel—knew from the moment Japan moved on Indochina what its ambitions really were.

Teddy's depression after Mel's death was compounded by the death of another friend in Chungking and the Mydanses' internment. That day, however, the sea was smooth and the sky was free of clouds and enemies. As a result, he told his mother, his depression was starting to ease.

"I know that Mel's death must have shocked you almost as bitterly as it shocked all of us here," Teddy told his family. "But I still haven't got over the bitterness of it though it's five weeks, now in the past. Mel was a very good kid, mama."

Teddy's letter emphasized just how much community and friendship he had found among Melbourne's press gang, particularly the "old gang" from Chungking, and especially Mel. The details of Mel's death were unimportant, Teddy told his mother. "But it was the sense that we ourselves were subject to death that upset me—Till and Mel and I had been through so much muck together (Till and Mel far more than me), and we had come to believe ourselves so completely immune to mortal death that to find death choosing one of us, and not by the enemy's hand, sobered us cold."

Teddy, who hadn't ever thought hard about marriage, had been struck by Mel and Annalee's relationship and what it had come to:

"Ten day honeymoon in Manila, three weeks of war and bombing, a month and a half of hell on Corregidor and Bataan, a month of escape, and then a month in a posh Melbourne ho-

tel; and then zingo, death, and the end of it. It will be a memory to her, I suppose, and then a dream, and then nothing but an echo in her afterlife."

Teddy was impressed by Annalee's resilience.

"She didn't cry and wasn't messy," he told his mother. "She was swell."

While Teddy, Peg Durdin, and others tried to take care of affairs for Annalee in Melbourne, Annalee corresponded with Elza about her wishes for memorial arrangements, photographs they wanted to share, what to do with Mel's possessions, and the letters each had received with messages they hoped to show one another.

Most importantly, Annalee and Elza wrote and telegrammed one another to process their shared loss.

"There is nothing to say except that I want to see you and thank you for being nicer than I thought anyone could be," Annalee told Elza from Australia. "And thank you for Mel—five months were wonderful enough to last the rest of my life."

In the months that followed, Annalee became much closer to Elza, her "Mom Number 2." After both women's wounds faded, this correspondence blossomed into a decades-long friendship. Elza would be a key source of support as Annalee returned to the United States to attempt to piece her life back together.

Annalee may have been stoic following Mel's death, but she wasn't unaffected. At first, she connected with her mother-in-law as a typical bereaved wife might. That June she arrived in New York aboard the USS *West Point* and settled into a room at the St. Moritz Hotel. She carried the photographic negatives from her wedding and the escape through the Philippines all across the Pacific and back home to the United States, where

she finally had them developed. She even had pictures from Mel's funeral that Time Inc. photographer Wallace Kirkland had given her, unsolicited, though she was eager to dispose of those.

"There was so many things Mel wanted to do when he got back that New York was almost a nightmare, on account of trying to do them all," Annalee wrote Elza in a letter from New York, listing her appointments with literary agents, editors, publishers, aid organizations, and government agencies to whom she exhaustively described the conditions in China and the Philippines that Mel would have wanted to share with the public.

She also spent hours with *Time* staff, telling them "everything he wanted to tell them in luncheon after luncheon and dinner after dinner. Sometimes answering questions until after midnight—I'd wanted to stay just two days but it took ten."

Before Annalee's arrival, *Time*'s leadership had insisted that the Pacific story wasn't a priority, but she persuaded the Luces otherwise.

"They were amazed to find out just how serious things really are; the next few issues will sound different, I know," Annalee said in a letter, explaining that Henry and Clare Boothe Luce had thought that the most newsworthy front of the war for *Time* and *Life* to focus on was the Russian one.

Annalee was overwhelmed by the activity in New York, but she nevertheless insisted on one thing: reiterating the message she'd begun to send that past fall, when she was working for United China Relief. Indeed, she told a United Press reporter, she "wanted an 18 hour day job right in the middle of the war, preferably China."

Likewise, Annalee's top priority was completing "This Is Our Battle," the book Mel had started and she planned to finish. In New York, she met with Mel's agent, Nancy Parker, and

Time's David Hulburd gave Annalee all of the dispatches, research notes, and communications Mel had sent the magazine. Combined with her photographic memory and close relationship to Elza, she had a great deal of material to draw upon. She wanted to finish it just as fast as she could.

"It meant a tremendous lot to Mel," Annalee wrote to Elza from New York. "It was more important than anything in the world to him, except coming home and being with you again."

Annalee wanted desperately to see Elza, and she planned to go to Los Angeles after completing her engagements in New York, even before she saw her own family in Bethesda. She also was nearing the end of her hiatus from MGM. Her contract stipulated that anything she produced while working for MGM would be its intellectual property; if she didn't complete the book before August 15, it might become the studio's property.

"And it seems almost impossible to finish it by August 15," Annalee admitted.

Happily, Elza invited Annalee to stay at her home in Bel Air once she was back in California. Annalee accepted the invitation and stayed with the Meybergs for two months while she settled matters at the studio. She instantly felt like she was part of the Meybergs' family. Everything about Elza's house felt familiar to Annalee, thanks to all the long conversations she'd had about it with Mel at Liloan and elsewhere in the Philippines.

"Every time things were terribly bad we'd talk about your garden and the terrace and iced drinks as just the nicest place in the world to be," Annalee told Elza.

Elza and Manfred even brought Annalee along on a family trip to Lake Arrowhead, in the San Bernardino Mountains outside of Los Angeles. Staying with Mel's mother helped An-

nalee feel a sense of normalcy she hadn't felt since before Mel died.

"I felt like a human for the very first time with you," Annalee told Elza.

When she wasn't working on Mel's book, she was helping Elza organize and notate his papers, news clippings, and other materials. Or she was brushing Elmer, Mel's dog, an activity she found soothing. She also realized that she didn't want to return to MGM. She was still grieving for Mel, and there was unfinished work in China.

In Los Angeles, Annalee picked up an assignment from *Douglas Airview*—a monthly magazine published by the public relations division of the Douglas Aircraft Company—to write about what she had experienced and observed in the Philippines. Titled "Ours Is Full of Holes," the article featured a handful of Mel's photographs from the reporters' escape. Perhaps it was being free of military censors, or no longer having to worry about *Time*'s in-house editors overediting her copy, or writing about something Douglas could readily endorse—the great need for planes in the Pacific—but Annalee's story seemed far more cutting than much of what Mel had been able to publish about the Philippines.

Annalee left Elza's house at the end of the summer. She cried for hours on the brutal train journey back to Washington, D.C. As the train crept across the United States, Annalee slept until 4:00 P.M. each day, waking only to eat, read the paper, eat again, work on her book, cry, and drift back to sleep. Arriving two hours late for a Chicago layover, she went to see a movie after dealing with baggage problems. She couldn't have been unluckier. After the problems at the train station, she "spent

an hour in a movie that turned out to be Clark Gable as a war correspondent in Bataan."*

Once she was back in Bethesda, Annalee continued to struggle with Mel's book, especially the portions that dealt with his time in Indochina. She knew this was one of the most important pieces of the story Mel was trying to tell, yet it was also the hardest part for her to write. There was just so much there. He'd kept reams of information-packed, narrow-spaced, typewritten notes full of vivid descriptions that were sometimes so incredibly dense that Annalee got lost in their excruciating detail.

"I've never read anything like them," Annalee said.

She had thought she could complete this portion of the book quickly, but she spent whole days making little progress. Meanwhile, she drifted more deeply into a depression that seemed to affect her writing.

"I write as if I were under ether, and when I read it the next day it sounds as if I were," she told Elza.

Sleeping for hours and hours, watching the days pass quickly because she was awake so briefly, Annalee started letters and never finished them. Over time, however, perhaps in the long, cathartic act of spending weeks on one letter to Elza, she began to recover, as she had first begun to do at Elza's house.

"I hope you don't think that I love you or miss you any the less, or am any less grateful for all the different kinds of wonderful things you did," Annalee stressed to Elza in that letter.

––––––––

* The film was Gable's *Somewhere I'll Find You*. Produced by Annalee's studio, MGM, the movie had a further tragic twist beyond its stinging subject matter. *Somewhere*'s production had been halted after Gable's wife, the actress Carole Lombard, died in a January 16, 1942, plane crash.

"You haven't any idea how much you helped; I felt like a human being for the very first time with you."

As bad as the year 1942 had already been for Annalee, even worse news came in the fall. On a Friday morning in October, shortly after Annalee had returned from Los Angeles, her father, Leland Whitmore, was driving a carpool to the office when he suddenly felt unwell, pulled to the curb, and collapsed. He died almost immediately afterward. In six short months, both of the men Annalee loved were ripped from her life.

Leland's death paralyzed Annalee, and she stopped working on "This Is Our Battle." For some time, she didn't pick up a pen for any reason. Tom Seller, Annalee's writing partner at MGM, saw her a month after her father's death and tried to talk her into working on the book again. Seller imagined that writing or another project might keep her from fixating on all the tragedy, but he wasn't able to convince her to return to it.

"She seems fine on the surface, but I fear that her tragedy is affecting her more deeply than any of us realize," Seller reflected. "It's as though, with Mel gone, she has no incentive to go on to other things."

Still, Annalee kept one eye on the many events transpiring in Asia. As early as that first summer she was back, she had begun advocating on United China Relief's behalf again. Eventually, she and Robert Barnett—an Institute of Pacific Relations fellow who had just returned from a trip to Chungking for United China Relief—paired up for fund-raising events that publicized the plight of China's "warphanages." She also arranged for the writing and photos that she and Mel had produced from Bataan and Corregidor to be used as source material for the 1943 Veronica Lake film *So Proudly We Hail*.

A year later, U.S. and Japanese officials agreed to a prisoner exchange supervised by the Red Cross. Among those set for release from Japanese captivity were Carl and Shelley Mydans. They finally arrived back in the United States aboard the SS *Gripsholm* in December 1943.

Two years after the noise of New Year's Eve at the Bay View Hotel in Manila, Carl and Shelley, though finally returned to the United States, headed into 1944 apart. For Carl, that New Year's Eve was as quiet and lonely as the end of 1941 had been chaotic and surrounded by friends. Shelley was headed home to California to see her mother, and after numerous engagements in the city, Carl found that the familiar Time-Life Building felt like the closest thing to home.

On the afternoon of December 31, 1943, Carl settled into the library of the magazines' back issues and source material. Two years after he last saw Mel, he pulled everything his friend had produced during those frantic months following the fall of Manila. Unpublished dispatches. Cables. Articles. Photographs. Especially his photographs. Carl paged through the last months of Mel's life all afternoon.

Across the country, Shelley walked up the front steps of her mother's home on Alvarado Street in Palo Alto, the house where lovesick Stanford kids, their landlord's daughter singing at the top of her lungs, and a grad student writing his thesis on coverage of the war in China once shared a roof.

This was where Carl and Shelley first met that sly-smiling kid from Los Angeles who wanted to know everything about photography. For the first time since Mel's death, Shelley had returned here. At the same time, her husband was 3,000 miles away closing the year and the adventure in the quiet of the place that had brought them all together, absorbing Mel's words, his images, and his memory.

═══

Shortly after Leland Whitmore's death, Annalee and her mother Anne left Bethesda and bought what Shelley Mydans once described as a "rambling" house in Larchmont, a bedroom community just north of New York City. Anne worked at Pearl Buck's East-West Association, and through her Annalee was able to stay connected to China.

While Annalee reassembled the pieces of her life on the East Coast, the pieces of a California family's lives were scattered by the paranoia following the attacks on Pearl Harbor. After the war's outbreak, in early February 1942, U.S. officials had rounded up and imprisoned more than 100,000 Americans of Japanese ancestry, known as *nisei*. Among the interned were a twenty-two-year-old medical student named Luie Shinno, his wife Ruth, his parents, and several siblings. Shinno, who was studying at the University of California at Berkeley, was months away from becoming a doctor and Ruth was pregnant. After first being held at a racetrack in Santa Anita, California, the Shinnos were transferred to an internment camp in Jerome, Arkansas. Their daughter, Norma, was born in January 1943.

That fall, because Shinno had studied in medicine, he was paroled from Camp Jerome to work as an orderly at Mount Sinai Hospital in New York. Ruth Shinno came along four months later, though she had to leave her baby behind with Luie's parents at Camp Jerome. Ruth met Pearl Buck in New York, and Buck hired her to be her bookkeeper. Through Buck, Ruth and Luie also met Annalee.

Annalee persuaded her mother to let Luie and Ruth stay in an apartment above their garage in Larchmont. Eventually Luie's parents were able to come with Norma as well, as were Luie's sister and other relatives. For the next four years, eight members of the Shinno family ultimately lived in the Whitmores' tiny Larchmont apartment. (Instead of resuming his

career in medicine after the ordeal, Luie Shinno became an engineer.)

Annalee had no reason to want anything to do with the Japanese. Unlike most people in the mainland United States, she'd seen directly what the war did to her countrymen and to those in her adopted homes of China and the Philippines. She knew intimately how the Japanese had hounded her love. She knew that Mel had been forced to carry weapons in Indochina after his arrest. She knew of the suspicions he endured when he was still a young man traveling in Asia. The Japanese attacks on the United States immediately disrupted Annalee's marriage, and the events that followed led to Mel's premature death.

But she understood that the actions of the Japanese empire that ravaged her life had nothing to do with the Japanese Americans whose own lives were forever altered by the conflict and by the U.S. internment policy. "She would really have every reason to really hate the Japanese," Anne Fadiman said. Still, as many wrongs wrought by Japan as Annalee had witnessed during the war, she felt that the internment policy was unfair. Her gesture was extraordinary, given her history, and the Shinnos would be tremendously grateful to her for the rest of their lives.

Two years before his death, Mel wrote that foreigners who left Chungking inevitably returned. By 1943, Annalee had finally shaken off her depression and returned to the fold at Time Inc., writing Pacific and Asia war news for a radio program called *Time Views the News.* She was also speaking on behalf of the East-West Association and otherwise plugging back into Asian affairs.

Teddy White had convinced Henry Luce to offer Annalee a correspondent's job so she could return to Chungking, and

in 1944 they both traveled there as *Time* reporters. But they almost immediately discovered that the city was falling apart.

"Inflation had increased so that no one could afford to be honest any more, and all our old idealistic friends from 1941 had to do rather unsavory things in order to stay alive and feed their children," Annalee recalled in 1982. As Annalee and Teddy reported on these "unsavory things," they witnessed how rapidly Chungking was decaying and corruption was spreading among China's leaders.

However, the stories Annalee and Teddy wrote weren't the ones that ended up appearing on *Time*'s pages. Whittaker Chambers, *Time*'s notoriously anti–Communist editor, had solidified power in the magazine's newsroom. A former Communist himself, Chambers warped, hacked, and distorted every report Annalee and Teddy sent from China. They pushed back, but Henry Luce continued to side with Chambers. Luce visited China in late 1945. After a rancorous meeting with Annalee during the trip, she quit.

"After all this censorship," Anne Fadiman said of her mother, "she felt the story wasn't getting through. She was really furious at Luce."

Though Luce pushed Annalee out of the Time Inc. fold, she and Teddy soon had enough for a book about then-contemporary China. Together they wrote the nonfiction best-seller *Thunder Out of China,* which was released in 1946. Published while World War II's wounds were still raw, *Thunder Out of China* shook an establishment trying to make sense of a postwar world that barely had time to take a breath before half a century of Cold War tensions began. *Thunder Out of China* was not a political book. It was the product of the expertise of three reporters (counting the contribution from Mel's notes) on China.

Nevertheless, the book was radioactive. Because he had supported the Kuomintang for so long, Henry Luce interpreted any critique of Chiang Kai-shek, however reasoned, as a betrayal. The publisher felt that Teddy was too biased in his reporting on the Generalissimo, but Teddy knew what was actually happening on the ground in Chungking. His influence at *Time* had already been greatly diminished. After *Thunder* was published, Luce forced Teddy to accept whatever job he was given at the magazine or resign. That July Teddy chose the latter.

In December 1949, three years after *Thunder*'s publication and two months after the Communists declared the People's Republic of China and assumed control of the mainland, the Kuomintang withdrew to Taiwan. In 1950, Senator Joseph McCarthy launched his congressional witch hunts, scouring the State Department, Hollywood, and the U.S. intelligentsia for the people who he and his anti-Communist allies believed "lost" China. The silence that followed the "red scare" destroyed a generation of intellectuals who understood China. This was the generation that Chilton Bush and his colleagues had once hoped to cultivate, the generation that included Melville Jacoby and students like him.

Some early hints of *Time*'s editorial distortions had been clear to Mel. In the summer of 1941, he had been fortunate to have Teddy's assistance at least. For some time, Mel could count on his friend as the backstop he needed to make sure his dispatches were not distorted. Nevertheless, errors began to emerge, especially after the United States entered the war and Teddy left New York to report from India and the Pacific Theater.

One need only compare Mel's dispatches with what appeared on the printed pages of *Time* and *Life* to know that his concerns were valid. For instance, in the photo essay "Philippine Epic," the introductory text features the pumped-up pa-

triotism and racial generalizations typical of the era—and was not written by Mel.

"It was more than destiny that in the whole sad panorama of white men's bitter failure in the Far East, the only men who did not fail were Americans, whose stake in the Far East was new and small," read one of many such lines.

Mel was proud to have his reporting featured in these publications but at the same time had legitimate concerns about their accuracy. In addition, many of his dispatches never saw publication, and the letters he received from New York revealed the editorial direction in which the publication wanted to go.

In 1947 Teddy became an editor at *The New Republic.* Shortly into his stint at the magazine, Teddy wrote Elza to thank her for a gift. A year after the release of *Thunder Out of China,* he was modest about the book's success, which he said exceeded his expectations. Still, he wanted to give Elza a special leatherbound copy of the book in addition to the original copy he and Annalee had sent.

"Somehow, I feel there is a part of you and yours woven through the whole spirit of the book," White told Elza.

After *Thunder*'s release, the gossip columnist Walter Winchell incorrectly reported that Teddy had proposed to Annalee. Annalee and Teddy had very briefly thought about a romance, but it never became anything. It was more about connecting with Mel. Their brief romantic experiment evaporated quickly, but the pair remained warm, caring friends. In 1947, soon after he was back in the United States, Teddy married Nancy Bean—a former *Time* librarian.

Annalee soon followed his lead. Clifton Fadiman, the public intellectual and host of the quiz show *Information Please,* also

curated the influential Book-of-the-Month Club, which se-
lected *Thunder* in 1947. The worldly Fadiman—who, coinci-
dentally, had attended college with Chambers, the paranoiac
Time editor—appealed to Annalee's intellect. She fell in love
with him, and they married in 1950. Together, the Fadimans
had two children, a son, Kim, and a daughter, Anne.

In November 1982, Annalee, Carl and Shelley Mydans, and
a number of other surviving journalists who had lived and
worked with Mel in Chungking's Press Hostel—as well as a
broader community of wartime reporters and press officers
who worked in China before and after them—were reunited
for a last academic gathering at Arizona State University; there
they dissected the role of journalists covering wartime China.
(Teddy White could not attend, but submitted an essay that
was read at the conference and included in a book transcribing
its proceedings.)

"It was a remarkable meeting, bringing together those who,
from radically different perspectives and backgrounds, had seen
the Chinese revolution run its course," Walter Sullivan of the
New York Times wrote of the conference for *Nieman Reports*.
Sullivan had been in China during the Chinese Civil War.
"So much time had elapsed since the participants had seen one
another and discussed such issues that, for at least some of us,
it was like meeting in heaven and looking back in serenity at
a period when, as Teddy White put it, we were young, igno-
rant and immersed in one of the greatest upheavals of human
history."

In 1985, Annalee returned to Chungking (which was then,
as now, more accurately transliterated as "Chongqing") one
more time. With her were a number of other surviving mem-
bers of the Press Hostel gang, including Peggy and Till Durdin,

Hugh Deane, and other friends of hers and Mel's. Invited by the Chinese government, the returning journalists also went to Yenan, Shanghai, and other cities. The excited journalists even returned to the site of the Press Hostel, near a district in contemporary Chongqing known as Lianglukou.

In the 1990s, after years of vacationing on the island of Captiva off the coast of Florida, Annalee and Clifton moved there. They became well-loved fixtures in the town. Clifton Fadiman died in 1999. In the summer of 2001, Annalee's brother, Sharp Whitmore, passed away from heart failure.

The next winter, sixty years after her great adventure with Mel, Annalee faced the prospect of deteriorating health and the possibility of losing her independence. She had been diagnosed with both breast cancer and Parkinson's disease.

On February 5, 2002, Annalee Whitmore Jacoby Fadiman ended her own life with the same sense of purpose and self-determination with which she had lived it.

Annalee's suicide was neither sudden nor unaddressed. Though it still upset her children, it was a reasoned response to a terrible situation and a decision she made as a member of the Hemlock Society (now known as Compassion and Choices), which advocates for the right to die.

But Annalee, ever the stickler for accuracy, did not end her life before correcting the historical record where it concerned herself. In late 2001, she sat down at her home in Captiva with her daughter Anne to discuss her impending death. Aside from talking about personal matters, Annalee dictated a series of corrections in texts that had addressed her life and the events she participated in.

"She had complained to me that much of the stuff that had been written [about herself or Mel and their travels] was riddled with errors, although much was correct," Fadiman said.

A compulsive and thorough note taker, Annalee filled nearly

every book she owned with extensive marginalia and other notes. Before she died, she fulfilled her daughter's requests and went through her library page by page to discuss the stories written about her and clarify any errors.

"There is a tremendous story here which someday soon we hope will be told in full," Mel had written Henry Luce early in 1942, when he and Annalee were still on Corregidor. "So far it has been touch and go each day so I hope you'll understand the reasons why my stories are not quite as full and colorful—and perhaps truthful—as they might be."

Like any story, the one Mel and Annalee shared faded as the decades passed. Nevertheless, one is strongly tempted to wonder what might have been. Even Anne Fadiman, who would not exist had events not proceeded the way they did, ponders such questions.

"I've often wondered what would have happened had [Mel and Annalee] stayed together," Fadiman reflected in 2013, explaining that while Annalee clearly loved her father, Clifton Fadiman, she always carried a torch for Mel. "She thought they were the perfect match."

Fadiman knew that her mother's love for Mel was a different sort of romance than she had with Clifton, even though it was always difficult for Annalee to discuss Mel. Their marriage may have been brief, but part of Annalee remained in love with Mel.

"She was always twenty-five," Fadiman said. "They never got old."

EPILOGUE

*I*n January 1944, nearly two years after Mel's death, the Walsh-Kaiser Company completed construction of the SS *Melville Jacoby*. The vessel was one of twenty-five "Liberty" ships named in honor of the war correspondents who'd been killed covering the U.S. war effort to that date. Built to ferry supplies, the *Melville Jacoby* earned a battle star for its role in the invasion of Normandy in June 1944.

Decommissioned in 1947, the 7,176-ton *Melville Jacoby* was then sold off by the government. Sailing for decades as a privately owned cargo vessel, the *Melville Jacoby* eventually became a Spanish-flagged ship renamed the SS *Dominator*.

On the night of March 13, 1961, thick fog and stormy waters surrounded the *Dominator* as it neared its destination in the Port of Los Angeles. Stuffed with beef and grain from Vancouver, British Columbia, the ship negotiated around the Palos Verdes Peninsula. In the bad weather, the *Dominator*'s crew misjudged the vessel's course and ran her aground on a nearby reef. The impact tore through the ship's hull. Though the *Dominator*'s

entire crew survived, efforts to recover the ship failed. The *Dominator* sank, as did one of the vessels sent to recover it.

Ever since, pieces of the ship once known as the SS *Melville Jacoby* have washed ashore mere miles from the place where its namesake was born. Fragments of the ship still remain on the rocky beach under the Palos Verdes Peninsula. Its ruins have long been a secret for scavengers who pick over the vessel's carcass and teenagers who hike down to it to smoke cigarettes and make out, hidden by rusted bulkheads.

Elza Meyberg died two decades to the day after the vessel named after her son shipwrecked. While Peggy Cole and Jackee Marks—Elza's nieces and the executors of her estate— were putting her Bel Air home in order, they noticed a neglected closet and looked inside. The shelves were stuffed with boxes of letters, albums, and envelopes full of photos and film negatives, sheets of foreign stamps, piles of yellowing newspaper and magazine clippings, a stack of wound 16-millimeter canisters, a treasury of silk scrolls with Chinese motifs, Asian swords, jade jewelry, and other artifacts. Nearly all of the treasures had been produced in the 1930s and 1940s, when Jackee and Peggy were growing up in Los Angeles.

Many of the photographs on the shelves depicted a young, dark-featured man, laughing, and a petite woman with wavy hair grinning with local residents of some Pacific island. In a set of Peggy's favorite images, the pair wore makeshift swimsuits and drank from coconuts on a sun-drenched beach. Other pictures captured candid glimpses of titanic historical figures like Chiang Kai-shek, Douglas MacArthur, and Manuel Quezon.

Eventually, the sisters had a chance to watch the home movies. In one film, a glamorous young lady from Macau sashayed in an evening gown along the former Portuguese colony's Avenida de la Republica. In another, American students feasted on corn during a temperate-weather Christmas on a

college campus in southern China, competed with Cantonese kids during a track meet, and traveled through crowded river waters on a boat rowed by a grinning Chinese dorm mother.

Many of the clips featured the handsome young man who appeared in the photos and a handful of his friends riding in a sampan to a warlord's compound deep in the lush countryside of the province of Guangxi or exploring the dusty land-scape outside the thick walls of Xi'an. In one brief segment, he negotiated the rushing chaos of China's wartime capital, Chongqing.

On the closet's shelves were incredibly fragile glass LPs. Their labels identified them as recordings of radio broadcasts from World War II. The vast majority of anything published among the papers featured similar bylines: Mel Jack, Mel Jacks, and, most often, Melville Jacoby. Something else was in that cabinet: a stack of meticulously lettered invitations to the chris-tening of a ship named after Mel, as well as newspapers and letters between the company that built it and his family.

Among the many documents were folders and folders over-flowing with eulogies, statements from civic organizations and other institutions memorializing Mel, and dozens of obituaries clipped from newspapers and magazines.

These remembrances were written by journalists. They were written by politicians. They were written by publishers. They were written by friends. They included famous figures from World War II, such as General MacArthur and Secretary of War Henry Stimson, who honored Mel as if he had been a soldier fallen at the side of their troops. Even Madame Chiang and Philippine president Manuel Quezon expressed personal regrets and the regrets of their nations' people. Old college sweethearts, former colleagues, professors and classmates from Stanford and Lingnan, all wrote of their sorrow.

Everything in the cabinet was a reminder of the cousin

Jackee and Peggy once revered. Aside from family mementos, much of what they found were the documents and dispatches that Annalee and Elza had gathered so that Annalee could finish "This Is Our Battle," though she set them aside when her father died. Over time these materials had been all but forgotten.

Peggy recalled that she, her sister, and their parents had hung on every bit of news about Mel that made it to their Los Angeles home: the excitement of Mel's marriage to Annalee Whitmore, the hilarious reports on the pandas they babysat, the dark accounts and uncertainty that arrived with Manila's fall, the months of intermittent stories from the Pacific Theater, their pride in their cousin Mel's work, the rush of excitement when they learned that Mel and Annalee had made it safely to Brisbane, and the crackle of the radio their father used to receive the *March of Time* broadcast that recounted the young couple's escape. How proud the whole family had been, especially Peggy and Jackee's father, Eugene.

Then there was that horrible day at the end of April 1942. Seventy years later, the Stern sisters could still recall hearing the news. Their tight-knit family was devastated.

"I remember it like it was yesterday," Peggy said in 2012. "My mom was crying. My dad was crying. My sister was crying. He was our hero, and we looked up to him all the time we were growing up."

After Peggy and Jackee found the trove of Mel's artifacts, they puzzled over what to do with it all. The rest of their family was caught up in other pursuits—finishing school, beginning careers, starting new families of their own—so Peggy brought the collection home with her. She pored over the papers Elza left behind, discovering nuances of Mel's life that she hadn't known or understood as a child. The more she explored the files the more she felt that her cousin's story needed to be told.

The journalism department at Stanford—which Peggy said she decided to attend after Mel first showed her the campus during a visit with her parents in 1935—helped transfer the audio recordings and home movies to modern formats, but little else ultimately happened. Mel's memory began to fade once more as the demands of daily life rose to the fore.

Then, in 2004, as Peggy prepared to move to Bakersfield, she came across Mel's artifacts again. That year she gave me the typewriter that would ultimately send me on his trail. Over the ensuing years, she shared with me the boxes full of documents related to Mel that she'd recovered from Elza's home. She knew what I came to realize after she gave me Mel's typewriter: had someone written his story as fiction, he'd have been dismissed as an unbelievable character.

"He was wealthy, handsome, and he was a wonderful human being," she said. "He was too good to be true. If a fiction writer invented him, the reader would say, 'That's a lousy book.'"

As I searched through all the documents in my grandmother's possession, and as we discussed what we found, marveled at the countless photographs, and even argued occasionally about which bits were most relevant to include in a book—which Peggy was certain I'd one day write—piecing together a bit more of Mel's story became a ritual every time I visited her. As we worked together, we became closer.

Through discovering Mel, I discovered levels of my grandmother's character I hadn't known when I was younger.

Cobbles on a sunburnt shoreline rattled beneath receding waves. Two bearded men in their early thirties and a slender twenty-something woman scrambled over loose rocks, dead stingrays, and discarded beer bottles. Gusts from the cloudless sky whipped a green windbreaker against the young wom-

an's body, causing her to stumble as strands of her brown hair
flipped loose from her ponytail, pulled through a black ball cap
that read, in white lettering, PORT OF L.A.

One of the men—in faded jeans, a white T-shirt, and a blue
Dodgers cap—helped the woman down from a discarded chunk
of concrete. Their feet scraped across the field of rounded stones
that passed for a beach. They slipped on ropes of seaweed. The
tide inched across the rocks, drawing the sea nearer to the trio.
If they remained much longer, the three friends would have to
turn back from their six-mile hike or scramble up a cliff into
the backyard of some millionaire's oceanfront roost.

Then they saw it: six or seven feet of a seawater-soaked pipe
caked red with rust. A few hundred yards ahead, the second
man—stubble on his chin and clad in a gray jacket, shorts, and
Converses—called back to the group, though the crashing of
the waves muffled his words. His friends caught up. All three
walked together toward another stretch of metal farther down
the beach. There, slivers of orange and brown iron mingled
with the eroded rocks at the friends' feet. The group's spirits
lifted, and they rushed around a bend. Dark shapes rose above
the tide line's aquamarine curve. The first was an elaborate
piece of machinery. Tanklike treads topped by a rusted maze
of gears climbed over a bed of rocks.

Sitting just at the water's edge, the vehicle appeared fro-
zen in the middle of some decades-old invasion. A few yards
away, a slightly curved sheet of metal, jagged at one torn edge,
stretched into the air. Waves sloshed over the recessed portion
of the bowed slab's center, while a porthole dotted a section
reaching to the sky. Yet farther away rested another enormous
hunk of crusty, red metal. Thin ribbons of the crumbling ma-
terial framed rectangles of the landscape beyond. Palm trees
and sea spray and bluffs topped with immaculate lawns ap-
peared between each, like postcard vistas of Los Angeles.

The man in the jeans and the Dodgers cap waited for a break in the waves, then climbed to the top of the biggest chunk of wreckage. He surveyed the detritus, his friends took his picture, and he sat in silence for a moment, staring out to sea. All three poked about the beach a little longer as they ate a packed lunch. Before they left, the first man grabbed a small triangular piece of the shipwreck. Slivers of the artifact—a piece of a ship once known as the SS *Melville Jacoby*—flaked across his hands, darkening his shirt and turning his fingertips the same bloody mix of red and orange and brown staining the shore.

The friends found a shortcut along a drainage culvert and emerged between two homes. They walked to a park atop the cliffs where a lazy Sunday afternoon crowd was gathered. Reaching the park, they heard a series of whirs and whines.

Tiny airplanes soared beyond the cliff's edge. The model planes dove, twisted, and raced above the ocean. Their lovingly painted bodies displayed deep, dark greens and smooth, silvery grays. Gleaming yellow letters, bright white stars, brilliant blue stripes, and lush red circles accented the sleek shapes dancing and darting across the spring sky. The planes were beautiful, loving re-creations of fighters from a war nearly three-quarters of a century past. Carefully and skillfully flown, they dove toward the ocean, then arced gracefully back toward the sun.

The scene these planes performed was but a dance, an idyll through the blue sky of a Sunday afternoon, beneath which 8,000 miles of Pacific Ocean and seven decades of history stretched to a place where the war machines these toys were modeled on had flown in a fury as violent as this afternoon was pleasant, a place that nevertheless brought these three friends together to share a moment, not of danger, but of peace.

ACKNOWLEDGMENTS

This book would not have become a reality without the encouragement, support, and backstopping provided by many family members, many friends, and even some strangers.

Thank you to Chan Ka Yik's daughter, Emmy Ma, for bringing together so much support. Emmy, her husband Dominic, her sisters Eva Cheung and Susie Poon, and Susie's husband Raymond encouraged other contributors who helped me afford to tell this story. It was such a delight to meet them over lunch at Susie and Raymond's house in 2012. An extraordinary coincidence at that lunch also led me to Deborah Ching. In turn, I must thank Debbie for the once-in-a-lifetime afternoon I spent with her father, George T. M. Ching, Mel's friend from Lingnan and Stanford.

Likewise, the children of many of Mel and Annalee's journalist friends provided access to private letters and papers, personal recollections, and simple cheerleading. These included Annalee's daughter, Anne Fadiman; Theodore White's children, David White and Heyden White Rostow; Shelley and Seth Mydans, who permitted me to quote from their father's

notebooks (thanks as well to Shelley and John Griffing for their hospitality); and Hugh Deane's son, Michael. I'd also like to thank Chris and Michael Hoogendyk for information about the pandas. Thank you as well to Darrow Carson, grandson of Lew Carson. I also wish to thank Paul French, Steven MacKinnon, and especially Peter Rand, who spent some time talking with me about Mel.

Jessica Papin at Dystel & Goderich Literary Management shepherded this book, answered my ceaseless questions, and assuaged many worries, all without complaint or lack of good cheer. Meanwhile, Henry Ferris and Nick Amphlett at William Morrow expertly guided me as I honed this narrative into a work of which I am proud. Thank you to all.

To the people of Chongqing, Beijing, Guangzhou, Jintian, Shanghai, Hong Kong, Macau, Manila, Corregidor, Pola, and Cebu (and along the roads, rails, and ferry lines in between): thank you for happily welcoming me into your countries, cities, and homes. Specifically, thank you to Zhangrong (Jackie) for your hospitality and for easing my transition into China. I also want to thank Manuel L. "Manolo" Quezon III and Liana and Roberto Romulo, who helped me understand the Philippines, its history, and their families. Thank you as well to Carsten Schael of the Foreign Correspondents Club of Hong Kong for making me feel welcome among the Press Hostel's inheritors even after I flubbed our schedule. I'd also be remiss if I didn't thank Shawna and Margaret at Oui Presse; their cookies, ceaseless warmth, and fermentation chats fueled much of this book.

When I began this book, I reconnected with Lindsey Miller, an enthusiastic "liver" who helped me launch this project, even as she taught me to dance in the rain and savor farmers' market tomatoes. She is missed. Lindsey and I also scrambled to the wreckage of the ship once known as the SS *Melville Jacoby*

with Jake Cunningham, whose consistent friendship has been matched only by Libby Buchanan, Justin Messina, Aaron Hoholik, Monica Garcia, and Noah Rolff. Through encouraging letters she wrote from her own Pacific adventures, Megan Knize, herself a former *Stanford Daily* editor, pushed me to share Mel and Annalee's story.

Emily Kemper's insistence that I couple my passion for this story with a plan to see it through spurred me to work hard enough to complete the book. I'd also like to thank Amanda Peacher and Thomas Schmidt, fellow writers who have coupled their professional encouragement with deep wells of loving friendship. Christina Cooke's long camaraderie as a freelancer and nonfiction writer has been as welcome as her breathtaking prose. Saikat Chakrabarti made me look better than I deserve in head shots. Suzi Steffen shared fortifying enthusiasm for this project over Byways meals. Doug Kenck-Crispin has made history cool again and amplified my work. Manfred Elfstrom provided timely hospitality in Shenzhen, helped me make travel plans, and even remotely routed a confused taxi driver. Carla and Joe McGarvey (and Moose!) made scouring the National Archives and Library of Congress more bearable. So did Will and Patti Carrington. My incomparable schedule twin, sounding board, and confidant Katelyn Petroka hosted me (assisted by Tarzan and Nugget), as did longtime friends Laura Veuve, Peter Prows, and Constance Brichford (Biff too!). Andrea Gerson has been in my corner since the day we met. This note understates your role in my life, but thank you, Andrea, for much more than Mexican food, bingo, and doughnuts. Also, for bringing Noah along.

Every member of my family has nudged this book along. Thanks to Susan and Matt Guasco, Thomas Lascher, Ted Lascher, and Liz Posner. Bear Wilner-Nugent and JJ Wilner have been my champions, as have Dedee Wilner-Nugent and the ever-delightful Wendolin and Rachel. Gretchen and Stew

Brandt welcomed me during a research trip Shabbat dinner. Susan Cole and Mike Forster (as well as Nestle, Zoe, and Lily) hosted me as I did research at Stanford; they also provided many great ideas for my work. Roger Cole and Michelle Kurtis Cole gave me an art-filled welcome in San Diego. Bill Cole and Carol Lombardini have been enthusiastic supporters from start to finish. Dave Cole handled many logistical needs while also providing levity.

But I wouldn't be where I am without Wendy Lascher. She has always been the most stringent, and best, editor I could want. More importantly, her love and support have kept me writing when it hasn't seemed possible. She is an inspiration both for her own work ethic and her encouragement. Likewise, I am so grateful to Peggy Cole and Jackee Marks for much more than keeping Mel's memory alive. I look up so proudly to these last three amazing women. "Thank you" is simply not an adequate sentiment. Still, thank you.

I'd also like to thank the following for their financial or other support: Michael Andersen, E. V. Armitage, James Armstrong, Stephen Baboi, Kathleen and Brian Back, Amy Baird, Wei Leng and Charles Baker, Roger Bartlett, Jim Baumer, Juliette Beale, Tim Berg and Pat Martin, Margaret Berger, Mellissa Betts and Jared Hedges, Katherine Blauvelt, Madeline Bodin, Ed Borasky, Denise and Tony Brogna, Valerie Brown, Dr. Moritz Butscheid, Harold and Carola Butschcid, Billy Calzada, Rachel Carbonell, Adam Carlson, Wendy Carrillo, Paul and Bessie Carrington, Helen Chan, Cheng Chang, Ethel Chang, Arthur Cheung, Kwok Ping Chiu, David Chott, Pat Chow, Katie Clunen, Sarah Corbitt, Stevi Costa and Marcus Gorman, Emily Craddick, Kyra Czar, Pete Danko, Mo Daviau, Ivor Davis, Rebecca Davis, Jen Dean, Vicki DeGoff and Richard

Sherman, Melissa Delzio and Ryan Scheel, Rick and Kathy Derevan, Gary Dickson, Ed Elrod, Ernestine Elster, David Ettinger, Peter Fairley, Sarah Fama, Suzanne Fischer, Whitney Fox, Andrew Galasetti, Elizabeth Gelner, Erica Gies, Matthew Gitchell, Ross Golowicz, Robert Greene, Sharon Greenfield, Sarah Guare, Hannah Guzik, Karen Hamberg, Elizabeth Hassett, Christine Heinreichs, Noah Heller, John Hribar, Audra Ibarra, Barry Johnson, Erin Kelley, Rhea Yablon Kennedy, Carrie Kilman, Eli Kress, Dennis and Jo Ann LaRochelle, Gabriele and James Lashly, James Lauter, Dien Le, Jennifer Lauren Lee, Edan Lepucki, Becky Lerner, Anne Leung, Tip Lin, Dottie Loebl, Dave Long, Jenny Lower, Alvin Lui, Amy Jo Luna, Clifton Ma, Connie and Eric Ma, Sue and Terry Ma, Jason MacDonald, Evan Manvel and Lillie Jones Manvel, Lisa Marks, Colm McHugh, Kate McLean, Kevin McVerry, Claudia Melendez, Tina Mercado, Rose Messina, Laura Miller, Andy Moran, Karen Adams Moran, Aaron Mucciolo, Patrick Mulligan, Scott Nichols, Patrick Nork, Jennifer Novak, Gabe O'Brien, Mary Catherine O'Connor, Toni Palacios, Michael Parks, Jonathan Partridge, Bill Paterson, Jennifer Peebles, Erin Pidot, T. Peter Pierce, Hadley and Max Porter, Cassandra Profita, Larry Pryor, Suzie Racho, Michelle Rafter, Emily Render, Casey Rentz, Colin Reyman, Whit Richardson, Rebecca Robinson, Harriet Rochlin, Karen and Andrew Rodney, Louise Sanchez, Karen Schaefer, Barbara Schultz, Erik Schwartz, Brooke Shepherd, Courtney Sherwood, Catherine Smith, Jaclyn Smith, Ezra Spier, David Stern, Deborah Stern, Taffy Stern, Joe Streckert, Brandon Stroman, Kristen Sullivan, Meri McCoy-Thompson, Solvej Todd, Jennifer Troolines, Maren Tusing, Lee Van Der Voo, Al Vargas, Lou Vigorita, Joel Villaseñor, Emily Vizzo, Jeff and Shelia Waters, Sam Weisberg, Amy Westervelt, Susan White, Jennifer Willis, Edward Wolf, Elaine and Kelly Wong, Roy Xavier, Nancy Young, and Linda Zin.

In closing, I would like to acknowledge the librarians and archivists I interacted with and the many more who prepared, cataloged, and indexed the sources I consulted. Your work is unsung. Specifically, thank you to the following institutions and their staffs: the Australian War Memorial; the Autry National Center; Beinecke Rare Book and Manuscript Library, Yale University; Filipinas Heritage Library; Harvard University Archives; Hoover Institution Library; Lewis and Clark Watzek Library; Library of Congress; Lingnan University Archives; Margaret Herrick Library; National Archives and Records Administration; Stanford University Library; Union Church of Manila Library; United States Air Force Historical Research Agency; University of California at Berkeley Ethnic Studies Library; University of California at San Diego Mandeville Library; and University of Oregon Knight Library, Special Collections and University Archives.

A NOTE ON SOURCING

Bibliographic listings and references have been condensed in the interest of space. A full bibliography of print, online and periodical works consulted as well as complete citations can be found at eveofahundredmidnights.com/sources.

Correspondence, writings, photography, and other materials of Melville Jacoby, Elza Stern Meyberg, and Manfred Meyberg were provided by Peggy Stern Cole and the estate of Melville J. Jacoby.

Acknowledgment is made to Shelley and Seth Mydans for permission to quote from Carl Mydans's notebooks. Please see the notes for specific citations.

The correspondence of Theodore H. White was quoted with permission from Heyden White Rostow and cited as such in the notes.

See the notes for details about Annalee Jacoby Fadiman that were provided or clarified by Anne Fadiman.

Archival Collections Consulted

The following archival and library collections were consulted for this work:

Harvard University Archives, Cambridge, MA
Theodore Harold White Papers, HUM 1.10, 1922–1986

Lewis and Clark University, Watzek Library, Special Collections, Portland, OR
Hugh Deane Collection

Margaret Herrick Library, Special Collections, Beverly Hills, CA
Louella Parsons Scrapbooks and Photographs

Sidney Skolsky Papers

National Archives, College Park, MD
"General Correspondence Files Relating to Civilian Employees, 1941–1955," Records of the Adjutant General's Office, 1917– [AGO], RG 407

"Motion Picture Films from the 'Combat Subjects' Program," Records of Army Air Forces, RG 18

"Records Relating to War Support Services, 1941–1947," Records of the Adjutant General's Office, 1917– [AGO], RG 407

"USN Deck Logs," Records of the Bureau of Naval Personnel, 1798–2007, RG 24

U.S. Department of State, General Records, Washington, D.C.
"Death in Australia of Melville J. Jacoby, American Citizen," 347.113 Briscoe
Estate Benjamin—347.113 Perry, RG 59

Hoover Institution Archives, Stanford, CA
Jack Belden Papers

Claire Lee Chennault Papers

Lauchlin Bernard Currie Papers, 1941–1943

Randall Chase Gould Papers

Stanley Kuhl Hornbeck Papers

Suzanne Norman Malloch Papers

Roger Mansell Collection

Charlotte Ellen Martin Papers, 1942–1982

Laurence E. Salisbury Papers

A. T. Steele Papers

Karl H. Von Wiegand Papers

Nym Wales Papers

Charles Andrew Willoughby Papers

Stanford University Libraries, Department of Special Collections, Stanford, CA
Estate of Carl Mydans Photography Collection, MSS PHOTO 243

University of California, Ethnic Studies Library, Berkeley, CA
Charles Leong Papers, 1932–1972

University of California, Special Collections and Archives, San Diego, CA
Frank Tillman Durdin Papers, MSS 95

University of Oregon, Knight Library, East Asian Collection, Eugene, OR
Charles E. Stuart Papers

Yale University, Beinecke Rare Book and Manuscript Library, Yale Collection of American Literature, New Haven, CT
Carl and Shelley Smith Mydans Papers

U.S. Library of Congress, Manuscript Division, Washington, D.C.
Cordell Hull Papers

Owen Lattimore Papers

Clare Boothe Luce Papers

Henry Robinson Luce Papers

Francis B. Sayres Papers

U.S. Library of Congress, Recorded Sound Reference Center, Washington, D.C.
National Broadcasting Company History Files

Miscellaneous
Filipinas Heritage Library, Ayala Museum, Makati City, the Philippines

Lingnan University Archives, Lingnan University, Hong Kong

NOTES

Note: Statements by Melville Jacoby not otherwise cited are quoted from correspondence between Jacoby and Elza and Manfred Meyberg. See the extended bibliography at eveofahundredmidnights.com/sources for full citation of these and other quotes.

Key to Abbreviations:

AWJF – Annalee Whitmore Jacoby Fadiman

CKY – Chan Ka Yik

DH – David Hulburd

ESM – Elza Stern Meyberg

HRL – Henry Robinson Luce

JH – John Hersey

MJ – Melville J. Jacoby

MM – Manfred Meyberg

THW – Theodore H. White

Prologue

4 **"There were no other ships":** MJ "In the Air Somewhere in Australia" (cable to DH), April 4, 1942, p. 4.

5 **Bombed and sabotaged vessels:** Charles Dana Gibson and E. Kay Gibson, *Over Seas: U.S. Army Maritime Operations, 1898 Through the Fall of the Philippines* (Camden, ME: Ensign Press, 2002), p. 227.

7 **"The last two weeks in Manila":** AWJF letter to ESM and MM, April 10, 1942, Melbourne, Australia.

Chapter 1: "Why Should I Contribute a Little More Trash?"

14 **Louis Loss Burns and Harry Revier:** Mary Mallory, "A Little Barn Started It All," *Hollywood Heritage Inc.* (Los Angeles) 32, no. 3 (Fall 2013).

15 **The epidemic . . . killed:** Molly Billings, "The Influenza Pandemic of 1918," June 1997 (modified 2005), virus.stanford.edu/uda/ (accessed August 26, 2014).

15 **"As young as [Mel] was":** ESM letter to JH, March 31, 1942, Bel Air, CA, p. 1.

17 **"I still remember":** Ibid., p. 4.

18 traits that later prompted: *Ta Kung Pao,* translated in C. L. Hsia, Director, Chinese News Service, Inc., May 18, 1942 letter to ESM.

18 "Mel was tall, dark": Clark Lee, *They Call It Pacific: An Eye-Witness Story of Our War Against Japan from Bataan to the Solomons,* New York: Viking Press, 1943, p. 125.

19 "because he always wanted": Winton Ralph Close to ESM, Oct. 28, 1942, New Orleans, LA, p. 2.

25 "I tried to take them": George T. M. Ching, interview, Aug. 27, 2012.

27 "For most of the American students": Hugh Deane, "Memories of Lingnan, Notes on Chung Shan," *China and US.* (U.S. China Peoples Friendship Association) 2, no. 5 (November–December 1973): 4.

28 Though it began with 100,000: History.com, "This Day in History: October 20, 1935: Mao's Long March Concludes," A&E Networks, history.com/this-day-in-history/maos-long-march-concludes.

28 After reaching Yenan: Rana Mitter, *Forgotten Ally: China's World War II, 1937–1945.* New York: Houghton Mifflin Harcourt, 2013, p. 70.

28 devised a scheme: Ibid., pp. 71–73.

33 "He talked about [Mel] often": Emmy Ma, telephone conversation, Aug. 8, 2011.

34 Mel later wrote in an essay: MJ, classroom assignment titled "4 Jacoby 25," Stanford University, Fall, 1937.

38 The question then became whether: Mitter, pp. 80–81.

39 "If it were just [Peiping]": Ibid., p. 81

40 "To return to a war": Ibid., p. 83

40 Japan did make a few: Ibid., p. 89.

Chapter 2: "The Itch Is Perpetual"

43 Hull acknowledged the violence: Cordell Hull, telegram to Grace Caulfield, July 21, 1937, 11:19 A.M., Washington, D.C.

43 Local leaders on each side": Mitter, p. 85.

48 "Propaganda is scattered": MJ, "Inside China," *Stanford Daily* 92, no. 7, (October 5, 1937), p. 4.

49 Keller had been in Asia: "Helen Keller: Her First Visit to Japan in 1937," Topics on Deaf Japan, September 26, 2013, deafjapan.blogspot.com/2013/09/helen-keller-her-first-visit-to-japan.html.

49 "Discussing the Japanese people": "Student Meets Helen Keller in Mid-Pacific," *Stanford Daily* 92, no. 3 (September 29, 1937), p. 3.

50 "The itch is perpetual": MJ, "4 Jacoby 25," p. 3.

50 "The air raid in Canton": CKY, letter to MJ, November 15, 1937, Canton (Guangzhou), China, p. 1.

51 "You Americans": Leîtao, Marie, letter to M. Jacoby, Oct. 4, 1937, Macau, p. 1.

51 "Life as an exchange student": MJ, "Inside China," *Stanford Daily* 92, no. 4 (September 30, 1937), p. 4.

52 "Personally, I hate": MJ, "Assignment 24" (classroom assignment), October 1937, Stanford University, Stanford, CA., p. 2.

52 But even his parents' help: Ibid.

52 But despite a full-page blitz: "Looking at Stanford Through the Eyes of Foreign Students," *Stanford Daily,* February 14, 1938, p. 2.

53 Creative (or desperate) solutions: Ibid.

54 "Mel, you are the best": CKY, letter to MJ, March 16, 1938, Canton (Guangzhou), China, p. 1.

54 they examined stories: MJ and Charles L. Leong, "An Analysis of Far Eastern News in Representative California Newspapers: 1934–38" (master's thesis), Stanford University, Division of Journalism, Stanford, CA, September 1939.

57 "Not one asked about the background": Ibid, p. 281.

58 Its highly touted features included: Golden Gate International Exhibition, *Official Guidebook* (San Francisco: Crocker Company, 1939).

62 "But if you aren't British": MJ, "Shanghai Is" (unpublished column), December 1939, Shanghai, China.

63 Between 20,000 and 300,000: Kate Merkel-Hess and Jeffrey N. Wasserstrom, "Nanjing by the Numbers," *Foreign Policy,* February 9, 2010, foreignpolicy.com/articles/2010/02/09/nanjing_by_the_numbers (accessed May 14, 2013).

63 Wang's underlings set up: John B. Powell, *My Twenty-Five Years in China* (New York: MacMillan Company, 1945), p. 335.

64 "Things went from bad to worse": Paul French, *Through the Looking Glass: China's Foreign Journalists from Opium Wars to Mao* (Hong Kong: Hong Kong University Press, 2009), Kindle Ebook location 4210.

65 Aside from Abend and Gould: Stephen R. MacKinnon and Oris Friesen, *China Reporting: An Oral History of American Journalism in the 1930s and 1940s* (Berkeley: University of California Press, 1987), p. 25.

66 Mel did publish: MJ (writing as "Mel Jack"), "Jews in Exile," *Los Angeles Times,* January 14, 1940, p. 17.

Chapter 3: The Voice of China

71 Leaf, who was also: Earl H. Leaf, "Behind Chinese Lines," in *Eye Witness* by members of the Overseas Press Club of America, ed. Robert Spiers Benjamin (New York: Alliance Book Corp., 1940), p. 132.

76 "the 20th Century caught up": MJ, "Unheavenly City" (unpublished article draft), Summer 1941, Chungking (Chongqing), China.

76 "Moving the entire government": Mitter, *Forgotten Ally,* p. 174.

77 "most raided city": MJ (writing as "Mel Jacks"), "China's 'Most Raided City,'" *This World (San Francisco Chronicle* Sunday magazine), September 8, 1940, p. 11.

77 "Chungking is probably": MJ, "Unheavenly City," p. 1.

77 "evil and new": Carl Mydans, *More Than Meets the Eye.* New York: Harper & Bros, 1959; reprint, Westport, CT: Greenwood Press, 1974, p. 40.

78 "Few foreigners desert": MJ, "Unheavenly City," p. 2.

80 "If you are a correspondent": Ibid, p. 7.

82 "those days in Chungking": THW, letter to Peggy and Tillman Durdin, August 30, 1955, Frank Tillman Durdin Papers, MSS 95, Special Collections and Archives, University of California at San Diego.

83 They were, as the author: Peter Rand, *China Hands.* New York: Simon & Schuster, 1995, p. 195.

83 "I don't know how, if ever": THW, August 30, 1955 letter.

84 "like suction cups plopping": MJ, "Monsieur Big-Hat (or) Chungking Interlude," unpublished short story, summer, 1940, Chungking (Chongqing), China, p. 5.

86 "You get to know Chinese officials": MJ, "Unheavenly City," p. 7.

89 "Thank you, NBC": MJ, NBC radio broadcast, April 17, 1940.

90 "Not the easiest capital": MJ, cable to DH, June 17, 1941, Chungking (Chongqing), China, p. 1.

91 "When you are climbing": MJ, "Unheavenly City," p. 3.

94 she'd censored it heavily: MJ, "China's First Lady" (prepublication article draft), May 4, 1940, Chungking (Chongqing), China.

95 "The atmosphere between": John Oakie, letter to MJ, April 11, 1940, San Francisco, CA, p. 2.

96 "Learning to bum cigarettes": MJ, "Unheavenly City," p. 8.

96 "You damn a government bureau": Ibid, p. 5.

Chapter 4: The Haiphong Incident

100 "I feel that your initiative": Hollington K. Tong, "Ref. No. 838" (letter to MJ, July 15, 1940, Chungking (Chongqing), China.

104 "The French have given": MJ as collated by AWJF, "Notes on Indo-China," typewritten copy of handwritten summaries collected fall, 1940, p. 2.

105 They'd liked his earlier reporting: Robert Bellaire, letter to MJ, September 11, 1940, Shanghai, China.

106 "In one way or another": MJ, letter to Bellaire, October 9, 1940, Hanoi, French Indochina (Vietnam), p. 2.

106 Bellaire had thought: Bellaire, September 11, 1940 letter.

107 "foreign correspondent, ahem": MJ quoted in Shirlee Austerland, "Tues," letter to ESM, Fall, 1940 (specific date unavailable), San Francisco, CA.

107 "Sometimes that takes a lot": MJ, October 9, 1940 letter, p. 2.

108 "From the Manila broadcasts": Ibid, p. 3.

111 She even sent a telegram: Austerland, telegram to MJ October 28, 1940, San Francisco, CA.

111 "frantically querying": MJ, telegram to United Press Shanghai office, October 2, 1940, Hanoi, French Indochina (Vietnam).

112 "If there are chances": MJ, October 9, 1940 letter, p. 1.

112 "I have been told": MJ, letter to Bellaire, November 1, 1940, Hanoi, French Indochina (Vietnam), p. 1.

112 The situation became so bad: MJ, letter to Charles S. Reed, November 12, 1940, Hanoi, French Indochina (Vietnam), p. 1.

113 A U.S. flag still flew: French officials stopped his cable: MJ, cable draft 128, translated from French, November 21, 1940, Haiphong, French Indochina (Vietnam).

114 "The French police": MJ, letter to Charles S. Reed, November 21, 1940, Hanoi, French Indochina (Vietnam).

114 Another writer later recounted: Moats, Alice-Leone. Blind Date with Mars. Garden City, NY: Doubleday, Doran and Co., 1943, p. 73.

115 "Four days later": Joseph Grew, State Department bulletin 1700, November 26, 1940, as reprinted at Foreign Relations of the United States, *Papers Relating to the Foreign Relations of the United States, Japan: 1931–1941,* p. 704, University of Wisconsin–Madison Libraries, Digital Collections (UWMDC), digicoll.library.wisc.edu/cgi-bin/FRUS/FRUS -idx?type=turn&entity=FRUS.FRUS193141v01.p0800&id=FRUS .FRUS193141v01&isize=text.

115 "By that time": Moats, *Blind Date with Mars,* p. 73.

116 "dismal, grimy place": Ibid.

117 Consul Reed reported: "The Consul at Hanoi (Reed) to the Secretary of State," as reprinted at United States Department of State, *Foreign Relations of the United States Diplomatic Papers, 1940 (The Far East),* UWMDC, digicoll.library .wisc.edu/cgi-bin/FRUS/FRUS-idx?type=turn&entity=FRUS.FRUS1940v04 .p0251&id=FRUS.FRUS1940v04&isize=M&q1=jacoby, p. 243.

119 "We thought of having a showdown": Maurice Votaw, letter to MJ, January 4, 1941, Chungking (Chongqing), China.

119 "He is extremely modest": Chilton R. Bush, letter to ESM, January 25, 1941, Stanford, CA.

Chapter 5: A True Hollywood Story

125 Shippey wrote that: Lee Shippey, "Lee Side o' L.A.: Direct from Indo-China," *Los Angeles Times,* February 22, 1941.

126 "I thought that I would": MJ, letter to Mary White, February 17, 1941, Los Angeles, CA.

128 Leland had been: Anna Liakas, "War Correspondent and Author Spends Last Days on Captiva," *Sanibel-Captiva Islander* (Captiva, FL), February 22, 2002.

128 Then, in 1934: "Whitmore; Ex-Housing Official in So. Cal Dies," clipping from unknown publication, October 1942.

129 For a while she even: Lloyd Shearer "Will the real Robert McNamara Please Stand Up," *Parade* magazine, March 5, 1967.

129 "Eyes closed, expression": AWJF, "Mischa Elman Gets Concert Series Ovation," *Stanford Daily* 84, no. 22 (November 2, 1933), p. 1.

130 "Annalee 'New Theater' ": Irv Jorgi, "Greek Gals Get Cash to Clinch Royal Rat Race," *Stanford Daily* 87, no. 21 (April 10, 1935).

130 "Why do supposedly intelligent": AWJF, "Fair Sex Lacking in Grid 'Savoir Faire,' " *Stanford Daily* 88, no. 44 (November 22, 1935), p. 10.

131 netted a dark green: "Co-eds Cut Capers in Cute Campus Clothes," *Stanford Daily* 91, no. 19 (February 26, 1937), p. 6.

131 Shelley Mydans wrote: Shelley Mydans, "Book-of-Month Author," *Stanford Alumni Review* (December 1946), p. 11.

132 "Extracurricular work on": "Poppa Time Swings Around Another Cycle as the Daily Toddles On," *Stanford Daily* 89, no. 62 (May 27, 1936), p. 4.

133 "used to being the first": Anne Fadiman, conversation with the author, January 4, 2013.

133 "In spite of her quick": S. Mydans, "Book-of-Month Author," p. 12.

134 "Travelers in the Middle West": AWJF, "Viewing the News: Midwest Dust Storms—Pettengill," *Stanford Daily* 87, no. 24 (April 15, 1935), p. 2.

135 No doubt Burgess: Chilton Bush, letter to ESM, December 30, 1943.

135 **"journalist through and through"**: Fadiman, January 4, 2013 conversation.

136 **A job anywhere:** "Stanford 'Kids' Write Scenario: 'Andy Hardy Meets Debutante,'" *Stanford Daily,* July 7, 1940, p. 4.

137 **"Annalee didn't know"**: Sidney Skolsky, "Hollywords and Picturegraphs," Syndicated Column, April 24, 1942.

137 **This shorthand was so cryptic:** S. Mydans, "Book-of-Month Author," p. 11.

137 **"She did it good enough"**: Skolsky, "Hollywords and Picturegraphs."

137 **"When I talk about odds"**: "Stanford 'Kids' Write Scenario," p. 4.

137 **At one point, Fitzgerald:** Fadiman, conversation with the author, July 31, 2014.

138 **"never let anyone forget that"**: "Stanford 'Kids' Write Scenario," p. 4.

138 **"I couldn't help but learn"**: Ibid.

138 **At Stanford, Seller:** "Prize Winning Play Will Be Read by Masquer's," *Stanford Daily,* November 6, 1934.

139 **"Their names are on the screen"**: "Stanford 'Kids' Write Scenario," p. 4.

139 **"Daphne, the 'deb,' he decides"**: Bosley Crowther, "Movie Review: Andy Hardy Meets Debutante (1940)," *New York Times,* August 2, 1940.

139 **"Annalee Whitmore is"**: Skolsky, "Hollywords and Picturegraphs."

139 **"She was at heart"**: Michael Churchill, "Bull Session: Honeymoon on Corregidor," *Stanford Daily,* February 3, 1942.

140 **"she found the prospect"**: Sorel, Nancy Caldwell. *The Women Who Wrote the War.* New York: Harper Perennial, 2000, p. 141.

141 **In school he and Mel's:** AWJF, "Dear Mother and Dad #2," letter to ESM and MM, Fall 1942.

Chapter 6: "I'll Be Careful"

144 **"For they are the largest"**: HRL, speech at United China Relief dinner, March 26, 1941, Waldorf-Astoria Hotel, New York, NY.

152 **Asking his constituents:** "Mrs. Nicholson Sends News of Baltimore 'China Week,'" *Mount Vernon Hawk-Eye,* March 6, 1941.

153 **Lee was a daredevil:** Rebecca Maksel, "China's First Lady of Flight," *Air and Space* magazine (Smithsonian Institution), Washington, D.C., July 23, 2008, airspacemag.com/history-of-flight/chinas-first-lady-of-flight-1725176/?no-ist (accessed April 18, 2015).

153 **"Said Shirlee"**: MJ, letter to THW, March 12, 1941, New York, NY.

153 **"For [the Chinese] are the largest"**: HRL, speech at United China Relief dinner.

157 **"He is in close touch"**: Otis P. Swift, letter to Selective Service Local Board 98 Chairman, April 3, 1941, New York, NY.

159 **Aware of himself:** HRL, "One Beautiful Day," speech for United China Relief, Los Angeles, CA, April 25, 1941.

160 **The animator agreed:** HRL, telegram to Corinne Thrasher, April 27, 1941, Beverly Hills, CA.

162 **Aside from the Luces:** Departure record for *American Clipper* NC 18606, April 28, 1941, San Francisco, CA, and April 30, 1941, Honolulu, HI.

162 There was also a British: Maochun Yu, *The Dragon's War: Allied Operations and the Fate of China, 1937–1945* (Annapolis, MD: Naval Institute Press, 2003).

163 And one woman on board: Sarah Kadosh, "Laura Margolis Jarblum: 1903–1997," in *Jewish Women: A Comprehensive Historical Encyclopedia,* March 1, 2009, Jewish Women's Archive, jwa.org/encyclopedia/article/jarblum-laura-margolis.

163 who was secretly traveling: Phyllis Gabell, listed on the passenger manifest as a representative of the British Ministry of Economic Warfare, was also a member of the United Kingdom's Special Operations Executive.

167 As Teddy White and: AWJF and THW, *Thunder Out of China.* 2nd ed. New York: William Sloane Associates, 1961 (originally published in 1946), p. 76.

167 "The Communist-Kuomintang": MJ, letter to DH, June 9, 1941, Chungking (Chongqing), China, p. 1.

Chapter 7: "Nothing but Twisted Sticks"

171 "Fires lit the city": MJ, cable to DH, June 7, 1941, Chungking (Chongqing), China.

175 The images also caused: M. M. Kornfeld, Russell Fitzpatrick, and Charles Kreiner, "Slaughter in China," letters to the editor, *Life,* August 21, 1941, p. 4.

176 "Well, my friend, the ball": MJ, letter to THW, June 2, 1941, Chungking (Chongqing), China, p. 2.

177 Indeed, Lattimore showed: MJ, "How Japan Moved into Indo-China," *Asia* (May 1941), p. 228.

179 "They got the view": MJ, letter to DH, June 17, 1941, Chungking (Chongqing), China, p. 1.

180 "Now that the shelter": Ibid., p. 2.

180 "But aside from living": MJ, letter to DH, July 12, 1941, Chungking (Chongqing), China, p. 3.

180 "press elsewhere in the world": Ibid, p. 4.

181 "not entirely satisfied": Ibid, p. 5.

182 This "heckling": Ibid, p. 2.

183 "The streets are drab": MJ, letter to DH, July 11, 1941, Chungking (Chongqing), China, p. 2.

183 "What it *did* gain": C. Mydans, entry from June 21, 1941, notebook 3 (emphasis in the original) (quoted courtesy of the Mydans family).

Chapter 8: "He Types on the Desk, and I Type on the Dressing Table"

190 It was August: Skolsky, "Hollywords and Picturegraphs," April 24, 1942.

191 "I admit we'd": AWJF, letter to ESM and MM, November 29, 1941, Manila, the Philippines.

192 "Chungking was no place": "The Press: In Line of Duty," *Time,* May 11, 1942.

192 "a Norwegian-captained": Norwegian National Archives voyage records listed in Siri Holm Larson, "M/S Granville," Warsailors.com, September 21, 2011, www.warsailors.com/singleships/granville.html (accessed November 7, 2015).

192 **"Passengers are about"**: AWJF, letter to Thomas Seller, September 11, 1941, Manila, the Philippines.

193 **"It takes brains"**: S. Mydans, "Annalee Jacoby," *Book-of-the-Month Club News*, p. 6.

193 **"Maybe people are right"**: AWJF, September 11, 1941, p. 2.

194 **The plane ended up:** Rand, *China Hands,* p. 216; details corrected by Anne Fadiman, July 31, 2014.

197 **She said as much four decades:** MacKinnon and Friesen, *China Reporting,* pp. 50–51.

199 **Other risks included:** AWJF, broadcast script for radio station XGOY – 9638 K.C., Sept. 26, 1941, 6:30 A.M. PST, Chungking (Chongqing), China.

199 **"From obscurity to overnight"**: Ibid.

201 **"did all they could"**: AWJF, November 29, 1941 letter.

202 **The first time Annalee:** Rand, *China Hands,* p. 216.

202 **On a visit to:** Carl Warren Weidenburner, *Inside Wartime China* (2009), an adaptation of the original 1943 edition (Chungking: Chinese Ministry of Information, December 1, 1943), available through China-Burma-India: Remembering the Forgotten Theater of World War II, at the web page cbi-theater.com/wartime/wartime.

202 **Later she would write:** AWJF, November 29, 1941 letter.

204 **"It seemed altogether different"**: Ibid., p. 2.

206 **Mel's eleven-year-old cousin:** Jackee S. Marks, "Jackee's Poem to Melville," October 17, 1941, Los Angeles, CA.

208 **"A good thing you are"**: Hollington K. Tong, "Ref. No. 3462" (letter to MJ), November 18, 1941, Chungking (Chongqing), China.

208 **She later told *Time*'s:** ESM, March 28, 1942 letter.

209 **Manila was relatively:** William J. Dunn, *Pacific Microphone*, Military History Series. College Station: Texas A&M University Press, 1988, p. 20.

209 **"The government of President"**: Ibid.

214 **"It was my only time"**: Ibid., p. 54.

217 **On November 14:** Lee, *They Call It Pacific,* p. 1.

217 **"tall, dark, husky, handsome"**: MJ, "Manila Cable 37," to DH, Dec. 25, 1941, Manila, the Philippines.

218 **Still, Mel was impressed:** Ibid.

218 **"I could see him"**: AWJF, November 29, 1941 letter.

220 **It didn't matter that:** Ibid.

221 **While on their way:** Lee, p. 29.

222 **Annalee's and Mel's friends:** AWJF, November 29, 1941 letter.

Chapter 9: Infamy

224 **"We saw the boat off"**: AWJF, November 29, 1941 letter, p. 3.

224 **In a saccharine coda:** "Named Pandas," *Milwaukee Journal,* November 30, 1942 p. 1.

224 **MacArthur's press aide:** LeGrande Diller, letter to ESM, February 2, 1944, San Francisco, CA.

225 **As the historian Eric Morris:** Eric Morris, *Corregidor: The End of the Line.* Briarcliff Manor, NY: Stein and Day, 1981, p. 23.

226 War was a near-certainty: MJ, "Confidential" (cable to DH), December 6, 1941, Manila, the Philippines.

227 "saw some screwy headline": MJ, "This Is Our Battle" (unpublished manuscript), March 18, 1942, somewhere at sea, p. 4.

227 "By noon the first day": AWJF, "Ours Is Full of Holes," *Douglas Airview* (Van Nuys, CA) (August 1942), p. 4.

228 "MacArthur's men wanted": MJ, "This Is Our Battle," p. 9.

229 "The whole picture seemed": Ibid., p. 4.

229 "Those days were eye-openers": Ibid., p. 9.

230 Shortly after the war: Ibid., p. 7.

231 "The Manila countryside": MJ, "Manila Cable No. 34" (cable to DH), northern Luzon front, the Philippines, December 23, 1941.

233 The story of the battle: MJ, "Manila Cable No. 38" (cable to DH), Manila, the Philippines, Dec. 26, 1941.

234 Manila nights were: MJ, "This Is Our Battle," p. 13.

236 "The ugliness of war": Ibid, p. 9.

237 "There are no uniforms": MJ, "Cable No. 42" (cable to DH), December 26, 1941.

238 "The last two weeks": AWJF, April 10, 1942 letter.

239 "China days had taught us": MJ, "In the air somewhere in Australia," p. 4.

239 For a time: MJ, "This Is Our Battle," p. 14.

240 "Congratulations": HRL, cable to MJ, December 26, 1941.

241 "I was scared then": MJ, "This Is Our Battle," p. 13.

241 "None of us knew": Dunn, *Pacific Microphone*, p. 160.

242 "just a stone's throw": MJ, "This Is Our Battle," p. 14.

242 "The same thing": Ibid.

243 "Anything to stay": Lee, *They Call It Pacific*, p. 151.

243 "By the time we'e [sic] finally": AWJF, April 10, 1942 letter.

244 The U.S. Army Transportation Service: Gibson and Gibson, *Over Seas*, p. 226.

245 "It still seemed better": AWJF, April 10, 1942 letter.

245 "Carl and Shelley decided": Ibid.

245 It is often the case: Sorel, p. 160.

247 They had to leave behind: AWJF, April 10, 1942 letter.

248 Another journalist in Manila: Royal Arch Gunnison, *So Sorry, No Peace.* New York, NY: The Viking Press, 1944, p. 50.

249 now he watched: MJ letter to ESM and MM, April 10, 1942, Melbourne, Australia. Additional accounts were made by Carl Mydans.

249 "Annalee supplied": Lee, *They Call It Pacific*, p. 153.

249 Unfortunately, they couldn't find: Ibid.; MJ, April 4 cable.

251 "Soon we'll be in the Indies": MJ, April 4 cable.

251 "We could just barely make out": MJ, "This Is Our Battle," p. 15.

Chapter 10: Into the Blackness Beyond

257 "We scrambled": AWJF, April 10, 1942 letter.

257 **"That was our introduction"**: MJ, "This Is Our Battle," p. 16.

257 **"MacArthur, he said"**: Ibid, p. 15.

257 **Nevertheless, the military:** Lee, *They Call It Pacific,* p. 160.

260 **"The Rock [Corregidor] was teeming"**: MJ, "This Is Our Battle," p. 16.

262 **"Help is on the way"**: General Douglas MacArthur, "Message from General MacArthur," January 15, 1942, Miscellaneous Papers, Fort Mills, 1941–42, "General Correspondence Files Relating to Civilian Employees, 1941–1955," Records of the Adjutant General's Office, 1917– [AGO], RG 407, National Archives, College Park, MD.

263 **"It is a matter of fact"**: AWJF, "With MacArthur: An Eyewitness Report," *Liberty,* April 18, 1942, p. 19.

263 **Clark Lee would later pointedly:** Lee, *They Call It Pacific.*

263 **"subdivision of hell"**: AWJF, "With MacArthur," p. 19.

263 **According to a War Department:** "FM 30-26," in *Regulations for Correspondents Accompanying U.S. Army Forces in the Field* (Washington, D.C.: U.S. War Department, January 21, 1942).

264 **"Pressmen are allowed"**: MJ, "Bataan Writers Allowed to File 500 Words Daily," *Editor and Publisher,* February 7, 1942, p. 7.

264 **"In Bataan the troops"**: MJ, "Corregidor Cable No. 79," *Field Artillery Journal,* The United States Field Artillery Association, Baltimore, MD, Vol. 32, No. 4, p. 267.

264 **"The pictures of Bataan"**: C. Gerston, "Bataan Wounded," letter to the editor in *Life Magazine,* May 11, 1942, p. 4.

265 **"Now they've gone through weeks"**: AWJF, "With MacArthur," p. 19.

266 **The same morning:** Colonel Carlos P. *I Saw the Fall of the Philippines.* Garden City, NY: Doubleday, Doran & Co., 1943, p. 92.

267 **"They were the sweethearts"**: Ibid.

267 **"We were of all ages"**: Amea Willoughby, *I Was on Corregidor: Experiences of an American Official's Wife in the War-Torn Philippines.* New York: Harper & Bros., 1943, p. 134.

268 **"That was her only concession"**: Fadiman, July 31, 2014 conversation.

269 **"eloquent of self-reliance"**: Willoughby, *I Was on Corregidor,* p. 138.

269 **"frilly, helpless"**: Fadiman, July 31, 2014 conversation.

269 **"We were impressed"**: Willoughby, *I Was on Corregidor,* p. 138.

269 **More often than not:** AWJF, "With MacArthur," p. 19.

270 **Pursuit Hal orchestrated:** MJ, "Melbourne Cable (Jacoby No. 1)" (dispatch to DH), April 18, 1942, Melbourne, Australia, p. 1.

271 **"Since the troops"**: MJ, "Corregidor Cable No. 75" (telegram dispatch to DH). February 7, 1942, Corregidor, the Philippines.

271 **Corregidor was "not the best place"**: Dunn, *Pacific Microphone,* p. 160.

272 **Her daughter Anne Fadiman would recall:** Fadiman, email to the author, January 21, 2013.

272 **In their January 2, 1942:** Louella O. Parsons, "Ruth Hussey to Play 'War Bride,' Story of Honeymoon Under Fire," *Los Angeles Examiner,* January 2, 1942.

273 **"there could be no Dunkirk"**: AWJF, "With MacArthur," p. 19.

274 **In mid-January:** Francis B. Sayre, "Confidential for Time Inc." (telegram),

January 15, 1942, Fort Mills, in Francis B. Sayres Papers, Manuscript Division, Library of Congress, Washington, D.C.

274 **"We have informed your families":** DH, telegram to MJ and AWJF, January 21, 1942, New York, NY, in Francis B. Sayres Papers, Manuscript Division, Library of Congress, Washington, D.C.

274 **The first of Mel's cables:** MJ, "Philippines Cable No. 65," January 18, 1942, Corregidor, the Philippines.

275 **Mel's second "magnificent" dispatch:** MJ, "Manila Cable No. 66," January 18, 1942, with USAFFE headquarters, Corregidor, the Philippines.

276 **"On Bataan, Mel":** *Melville Jacoby: 1916–1942* (memorial pamphlet), Division of Journalism, Stanford University, Palo Alto, CA, 1942, p. 8.

276 **What Mel was hearing:** "Jack Can't Get a Date on His Birthday" (episode synopsis for *The Jack Benny Show*), available at Jack Benny in the 1940s, "The 1941–1942 Season," sites.google.com/site/jackbennyinthe1940s/Home/1941-1942-season.

278 **"Annalee will be able":** Churchill, "Bull Session," February 23, 1942.

278 **"There is keenest rivalry":** MJ, "Philippines Cable No. 72," February 1, 1942, Bataan, the Philippines.

279 **"Do you want to go":** MJ, "In the Air Somewhere in Australia," pp. 1–2.

281 **"must have been boiling":** MJ, "This Is Our Battle," p. 21.

284 **"I believe you will make it":** MJ, "In the Air Somewhere in Australia," p. 2.

284 **"We could say goodbye":** Ibid., p. 1.

285 **"I will be very busy":** MJ, "Corregidor cable—Part I" (cable to DH), February 23, 1942, received over telephone from Army Radio, Corregidor, the Philippines.

285 **"We sit by":** MJ, "CEBU (Philippines) Cable" (cable to DH), March 17, 1942, somewhere in the Philippines.

286 **"impregnable as the mountain":** Ibid., p. 1.

287 **"It was hard to realize":** Charles Van Landingham, "Escape from Bataan," *Saturday Evening Post,* October 3, 1942, p. 63.

288 **"too bright moon":** MJ, "In the Air Somewhere in Australia," p. 2.

289 **"We talk very little":** Ibid.

Chapter 11: False Convoy

292 **"Two Japanese cruisers":** AWJF, "Ours Is Full of Holes," p. 39.

292 **Once scouts:** MJ, "In the Air Somewhere in Australia," p. 5.

294 **"We heard the same thing":** AWJF, "Ours Is Full of Holes," p. 39.

294 **"We stuffed ourselves":** Van Landingham, p. 63.

294 **Wine flowed readily:** MJ, "In the Air Somewhere in Australia," p. 6.

295 **"It was warm":** Van Landingham, p. 63.

295 **"Each little fishing boat":** MJ, "In the Air Somewhere in Australia," p. 6.

296 **"Every night on the ship":** AWJF, April 10, 1942 letter.

297 **wearing Mickey Mouse:** MJ, "CEBU (Philippines) Cable," p. 7.

297 **"They are short on food":** Ibid.

299 **On the third day:** Lee, *They Call It Pacific,* p. 255.

300 **"We had forgotten there"**: Ibid.

300 **As soon as the *Princesa*:** MJ, "In the Air Somewhere in Australia," p. 6.

300 **"Fine. Travelling":** Anne Whitmore, letter to ESM and MM, February 27, 1942.

300 **In Los Angeles:** MJ, telegram to ESM and MM, February 27, 1942, Cebu, the Philippines.

301 **In Barili:** Lee, *They Call It Pacific*, p. 256.

303 **"Cebu brought back":** Van Landingham, p. 63.

303 **"It is amazing":** MJ, "Background on Cebu" (cable to DH), April 11, 1942.

304 **Cebu City seemed:** Lee, *They Call It Pacific*, p. 256.

305 **"jittery as race colts":** MJ, "Background on Cebu."

305 **532-foot light cruiser:** Bob Hackett and Sander Kingsepp, "IJN Kuma: Tabular Record of Movement" (revision 9), 2014, available at: Junyokan! Stories and Battle Histories of the IJN's [Imperial Japanese Navy's] Cruiser Force, combinedfleet.com/kuma_t.htm.

305 **The shelling destroyed:** Kemp Tolley, "Target: Corregidor," *World War II Journal* 5, ed. Ray Merriam (Bennington, VT: Merriam Press, 1999), p. 22.

306 **"One [shell] struck":** Van Landingham, p. 63.

306 **"postcard beauty":** MJ, "In the Air Somewhere in Australia," p. 7.

307 **Given as much privacy:** Lee, *They Call It Pacific*, p. 257.

307 **Mel described Elza's gardens:** AWJF, "Dear Mother and Dad #2," letter.

309 **"The moon rising, shadows":** MJ, "In the Air Somewhere in Australia," p. 7.

309 **"progressing as rapidly":** AWJF, Cable to DH, Feb. 28, 1942, Cebu, the Philippines.

311 **"All kinds of men make up":** MJ, "Corregidor Cable No. 79," p. 267.

311 **"We keep thinking":** AWJF, April 10, 1942 letter.

312 **"Some of the most courageous":** Tolley, p. 22.

312 **At first, Cebu:** "Report of Army Transport Service in Philippines. 8 Dec 1941–6 May 1942," Records Relating to War Support Services, 1941–1947, Records of the Adjutant General's Office, 1917– [AGO], RG 407, National Archives, College Park, MD.

313 **Pons had led:** "Blockade Runner: Gallant Captain Outwits Japs in Small Philippine Freighter," *San Francisco Chronicle*, November 6, 1942.

313 **Colonel Alexander Johnson:** Gibson and Gibson, *Over Seas*, p. 249.

313 **Pons, who had been:** Van Landingham, p. 65.

313 **At 4:00 A.M. on March 10:** Lee, *They Call It Pacific*, p. 259.

315 **"Don't be damn fools":** Ibid., p. 260.

315 **Doña Nati's crew:** Fadiman, July 31, 2014 conversation.

316 **"cross-legged, cross-fingered":** MJ, "In the Air Somewhere in Australia," p. 8.

317 **"like a brick chimney":** Ibid.

317 **No planes came, but:** Van Landingham, p. 63.

318 **Pons later said:** *San Francisco Chronicle*, "Blockade Runner."

318 **"To me, the trip":** Van Landingham, p. 65.

320 **On that anxious night:** Lee, *They Call It Pacific,* p. 266.

320 **Captain Pons told:** Ibid., p. 267.

321 **"right through a hornet's":** MJ, "In the Air Somewhere in Australia," p. 9.

321 **Pons was trying to:** *San Francisco Chronicle,* "Blockade Runner."

322 **Annalee filed:** MJ, "In the Air Somewhere in Australia," p. 9.

322 **"I only wish":** DH, letter to ESM, March 16, 1942, New York.

322 **On the morning:** "USN Deck Log *USS Lexington* March 1942," USN Deck Logs, Records of the Bureau of Naval Personnel, 1798–2007, RG 24, National Archives, College Park, MD.

323 **"With little to do":** MJ, "This Is Our Battle" (unpublished manuscript), March 18, 1942, Somewhere at Sea, p. 1.

324 **that same night:** *USS Lexington* Deck Log.

325 **Mel noted that none:** MJ, "In the Air Somewhere in Australia," p. 10.

325 **Crewmen played:** Ibid.

325 **"I wish I knew":** DH, memorandum to F. D. Pratt, Time Inc., March 30, 1942, New York, NY, p. 1.

326 **Around the same time:** DH, letter to Selective Service headquarters, Local Board 98, March 23, 1942.

326 **"We had come far enough":** MJ, "In the Air Somewhere in Australia," p. 11.

327 **"Our first glimpse of the country":** Ibid.

Chapter 12: "Almost Too Good to Be True"

328 **"No details yet":** DH, March 30, 1942 memorandum, p. 1.

329 **Shortly after the *Doña Nati:*** MJ, "Personal Statement by Alien Passenger," Commonwealth of Australia.

329 **After filling out the forms:** Lee, *They Call It Pacific,* p. 269.

330 **"In Bataan at night":** MJ, "In the Air Somewhere in Australia," p. 1.

331 **"I found, you know":** THW, letter to family, June 12, 1942, somewhere in the Indian Ocean, copy courtesy of Heyden White Rostow.

332 **"*Time*'s Corregidor correspondent":** THW, cable to Robert Haas and Bennett Cerf, undated (April, 1942), Melbourne, Australia.

332 **"There are a lot of familiar":** MJ, "Melbourne Cable" (cable to DH), April 9, 1942.

332 **"Unbelievably in months":** "Philippine Epic" (Composite Story), *Life,* April 13, 1942.

334 **All the comforts:** AWJF, April 10, 1942 letter.

335 **"At last Bataan fell":** "Bataan Wounded Lived with Pain," *Life,* April 20, 1942, p. 33.

335 **"If ever men were":** MJ, "Melbourne Cable," p. 1.

336 **"In Australia we saw":** AWJF, "Ours Is Full of Holes," p. 39.

336 **"Being married is wonderful":** AWJF, April 10, 1942 letter.

338 **But when the announcer:** *March of Time,* radio rebroadcast, May 17, 1942.

339 **"Indeed, it was a case":** Allison Ind, *Bataan: The Judgment Seat,* New York: Macmillan, 1944, p. 373.

340 **"short hop":** Lee, *They Call It Pacific,* radio adaptation from "Words at War," NBC, July 10, 1943, available at: archive.org/details/WordsAtWar_995.

340 **Two days before:** "Jacoby, M., Correspondent Killed in Crash, Gave His $1,600 Savings to Chinese Relief," *Evening Star* (Washington, D.C.), April 30, 1942.

340 **Before Mel left:** Romulo, p. 315.

341 **"[Mel and Annalee] had":** Diller, February 2, 1944 letter.

342 **"had narrow escapes":** MJ, "In the Air Somewhere in Australia," p. 12.

343 **"We heard of unspeakable":** Romulo, p. 314

343 **"I hope something":** MJ, cable to DH, April 8, 1942, Melbourne, Australia.

344 **"manly, handsome":** Ind, p. 375.

344 **"especially dark":** AWJF, cable to DH, May 28, 1942, p. 4.

346 **Lieutenant Jack Dale:** Bob Alford, *Darwin's Air War: 1942–1945: An Illustrated History* (Knoxville, TN: Coleman's Printing, 2011).

348 **Colonel Ind recounted:** Ind., p. 377.

Chapter 13: Soldier of the Press

349 **Early in the morning:** AWJF, telegram to ESM, April 30, 1942, Melbourne, Australia.

351 **But Annalee was furious:** Fadiman, July 31, 2014 conversation.

352 **"Mel's career was":** THW, letter to ESM, May 28, 1942, p. 2, Melbourne, Australia.

352 **"I think that those last weeks":** Fadiman, July 31, 2014 conversation.

352 **"When we heard":** THW, May 28, 1942 letter, p. 2.

352 **Finally, one afternoon:** THW, letter to Mary White, June 12, 1942, Somewhere in the Indian Ocean, p. 1.

354 **"There is nothing":** AWJF, letter to ESM, date unknown (probably late May or June 1942).

355 **"There was so many":** Ibid.

356 **She instantly felt:** AWJF, "Dear Mother and Dad #2."

357 **"spent an hour in a movie":** Ibid.

359 **He died almost immediately:** "Whitmore Rites Today" (news clipping from unknown publication), October 1942.

359 **Tom Seller:** Thomas Seller, letter to ESM, January 24, 1943, p. 1.

359 **1943 Veronica Lake:** "So Proudly We Hail: Realistic Story in the Philippines Draws on 'LIFE' Pictures for Authentic Detail," *Life,* October 4, 1943, p. 69.

360 **On the afternoon:** C. Mydans, personal notes, "Dec. 31, 1943," in Notebook 6 (courtesy of the Mydans' family).

361 **Shortly after Leland's:** S. Mydans, "Book-of-the-Month Author," p. 6.

361 **Among the interned:** Fadiman, July 31, 2014 conversation.

361 **Annalee persuaded her mother:** Fadiman, email to the author, August 1, 2014.

362 **"She would really have":** Fadiman, July 31, 2014 conversation.

362 writing Pacific and Asia: S. Mydans, "Annalee Jacoby," p. 6.

363 "Inflation had increased": MacKinnon and Friesen, *China Reporting,* p. 51.

363 "After all this censorship": Fadiman, July 31, 2014.

365 "It was more than destiny": "Philippine Epic."

365 "Somehow, I feel there": THW, letter to ESM, May 29, 1947, New York, NY, p. 2.

366 "It was a remarkable": Walter Sullivan, "1983: . . . The Crucial 1940's," *Nieman Reports* (Spring 1983), niemanreports.org/articles/1983-the-crucial-1940s/.

366 In 1985, Annalee: "Memories Come Flooding Back as Chongqing Is Revisited," *China Daily,* April 10, 1985, chinadaily.com.cn/epaper/html/cd/1985/198504/19850410/19850410004_1.html.

367 But Annalee: Fadiman, July 31, 2014 conversation.

368 "There is a tremendous": MJ, letter to HRL, January 28, 1942, Corregidor, the Philippines.

368 "I've often wondered": Fadiman, July 31, 2014 conversation.

Epilogue

372 "I remember it like": Peggy S. Cole, interview, May 30, 2013.

373 "He was wealthy, handsome": Ibid.

INDEX